500 CERAMIC SCULPTURES

500 CERAMIC SCULPTURES

CONTEMPORARY PRACTICE, SINGULAR WORKS

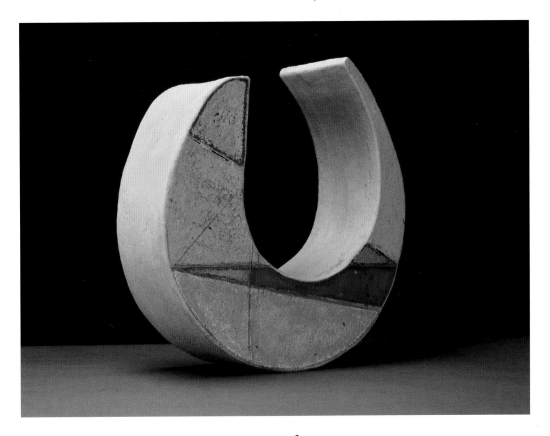

LARK
BOOKS

A Division of Sterling Publishing Co., Inc.
New York / London

SENIOR EDITOR
Suzanne J. E. Tourtillott

EDITOR
Julie Hale

ART DIRECTOR
Matt Shay

COVER DESIGNER
Matt Shay

FRONT COVER
Jeff Kaller *Cone Form*, 2007

SPINE
Conor Wilson *Capellino Stupito*, 2007

BACK COVER, CLOCKWISE FROM TOP LEFT
Jamin London Tinsel *The Blue Child, The Green Child*, 2006

Michael A. Gregory *Untitled: Object in Space*, 2007

Katy Rush *Nourish*, 2007

Andy Rogers *Seed Pod*, 2008

Ruth Borgenicht *Rosette*, 2005

FRONT FLAP, FROM TOP
Peter Beard *Disc*, 2007

Jared Janovec *An Understatement of Life*, 2006

BACK FLAP, FROM TOP
Michelle Tobia *Corner Study: Convergence #17*, 2005

Scott Bennett *Strut*, 2005

TITLE PAGE
Siddiq Khan *Cipher C*, 2007

OPPOSITE
John Williams *Contour Globe*, 2008

Library of Congress Cataloging-in-Publication Data

Tourtillott, Suzanne J. E.
 500 ceramic sculptures : contemporary practice, singular works /
Suzanne J. E. Tourtillott.
 p. cm.
 Includes index.
 ISBN 978-1-60059-247-8 (pb-pbk. with flaps : alk. paper)
 1. Ceramic sculpture--21st century. I. Title. II. Title: Five hundred
ceramic sculptures.
 NK3940.T68 2009
 735'.24--dc22

 2008035488

10 9 8 7 6 5 4 3 2 1

First Edition

Published by Lark Books, A Division of
Sterling Publishing Co., Inc.
387 Park Avenue South, New York, NY 10016

Text © 2009, Lark Books
Photography © 2009, Artist/Photographer

Distributed in Canada by Sterling Publishing,
c/o Canadian Manda Group, 165 Dufferin Street
Toronto, Ontario, Canada M6K 3H6

Distributed in the United Kingdom by GMC Distribution Services,
Castle Place, 166 High Street, Lewes, East Sussex, England BN7 1XU

Distributed in Australia by Capricorn Link (Australia) Pty Ltd.,
P.O. Box 704, Windsor, NSW 2756 Australia

If you have questions or comments about this book, please contact:
Lark Books
67 Broadway
Asheville, NC 28801
828-253-0467

Manufactured in China

ISBN 13: 978-1-60059-247-8

For information about custom editions, special sales, premium and cor-
porate purchases, please contact Sterling Special Sales Department at
800-805-5489 or specialsales@sterlingpub.com.

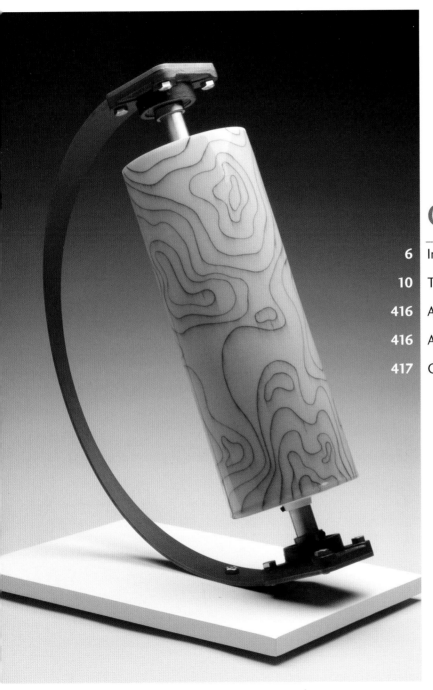

Contents

Diverse Directions

As the images in *500 Ceramic Sculptures: Contemporary Practice, Singular Works* attest, contemporary ceramic sculpture is the very picture of diversity. Examples run the gamut from naturalism to non-representation, include every format from free-standing object to installation, and span the spectrum of content from formalist self-reflection to cultural narrative and social critique. In mood, they can be carefree or brooding, contemplative or comical, passionately sensual or coolly standoffish. They may adopt a puritanical attitude toward materials or, on the contrary, become so enthralled with the possibilities of mixing media as to give the impression of indifference to clay. They may deliberately emphasize connections to centuries of vessel making or, conversely, be entirely oblivious to a utilitarian ceramics tradition. In short, there is little the field seems incapable of embracing.

The all-encompassing nature of contemporary ceramic sculpture is, I think, due largely to the curious fact that nothing ever seems to fall from favor. Some intriguing genres have emerged in recent years, but these have in general coexisted peacefully with the living legacy of abstract expressionism, funk, minimalism, eighties-style narrative figuration, and a variety of other longstanding traditions. Consequently, in selecting images for this book, I have sought to emphasize new genres, but not at the expense of those earlier forms of ceramic sculpture that still contribute to the definition of the field. Though I have oriented this survey toward the pole of innovation, my purpose in doing so has been primarily to compensate for the weight that familiarity lends to more established forms rather than to promote new movements.

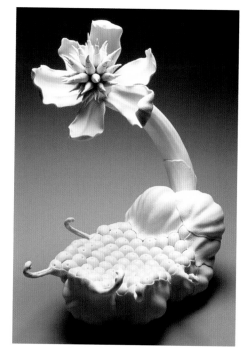

Lindsay Feuer
Hybrid 'Cluster' No. 7 | 2005

Determining what is actually new in contemporary ceramics is a task perhaps best left to future historians (who will, in any event, draw their own conclusions about our period regardless of any explanations we might offer). For that reason I will confine myself to a few observations on what I would describe as various characteristics of ceramic sculpture over the last several years without making any absolute claims about trends or final judgments regarding the importance of certain developments. The number of contradictions that

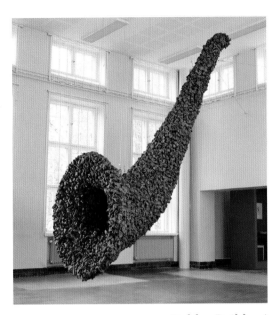

Pekka Paikkari
Scream | 2006

exist among types of contemporary ceramic sculpture—a consequence of the extreme diversity of styles, techniques, content, and media—makes any single characteristic, save diversity itself, representative of only a fraction of the overall field. These contradictions are not usually strategic in the way that avant-garde practices were once deliberate negations of the status quo. Rather, they seem to have arisen almost as a matter of course from a happy coalescence of the broad potential of clay and an increasingly elastic concept of what constitutes sculpture.

Reduction toward discrete, immediately graspable form typifies a great many contemporary ceramic sculptures. In the best of this work the effect is not of austerity but rather of conceptual complexity arising from material simplicity. Jeff Mongrain's haunting *An Evening's Breath* and Pekka Paikkari's imposing *Scream* represent the very poles of intimacy and monumentality, yet both employ simple forms to direct the mind onto endless paths of association. Monochromy, especially a transcendent, antiseptic white, is a reductive device similarly employed by many contemporary ceramic sculptors. This may—as in the case of Susan Schultz's ghostly allusions to Baroque still-life compositions or Walter McConnell's conical array of pale slip-cast figurines—involve representation. In other instances, for example Backa Carin Ivarsdotter's *Corridor*, or Michelle Tobia's *Corner Study: Convergence #17*, monochromy may signify that no representation is intended.

If a tendency toward reduction is common to much contemporary ceramic sculpture, this seems to coexist quite nicely with a contrary interest in decoration and ornament. Works such as Erin Furimsky's *Congruous* and Amy Chase's *Restless Countenance* even manage to adopt both orientations at once. Like reduction, decoration and ornament are themselves hardly new to ceramics, but one of the key points distinguishing the majority of current investigation of these elements is the degree to which contemporary ceramic sculpture frames them in relation to architecture rather than the vessel. In part, this has involved relating work to the walls, floors, and ceilings of exhibition sites, as in the case of Rain Harris's *Cherry Crush*, Tsehai Johnson's *Field #4*, or Robert Raphael's untitled works. In fact, one of the

benefits of considering relations among ceramics, ornament, and architecture has been a reinvigoration of the installation format.

Issues in architecture and urban planning serve as the focus of some of the most complex contemporary ceramic sculptures. Architectonics, ornament, and colonization in nature meld seamlessly as influences in the work of Neil Forrest, whose *Hiving Mesh* investigates the history of ceramics, the structures of living spaces, and a phenomenon known as particle packing. Architectural systems based on the repetition of units also inform other works, such as Nicholas Kripal's *W. S. Variation No. 5,* John Roloff's *Devonian Shale: Aquifer I,* and Dylan Beck's *A Modular City.* In each, the artist's consideration of potentially infinite modular systems leads to subversion of the stability ordinarily associated with order and opens channels onto the sublime.

Current interest in architectural systems is consistent with an affinity for natural structure in recent ceramic sculpture. The strange beauty of diagrams originating in microbiology and particle physics has evidently inspired much of this. David East's *Suburban Biochemical Transcription,* Jamie Walker's *Cloud #2,* and Timothy Van Beke's *Displacement,* for example, adopt the familiar format of space-filling molecular models. Many other sculptures represented in this book evoke the kinds of minute relations that are ordinarily evident only through microscopic inquiry. Gerhard Lutz's *Object, Three-Sphered,* Eva Zethraeus's *Bubble-Tipped Anemone,* and Hans Borgonjon's *Microtubuli x 4* all evoke impressions of diminutive fragility and complex order. Such works may allude to the symmetry of tiny parts in microorganisms, the recursive self-similarity of fractals, or the cagelike structures of certain molecules. Fascination with what recent science has unveiled about the basic structures of reality imbues much contemporary ceramic sculpture with an air of wonder and even optimism.

This optimism is, however, curiously at odds with the melancholy reflected by much contemporary ceramic sculpture of the human figure. Recurring images of fallen puppets, broken dolls, detached limbs, and gri-

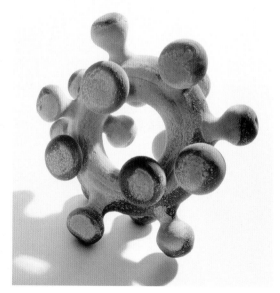

Eva Zethraeus
Bubble-Tipped Anemone | 2006

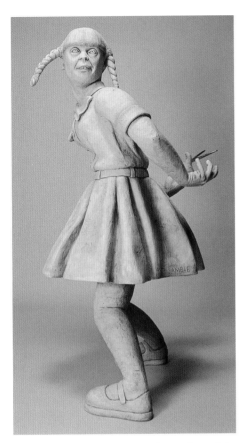

Misty Gamble
Nelly Has Scissors | 2006

macing faces bespeak an anguish and alienation that, while hardly new in art, have not until recently characterized ceramic sculpture. Anne Drew Potter's *Tar Baby Number Two*, Misty Gamble's *Nelly Has Scissors*, and Antigoni Pantazi's untitled work favor agitated psychological states over quiescence. Contemporary depiction of animals, as in the masterful works of Adelaide Paul and Beth Cavener Stichter, can be equally disturbing. Unlike their bronze counterparts in earlier centuries who fell to the claws of natural predators, when these sculpted creatures writhe in pain they direct unmistakable reproach to the hubris of science and the demagogic aspirations of human beings. An ominousness and pessimism about human motives plagues much contemporary figural ceramic sculpture, and one can only speculate whether this grimness or its psychological contrary in starry-eyed captivation by science and technology will someday be seen as the tenor of our times.

Such questions are, of course, born from the range of things one chooses to contemplate, whether these happen to be particular ceramic sculptures selected for a book or other quite different human activities and attitudes at a certain point in time. Defining such a range always involves a degree of concealment as well as revelation, and I freely admit that some genres of ceramic sculpture—in particular a craft-based and often whimsical narrative figuration—are less well represented in these pages than in the contemporary field as a whole. This and other discrepancies reflect value judgments that I have made, both for reasons stated above and in accordance with my own sense of what constitutes quality in ceramic sculpture. No doubt many very different surveys could have been formed from the approximately 7,500 images submitted for consideration. The 500 works that I have chosen to present are therefore understood to be both representative of the field and exclusive of certain aspects of it. Given the virtually all-inclusive nature of ceramic sculpture today, any juried body of work could hardly be otherwise.

–Glen R. Brown, Juror

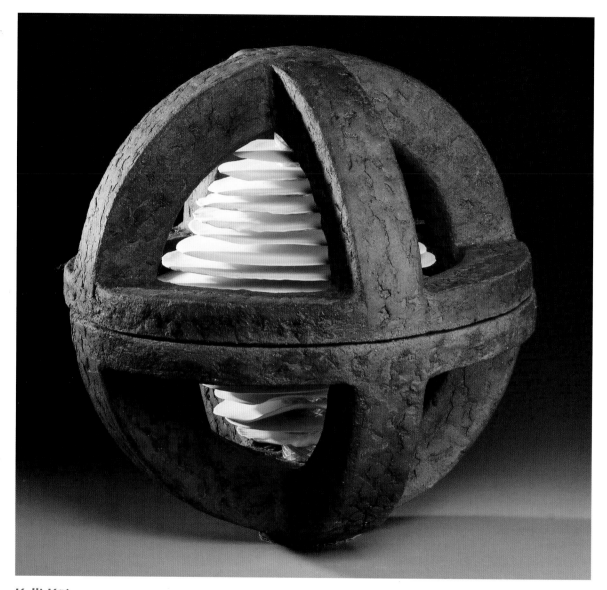

Kylli Kõiv

Memory | 2006

18¹/₂ X 18¹/₂ X 18¹/₂ INCHES (47 X 47 X 47 CM)

Hand-built stoneware and porcelain; wood fired, 2372°F
(1300°C); electric fired, 2300°F (1260°C)

PHOTO BY JUTA KÜBARSEPP

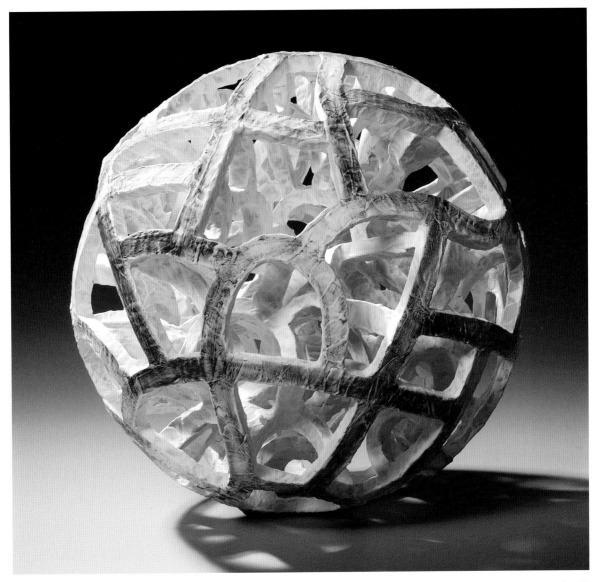

Lauri Kilusk
Connections | 2004
14⁹/₁₆ X 14⁹/₁₆ X 14⁹/₁₆ INCHES (37 X 37 X 37 CM)
Hand-built stoneware covered with porcelain;
electric fired, 2300°F (1260°C)
PHOTO BY MARTIN VUKS

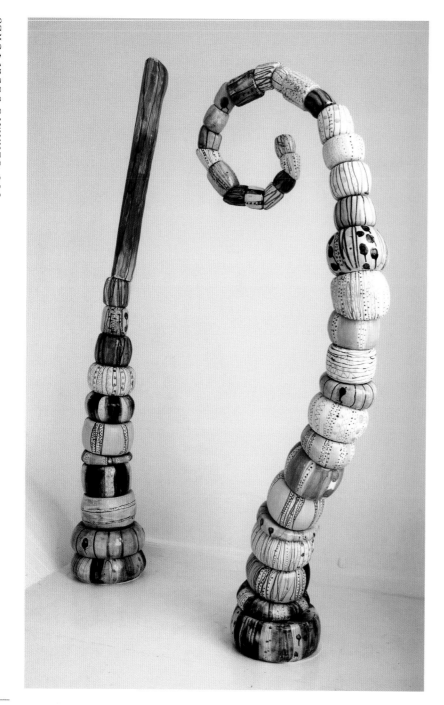

Sandy Brown
Prelude | 2006
HEIGHT, 154 INCHES (390 CM)
Slab-built grogged stoneware;
gas fired, cone 06; colored
glazes, cone 6; steel poles
PHOTOS BY JOHN ANDOW

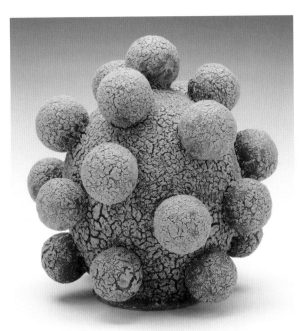

Virginia Scotchie
Chrome Ball/Knob | 2007

8 X 8 X 8 INCHES (20.3 X 20.3 X 20.3 CM)

Wheel-thrown and assembled stoneware;
electric fired, cone 6; glaze

PHOTO BY ARTIST

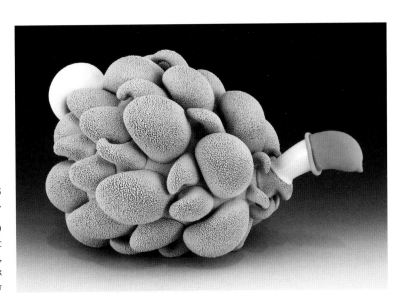

Joe Davis
Pumper | 2007

10 X 12⁹/₁₆ X 14⁹/₁₆ INCHES (25.5 X 32 X 27 CM)

Slip-cast and assembled porcelain; electric
fired, cone 6; textured engobes, glazes,
flocking, colored epoxy, latex

PHOTO BY ARTIST

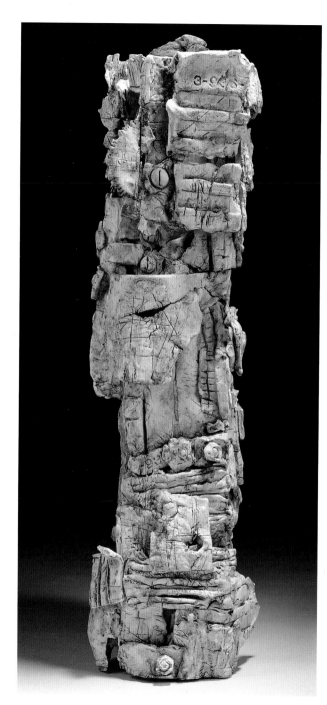

Chris Vicini

Untitled | 2006

30 5/16 X 11 3/8 X 10 5/8 INCHES (77 X 29 X 27 CM)

Hand-built and press-molded porcelain; oxidation fired, cone 10

PHOTO BY ARTIST

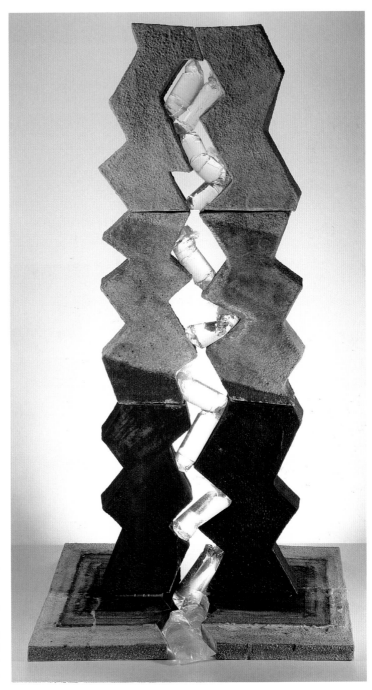

Güngör Güner
Untitled | 1999

TALLEST, 88⁷/16 X 23⁵/8 X 9¹³/16 INCHES
(225 X 60 X 25 CM)

Hand-built stoneware; natural-gas fired, 2102°F (1150°C); ash glaze; plastic bags filled with water

PHOTO BY ARTIST

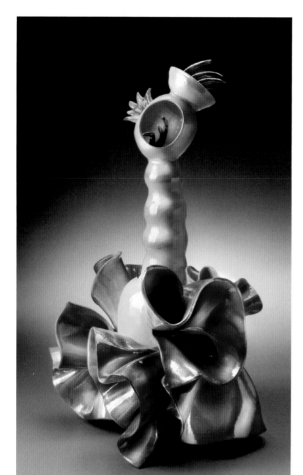

Linda Lighton
Ricci's Samba Partner | 2007
21 1/4 X 13 X 11 3/8 INCHES (54 X 33 X 29 CM)
White ware, thrown and hand-built fiber clay; electric fired, cone 2; glazes, cone 04; multiple luster firings, cone 017
PHOTO BY E.G. SCHEMPF

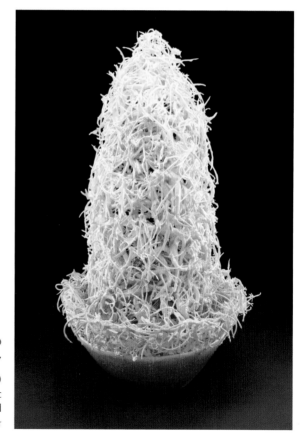

Yumiko Goto
Flora | 2007
27 9/16 X 12 9/16 X 12 9/16 INCHES (70 X 32 X 32 CM)
White stoneware, casting slip; electric fired, cone 03; glazed
PHOTO BY ARTIST

Jason Bige Burnett

Cherry Topper | 2007

7¹/₂ X 8 X 8 INCHES (19.1 X 20.3 X 20.3 CM)

Slip-cast porcelain and kiln element wire; electric fired, cone 06; underglazed, cone 04; underglaze, glazed, cone 04; laser jet decals, cone 06; doily

PHOTO BY BRYAN MOATS

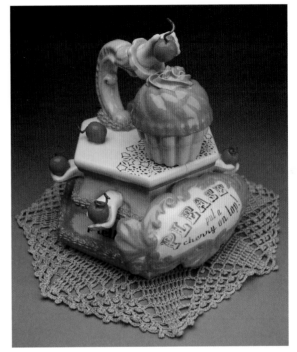

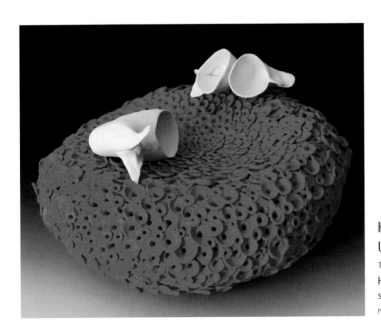

Keri Straka

Untitled | 2007

11 X 12 X 10 INCHES (27.9 X 30.5 X 25.4 CM)

Hand-built, coiled, and pinched stoneware; oxidation fired, cone 6

PHOTO BY ARTIST

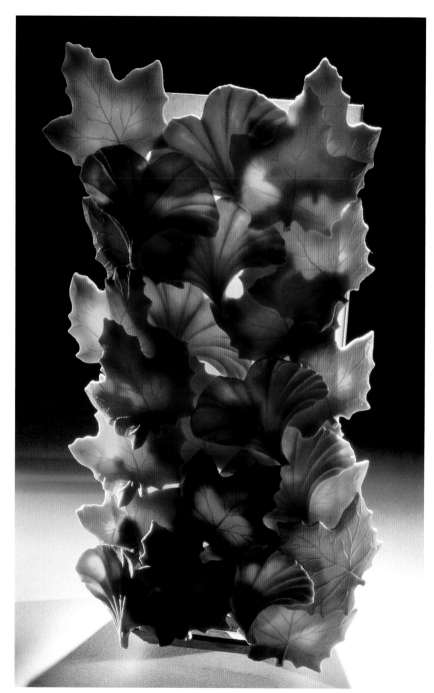

Curtis Benzle

Untitled | 2002

11 13/16 X 5 7/8 X 3 9/16 INCHES
(30 X 15 X 9 CM)

Press-molded porcelain;
electric fired, cone 8

PHOTO BY ARTIST

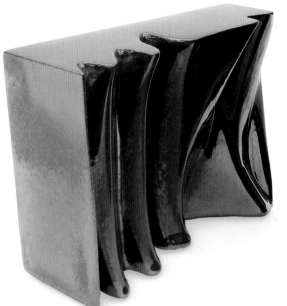
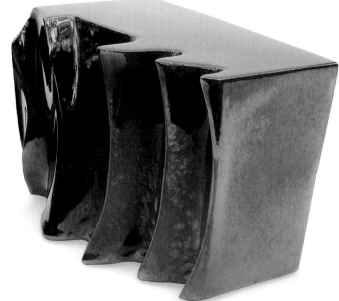

Ira Winarsky

Chasm | 2004

4⁵/₁₆ X 11 X 5¹/₂ INCHES (11 X 28 X 14 CM)

Slip-cast earthenware; electric fired,
cone 4; iridescent lusters

PHOTOS BY ARTIST

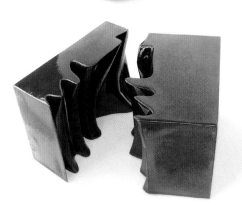

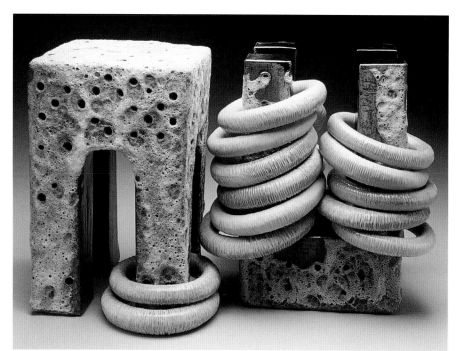

Todd Leech
Stephanie Craig
Choke | 2008

13³/₄ X 23⁵/₈ X 13³/₄ INCHES
(35 X 60 X 35 CM)

Hand-built stoneware; gas
fired in reduction, cone
10; electric fired, cone 6

PHOTO BY ARTIST

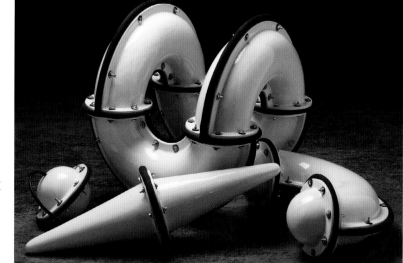

Derek Harding
Grouping | 2005
VARIOUS DIMENSIONS
Slip-cast porcelain; gas fired,
cone 10; rubber, steel
PHOTO BY KOHLER CO.

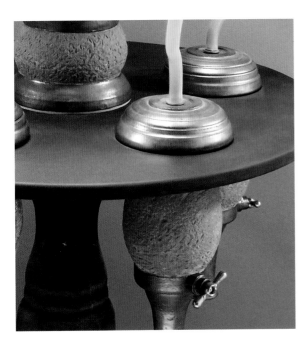

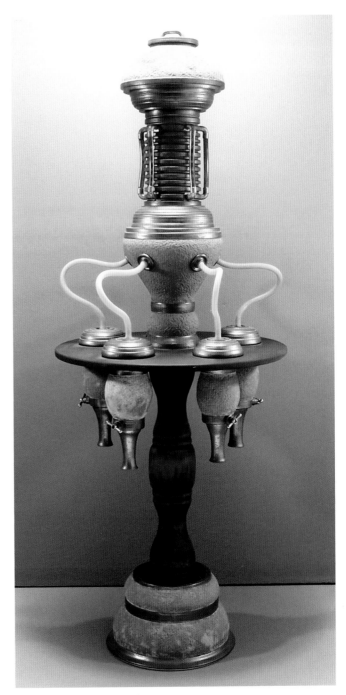

Todd Volz

Apparatus #6 | 2004

71 7/8 X 27 15/16 X 27 15/16 INCHES (183 X 71 X 71 CM)

Thrown and assembled stoneware; electric fired,
cone 08; glazed, cone 6; wood, latex hose

PHOTOS BY ARTIST

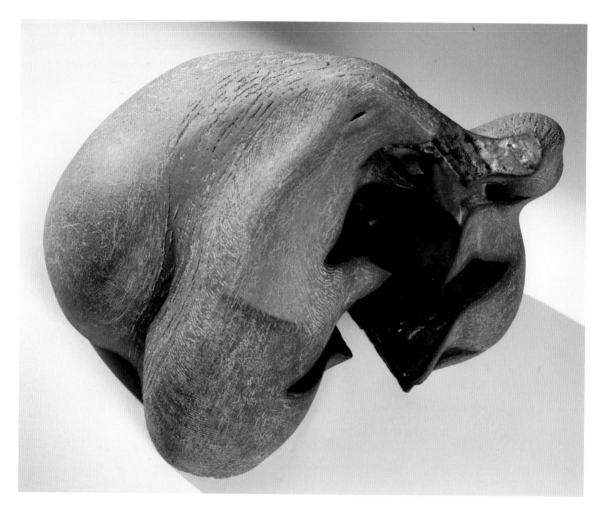

Natalia Dias

Dancing Cloud | 2007

18 1/8 X 15 5/16 X 13 3/4 INCHES (46 X 39 X 35 CM)

Raku clay, hand-built stoneware; electric fired, 2228°F (1220°C); glazed, 2228°F (1220°C)

PHOTOS BY ARTIST

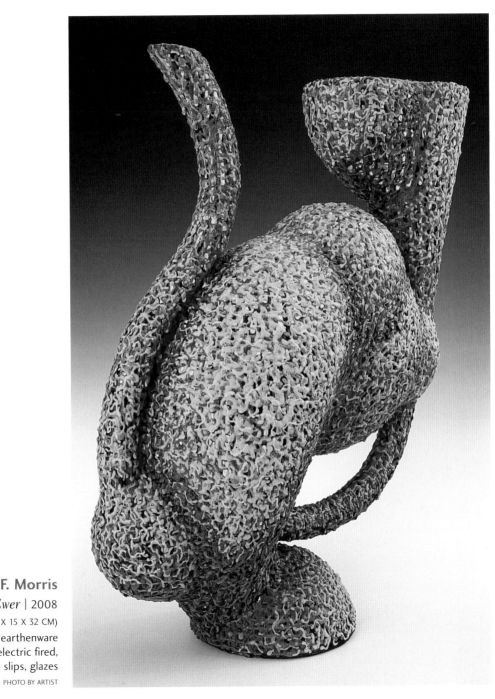

Paul F. Morris
Molto Caldo Ewer | 2008
16¹/₂ X 5⁷/₈ X 12⁹/₁₆ INCHES (42 X 15 X 32 CM)
Slab-built and assembled earthenware
with press-molded parts; electric fired,
cones 03–06; slips, glazes
PHOTO BY ARTIST

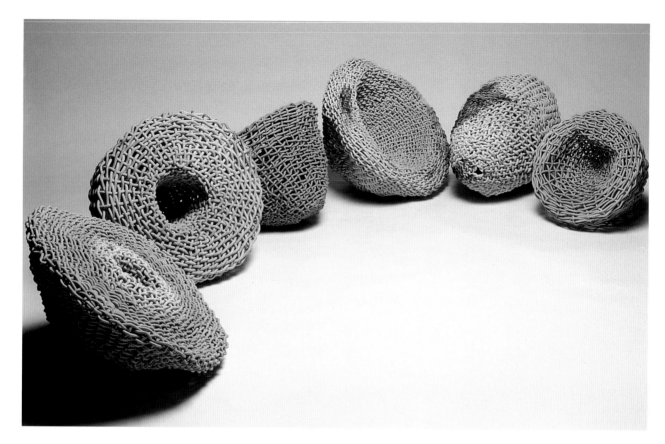

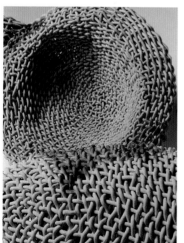

Phyllis Kudder Sullivan

Vortices | 2006

18 1/8 X 41 3/4 X 72 3/4 INCHES (46 X 106 X 185 CM)

Interlaced stoneware coils; electric fired, cone 7; pit fired

PHOTOS BY JOSEPH D. SULLIVAN

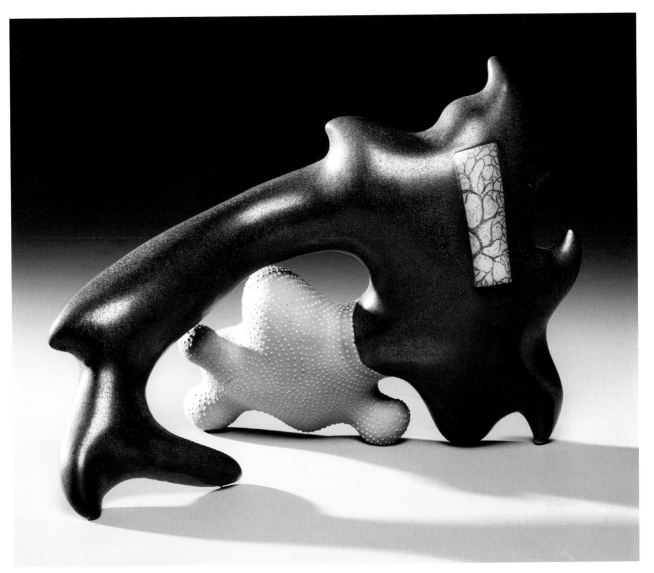

Kadri Pärnamets

Remind | 2007

9 13/16 X 13 3/8 X 6 5/16 INCHES (25 X 34 X 16 CM)

Slab- and hand-built stoneware; electric fired, 2300°F (1260°C);
bone china dots, drawing with pencil, 2300°F (1260°C); glazed

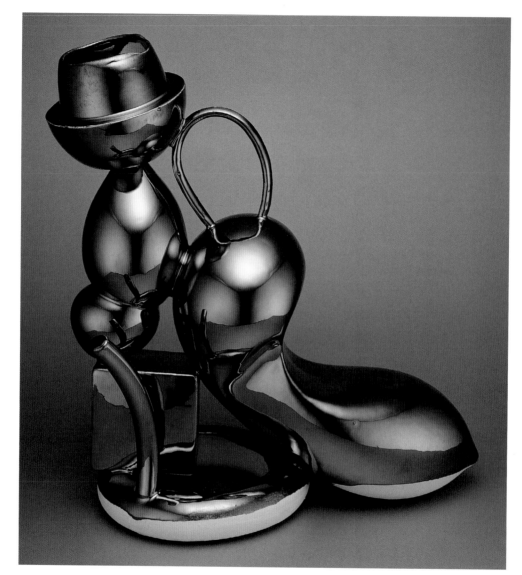

Sewon Minn

Balloon Teapot II | 2005

12 X 11 X 5 1/2 INCHES
(30.5 X 27.9 X 14 CM)

Slip-cast porcelain;
electric fired, cone 6

PHOTO BY ARTIST

Von Venhuizen

Tag Along | 2007

35 13/16 X 35 13/16 X 12 INCHES (91 X 91 X 30.5 CM)

Mixed media and wheel-thrown stoneware with press-molded additions; wood fired, cone 12; salt fired, cone 12; electric fired, cone 01

PHOTO BY ARTIST

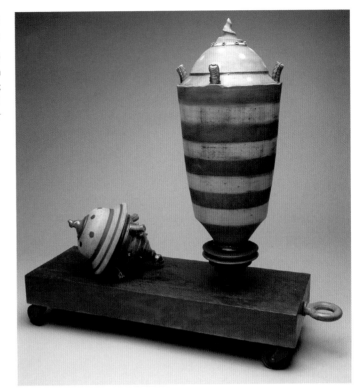

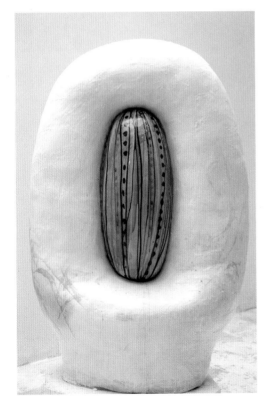

Sandy Brown

Genesis | 2007

62 7/8 X 47 1/4 X 27 9/16 INCHES (160 X 120 X 70 CM)

Hand-built grogged stoneware; gas fired, cone 06; colored glazes, cone 7

PHOTO BY ARTIST

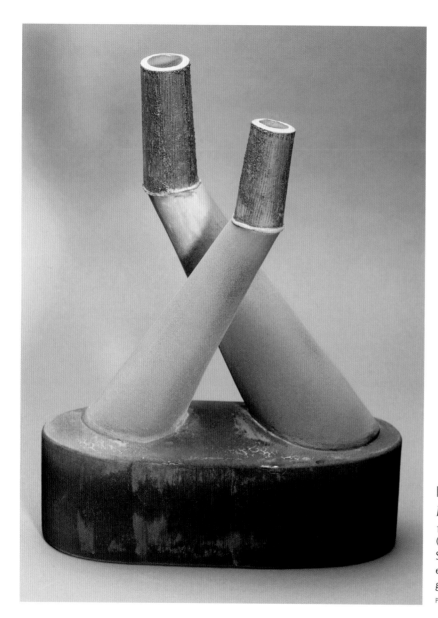

Lynn Duryea
Iron 2 x 2 | 2007

15 5/16 X 11 13/16 X 5 1/8 INCHES
(39 X 30 X 13 CM)

Slab-constructed terra cotta;
electric fired, cone 04; slips,
glazes; sandblasted

PHOTO BY TROY TUTTLE

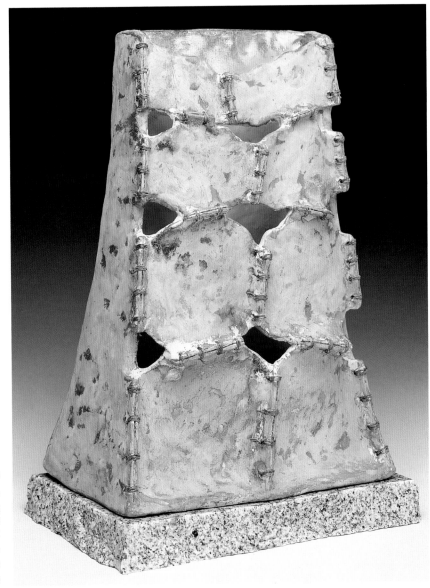

Maria Rudavska

Composition with Clouds III | 2006

14⁹/₁₆ X 10⁷/₁₆ X 5¹/₂ INCHES
(37 X 26.5 X 14 CM)

Terra cotta; electric fired, 2012°F
(1100°C); sewn with partially
gold-filled copper wire

PHOTO BY MILAN MATASOVSKY

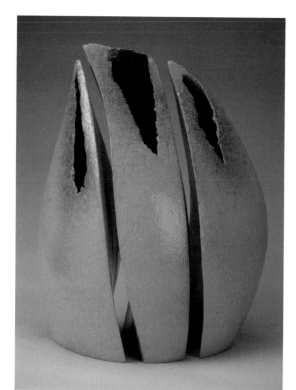

Vladica Sivčev

Togetherness | 2007

19¹¹/₁₆ X 16¹/₈ X 7¹/₁₆ INCHES (50 X 41 X 18 CM)

Coiled stoneware; electric fired, 2300°F
(1260°C); glazed

PHOTO BY PATRICK WATTEEUW

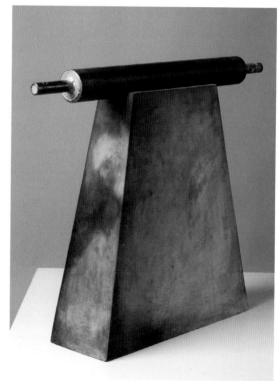

Mutlu Baskaya

Oppression | 2007

20⁷/₁₆ X 17¹¹/₁₆ X 6⁵/₁₆ INCHES (52 X 45 X 16 CM)

Grogged clay body; electric fired, cone 06;
smoke fired with paper, cone 019; applied
slip; metal rolling pin

PHOTO BY SERDAR PEHLIVAN

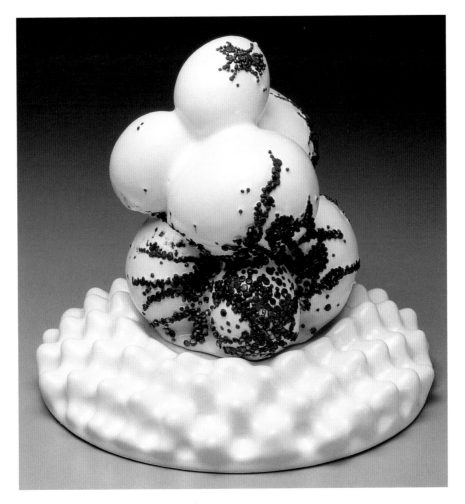

Sumi Maeshima
Flied Eggs | 2003

11 3/8 X 13 3/8 X 13 3/8 INCHES
(29 X 34 X 34 CM)

Press-molded and hand-built
earthenware with nails; electric
fired, cone 03

PHOTOS BY ARTIST

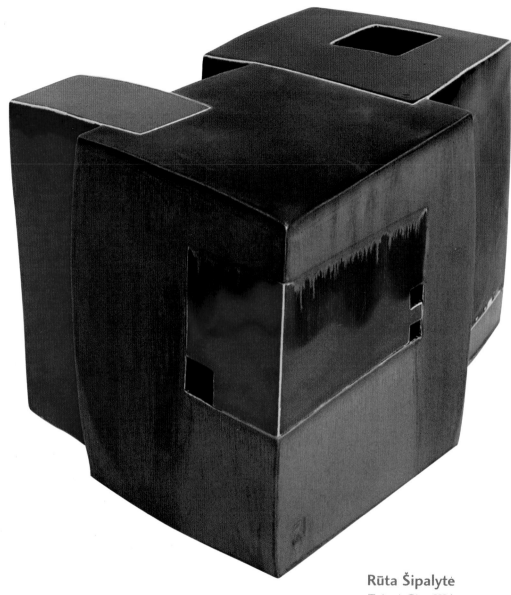

Rūta Šipalytė
Taipei City III | 2008
7¼ X 11 X 8¼ INCHES (18.5 X 28 X 21 CM)
Slab-built white clay; electric fired, 1652°F
(900°C); glazed, 1832°F (1000°C)
PHOTO BY ARTIST

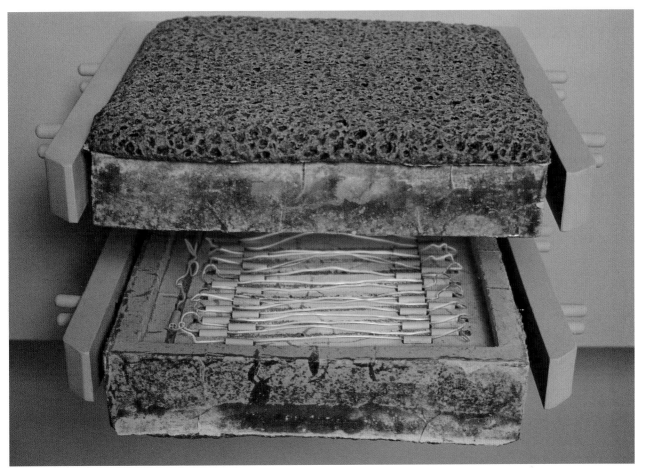

Susannah Biondo

Toys for Prometheus II | 2006

INSTALLATION

Cast lava glaze; electric fired, cone 04; porcelain,
kanthal wire, silver leaf, steel, various electronics

PHOTO BY JOE NUELLE

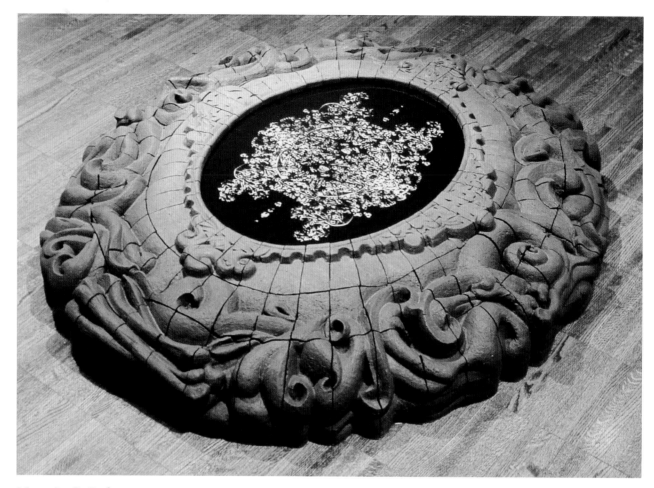

Mary Jo S. Bole

Ossified Alliance | 2003–2005

8 X 84 X 84 INCHES (20.3 X 213.4 X 213.4 CM)

Enamel on steel, Belden brick, terra
cotta; carved, fumed

PHOTO BY CHAS RAY KRIDER

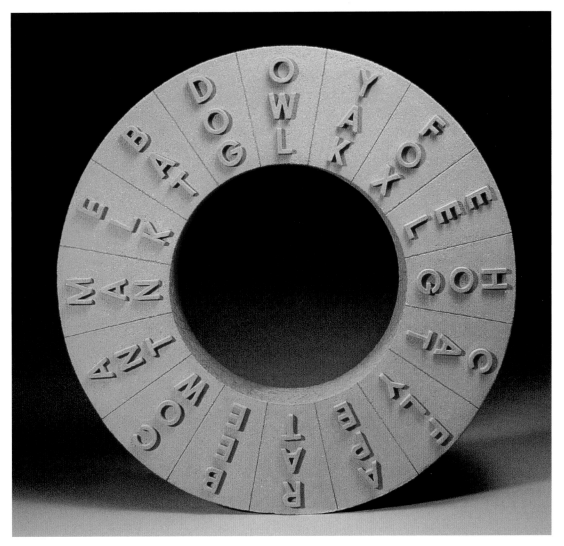

Steve Frederick

Game Marker #1 | 1990

16 X 60 X 6 INCHES (40.6 X 152.4 X 15.2 CM)

Earthenware; electric fired, cone 04

PHOTO BY JOSEPH GRUBER

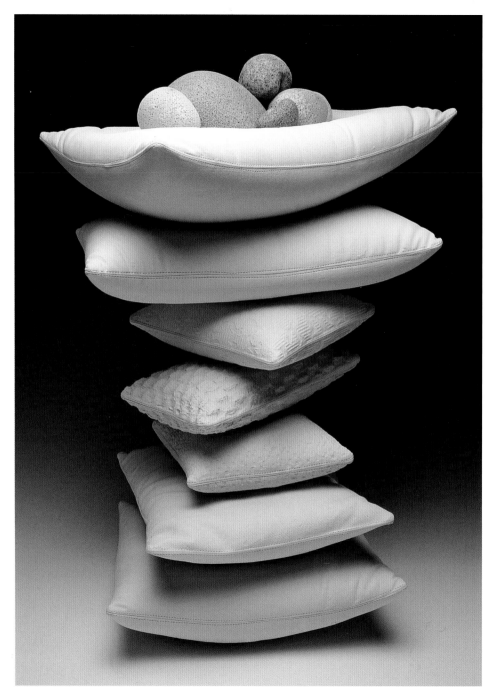

Mika Negishi Laidlaw

Rest | 2007

19 11/16 X 9 13/16 X 11 3/8 INCHES
(50 X 25 X 29 CM)

Slip-cast and press-molded
earthenware; electric fired,
cone 01

PHOTO BY ARTIST

Nan Smith

Serendipity | 2006

11 X 11 ¹³⁄₁₆ X 13 INCHES (28 X 30 X 33 CM)

Slip-cast and press-molded earthenware;
electric fired, cone 03; glaze, cone 06;
photo decal, cone 09

PHOTO BY ALLEN CHEUVRONT

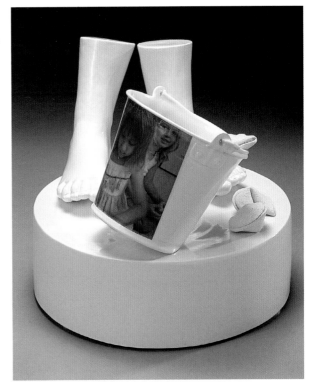

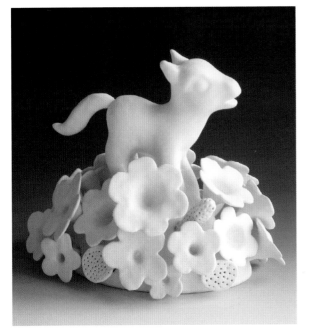

Lynda Draper

Dream Pony | 2007

6 ¹⁄₁₆ X 6 ¹¹⁄₁₆ X 5 ¹⁄₈ INCHES (15.5 X 17 X 13 CM)

Hand-built porcelaneous stoneware;
electric fired, cone 6; glazed

PHOTO BY ARTIST

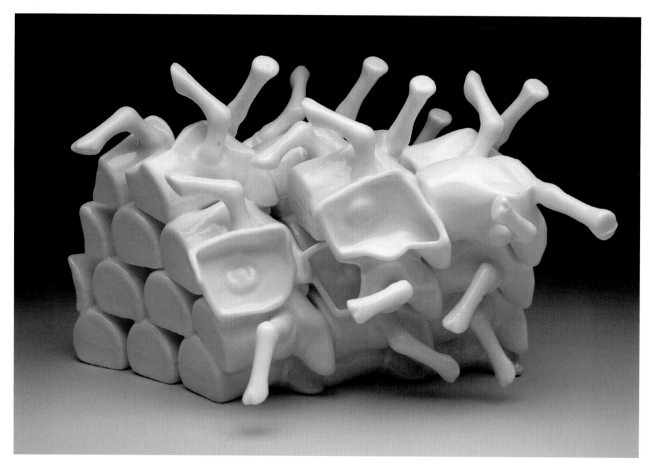

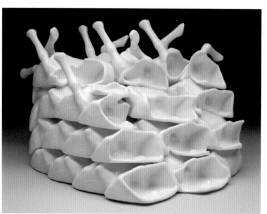

Dryden Wells

Stack–1 | 2007

9 1/16 X 9 1/16 X 9 1/16 INCHES (23 X 23 X 23 CM)

Slip-cast porcelain; gas fired, cone 11

PHOTOS BY WESLEY HARVEY

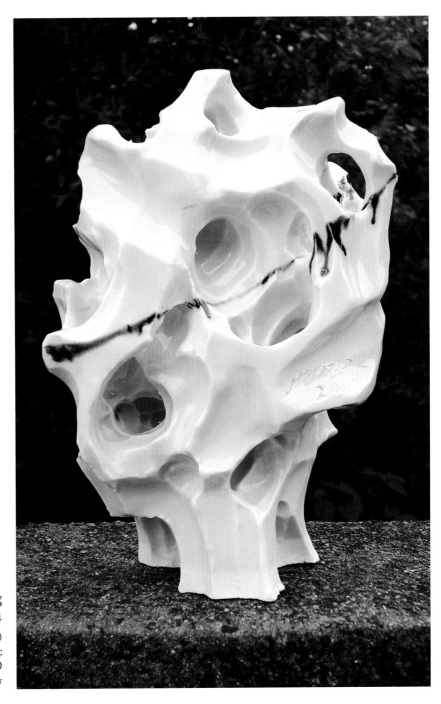

Bai Ming

Between Ceramics and Stone | 2004

8¹/₄ X 5⁷/₈ X 4¹/₈ INCHES (21 X 15 X 10.5 CM)

Porcelain, press-molded stoneware;
restored fired; gas fired, cone 10

PHOTO BY ARTIST

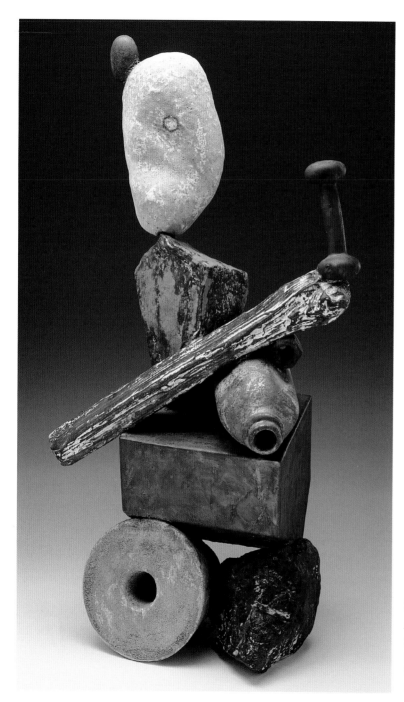

Steven Portigal

Alchymia (Two Pound) | 2004

27⁹/₁₆ X 12⁹/₁₆ X 9⁷/₁₆ INCHES (70 X 32 X 24 CM)

Press-molded, mid-range stoneware; electric fired, cone 4; electric fired, cone 08

PHOTO BY ANTHONY CUÑHA

Clive Tucker
A Twist of the Knob | 2003
30 11/16 X 18 1/2 X 24 13/16 INCHES (78 X 47 X 63 CM)

Thrown, hand-built, and slip-cast stoneware;
oxidation fired, cone 6; glazed; re-glazed and
re-fired to cone 04; steel bolts, wood, concrete

PHOTO BY ALEXANDER DUFF

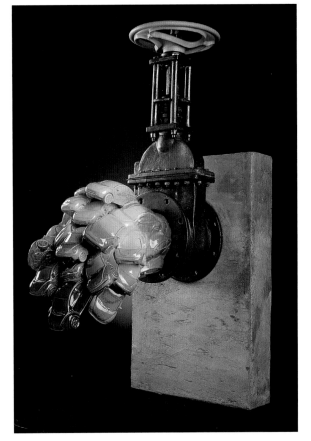

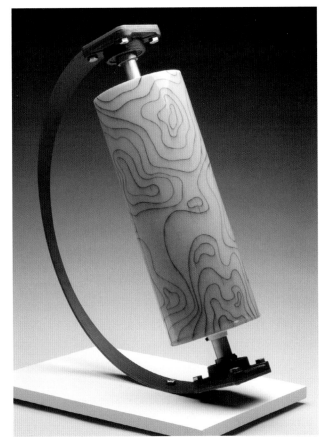

John Williams
Contour Globe | 2008
18 7/8 X 13 15/16 X 11 INCHES (48 X 35.5 X 28 CM)

Slip-cast porcelain; reduction fired,
cone 10; steel, wood

PHOTO BY ARTIST

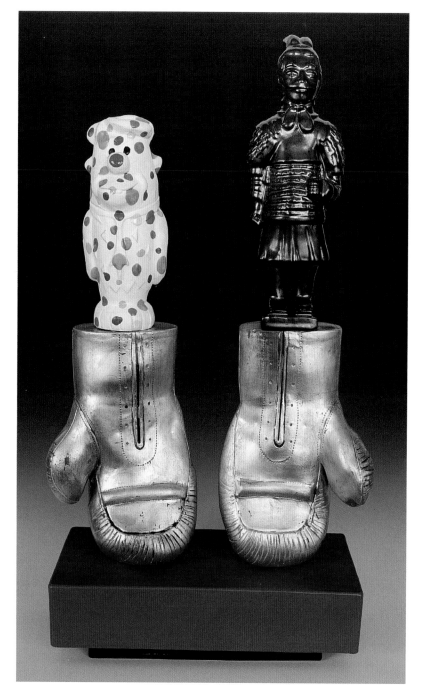

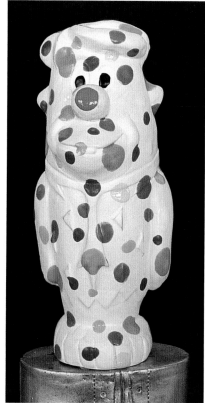

Billy R. Mayer
The Great Battle | 2007–2008
22⁷/₁₆ X 11¹³/₁₆ X 5⁷/₈ INCHES (57 X 30 X 15 CM)
Hand-formed earthenware; electric fired,
cone 06; glazes, gold leaf
PHOTOS BY ARTIST

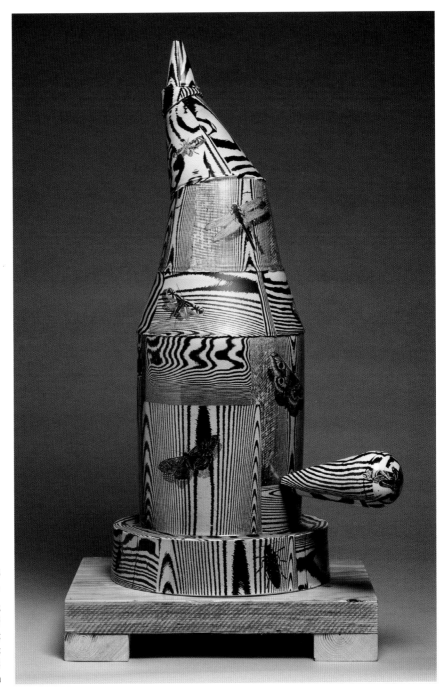

Vince Palacios
Alchemy Series: Crystalis | 2007

33⁷/₁₆ X 12³/₁₆ X 16¹⁵/₁₆ INCHES
(85 X 31 X 43 CM)

Wheel-thrown stoneware;
electric fired, cone 6; decals;
electric fired, cone 018

PHOTO BY LARRY DEAN

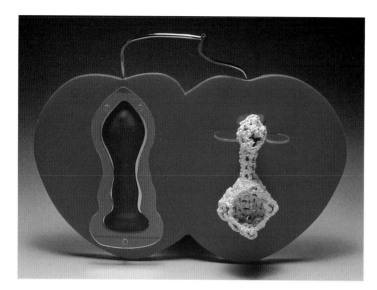

Robin Tieu

She Steams He Creams
We All Dream For I Scream | 2005

15 X 5 X 9 INCHES (38.1 X 12.7 X 22.9 CM)

Clay; electric fired, cone 6; slip, cutting board, acrylic, copper

PHOTO BY ARTIST

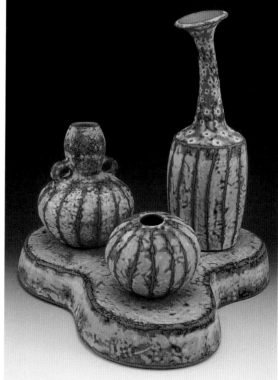

Jeffrey Nichols

Blue/Red Still Life | 2007

10¹/₂ X 10 X 10 INCHES (26.7 X 25.4 X 25.4 CM)

Wheel-thrown, altered, and hand-built earthenware; electric fired; bisque fired, cone 02; glazed, cone 04; colored engobes

PHOTO BY ARTIST

Richard Shaw

Pastel Cabin on a Paintbox | 2007

8¹/₂ X 18 X 11 INCHES (21.6 X 45.7 X 27.9 CM)

Cast and hand-built porcelain; glaze fired,
cone 6; overglaze decals, cone 018

PHOTO BY CHARLES KENNARD

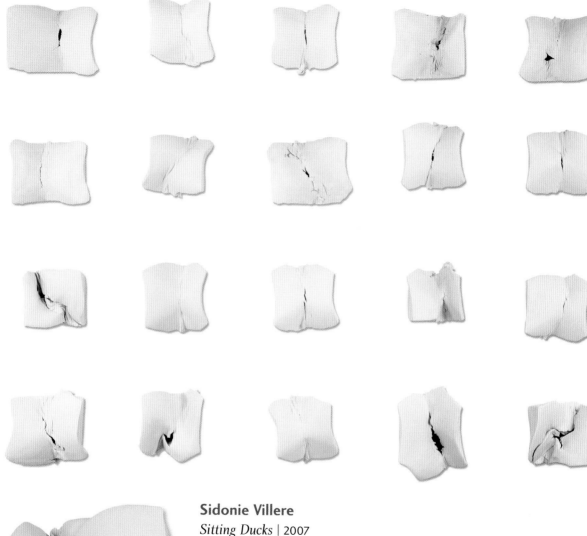

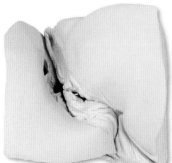

Sidonie Villere

Sitting Ducks | 2007

LARGEST, 3 X 14 X 2 INCHES (7.6 X 35.6 X 5.1 CM)

Hand-built stoneware; electric fired, cone 6; unglazed; gauze, paraffin, gold leaf

PHOTOS BY MICHAEL SMITH

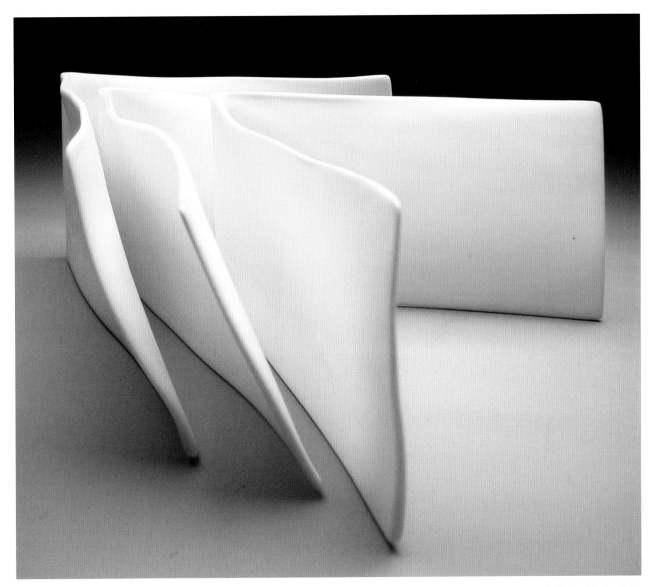

Michelle Tobia

Corner Study: Convergence #17 | 2005

4 X 12 X 14 INCHES (10.2 X 30.5 X 35.6 CM)

Slip-cast porcelain; gas fired in reduction, cone 10

PHOTO BY ARTIST

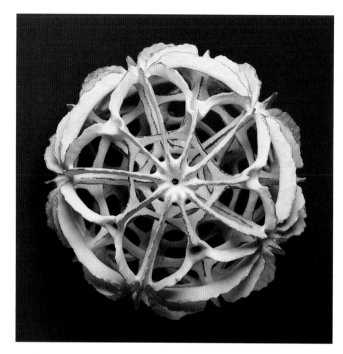

Gerhard Lutz

Object, Three-Sphered | 2002

DIAMETER, 7⁷/₈ INCHES (20 CM)

Porcelain, gold; electric fired, 1652°F (900°C);
glaze, 2246°F (1230°C); model built

PHOTO BY ARTIST

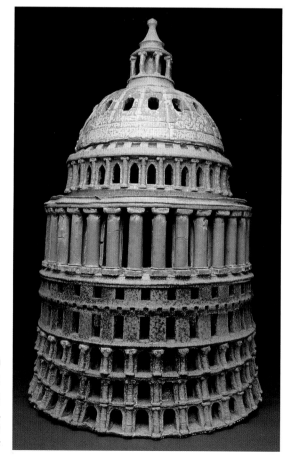

Denny Gerwin

Post-Capitol Entertainment | 2006

42 X 24 X 24 INCHES (106.7 X 61 X 61 CM)

Wheel-thrown stoneware; wood fired,
cone 12; soda fired, cone 10

PHOTO BY ARTIST

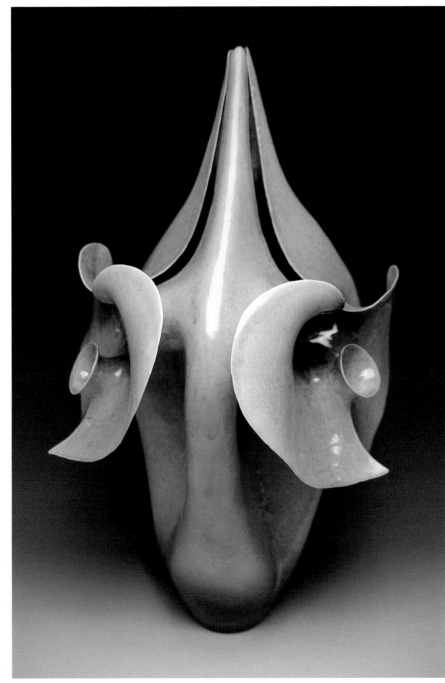

Les Laidlaw
Delbina | 2006
27 15/16 X 15 7/16 X 15 7/16 INCHES
(71 X 39.2 X 39.2 CM)
Thrown, altered, and hand-
built stoneware; electric fired,
cone 5; crystalline glaze
PHOTO BY ARTIST

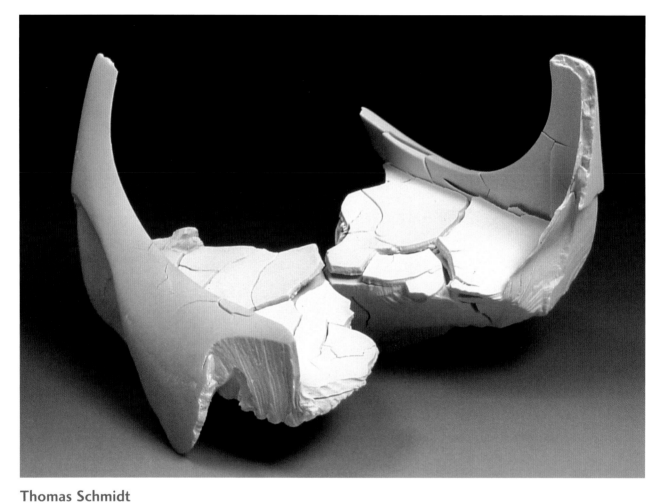

Thomas Schmidt

A Held Moment | 2006

9⁷/₁₆ X 14¹⁵/₁₆ X 12⁹/₁₆ INCHES (24 X 38 X 32 CM)

Solid-cast and altered porcelain;
electric fired, cone 10

PHOTO BY ARTIST

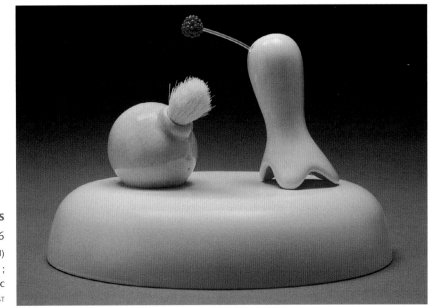

Shane Harris
Untitled | 2006
4 11/16 X 4 11/16 X 3 9/16 INCHES (12 X 12 X 9 CM)
Slip-cast stoneware; electric fired, cone 01;
glazed, cone 05; hair, paint, beads, plastic
PHOTO BY ARTIST

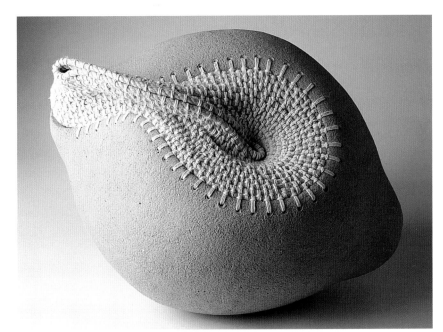

Veronique Maria
Emily | 1998
19 11/16 X 24 13/16 X 15 3/4 INCHES (50 X 63 X 40 CM)
Press-molded stoneware; electric
fired; sewn with hemp and linen
PHOTO BY JOSH PULMAN

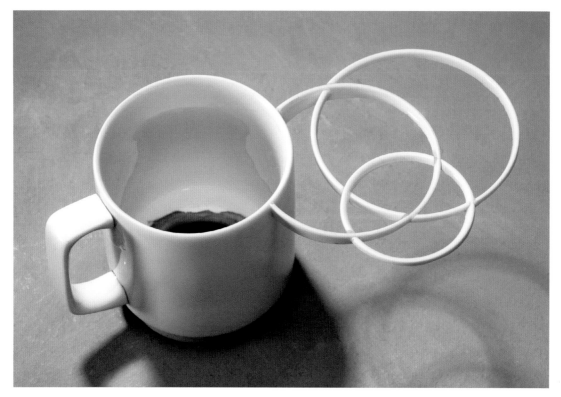

Kjell Rylander
Untitled | 2005
3⁹/₁₆ X 7¹/₁₆ X 3⁹/₁₆ INCHES (9 X 18 X 9 CM)
Ceramic readymades, cups, glue; sawed
PHOTO BY JANNE HOGLUND

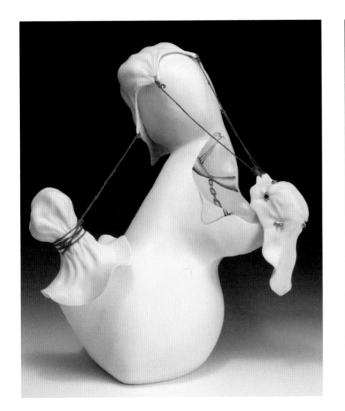

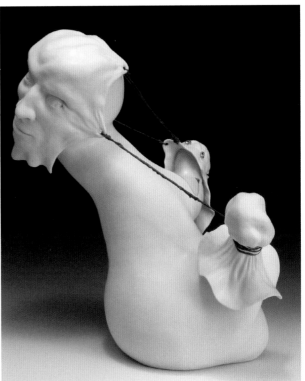

Darien O. Johnson
Untitled | 2007

31 7/8 X 14 3/16 X 9 13/16 INCHES (81 X 36 X 25 CM)

Hand-built porcelain; electric fired, cone 06; glazed, cone 6; china paint, cone 018; gold luster, cone 019; string with acrylic paint

PHOTOS BY ARTIST

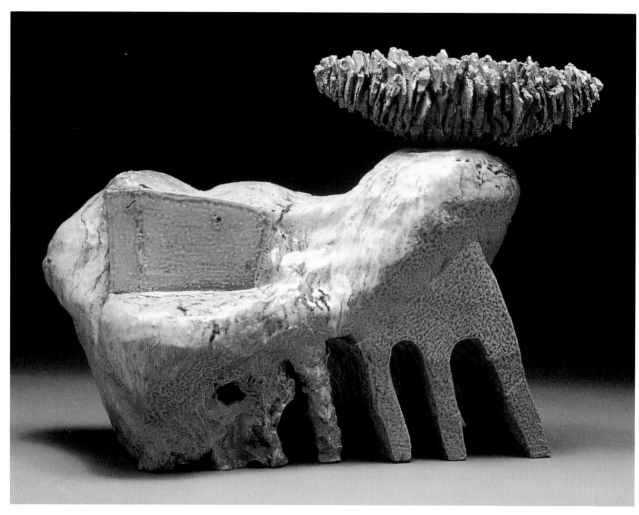

Keith Ekstam
Architectonic/Landscape Series #3 | 2008
14 X 18 X 8 INCHES (35.6 X 45.7 X 20.3 CM)
Hand-built stoneware; salt fired, cone 9
PHOTO BY ARTIST

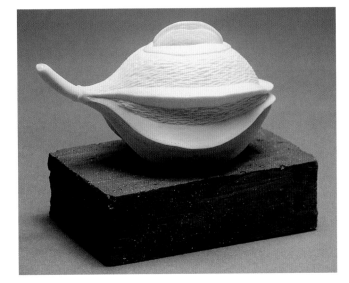

Diane King

Polygeniculate | 2007

3⁹⁄₁₆ X 4¹⁄₂ X 2⁹⁄₁₆ INCHES (9 X 11.5 X 6.5 CM)

Hand-built porcelain; electric fired, cone 10; partially glazed; hand-built terra cotta; electric fired, cone 3; copper wash

PHOTO BY CHARLIE OLSON

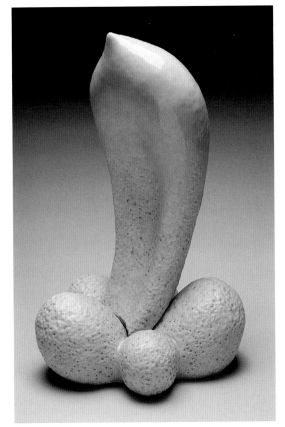

Lisa Conway

Tall Pink Succulent | 2007

31⁷⁄₈ X 18¹⁄₈ X 18¹⁄₈ INCHES (81 X 46 X 46 CM)

Pinched and coiled earthenware and paper clay; electric fired, cone 04; glaze

PHOTO BY GRACE WESTON

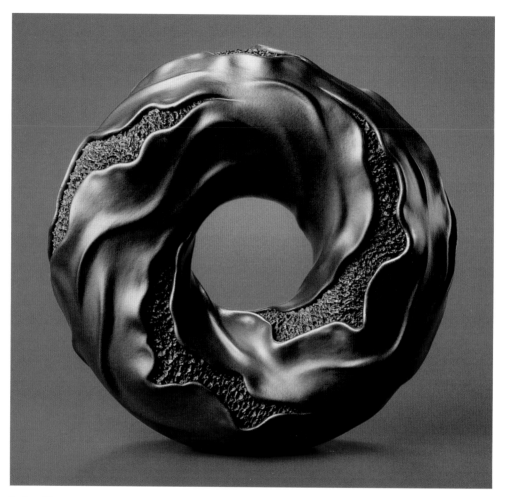

John Ferguson

Swirl | 2005

9 1/16 X 9 1/16 X 3 1/8 INCHES (23 X 23 X 8 CM)

Thrown, enclosed earthenware form; saggar fired with sawdust in gas kiln, cone 02; relief texturing; lamb's wool terra-sigillata burnish

PHOTO BY GRANT HANCOCK

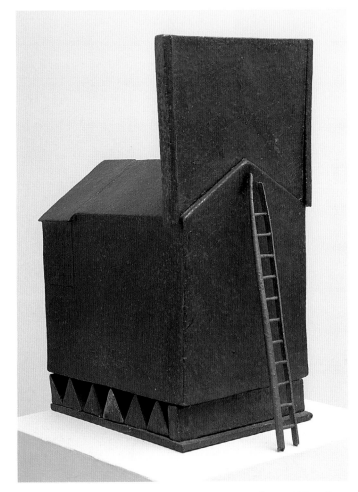

Robert Winokur

Brancusi's Barn with Ladder | 2001

17¹/₂ X 13¹/₂ X 8¹/₂ INCHES (44.5 X 34.3 X 21.6 CM)

Slab-constructed brick clay; reduction
fired, cones 9 and 10; salt glazed

PHOTO BY JOHN CARLANO

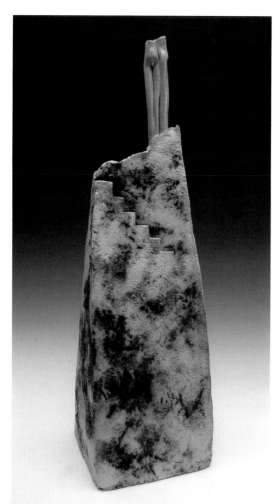

Steve Mattison

Senterione | 2007

39³/₈ X 9¹³/₁₆ X 9¹³/₁₆ INCHES
(100 X 25 X 25 CM)

Hand-built stoneware; wood fired, cone 10; soda glaze

PHOTO BY ARTIST

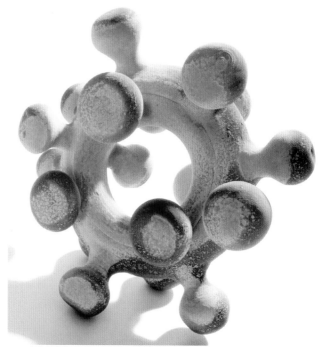

Eva Zethraeus

Bubble-Tipped Anemone | 2006

7⁷/₈ X 7⁷/₈ X 4⁵/₁₆ INCHES (20 X 20 X 11 CM)

Thrown, altered, and assembled porcelain; electric fired, cone 8

PHOTO BY THOMAS D. JOHANSSON

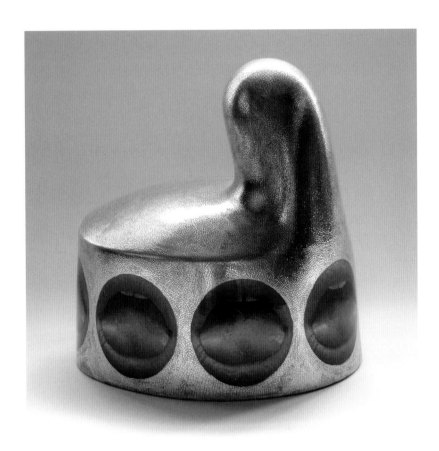

Conor Wilson

Capellino Stupito | 2007

7⁷⁄₈ X 7⁷⁄₈ X 7¹⁄₁₆ INCHES (20 X 20 X 18 CM)

Slip-cast earthenware; electric fired, cone 01; glazed, cone 04; gold luster, cone 017; photographic transfer, cone 017

PHOTOS BY ARTIST

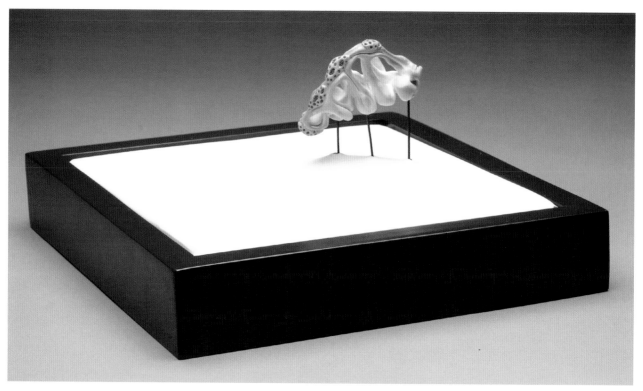

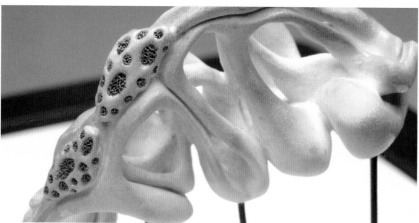

Daniel Van Tassell

IO #2 | 2007

5 X 10¹/₂ X 10¹/₂ INCHES (12.7 X 26.7 X 26.7 CM)

Porcelain with terra sigillata; soda fired, cone 10; vinyl, wood, copper

PHOTOS BY ARTIST

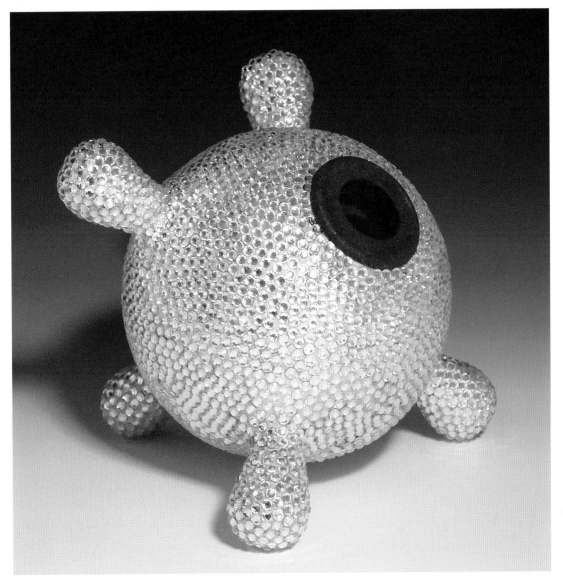

Raymond W. Gonzalez
Collectible IV (Liberace) | 2005
6 X 6 X 6 INCHES (15.2 X 15.2 X 15.2 CM)
Cast earthenware; electric fired, cone 06;
flocking; Swarovski crystals, rubber grommet
PHOTO BY ARTIST

Alison Petty Ragguette

Congealed | 2005

4 X 24 X 24 INCHES (10.2 X 61 X 61 CM)

Thrown porcelain; electric fired, cone 8; unglazed; cast rubber, silk, glass

PHOTO BY ARTIST

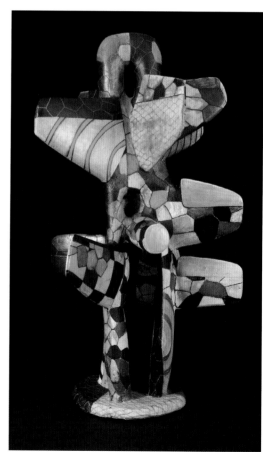

John Balistreri

Marker | 2006

61¹¹⁄₁₆ X 38³⁄₁₆ X 37¹³⁄₁₆ INCHES (157 X 97 X 96 CM)

Stoneware with slips; salt fired, cone 6; wheel-thrown parts

PHOTO BY ARTIST

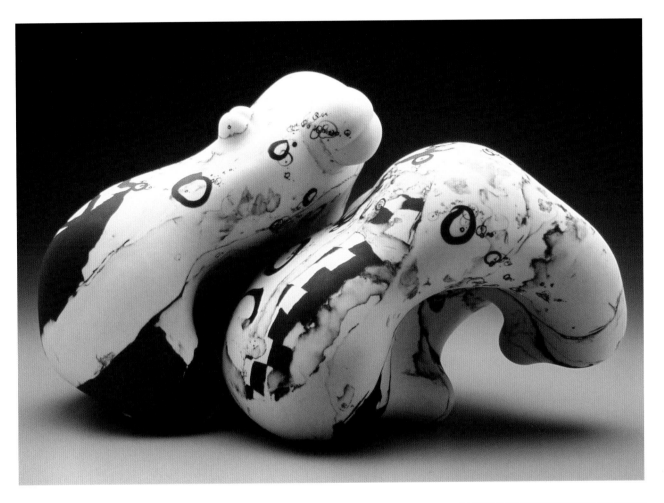

Katherine Taylor
Body # 14
9 1/16 X 11 3/8 X 14 15/16 INCHES (23 X 29 X 38 CM)
Laminated and coil-built black-and-white
porcelain; reduction fired, cone 10
PHOTOS BY HARRISON EVANS

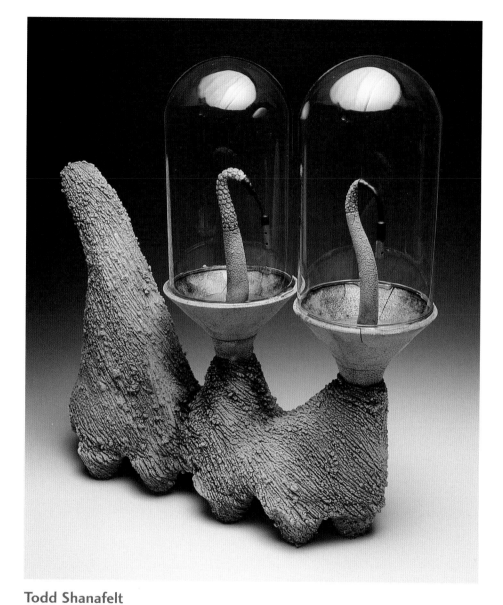

Todd Shanafelt

Fluxational Migration | 2007

13 X 11 3/8 X 5 7/8 INCHES (33 X 29 X 15 CM)

Earthenware; electric fired,
cone 04; rubber, metal, glass

PHOTO BY ARTIST

Carol Lebreton

Prickly Pod | 2003

10¹/₄ X 6¹/₂ X 6¹/₂ INCHES
(26 X 16.5 X 16.5 CM)

Hand-built stoneware; electric
fired, cone 7; oxides

PHOTO BY BILL BACHHUBER

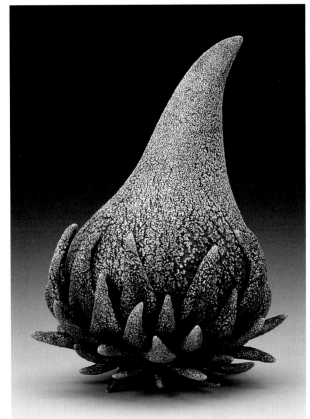

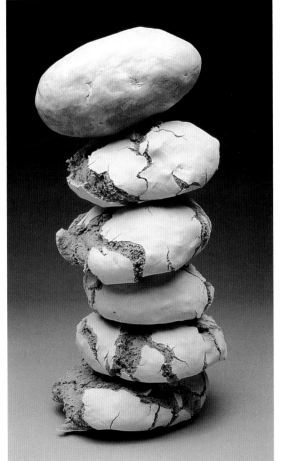

Warren Smith

Stack | 1996

20¹/₁₆ X 7¹/₁₆ X 2³/₄ INCHES (51 X 18 X 7 CM)

Hand-built earthenware; electric
fired, cone 04; Cryolite, glaze

PHOTO BY ARTIST

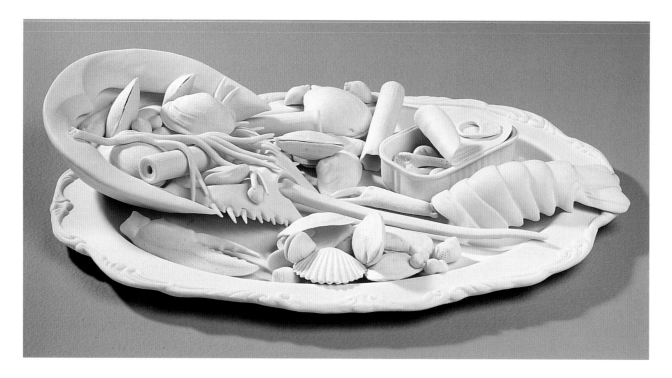

Susan Schultz

Abundance—Watch Hill | 2006

2 1/2 X 15 X 10 INCHES (6.3 X 38 X 25.4 CM)

Hand-sculpted, press-molded, and carved porcelain paper clay; electric fired, cone 6; unglazed

PHOTOS BY DEAN POWELL

Rob Tarbell

Red-Tip Rabbit | 2007

11 X 9 X 6 INCHES (27.9 X 22.9 X 15.2 CM)

Porcelain; electric fired, cone 10; resin

PHOTO BY ARTIST

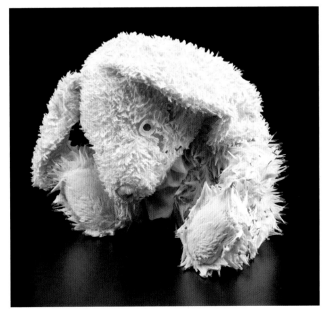

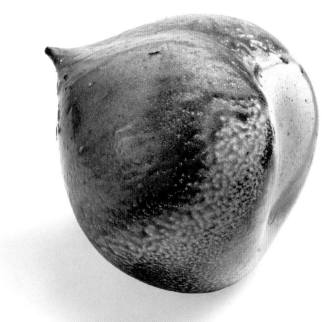

Eva Kwong

*Buckeye Peach from the
Immortal Peach Series* | 2005

8 X 9 X 8 INCHES (20.3 X 22.9 X 20.3 CM)

Wheel-thrown stoneware;
wood fired, cone 10

PHOTO BY KEVIN OLDS

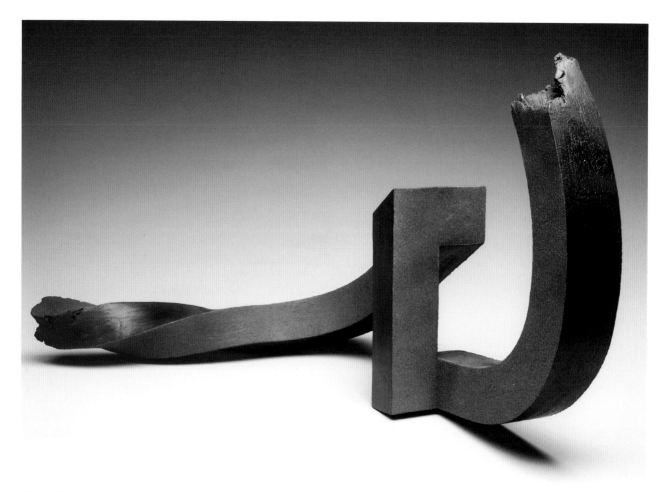

Gina Quadrone
Untitled | 2007

20 X 16 X 30 INCHES (50.8 X 40.6 X 76.2 CM)

Extruded earthenware; electric fired, cone 04;
black paint, textured spray paint

PHOTO BY ARTIST

Xueli Pei

A Land of Prosperity—Rebirth: 2 | 2000

15³⁄₄ X 8⁵⁄₈ X ³⁄₄ INCHES (40 X 22 X 2 CM)

Red pottery clay patted with batten, wooden hammer, and steel ruler; gas fired, 2138˚F (1170˚C), oxidation; matte black glaze

PHOTO BY ARTIST

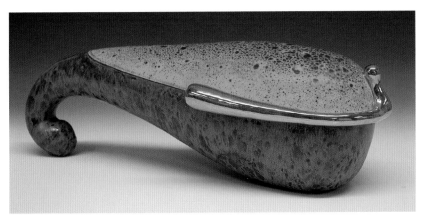

Scott Bennett

Roadmaster | 2007

5¹⁄₂ X 16¹⁄₈ X 7¹⁄₁₆ INCHES (14 X 41 X 18 CM)

Thrown and hand-built earthenware; electric fired, cone 05; glazed; luster, cone 018

PHOTO BY ARTIST

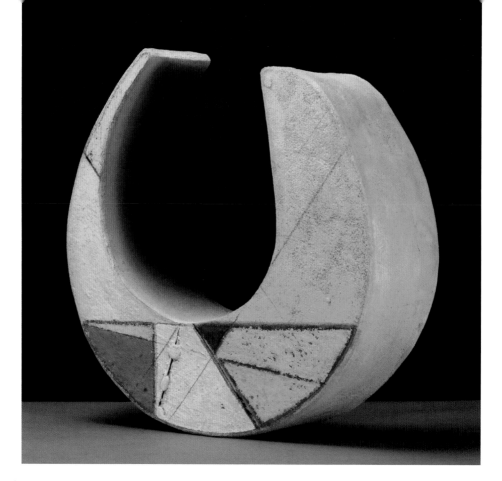

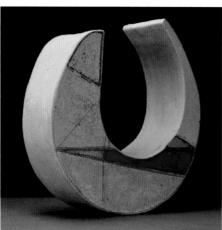

Siddiq Khan

Cipher C | 2007

8 5/8 X 7 1/16 X 2 3/8 INCHES (22 X 18 X 6 CM)

Slab-constructed stoneware; electric fired, cone 8; slips, glaze, acrylic, oil

PHOTOS BY ARTIST

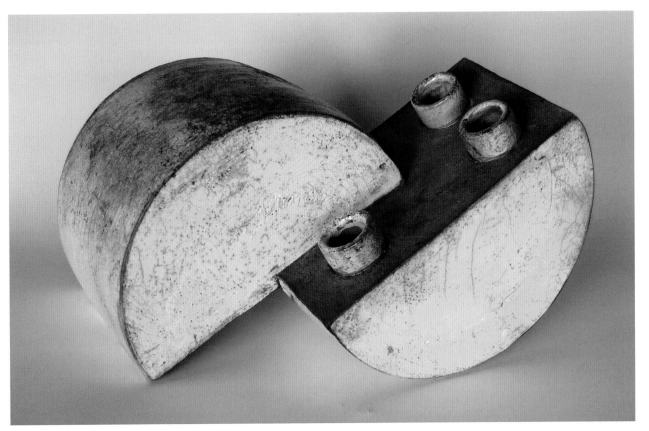

Michael Lancaster

Untitled | 2008

9 1/16 X 16 15/16 X 12 3/16 INCHES (23 X 43 X 31 CM)

Wheel-thrown, altered, and assembled
earthenware; raku fired; fumed with ferric
chloride; underglaze, clear overglaze

PHOTO BY ARTIST

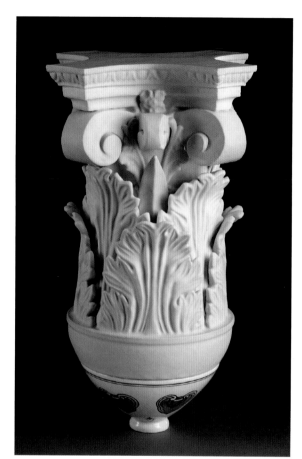

Dirk Staschke

Fruits of Labor Series: Structure | 2006

20 1/16 X 11 X 11 INCHES (51 X 28 X 28 CM)

Hand-built and press-molded stoneware,
found object; electric fired, cones 6 and 04

PHOTO BY FOSBROOK PHOTOGRAPHY

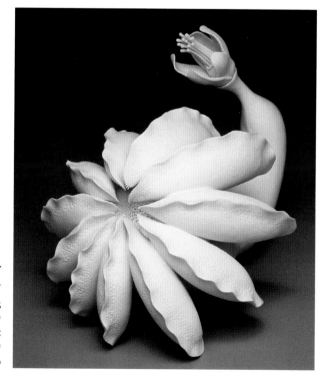

Lindsay Feuer

Hybrid 'Flora' No. 7 | 2007

9 1/16 X 7 7/8 X 5 1/8 INCHES
(23 X 20 X 18 CM)

Hand-built porcelain;
oxidation fired, cone 10

PHOTO BY JOHN CARLANO

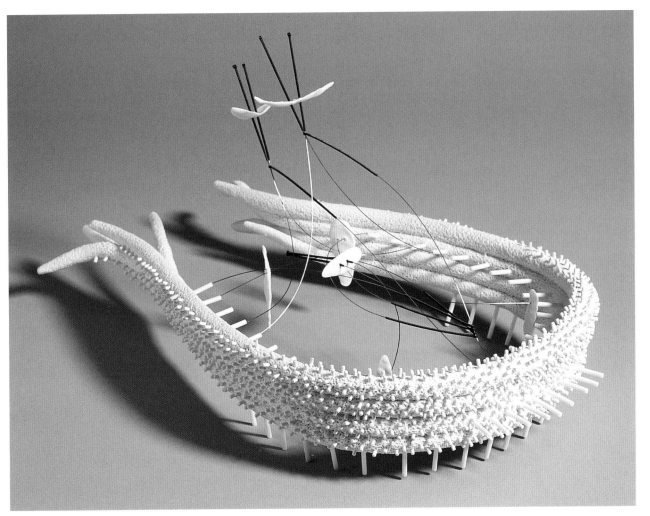

Annie Woodford

Piercing Rim | 2007

6⁵/₁₆ X 7¹/₁₆ X 11 INCHES (16 X 18 X 28 CM)

Hand-built porcelain; electric fired,
2300°F (1260°C); stainless steel, copper

PHOTO BY JERRY MASON

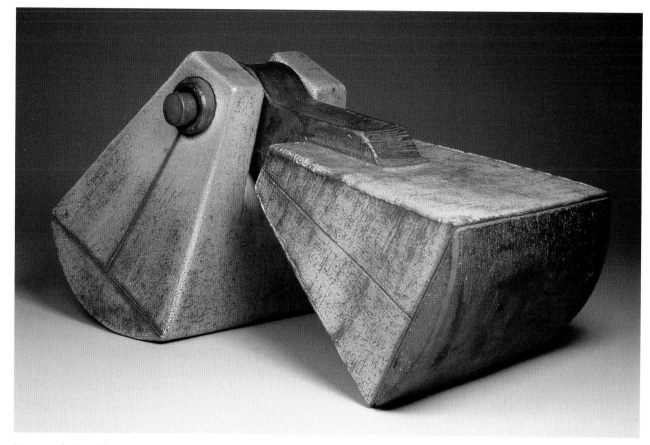

Kenneth Baskin

*Industrial Intuitions Series:
Connections* | 2007

13 X 24 X 12 INCHES (33 X 61 X 30.5 CM)

Slab-built stoneware; soda fired,
cone 10; glaze, slip; steel

PHOTO BY ARTIST

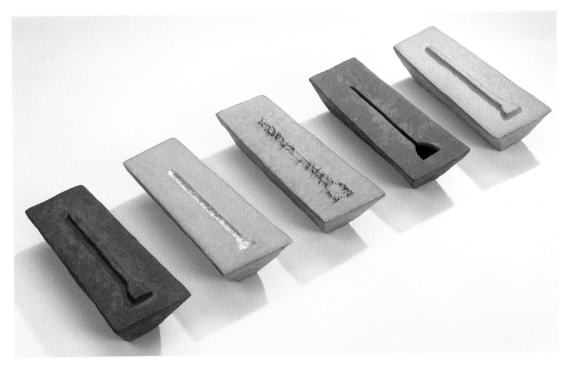

Ronit Zor

Metronomes | 2005

EACH, 23 5/8 X 5 7/8 X 4 11/16 INCHES
(60 X 15 X 12 CM)

Hand-built stoneware; electric
fired, 2282°F (1250°C)

PHOTOS BY DAVID GARB

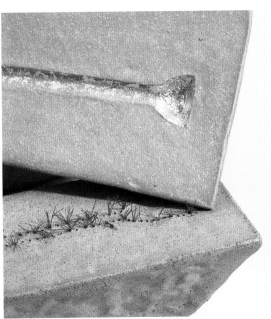

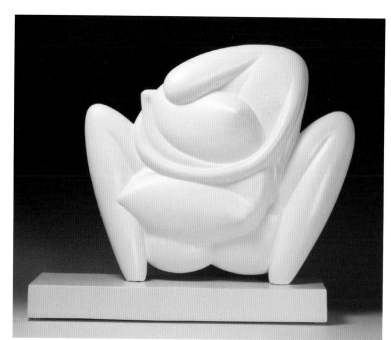

Biliana Popova
Pillow | 2007

18 X 20 X 5¹/₂ INCHES (45.7 X 50.8 X 14 CM)

Press-molded and slab-built earthenware; electric fired, cone 06; terra sigillata

PHOTO BY ARTIST

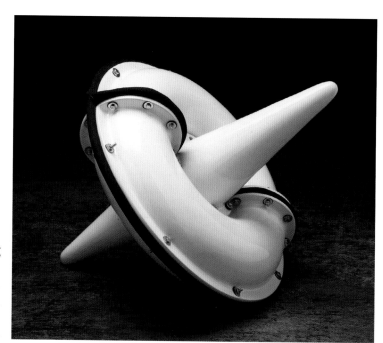

Derek Harding
Untitled | 2005

47¹/₄ X 36³/₁₆ INCHES (120 X 92 CM)

Slip-cast porcelain; gas fired, cone 10; rubber, steel

PHOTO BY KOHLER CO.

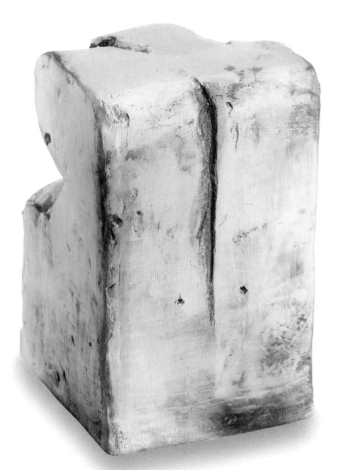
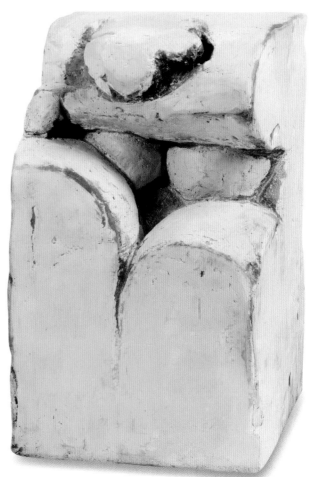

Ucki Kossdorff
Crouching Woman | 2005
12 ¹³/₁₆ X 7 ⁷/₈ X 8 ⁵/₈ INCHES (32.5 X 20 X 22 CM)
Built and pressed stoneware; bisque
fired, 1652°F (900°C); smoke
fired; polished; engobes, oxides

PHOTOS BY ARTIST

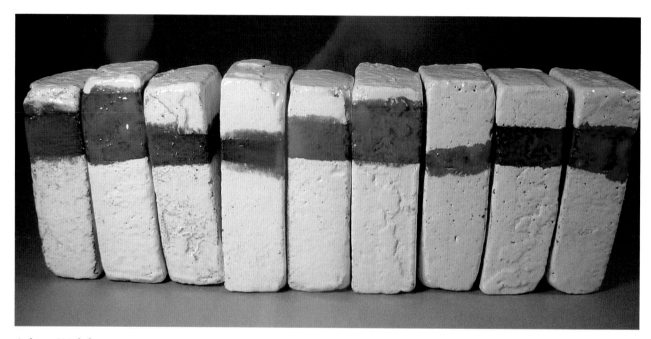

Adam Welch
Nine Soldiers | 2006
7⁷/₈ X 20¹/₁₆ X 4⁵/₁₆ INCHES (20 X 51 X 11 CM)
Handmade brick, glaze
PHOTO BY ARTIST

Angela K. Hung
Containment Series:
Object #3 | 2006

2³/₄ X 9 X 2¹/₂ INCHES
(7 X 22.9 X 6.4 CM)

Extruded and altered slip,
oxides, and soft bricks; soda
and salt fired, cone 10

PHOTO BY ARTIST

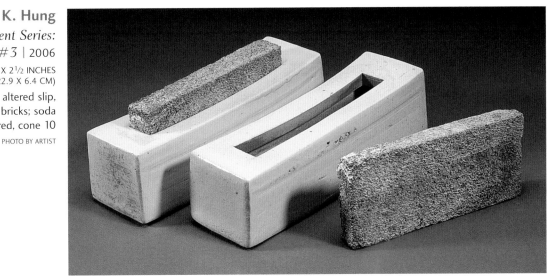

Josephine Burr
Lumen | 2005

4¹⁵/₁₆ X 14¹⁵/₁₆ X 9¹/₁₆ INCHES
(12.5 X 38 X 23 CM)

Hand-built earthenware;
multi-fired, cones 02–06; platinum
luster, cone 018; graphite, wax

PHOTO BY ARTIST

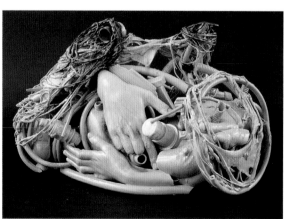

Ruta Pakarklyte

I Don't Remember It | 2006

11 X 16 15/16 X 11 13/16 INCHES (28 X 43 X 30 CM)

Molded porcelain; electric fired, 2336°F
(1280°C); glazed, 1760°F (960°C)

PHOTOS BY JAN INGE JANBU

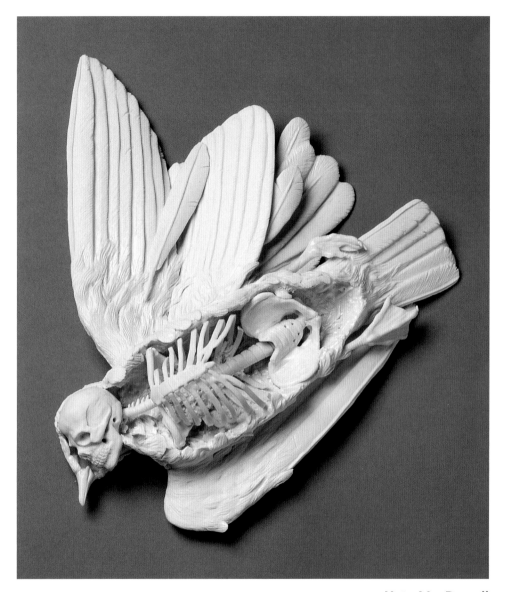

Kate MacDowell

Icarus | 2007

3⁹/₁₆ X 12³/₁₆ X 13³/₄ INCHES (9 X 31 X 35 CM)

Hand-built porcelain; electric
fired, cone 04; glazed, cone 5

PHOTO BY BILL BACHHUBER

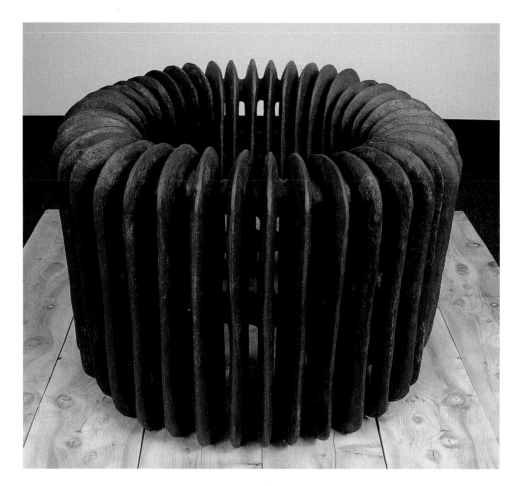

Joseph E. Pintz

Radiator | 2004

46 1/16 X 46 1/16 X 12 9/16 INCHES
(117 X 117 X 32 CM)

Hand-built earthenware; gas
fired, cone 04; terra sigillata

PHOTOS BY LARRY GAWEL

Samuel Dowd

All-Terrain Rover with Grasper Arm | 2005

4 15/16 X 4 15/16 X 10 INCHES (12.5 X 25.5 X 12.5 CM)

Slip-cast and altered porcelaneous
stoneware; electric fired, cone 6;
glazed, cone 06; glazed, cast aluminum

PHOTO BY ARTIST

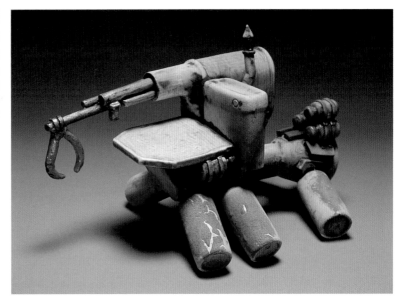

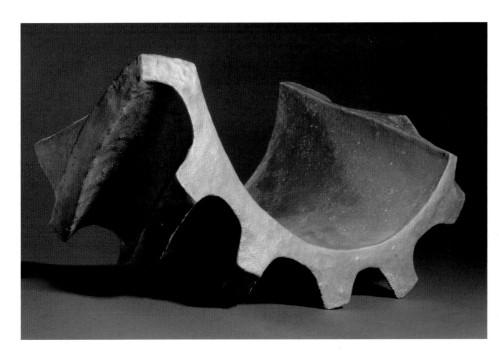

Tim Rowan

Untitled | 2007

12 X 22 X 14 INCHES
(30.5 X 55.9 X 35.6 CM)

Hand-built stoneware;
wood fired

PHOTO BY JOHN LENZ

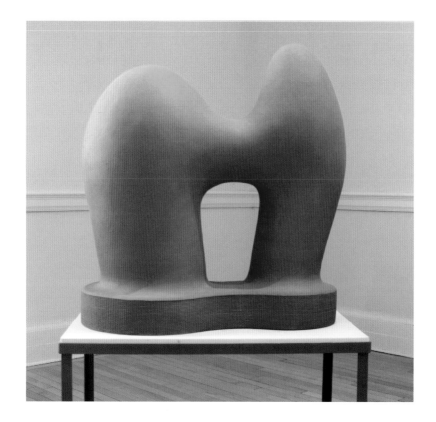

David Hicks

Tug | 2006

35 13/16 X 21 5/8 X 34 5/8 INCHES
(91 X 55 X 88 CM)

Coil-built terra cotta; electric
fired, cone 04; unglazed

PHOTOS BY ARTIST

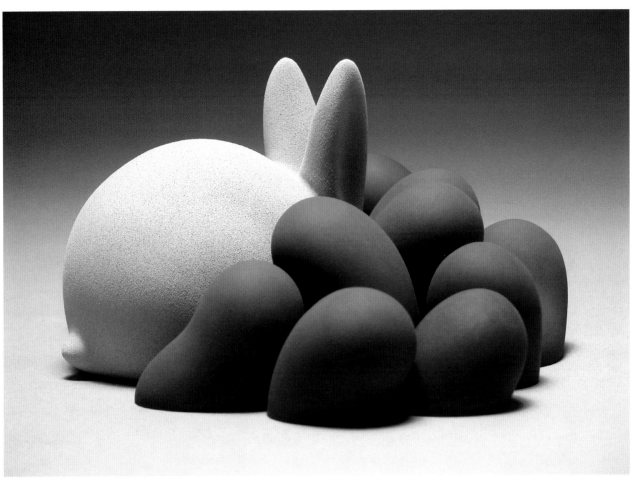

Jeremy R. Brooks
The White Rabbit | 2007
3 15/16 X 7 7/8 X 7 7/8 INCHES (10 X 20 X 20 CM)
Slip-cast porcelain; electric fired,
cone 02; underglaze, cone 05; textured
spray paint, fragrant paraffin wax
PHOTO BY ARTIST

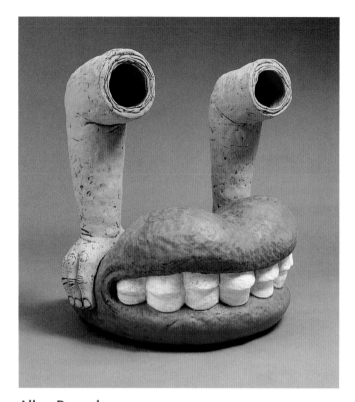

Allan Rosenbaum

Looking and Grinning | 2005

58 X 61 X 46 INCHES (147.3 X 154.9 X 116.8 CM)

Hand-built earthenware; electric fired,
cone 05; stain, glaze, underglaze

PHOTO BY ARTIST

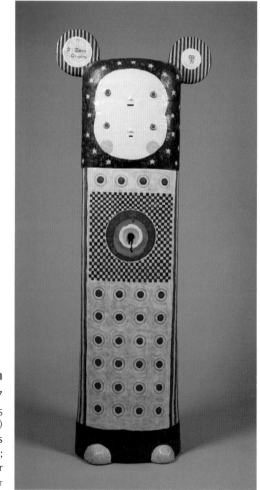

Tae-Hoon Kim

Aerialist: Boy Meets Girl | 2007

79³/4 X 35 X 14¹⁵/16 INCHES
(203 X 89 X 38 CM)

Hand-built stoneware; gas
fired, cone 6; glazed, cone 06;
glazed, cone 018; gold luster

PHOTO BY ARTIST

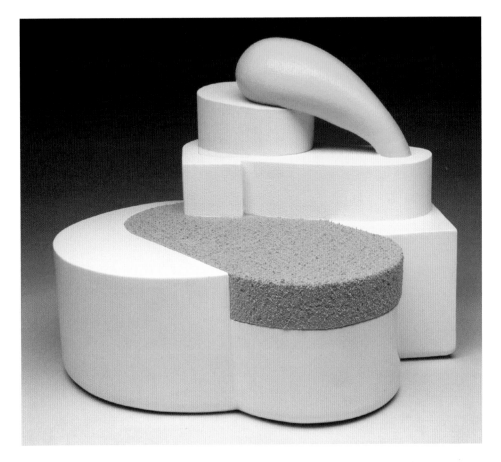

Nathan Prouty
Field House | 2007

14 X 14 X 10⁷/₁₆ INCHES
(35.5 X 35.5 X 26.5 CM)

Slab-built white earthenware; electric
fired, cone 02; lacquer, paint

PHOTOS BY ARTIST

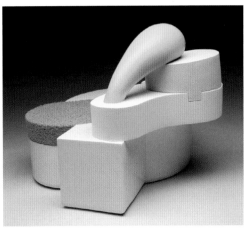

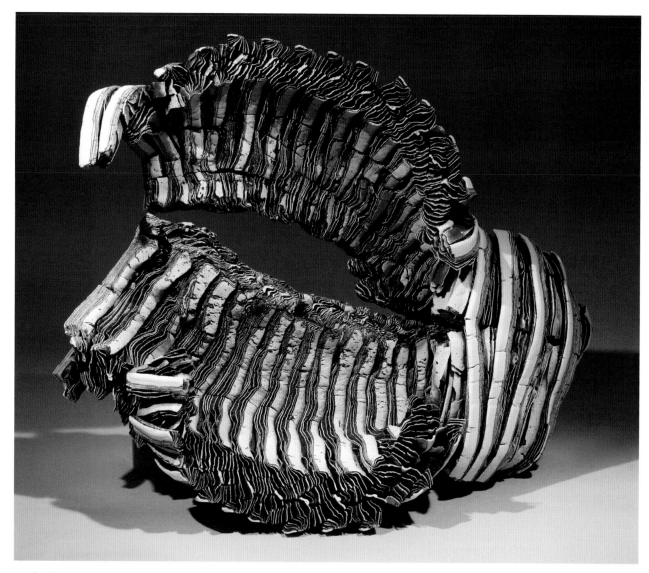

Rafael Perez
Untitled | 2007
17 11/16 X 23 5/8 X 11 13/16 INCHES (45 X 60 X 30 CM)
Porcelain and personal clay; gas fired in
oxidation, 2138°F (1170°C); sandblasted
PHOTO BY CARLOS E. HERMOSILLA

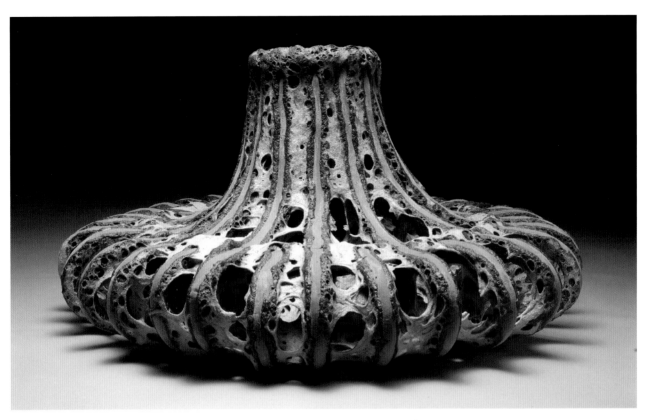

Jeff Kaller
Cone Form | 2007
25⁹⁄₁₆ X 25⁹⁄₁₆ X 13³⁄₄ INCHES
(65 X 65 X 35 CM)
Constructed ceramic, glaze
PHOTOS BY ARTIST

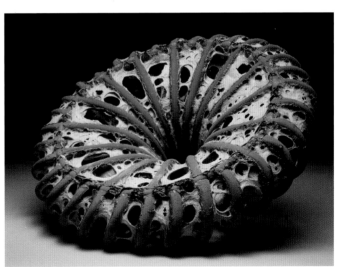

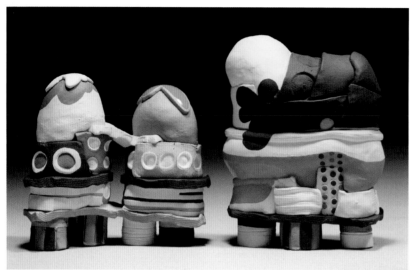

John Oliver Lewis
Me and Me and Meathead | 2006
9 13/16 X 7 7/8 X 4 11/16 INCHES (25 X 20 X 12 CM)
Hand-built earthenware; electric fired,
cone 04; acrylic and enamel paint
PHOTO BY ARTIST

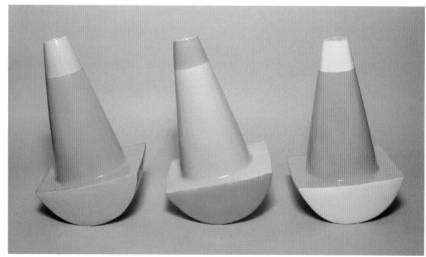

Jen Mills
Caution Cones | 2008
13 X 6 7/8 X 8 5/8 INCHES
(33 X 17.5 X 22 CM)
Slip-cast porcelain; electric
fired, cone 6; glazed, cone 6
PHOTO BY ARTIST

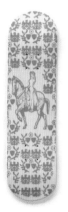

Fabien Clerc

Skateboards | 2004

EACH, 7/16 X 9¹³/₁₆ X 28⁵/₁₆ INCHES
(1.2 X 25 X 72 CM)

Hearthenware; gas fired,
1922°F (1050°C) with serigraphy

PHOTO BY VINCENT CALMEL

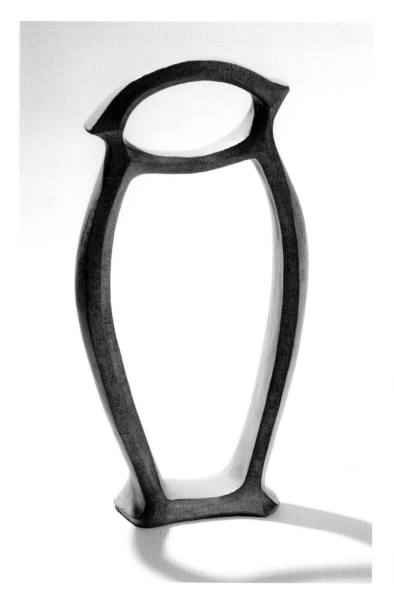

Lene Kuhl Jakobsen

Contour | 2006

14³/₁₆ X 7⁷/₁₆ X 2³/₄ INCHES (36 X 19 X 7 CM)

Hand-built stoneware; electric
fired, cone 9; partially glazed

PHOTOS BY ANDREW BARCHAM

Maciej Kasperski

Triplex System, Ninja Cuts 4 | 2007

39³/₈ X 14³/₁₆ X 7⁷/₈ INCHES (100 X 36 X 20 CM)

Chamotte; electric fired,
2192°F (1200°C); engobes

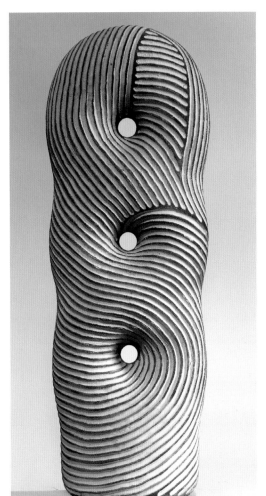

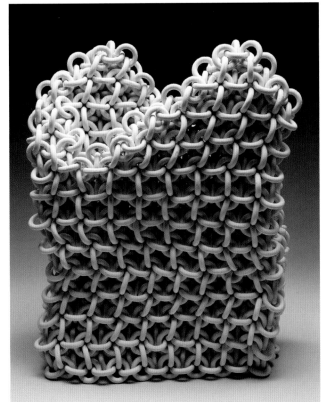

Ruth Borgenicht

After Gehry | 2006

20¹/₁₆ X 19¹/₄ X 14¹⁵/₁₆ INCHES (51 X 49 X 38 CM)

Slip-cast stoneware; electric fired, cone 10

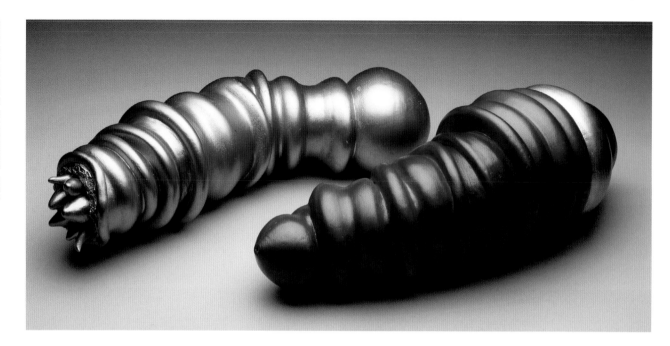

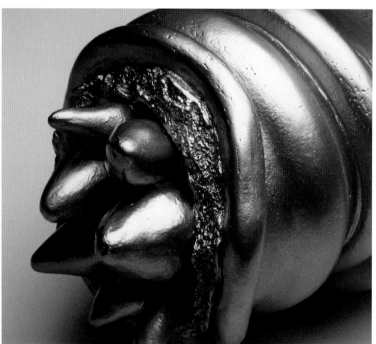

Jamin London Tinsel

The Blue Child, The Green Child | 2006

TALLEST, 11 X 20¹/₁₆ X 9¹³/₁₆ INCHES (28 X 51 X 25 CM)

Wheel-thrown stoneware; gas fired, cone 06; auto body primer, auto body paint

PHOTOS BY MATHEW HOLLERBUSH

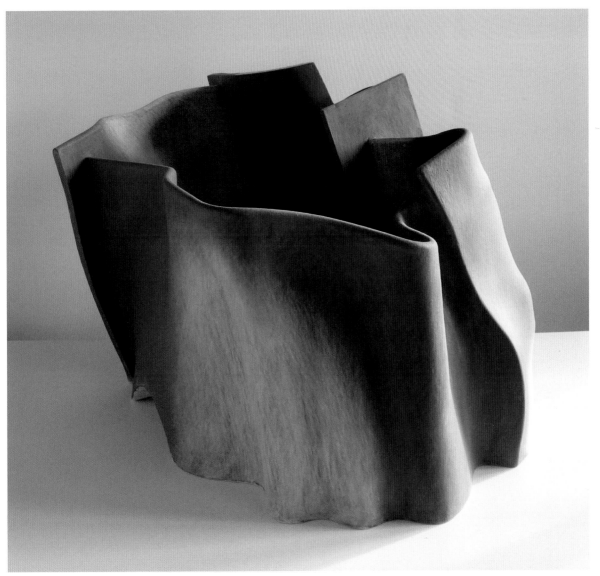

Ken Eastman
Aber Mawr | 2007
13³/₈ X 18⁷/₈ X 18¹/₈ INCHES (34 X 48 X 46 CM)
Slab-built white stoneware; electric fired,
2156°F (1180°C); colored slips, oxides
PHOTO BY ARTIST

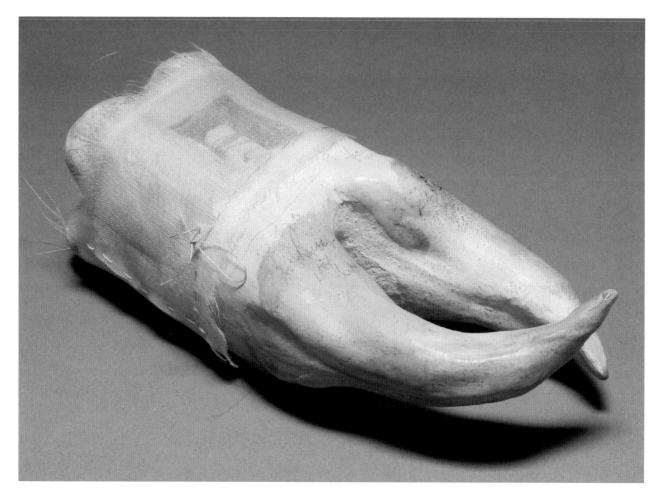

Jenny K. Dowd

Tooth Diary Pg. 4 | 2008

1 15/16 X 4 15/16 X 2 7/16 INCHES
(5 X 12.5 X 6.3 CM)

Hand-built porcelain; electric
fired, cone 2; terra sigillata, tea
graphite, silk, thread, beeswax

PHOTOS BY ARTIST

Mika Negishi Laidlaw

Lullaby | 2007

9 13/16 X 8 5/8 X 6 11/16 INCHES
(25 X 22 X 17 CM)

Slip-cast earthenware; electric
fired, cone 03; glazed

PHOTO BY ARTIST

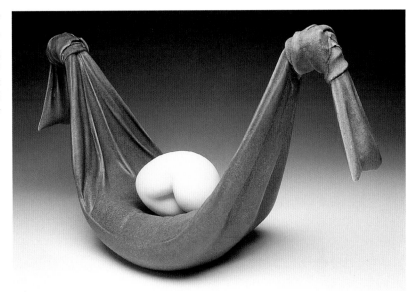

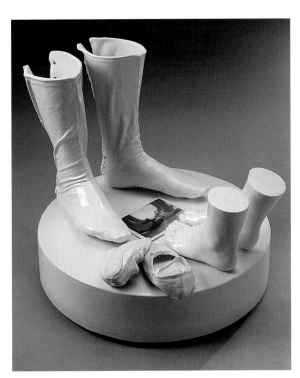

Nan Smith

Sisters | 2005

16 1/2 X 18 7/8 X 18 1/8 INCHES (42 X 48 X 46 CM)

Slip-cast and press-molded earthenware with
tamped slab tile; electric fired, cone 03;
glazed, cone 04; photo decal, cone 09

PHOTO BY ALLEN CHEUVRONT

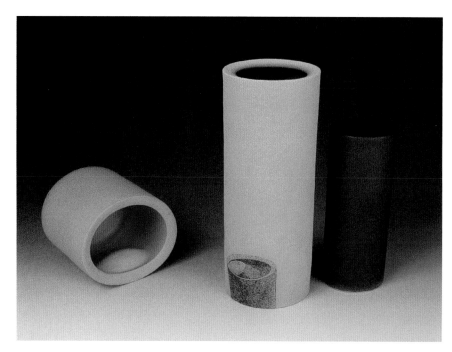

Bettina Baumann

Influences | 2005

9⁷/₁₆ X 15³/₄ X 8⁵/₈ INCHES (24 X 40 X 22 CM)

Thrown, altered, and printed stoneware; electric fired, cone 6; glazed, cone 7

PHOTOS BY ARTIST

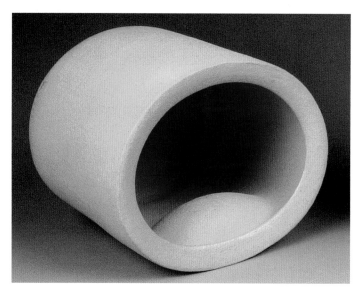

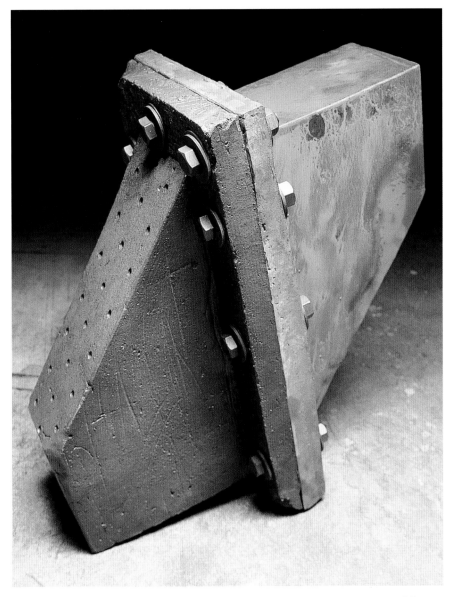

Matt Moyer
Wedges | 2004
7⁷/₈ X 3⁹/₁₆ X 7⁷/₈ INCHES (20 X 9 X 20 CM)
Wood-fired stoneware; steel
PHOTO BY ARTIST

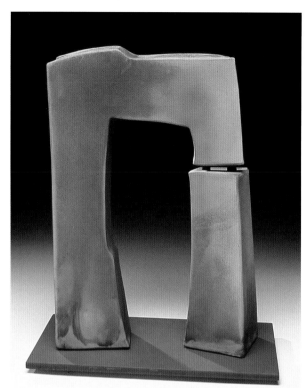

Penny Truitt

Arch V | 2005

21 5/8 X 15 3/4 X 5 1/2 INCHES (55 X 40 X 14 CM)

Slab-built clay; bisque fired,
cone 08; raku fired; glaze

PHOTO BY CHRIS STEWART

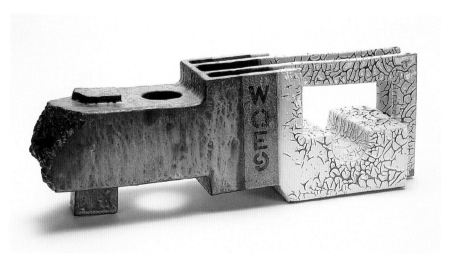

Peter Anderson

Component WQE9 | 2006

11 X 22 1/16 X 8 5/8 INCHES (28 X 56 X 22 CM)

Slab-constructed stoneware; reduction
fired, cone 10; shino and bronze glazes

PHOTO BY ARTIST

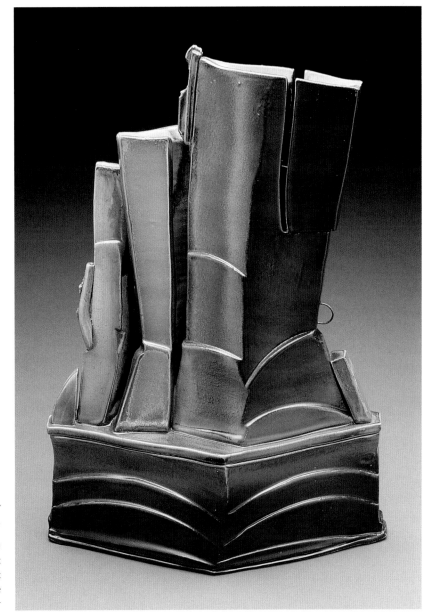

Brad Schwieger

Construction #1 | 2007

27 15/16 X 16 15/16 X 8 5/8 INCHES (71 X 43 X 22 CM)

Press-molded and wheel-thrown stoneware; soda fired, cone 10; slips, multiple glazes; nickel-chromium resistance wire

PHOTO BY STEVE PASZT

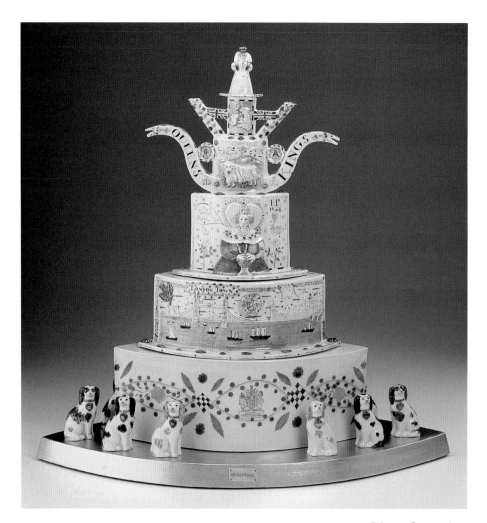

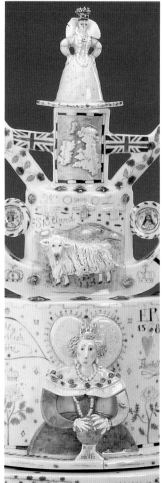

Mara Superior

Oh Britannia | 2006

10¼ X 7⅞ X 3¹⁵/₁₆ INCHES (26 X 20 X 10 CM)

High-fired slab-built porcelain; cast Marashire dogs; ceramic underglazes and oxides; wood, gold leaf, bone, ink, brass

PHOTOS BY JOHN POLAK

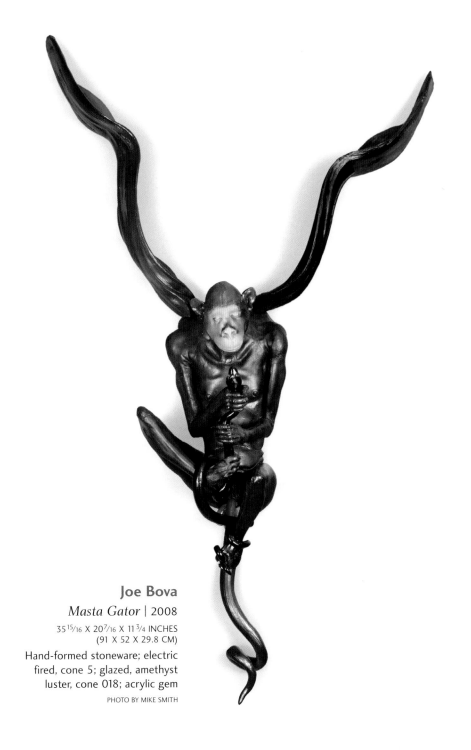

Joe Bova

Masta Gator | 2008

35 15/16 X 20 7/16 X 11 3/4 INCHES
(91 X 52 X 29.8 CM)

Hand-formed stoneware; electric
fired, cone 5; glazed, amethyst
luster, cone 018; acrylic gem

PHOTO BY MIKE SMITH

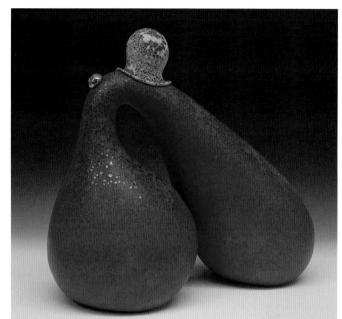

Scott Bennett

Strut | 2007

13 X 14¹⁵/₁₆ X 7¹/₁₆ INCHES (33 X 38 X 18 CM)

Thrown and hand-built earthenware; electric fired, cone 05; glazed; luster, cone 018

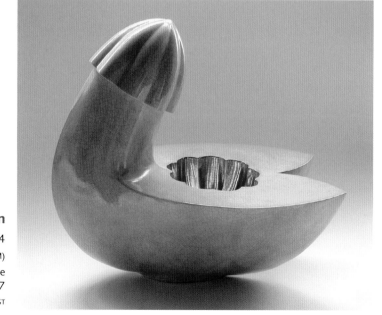

Conor Wilson

Lemon Squeezer | 2004

14⁹/₁₆ X 9¹/₁₆ X 14³/₁₆ INCHES (37 X 23 X 36 CM)

Press-molded earthenware; electric fired, cone 06; glazed, cone 04; gold luster, cone 017

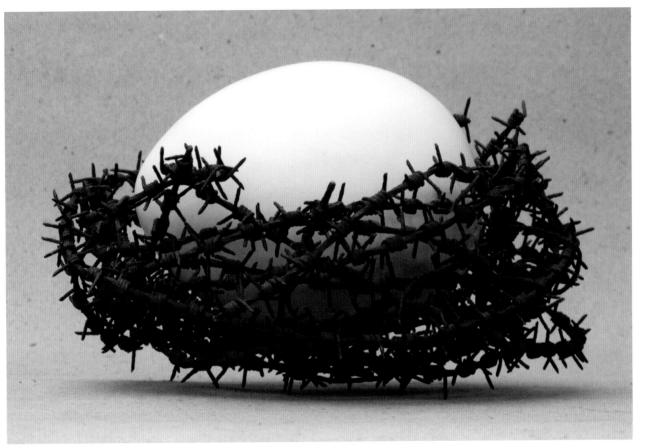

Kristin Antonsen

Perspective | 2008

13³/₄ X 13³/₄ X 17¹¹/₁₆ INCHES (35 X 35 X 45 CM)

Press-molded stoneware; electric fired,
cone 06; glazed, cone 6; barbed wire

PHOTO BY JOHN ERIK KRISTENSEN

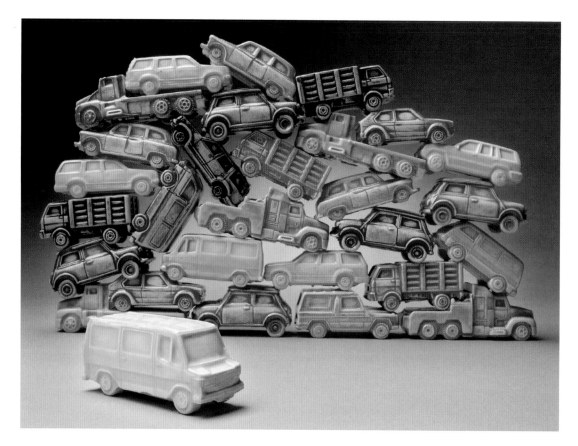

Irianna Kanellopoulou

Dreamscape | 2006

7⁷/₈ X 13 X 3⁵/₁₆ INCHES (20 X 33 X 10 CM)

Slip-cast and hand-built mid-fire clay;
electric fired, cone 02; glazed, cone 04

PHOTOS BY ANDREW BARCHAM

Lazare Rottach

Neglect | 2006

17 X 6 X 4 INCHES (43.2 X 15.2 X 10.2 CM)

Slab-built earthenware; oxidation
fired, cone 1; terra sigillata, glaze

PHOTO BY ARTIST

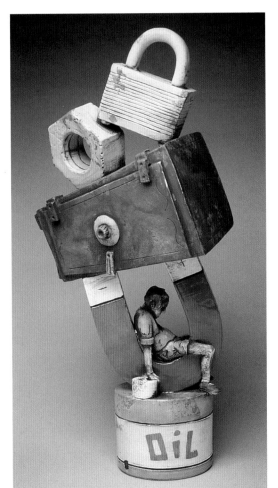

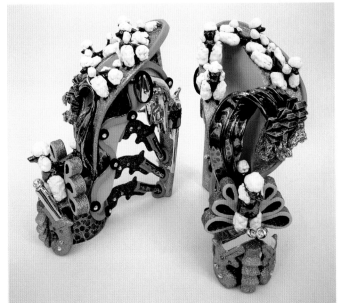

Toby Buonagurio

Poodle Puff Gun Shoes | 1993

EACH, 17 1/2 X 11 1/2 X 7 1/2 INCHES
(44.5 X 29.2 X 19.1 CM)

Earthenware; multi-process construction;
mixed media; fired and unfired surfaces

PHOTO BY EDGAR BUONAGURIO

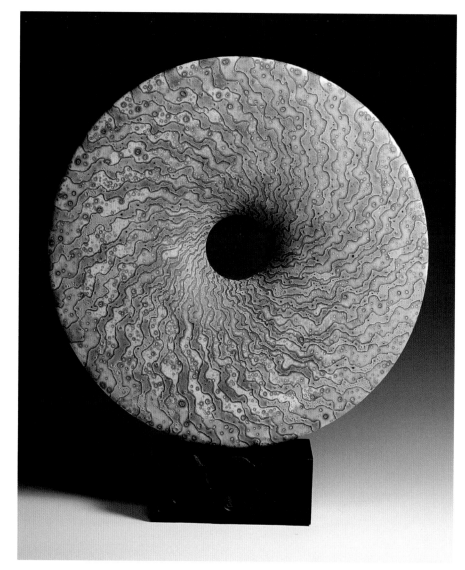

Peter Beard

Disc | 2007

16 15/16 X 14 3/16 X 5 1/8 INCHES (43 X 36 X 13 CM)

Thrown oxidized stoneware; electric fired,
2336°F (1280°C); multi-glaze layering with wax;
Cumbrian slate base, signature mark in bronze

PHOTO BY ARTIST

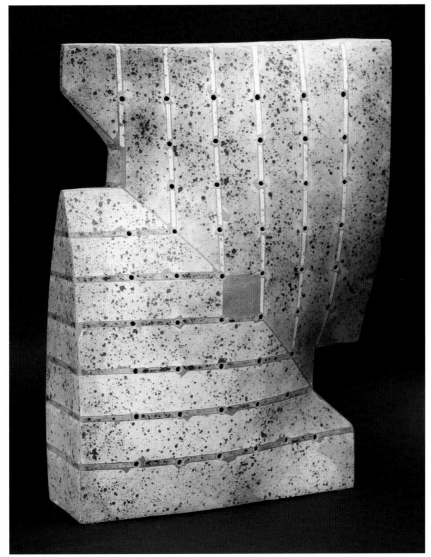

Regina Maria Heinz
With a Twist | 2005
24 13/16 X 21 5/8 X 11 13/16 INCHES (63 X 55 X 30 CM)
Hand-built grogged stoneware; electric fired,
1895°F (1035°C); brushed lithium glaze, colors
PHOTO BY ALFRED PETRI

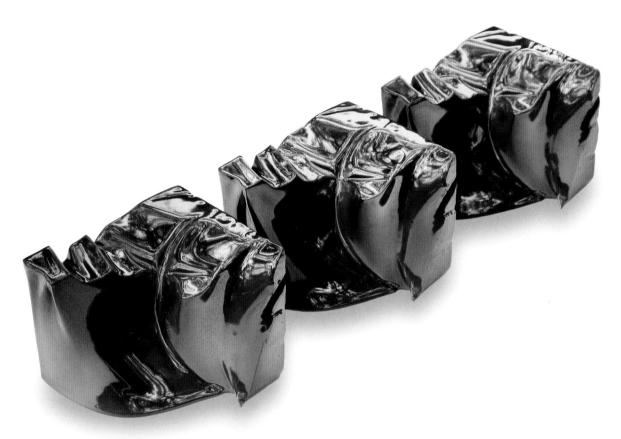

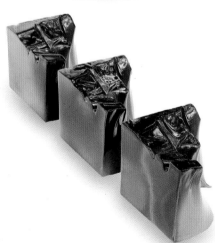

Ira Winarsky

Repeating Landscape | 2007

4⁵⁄₁₆ X 5¹⁄₈ X 5¹⁄₂ INCHES (11 X 13 X 14 CM)

Slip-cast earthenware; electric
fired, cone 4; iridescent lusters

PHOTOS BY ARTIST

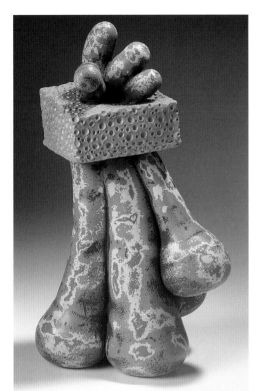

John Schnick

Whyus | 2007

18⁷/₈ X 11 X 8¹/₄ INCHES (48 X 28 X 21 CM)

Wheel-thrown and altered clay; electric fired, cone 1; abraded acrylic paint

PHOTO BY JEAN-MICHEL ADDOR

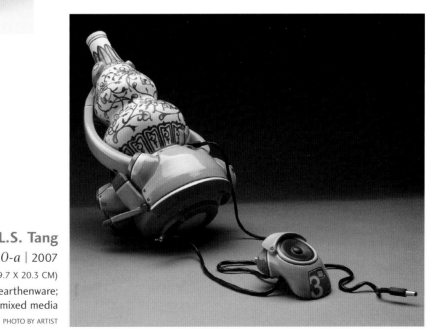

Brendan L.S. Tang

Manga Ormolu version 3.0-a | 2007

13¹/₂ X 23¹/₂ X 8 INCHES (34.3 X 59.7 X 20.3 CM)

Wheel-thrown and altered earthenware; electric fired, cone 04; mixed media

PHOTO BY ARTIST

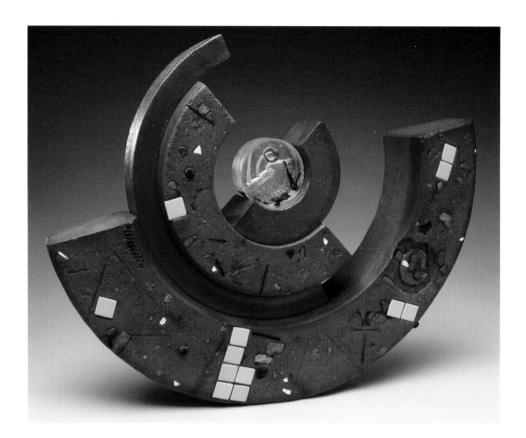

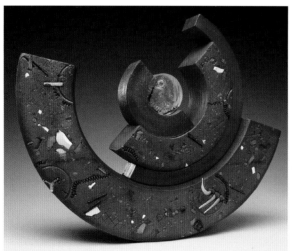

Robert L. Wood

Seeking Alignment | 2004

19 X 25 X 5 INCHES (48.3 X 63.5 X 12.7 CM)

Slab-built and press-molded earthenware embedded with kiln elements, pyrometric cones, glass, broken pottery, clay shards, steel, glaze, found objects; electric fired, cone 1; kiln-cast glass; iron-oxide stain and frit pre-firing application

PHOTOS BY ARTIST

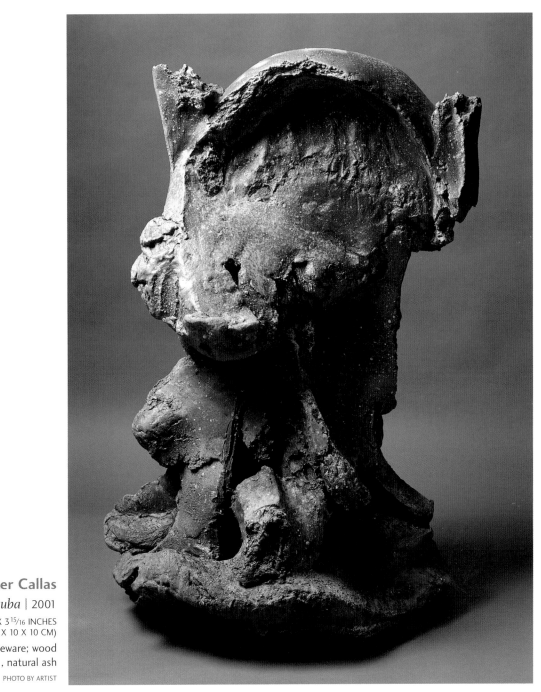

Peter Callas

Ubatuba | 2001

5 1/2 X 3 15/16 X 3 15/16 INCHES
(14 X 10 X 10 CM)

Slab-built stoneware; wood
fired, cone 11, natural ash

PHOTO BY ARTIST

Ken Takahashi

Figuration B-3 | 2008

28⁹⁄₁₆ X 15³⁄₄ X 10¹³⁄₁₆ INCHES (72.5 X 40 X 27.5 CM)

Slab-built sculpture clay; gas fired, cone 6;
glazed, cone 3; palladium luster, cone 018

PHOTO BY ARTIST

Harris Deller

Dialectic, Ceramic Vessel | 2007

14¹⁄₂ X 15¹⁄₂ X 6 INCHES (36.8 X 39.4 X 15.2 CM)

Hand-built porcelain; reduction fired,
cone 10; glaze; incised; steel plinth

PHOTO BY ARTIST

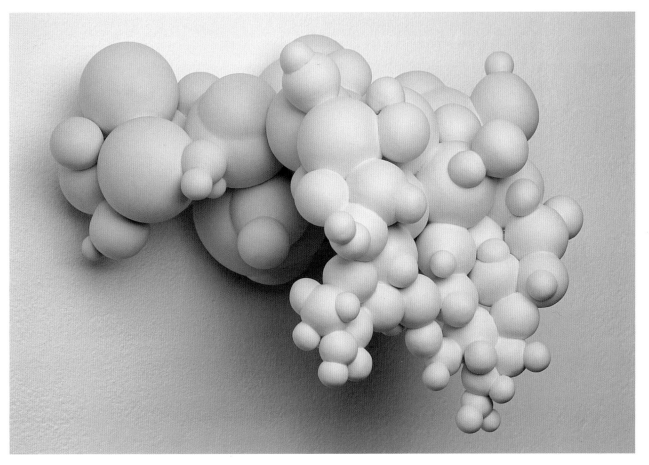

Jamie Walker

Cloud #2 | 2007

11 $^{13}/_{16}$ X 15 $^{3}/_{4}$ X 11 $^{13}/_{16}$ INCHES
(30 X 40 X 30 CM)

Wheel-thrown porcelain;
electric fired, cone 6

PHOTOS BY ARTIST

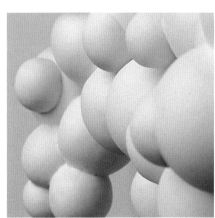

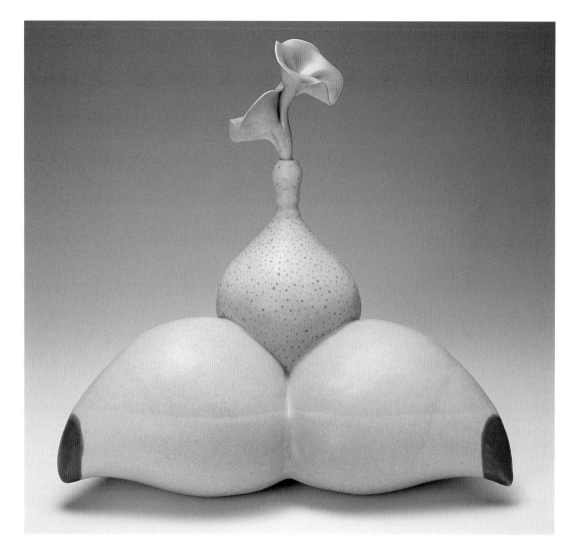

Angela Cunningham

Sprout | 2006

12 13/16 X 12 13/16 X 9 13/16 INCHES
(32.5 X 32.5 X 25 CM)

Hand-built white stoneware;
oxidation fired, cone 10

PHOTOS BY ARTIST

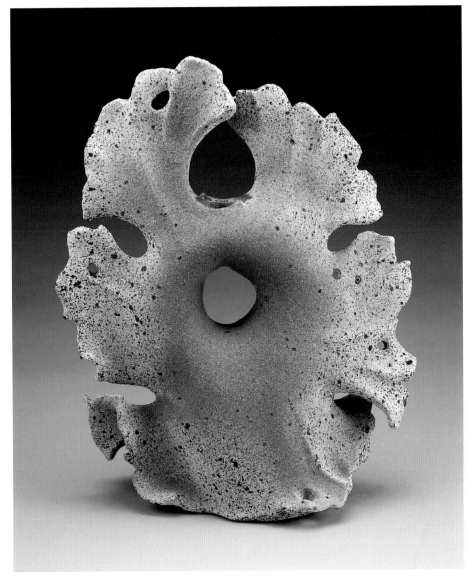

Donna Cole
Windswept | 2005
18 X 14 X 7 INCHES (45.7 X 35.6 X 17.8 CM)
Slab-constructed aggregate stoneware;
oxidation fired, cone 10; glass infusion
PHOTO BY ARTIST

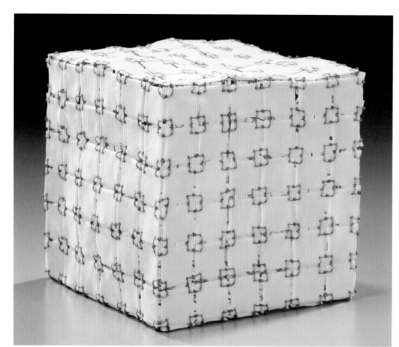

Allison Paschke

Raissa | 1999

4 X 4 X 4 INCHES (10.2 X 10.2 X 10.2 CM)

Hand-formed, ball-milled translucent porcelain; electric fired, cone 7; fine wire

PHOTO BY MARK JOHNSTON

Vincent Burke

Elegy for Kevin and Jeremy | 2002

18 1/8 X 35 13/16 X 14 3/16 INCHES
(46 X 91 X 36 CM)

Porcelain; reduction fired, cone 10; foam, wood, vinyl

PHOTO BY MARTY SNORTUM

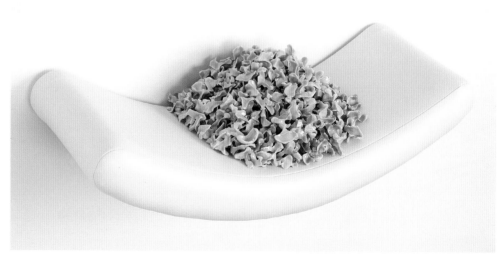

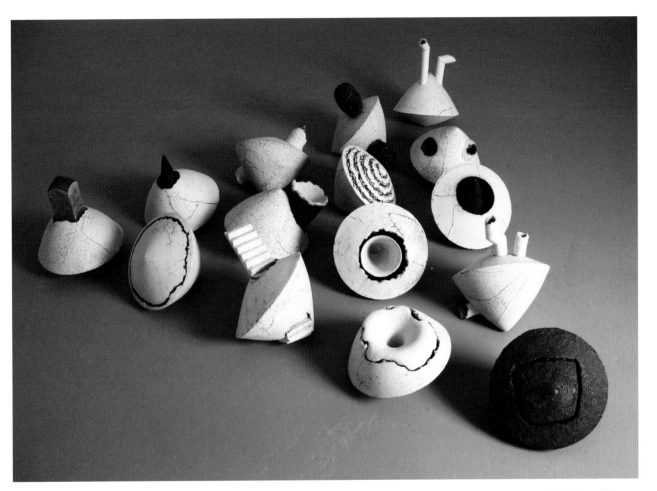

Jia-Haur Liang
Untitled | 2007

9⁷/₁₆ X 75⁷/₁₆ X 75⁷/₁₆ INCHES
(24 X 192 X 192 CM)

Press-molded stoneware; electric
fired, cone 6; glazed, cone 7

PHOTO BY ARTIST

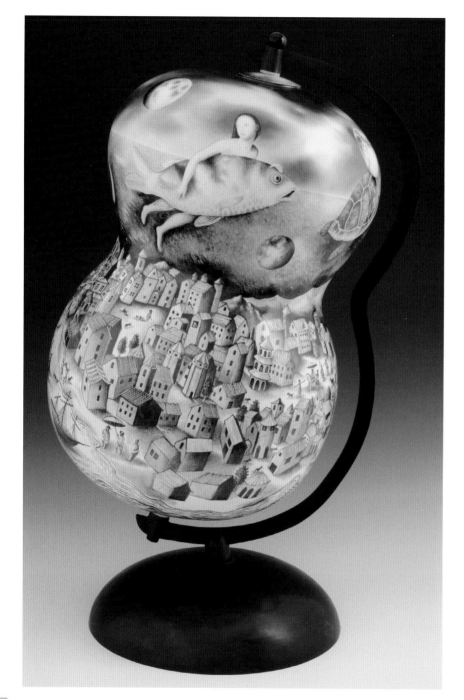

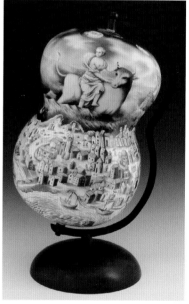

Kurt Weiser
Europa | 2005
27 X 17 INCHES (68.6 X 43.2 CM)
Cast porcelain and bronze; electric
fired, cone 10; china paint, cone 018
PHOTOS BY ARTIST

Steve Mattison

We Are Still Here V | 2006

21 ⁵/₈ X 13 ³/₄ X 13 ³/₄ INCHES (55 X 35 X 35 CM)

Hand-built stoneware; oil-reduction raku

PHOTO BY ARTIST

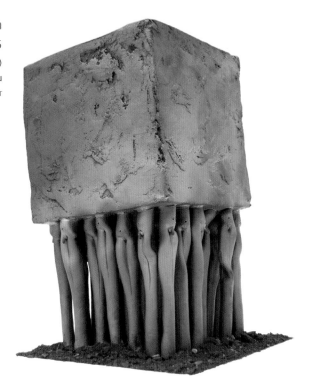

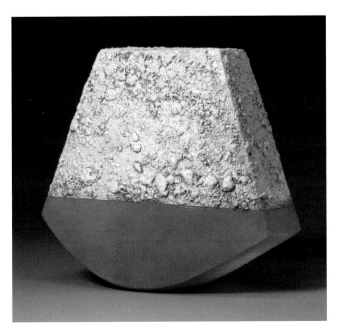

Liz Howe

Red Handle | 2008

14 ¹⁵/₁₆ X 13 ³/₄ X 9 ⁷/₁₆ INCHES (38 X 35 X 24 CM)

Hand-built stoneware and porcelain; electric fired, cone 6; post-fire acrylic; flocking

PHOTO BY GEOFF TESCH

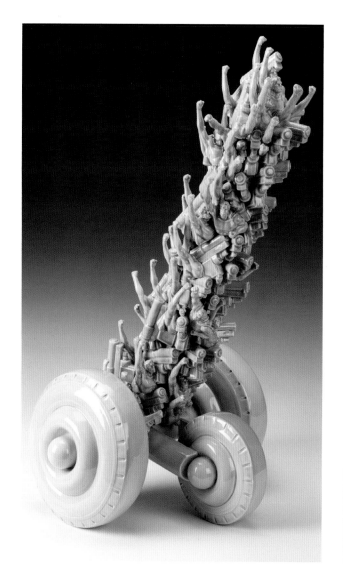

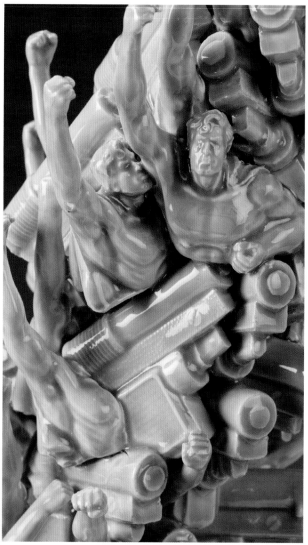

Nikki Blair

Trojan | 2007

12 X 9¹³/₁₆ X 30 INCHES (30.4 X 25 X 76.2 CM)

Hand-built and slip-cast
earthenware; electric fired, cone 04

PHOTOS BY ARTIST

Jesse Armstrong
Untitled | 2008
19 11/16 X 48 X 48 INCHES (50 X 122 X 122 CM)
Press-molded porcelain; gas fired,
cone 10; wood, rubber, epoxy, hardware
PHOTO BY ARTIST

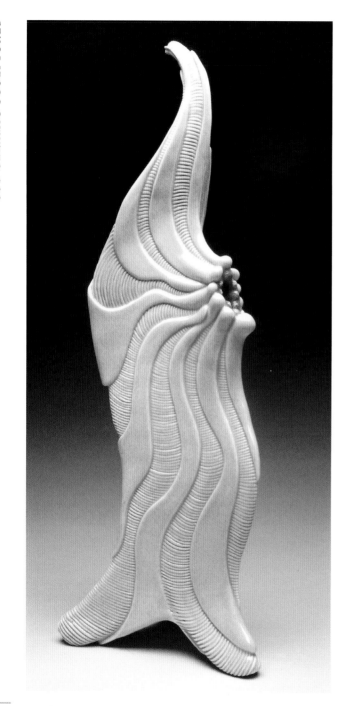

KyoungHwa Oh
Current #2 | 2008
21 1/2 X 7 X 8 1/2 INCHES (54.6 X 17.8 X 21.6 CM)
Hand-built carved porcelain;
gas fired in reduction, cone 10
PHOTOS BY ARTIST

Adam Shiverdecker

*Memory and Containment
Series: Head A* | 2005

20 1/16 X 9 13/16 X 15 3/4 INCHES
(51 X 25 X 40 CM)

White earthenware; electric
fired, cone 02; glazed, cone 04;
nickel-chromium resistance wire

PHOTO BY ARTIST

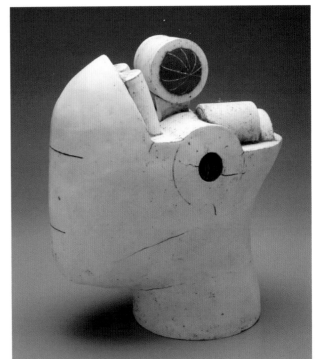

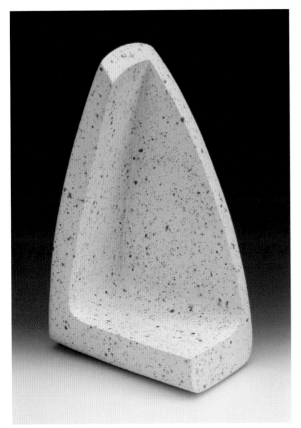

David Binns

Fragment | 2004

21 5/8 X 11 13/16 X 6 11/16 INCHES (55 X 30 X 17 CM)

Hand-built porcelain with copper, terra cotta,
and molochite aggregates; electric fired,
2192°F (1200°C); ground and polished

PHOTO BY ARTIST

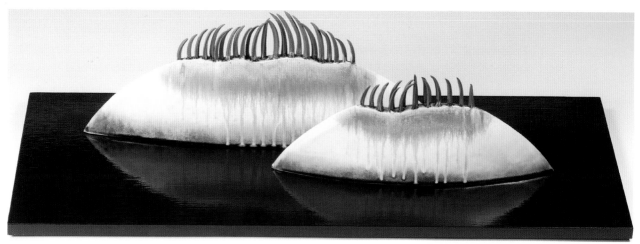

Fu-Chi Shih

Sights of Fields #3 | 2004

43 5/16 X 13 3/4 X 11 13/16 INCHES (110 X 35 X 30 CM)

Stoneware; electric fired, cone 6

PHOTO BY ARTIST

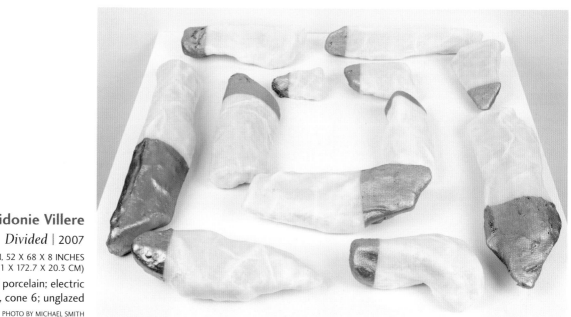

Sidonie Villere

Divided | 2007

INSTALLATION, 52 X 68 X 8 INCHES
(132.1 X 172.7 X 20.3 CM)

Hand-built porcelain; electric
fired, cone 6; unglazed

PHOTO BY MICHAEL SMITH

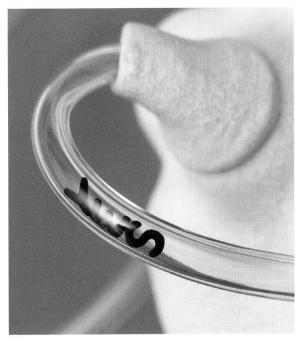

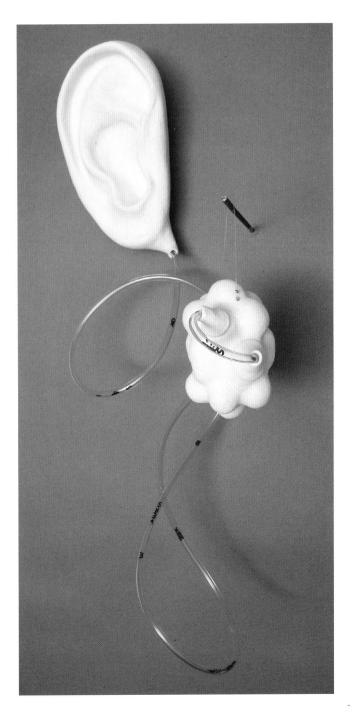

Leandra C. Urrutia
Plexus | 2008

21 X 10½ X 5¼ INCHES (53.3 X 26.7 X 13.3 CM)

Slip-cast and hand-built ceramic; electric
fired, cone 04; engobe; plastic tubing,
hand-dyed letters, steel

PHOTOS BY ARTIST

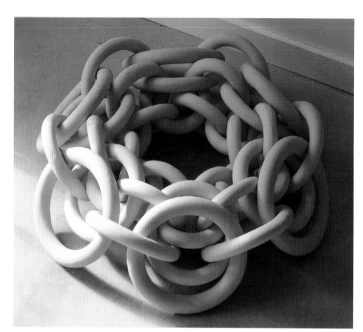

Ruth Borgenicht
Rosette | 2005
9 1/16 X 33 1/16 X 33 1/16 INCHES (23 X 84 X 84 CM)
Slip-cast stoneware; electric fired, cone 10
PHOTO BY ROBERT FISHMAN

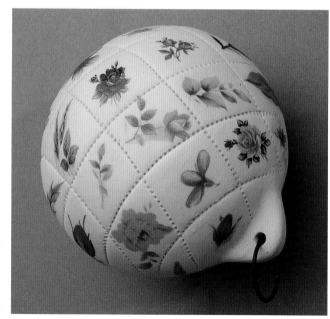

Janet E. Kastner
Quilted Urchin | 2000
3 15/16 X 5 1/8 X 3 15/16 INCHES (10 X 13 X 10 CM)
Hand-built porcelain; gas fired, cone 10;
decals and metal ring, cone 015
PHOTO BY CHRISTOPHER ZALESKI

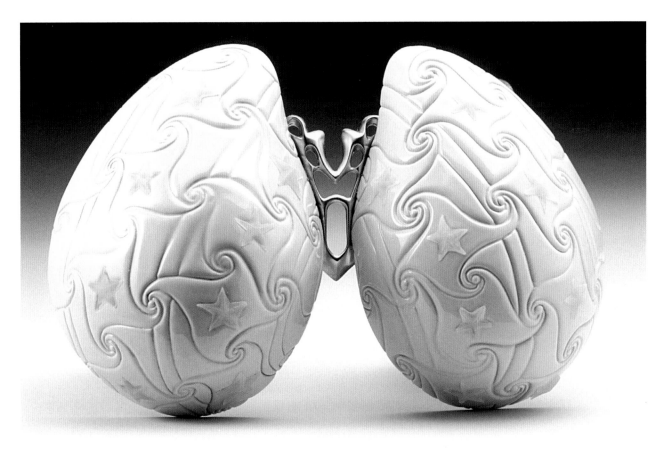

Carrie Edith Olson

All American Series:
Gluteus Implant | 2004

7⁷/₁₆ X 14³/₁₆ X 3¹⁵/₁₆ INCHES
(19 X 36 X 10 CM)

Slip-cast and hand-carved
porcelain; electric fired, cone 10;
silicone, chrome-plated brass

PHOTOS BY ARTIST

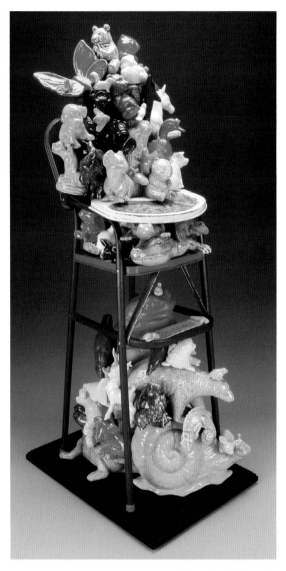

Wendy Walgate
Hannibal High Chair | 2007

31 7/8 X 11 X 14 15/16 INCHES (81 X 28 X 38 CM)

Slip-cast white earthenware; electric fired,
cone 04; glazed, cone 06; vintage child's toy,
metal high chair with storybook paper decal

PHOTOS BY ARTIST

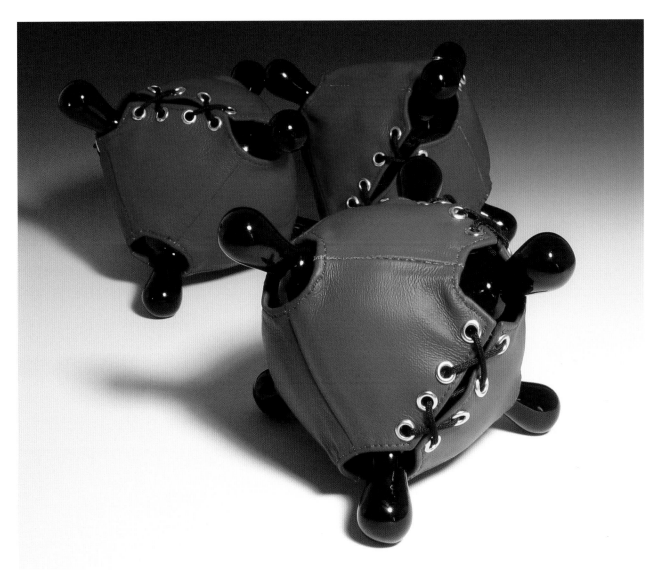

Raymond W. Gonzalez
Collectible VI | 2006
EACH, 6 X 6 X 6 INCHES (15.2 X 15.2 X 15.2 CM)
Cast earthenware; electric fired, cone 06;
glazed; custom-manufactured leatherwork,
brass grommets, lacing
PHOTO BY ARTIST

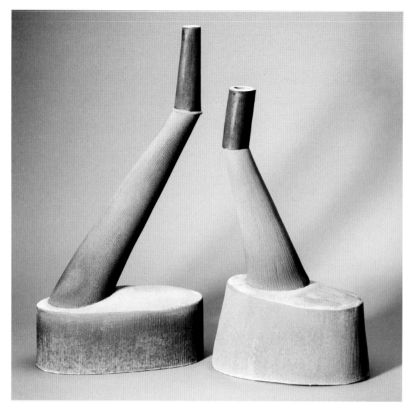

Lynn Duryea

Iron II & III | 2006

TALLEST, 18 1/8 X 9 7/16 X 4 5/16 INCHES (46 X 24 X 11 CM)

Slab-constructed terra cotta;
electric fired, cone 04; slips, glazes

PHOTO BY TROY TUTTLE

Bettina Baumann

Causalities | 2005

4 X 15 3/4 X 10 INCHES (11 X 40 X 26 CM)

Thrown, altered, assembled, and printed
stoneware; electric fired, cone 06; glazed,
cone 7; printed, cone 018

PHOTO BY ARTIST

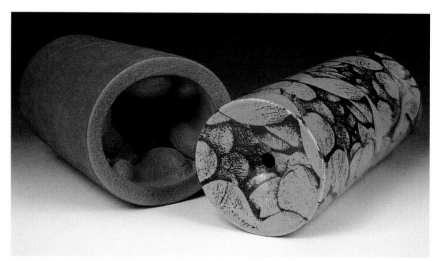

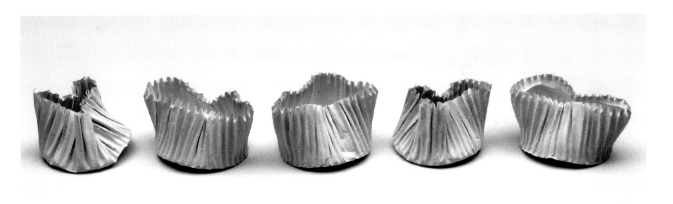

Anna Velkoff Freeman
Waste 2 | 2006
EACH, 1 9/16 X 2 3/8 X 2 3/8 INCHES (4 X 6 X 6 CM)
Slip-cast porcelain; electric fired, cone 6
PHOTO BY ARTIST

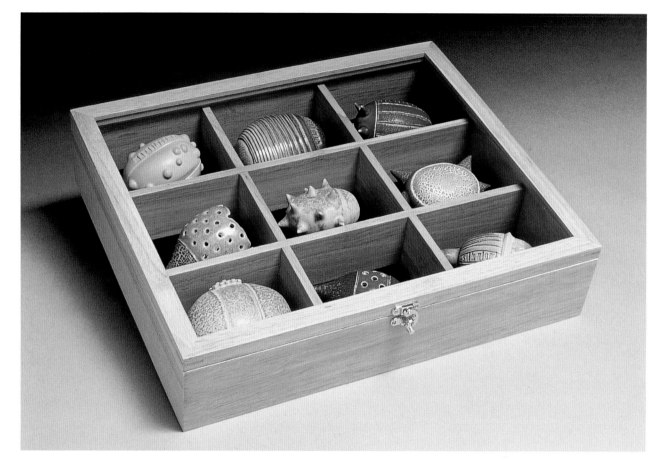

Stephanie Craig

Supervision Collection | 2007

3 15/16 X 16 15/16 X 14 INCHES (10 X 43 X 35.5 CM)

Hand-built stoneware;
electric fired, cone 6; wood, felt

PHOTOS BY ARTIST

Cynthia Levine
Vessel #160 | 2008

7 1/16 X 4 5/16 X 4 5/16 INCHES
(18 X 11 X 11 CM)

Coil-built earthenware; electric
fired, cone 02; terra sigillata

PHOTO BY PETER LEE

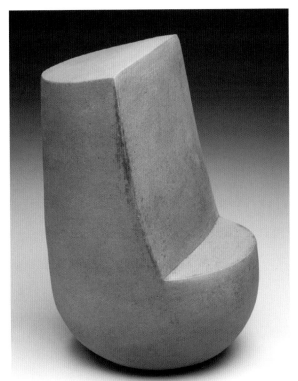

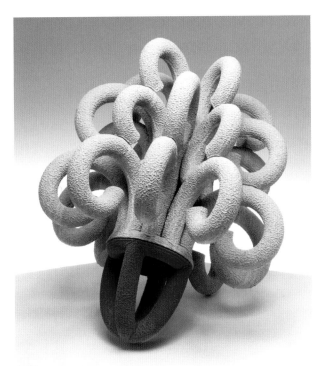

Tyler Lotz
Anchor | 2007

22 13/16 X 22 13/16 X 20 7/8 INCHES
(58 X 58 X 53 CM)

Slip-cast and assembled clay;
electric fired, cone 1; acrylic surface

PHOTO BY ARTIST

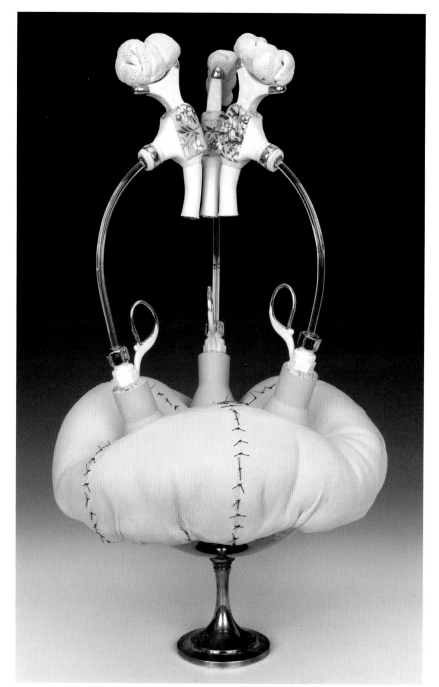

Colleen Toledano
Handled Stitchery III | 2007
18 1/8 X 5 7/8 X 5 7/8 INCHES (46 X 15 X 15 CM)
Slip-cast porcelain; electric fired, cone 6;
gold luster, decals, cone 018; leather,
glass rods, foam, suture thread
PHOTOS BY ARTIST

Rain Harris

Bauble | 2006

7⁷/₁₆ X 12³/₁₆ X 12³/₁₆ INCHES
(19 X 31 X 31 CM)

Slip-cast and altered porcelain;
electric fired, cone 6; glazed; luster
and decal, cone 018; wallpaper,
Swarovski crystals, freshwater pearls

PHOTO BY DOUG WEISMAN

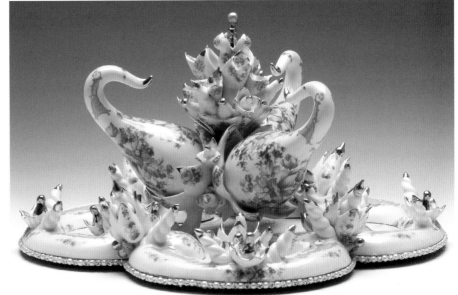

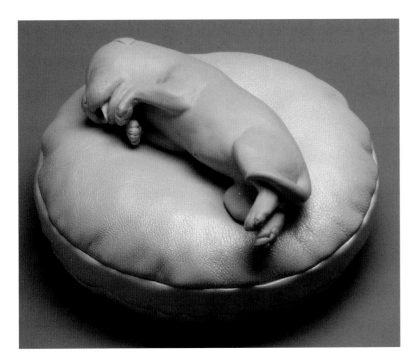

Adelaide Paul

Untitled | 2008

2³/₄ X 7¹/₁₆ INCHES (7 X 18 CM)

Pink leather, pink porcelain

PHOTO BY JOHN CARLANO

137

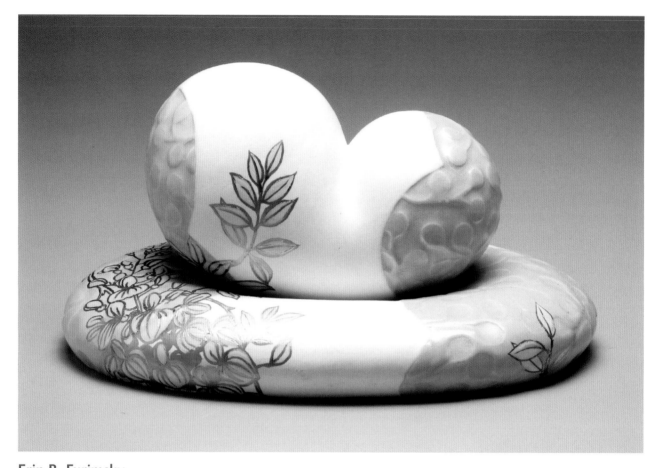

Erin B. Furimsky

Untitled | 2007

6⁵/₁₆ X 9¹³/₁₆ X 5⁷/₈ INCHES (16 X 25 X 15 CM)

Hand-built porcelain; electric fired, cone 06; glazed, cone 04; commercial decal, cone 018; gold luster, cone 019

PHOTO BY TYLER LOTZ

Lindsay Feuer
Hybrid 'Fruit' No. 2 | 2007
7⁷/₈ X 9¹/₁₆ X 5¹/₈ INCHES (20 X 23 X 13 CM)
Hand-built porcelain; oxidation fired, cone 10
PHOTO BY JOHN CARLANO

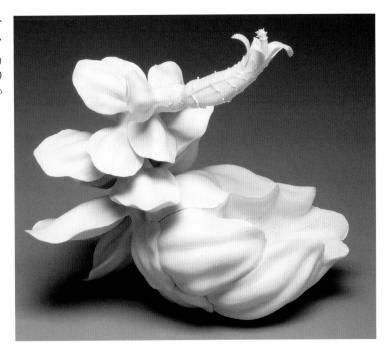

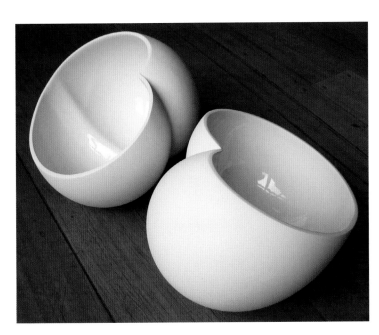

Belinda Marquis
Float Vessels | 2007
7⁷/₈ X 7⁷/₈ X 11¹³/₁₆ INCHES (20 X 20 X 30 CM)
Slip-cast earthenware; electric
fired; internal clear glaze
PHOTO BY ARTIST

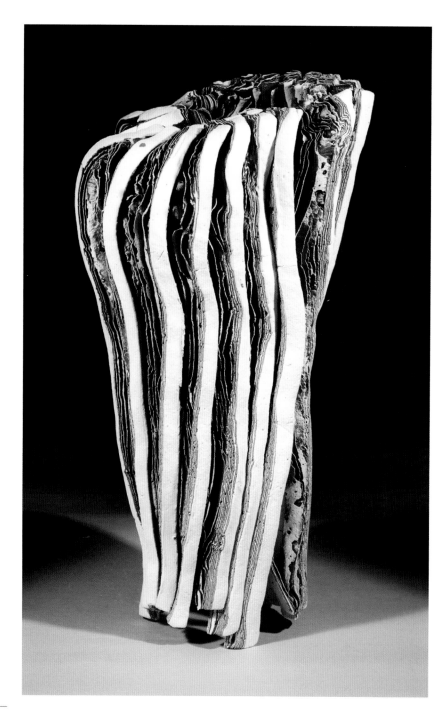

Rafael Perez
Untitled | 2007
15³/₄ X 7⁷/₁₆ X 6¹¹/₁₆ INCHES (40 X 19 X 17 CM)
Porcelain and personal clay; gas fired in
oxidation, 2138°F (1170°C); sandblasted
PHOTO BY CARLOS E. HERMOSILLA

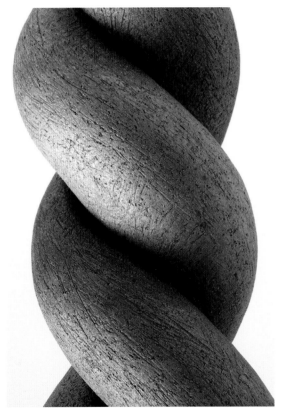

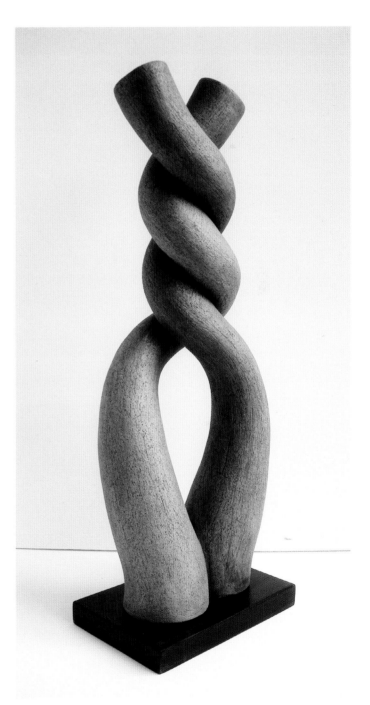

Roger Lewis
Double Twist | 2008

21⅝ X 8¼ X 5½ INCHES (55 X 21 X 14 CM)

Coiled stoneware, bisque fired, 1832°F
(1000°C); manganese dioxide, 2300°F
(1260°C); luster, 1382°F (750°C)

PHOTOS BY ARTIST

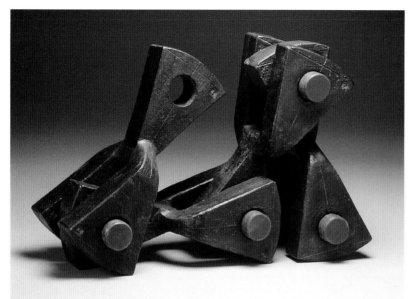

Kenneth Baskin
Industrial Intuitions Series: Link | 2007
12 X 21 X 7 INCHES (30.5 X 53.3 X 17.8 CM)
Slab-built stoneware; soda fired,
cone 10; bronze glaze, slip; steel
PHOTO BY ARTIST

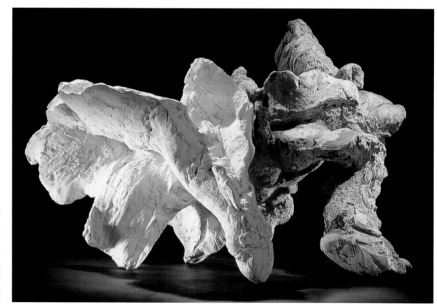

Ray Chen
Mother and Child | 2006
67 X 54 X 46 INCHES (170.2 X 137.2 X 116.8 CM)
Hand-built stoneware, earthenware; gas
fired in reduction, cone 4; glazed
PHOTO BY FRANCOIS GAGNE

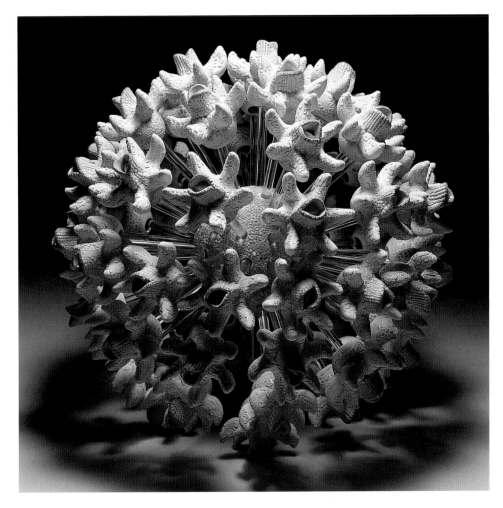

Ying-Yueh Chuang

It Blooms on the Day . . . | 2005

16¹/₂ X 16¹/₂ X 16¹/₂ INCHES (42 X 42 X 42 CM)

Slip-cast and hand-built porcelain; oxidation fired, cones 6–06; clear plastic sheeting rod

PHOTOS BY ARTIST

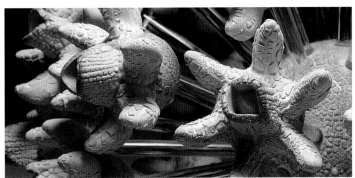

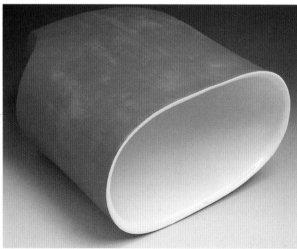

Peter Christian Johnson
Industrial Abstraction | 2006
7 1/16 X 10 5/8 X 16 15/16 INCHES (18 X 27 X 43 CM)
Press-molded terra cotta; electric
fired, cone 04; glaze, terra sigillata
PHOTOS BY ARTIST

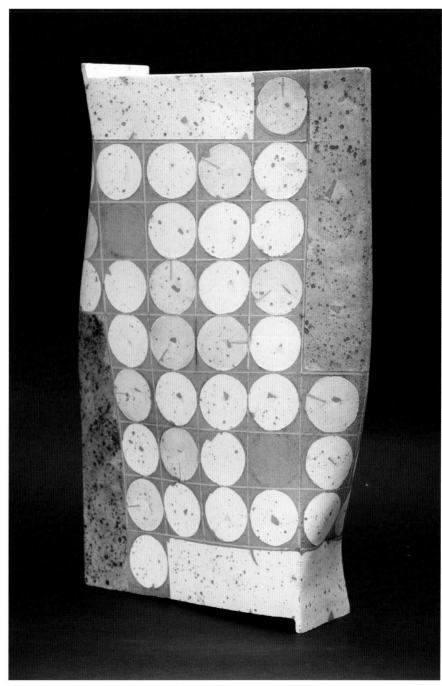

Regina Maria Heinz
Time Zone | 2007

23 5/8 X 14 15/16 X 5 1/8 INCHES
(60 X 38 X 13 CM)

Hand-built grogged stoneware;
electric fired, 1895°F (1035°C);
brushed lithium glaze, colors

PHOTO BY ALFRED PETRI

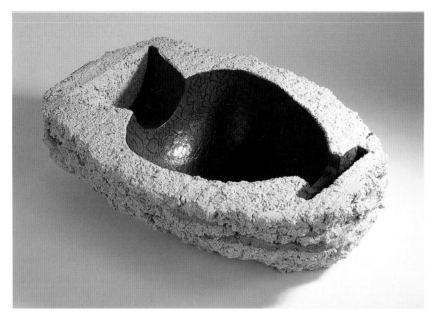

Kersti Laanmaa

Fossil | 2003

5 1/2 X 18 1/8 X 12 3/16 INCHES (14 X 46 X 31 CM)

Hand-built stoneware, earthenware clay as glaze; electric fired, cone 8

PHOTO BY TIIT RAMMUL

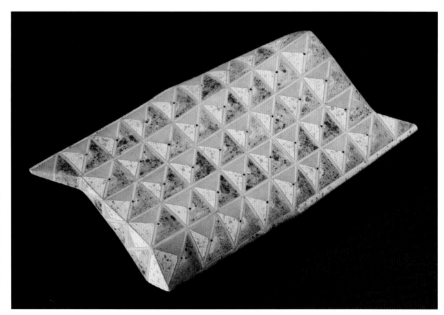

Regina Maria Heinz

Keeping Time | 2006

3 15/16 X 23 3/16 X 11 13/16 INCHES
(10 X 59 X 30 CM)

Hand-built grogged stoneware; electric fired, 1895°F (1035°C); brushed lithium glaze, colors

PHOTO BY ALFRED PETRI

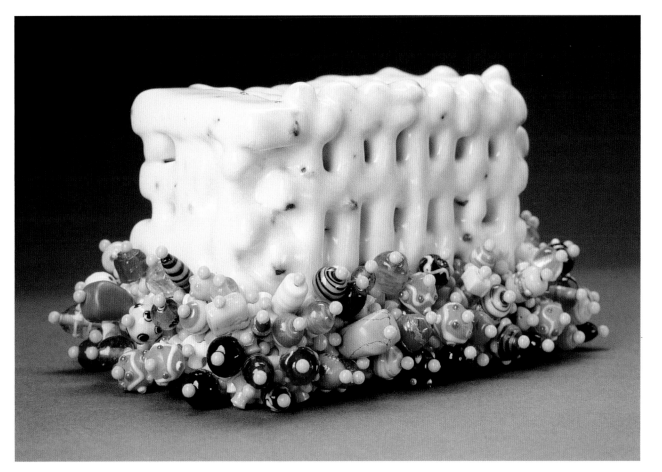

Todd Cero-Atl
The Lament | 2006
5 1/8 X 5 7/8 X 8 5/8 INCHES (13 X 15 X 22 CM)
Contaminated porcelain; gas fired,
cone 11; glaze; felt, mixed media
PHOTO BY ARTIST

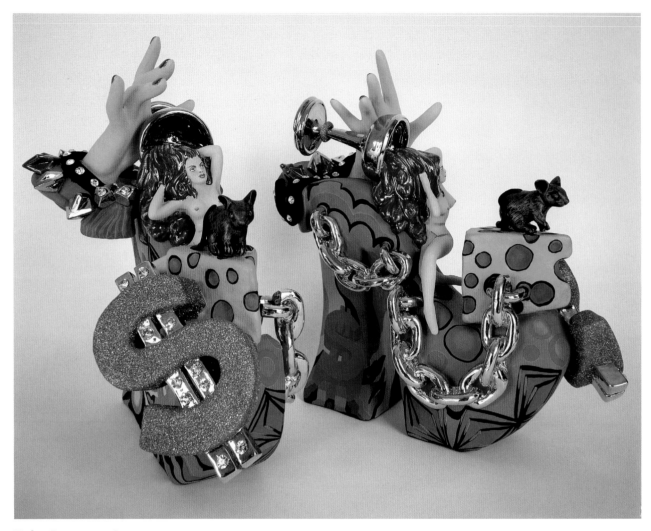

Toby Buonagurio

Hungry for Love Party Shoes | 1993

EACH, 16 X 14$^{1}/_{2}$ X 8$^{1}/_{2}$ INCHES (40.6 X 36.8 X 21.6 CM)

Handmade ceramic with multi-process construction;
mixed media; fired and unfired surfaces

PHOTO BY EDGAR BUONAGURIO

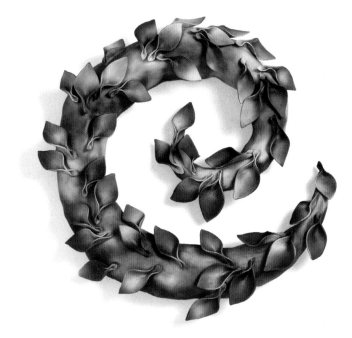

Whitney Forsyth
Red Spiral | 2007
35⁷/₁₆ X 35⁷/₁₆ X 7⁷/₈ INCHES (90 X 90 X 20 CM)
Hand-built, low-fire clay; electric
fired, cone 02; oil patina wash
PHOTO BY GENE JOHNSON

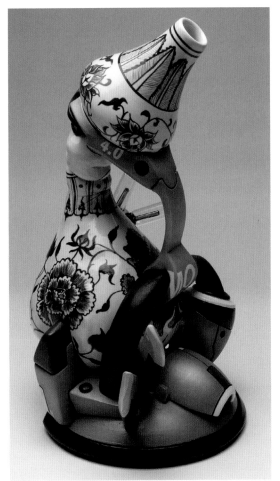

Brendan L.S. Tang
Manga Ormolu version 4.0-c | 2008
16¹/₂ X 9¹³/₁₆ X 10¹/₄ INCHES (42 X 25 X 26 CM)
Wheel-thrown and altered earthenware;
electric fired, cone 04; mixed media
PHOTO BY ARTIST

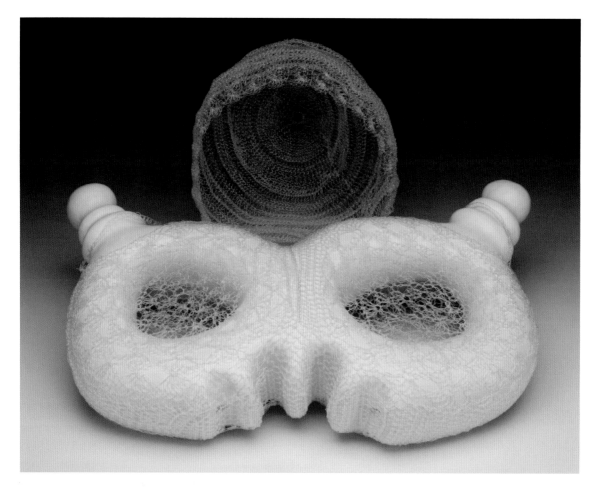

Stephanie Lanter
Double Sucker with Bonnet | 2007
5¹/₂ X 11 X 13 INCHES (14 X 28 X 33 CM)
Hand-formed and burnished earthenware;
electric fired, cone 06; terra sigillata;
crocheted nylon monofilament
PHOTOS BY ARTIST

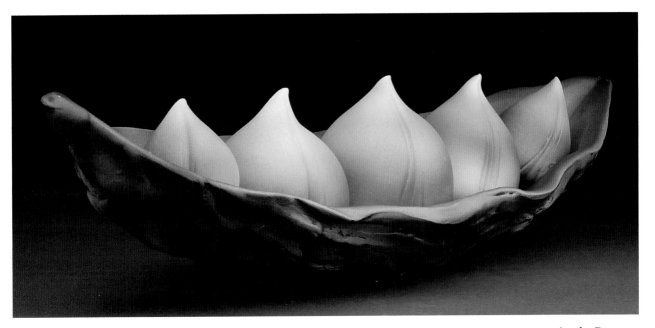

Andy Rogers
Seed Pod | 2008

7⁷/₈ X 4¹¹/₁₆ X 16¹⁵/₁₆ INCHES (20 X 12 X 43 CM)

Hand-built porcelain pod with wheel-thrown
porcelain seeds; electric fired, cone 6; glaze,
terra sigillata, stains, airbrushed acrylics

PHOTO BY ARTIST

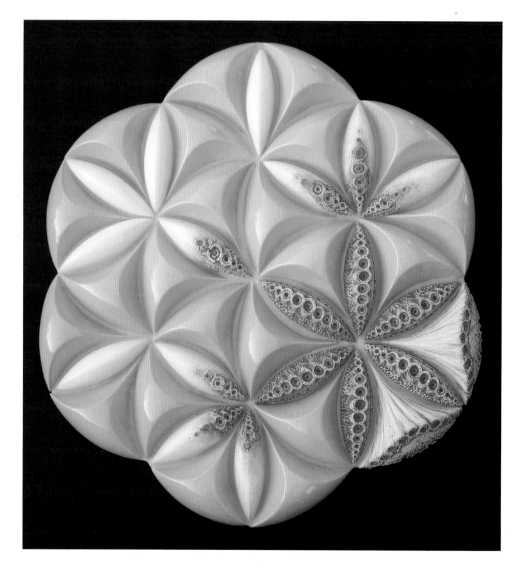

Scott Chatenever

Infection (In the Safety of My Childhood Kitchen) | 2007

30 X 31 X 3 INCHES (76.2 X 78.7 X 7.6 CM)

Cast, press-molded, carved, and hand-tooled stoneware; electric fired, cone 5; glazes, stains

PHOTOS BY ARTIST

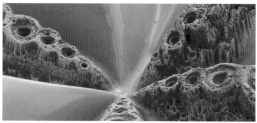

Beth Cavener Stichter

I Am No One | 2006

32¼ X 37 X 30⁵⁄₁₆ INCHES (82 X 94 X 77 CM)

Solid-built stoneware; cut, hollowed, reassembled; electric fired, cone 3

PHOTO BY NOEL ALLUM

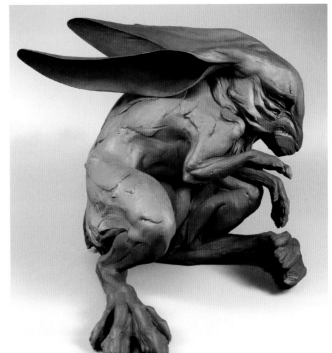

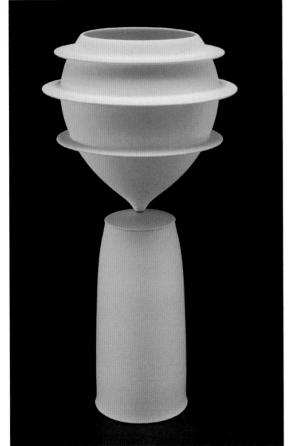

Rebekah Diamantopoulos

Revolving | 2007

7⅞ X 3¹⁵⁄₁₆ X 3¹⁵⁄₁₆ INCHES (20 X 10 X 10 CM)

Wheel-thrown porcelain, colored slip; electric fired, cone 6

PHOTO BY COURTNEY FRISSE

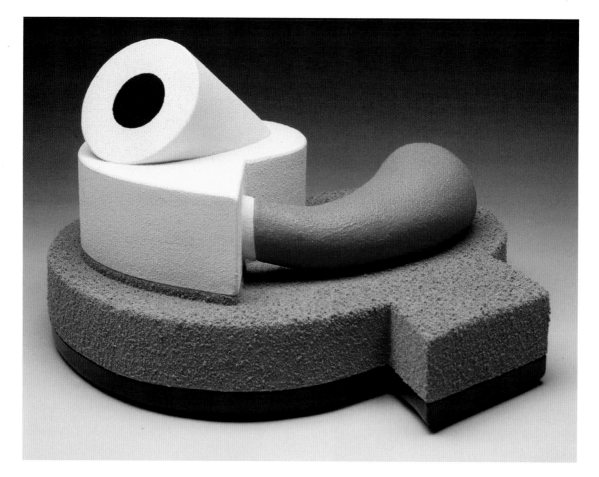

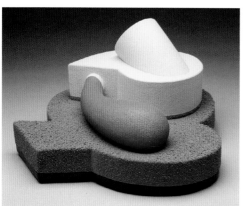

Nathan Prouty

Progress Plant II | *2007*

11 X 14 X 7¹/₁₆ INCHES (28 X 35.5 X 18 CM)

Slab-built white earthenware; electric fired, cone 02; lacquer, paint, flocking

PHOTOS BY ARTIST

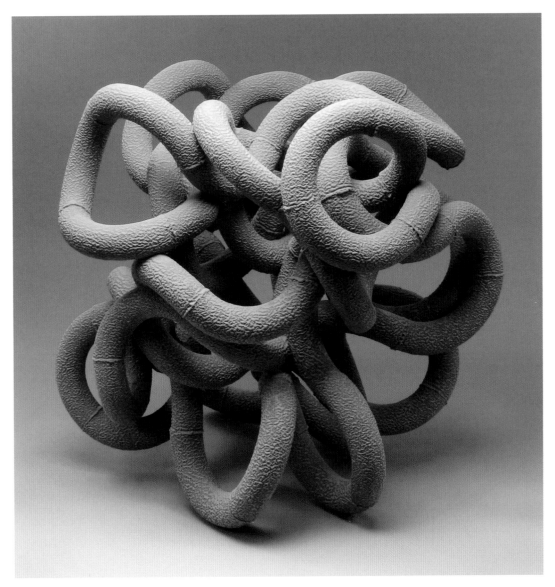

Tyler Lotz
Spirulina | 2007
22 13/16 X 27 15/16 X 24 INCHES (58 X 71 X 61 CM)
Slip-cast and assembled clay;
electric fired cone 1; acrylic surface
PHOTO BY ARTIST

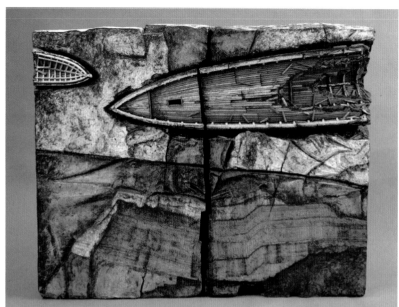

Frank Steyaert
Fossilized Vessels | 2004
27⁹/₁₆ X 35⁷/₁₆ X 7⁷/₈ INCHES
(70 X 90 X 20 CM)
Hand-built earthenware;
electric fired, 1985°F (1085°C)
PHOTO BY ARTIST

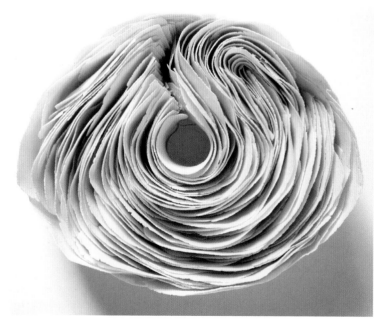

Amy Kennedy
Untitled | 2006
2³/₄ X 5¹/₈ X 4¹/₈ INCHES (7 X 13 X 10.5 CM)
Dry glaze material; hand built;
electric fired, cone 6
PHOTO BY JEREMY DILLON

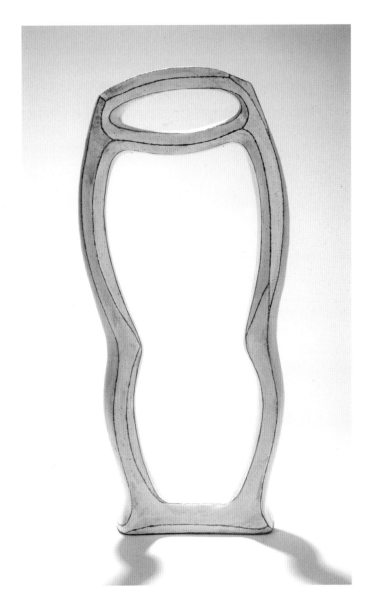

Lene Kuhl Jakobsen

Empty Vessel | 2007

18¹/₈ X 8¹/₄ X 2⁹/₁₆ INCHES (46 X 21 X 6.5 CM)

Hand-built stoneware;
electric fired, cone 9; glazed

PHOTOS BY ANDREW BARCHAM

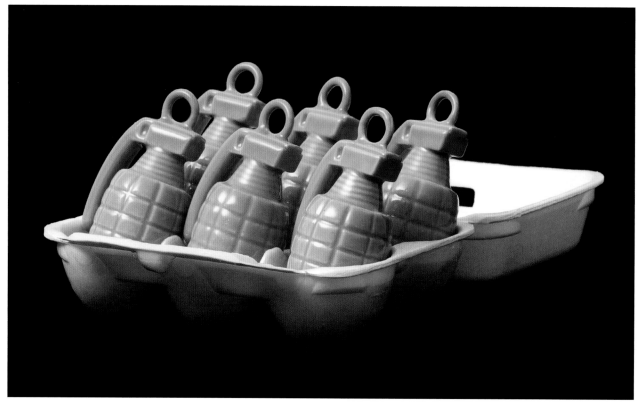

E. Elizabeth Peters

American Breakfast | 2007

9 X 20 X 12 FEET (2.7 X 6.1 X 3.7 METERS)

Slip-cast porcelain; reduction
fired, cone 10; glazed

PHOTO BY CHRIS KENDALL

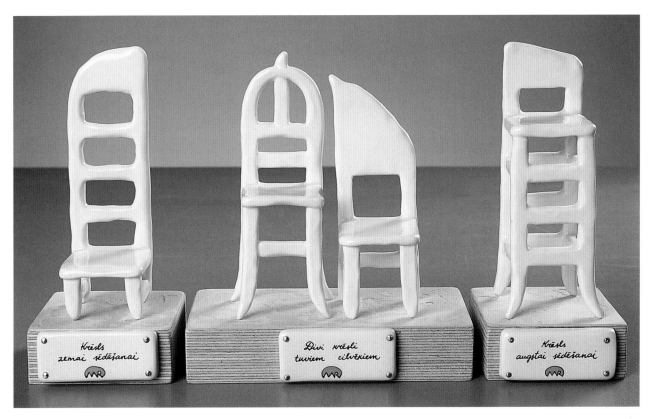

Maruta Raude

Chairs for Different Sitting | 2007

6 $^{11}/_{16}$ X 11 $^{13}/_{16}$ X 2 $^{3}/_{4}$ INCHES (17 X 30 X 7 CM)

Hand-built porcelain; electric fired,
1230°C (2246°F); surface painting,
1382°F (750°C); plywood

PHOTO BY ARMANDS LĀCIS

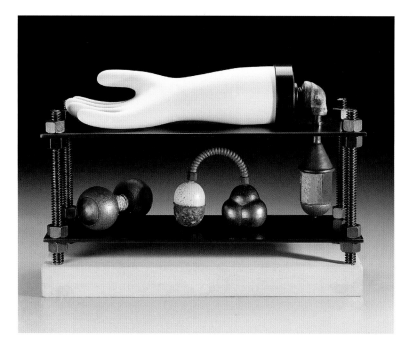

Matt Wilt

Delicate Apparatus | 2006

14 X 24 X 10 INCHES (35.6 X 61 X 25.4 CM)

Slip-cast and wheel-thrown stoneware and porcelain; reduction fired, cone 9; concrete, steel

PHOTO BY TONY DECK

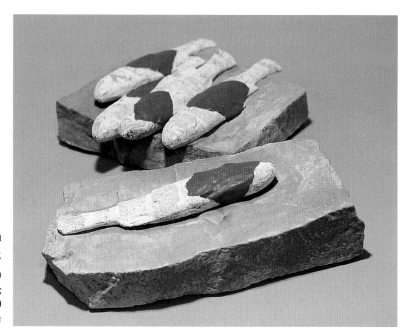

Lu Bin

Fossil: Fish of Abundance | 2005

4 11/16 X 15 3/4 X 23 5/8 INCHES (12 X 40 X 60 CM)

Press-molded and hand-built stoneware; gas fired, cone 4; slip, cone 010

PHOTO BY ARTIST

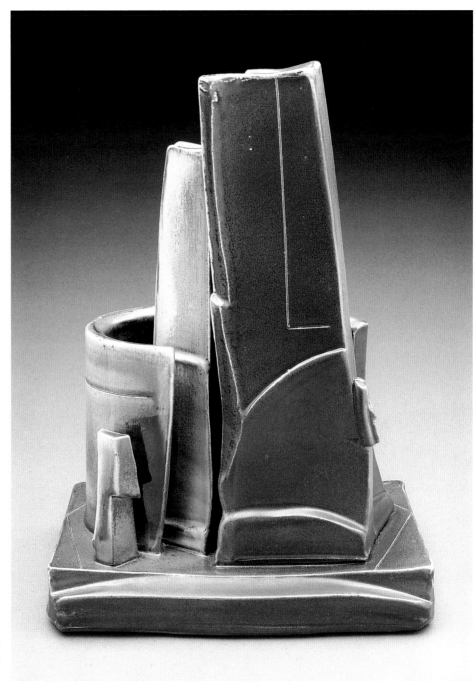

Brad Schwieger

Construction #1 | 2007

27 15/16 X 16 15/16 X 8 5/8 INCHES
(71 X 43 X 22 CM)

Press-molded and wheel-thrown stoneware; soda fired, cone 10; slips, multiple glazes; nickel-chromium resistance wire

PHOTO BY STEVE PASZT

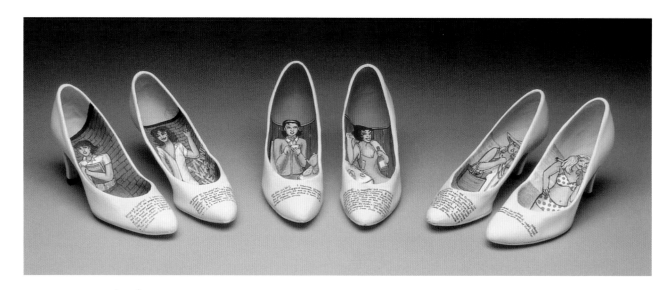

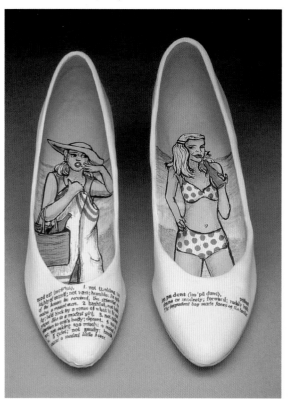

Shalene Valenzuela

*Goody Two-Shoes: Dichatoics
(Pairs, 1,2 & 3)* | 2007

EACH, 3 9/16 X 3 1/8 X 7 1/16 INCHES (9 X 8 X 18 CM)

Slip-cast ceramic; electric fired, cone 02;
underglaze screen-printing, illustrations

PHOTOS BY CHRIS AUTIO

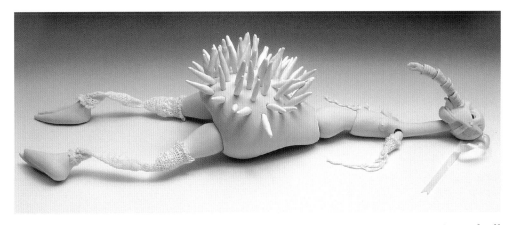

Kira Campbell

Sugar Pachyderm | 2007

26³/₈ X 6¹/₂ X 5⁷/₈ INCHES (67 X 16.5 X 15 CM)

Hand-built porcelain; electric fired,
cone 9; rubber, cotton crochet,
glass eyes, ribbon, elastic cord

Katy Rush

Nourish | 2007

11 ¹³/₁₆ X 5¹/₈ X 5⁷/₈ INCHES (30 X 13 X 15 CM)

Slip-cast and press-molded
porcelain; electric fired, cone 6

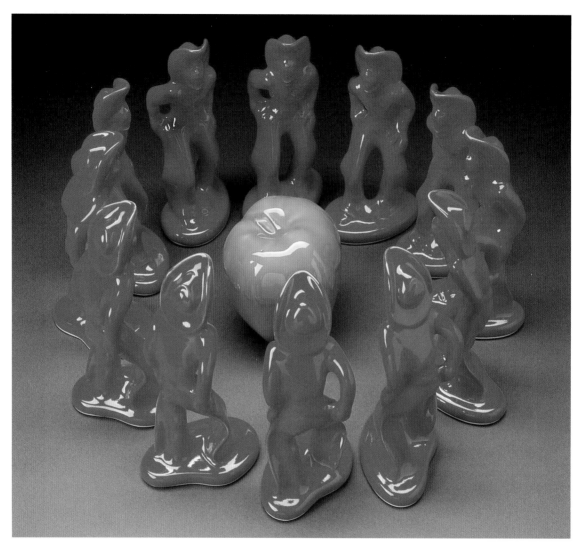

Todd Cero-Atl

Fruit | 2004

5⁷/₈ X 17¹¹/₁₆ X 17¹¹/₁₆ INCHES
(15 X 45 X 45 CM)

Slip-cast earthenware; electric fired,
cone 04; lead glaze, cone 06

PHOTO BY ARTIST

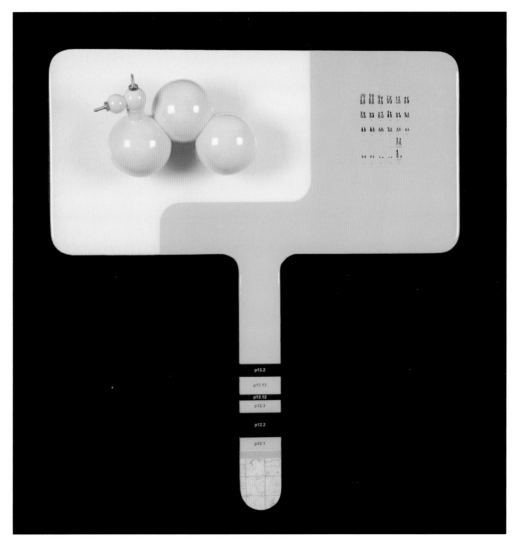

Timothy Van Beke

Displacement | 2008

20⁹/₁₆ X 23³/₄ X 4 INCHES (52.3 X 60.3 X 10.2 CM)

Slip-cast earthenware; electric fired, cone 04;
glazed, cone 05; brass fittings on shaped
wood panel with acrylic, decals, epoxy resin

PHOTO BY ARTIST

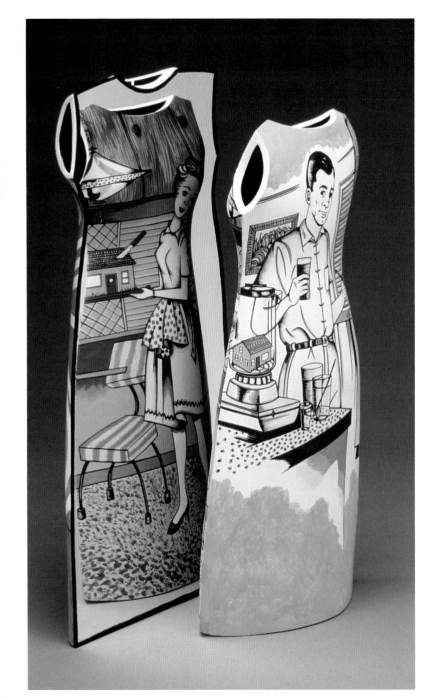

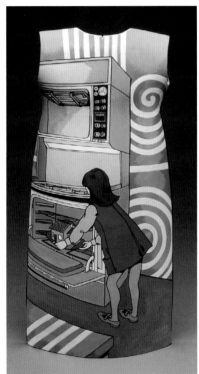

Anita D. Powell
Family | 2005
28 X 24 X 7 INCHES (71.1 X 61 X 17.8 CM)
Hand-built and slab-constructed clay; electric fired, cone 05; underglaze, glaze; mirror
PHOTOS BY ARTIST

Amanda Salov

Tip-Toe | 2006

7¹/₁₆ X 5⁷/₈ X 9¹/₁₆ INCHES (18 X 15 X 23 CM)

Burn-out porcelain; gas fired, cone 10;
terra sigillata with lobster stain;
electric fired, cone 6; wax, sugar

PHOTO BY TOM SCHMIDT

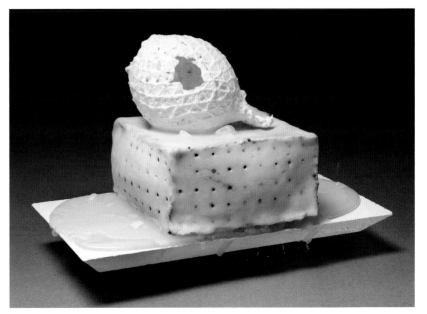

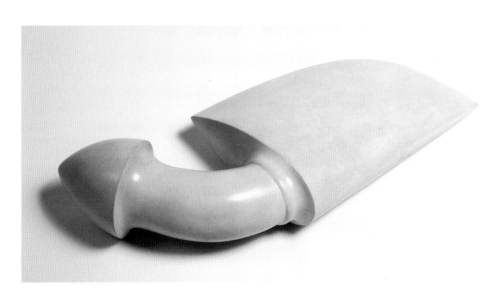

Conor Wilson

Holster | 2003

2³/₈ X 11¹³/₁₆ X 4¹¹/₁₆ INCHES
(6 X 30 X 12 CM)

Press-molded earthenware;
electric fired, cone 06;
diamond abrasives; electric
fired, cone 01; beeswax

PHOTO BY ARTIST

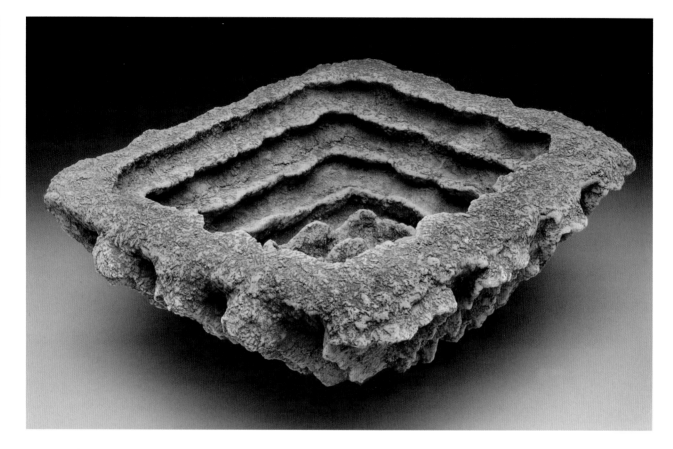

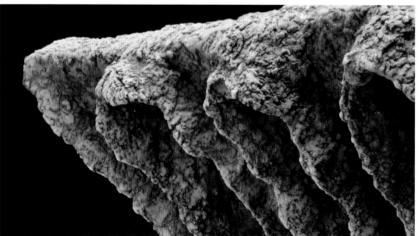

Michael A. Gregory
Untitled: Object in Space | 2007
8 X 13 X 12 INCHES (20.3 X 33 X 30.5 CM)
Press-molded stoneware; electric fired, cone 03; fritted washes, oxide wash, glaze
PHOTOS BY EDDIE ING

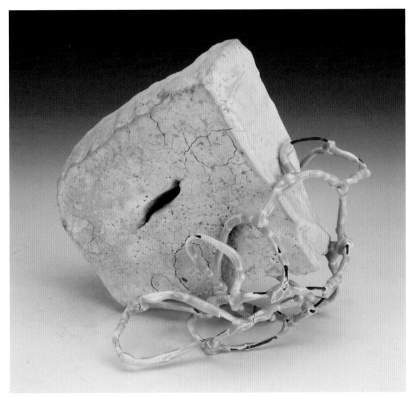

Alicia Basinger
Pink Tangle | 2008
7 X 8 X 8½ INCHES (17.8 X 20.3 X 21.6 CM)
Porcelain, wire; soda and
electric fired, cones 6 and 4
PHOTO BY ARTIST

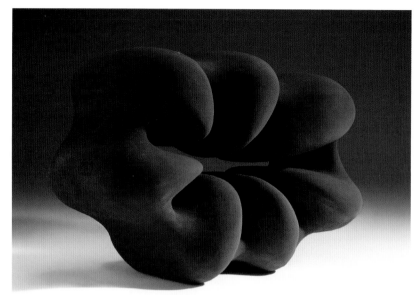

Merete Rasmussen
Black Dynamic Form | 2006
23 5/8 X 31 1/2 X 19 11/16 INCHES
(60 X 80 X 50 CM)
Hand-built stoneware; electric
fired, cone 08; glazed, cone 5
PHOTO BY ARTIST

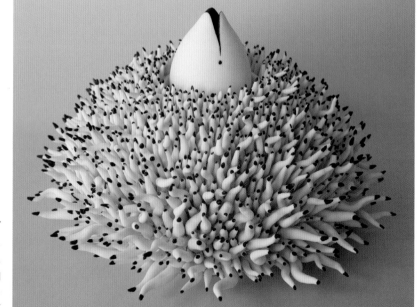

Lorna Fraser
Water Lily | 2008
6 5/16 X 9 7/16 X 9 7/16 INCHES (16 X 24 X 24 CM)
Hand-built and wheel-thrown white and
black porcelain; electric fired, cone 8
PHOTO BY ARTIST

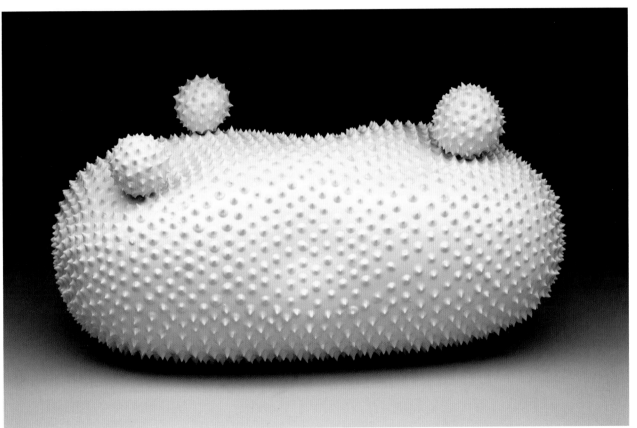

Amy Chase
Milieu | 2008
5 X 11 X 6 INCHES (12.7 X 27.9 X 15.2 CM)
Wheel-thrown and altered earthenware;
electric fired, cone 04; underglaze, glazes
PHOTO BY DAVE TRUESDALE

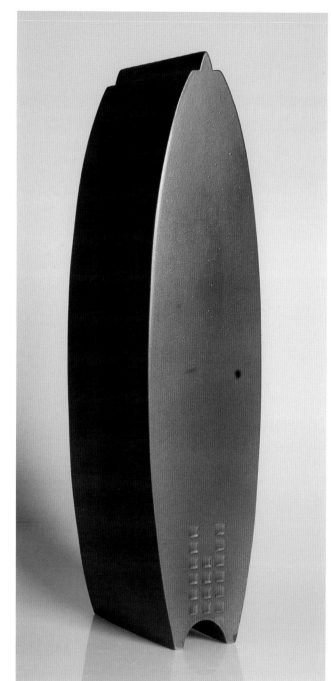

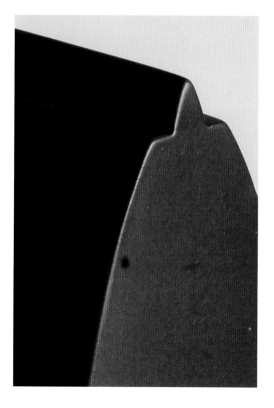

Kemal Tizgöl

Sarcophagus | 2006

18 1/8 X 4 15/16 X 7 1/16 INCHES (46 X 12.5 X 18 CM)

Press-molded white earthenware; electric fired, cone 05a; glazed, cone 03a

PHOTOS BY GÖZDE YENIPAZARLI

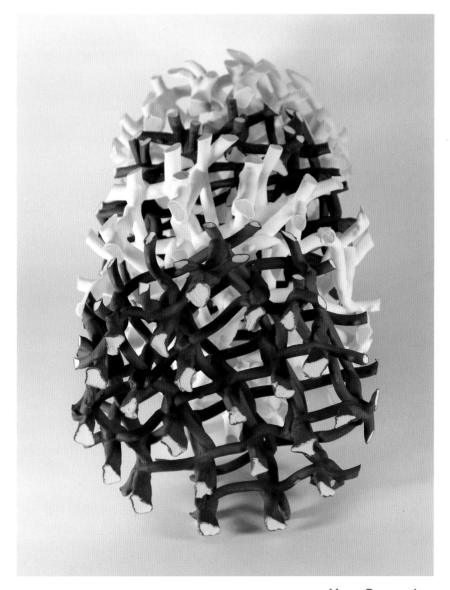

Hans Borgonjon
Microtubulix 4 | 2007
EACH, 9⁷/₁₆ X 9⁷/₁₆ X 4⁵/₁₆ INCHES (24 X 24 X 11 CM)
Slip-cast and hand-built porcelain, red
earthenware, stoneware; electric fired, cone 6
PHOTO BY ARTIST

173

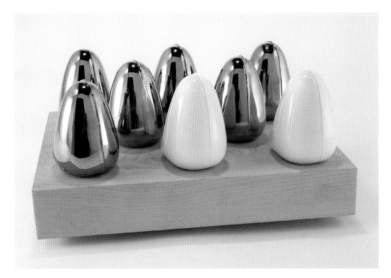

Ian F. Thomas

6:Z for Show | 2007

5 1/2 X 11 13/16 X 9 INCHES (14 X 30 X 22.9 CM)

Thrown and molded porcelain; reduction fired, cone 11; electroplated; wood

PHOTO BY ARTIST

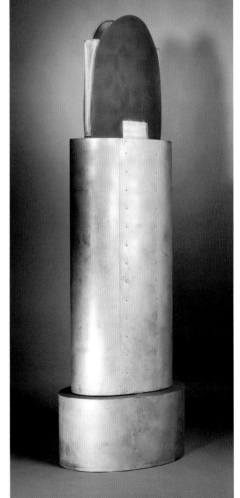

Lynn Duryea

Stepped Stack | 2006

75 13/16 X 24 X 18 1/8 INCHES (193 X 61 X 46 CM)

Slab-constructed terra cotta; electric fired, cone 04; slips, glazes; steel

PHOTO BY TROY TUTTLE

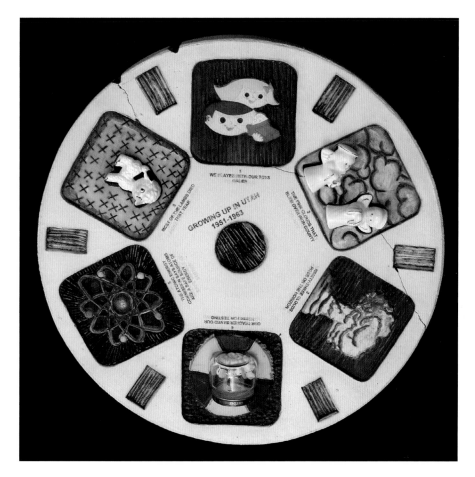

Jennifer Mettlen Nolan

Viewmaster: Growing Up in Utah | 2006

19 X 19 X 2 INCHES (48.3 X 48.3 X 5.1 CM)

Slab-built and carved stoneware; electric fired, cone 08; glazed, cone 04; stains, underglazes, laser decal; found objects

PHOTOS BY ARTIST

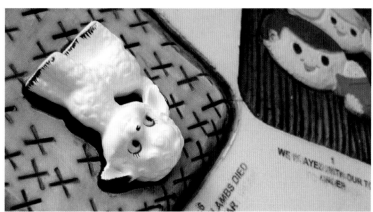

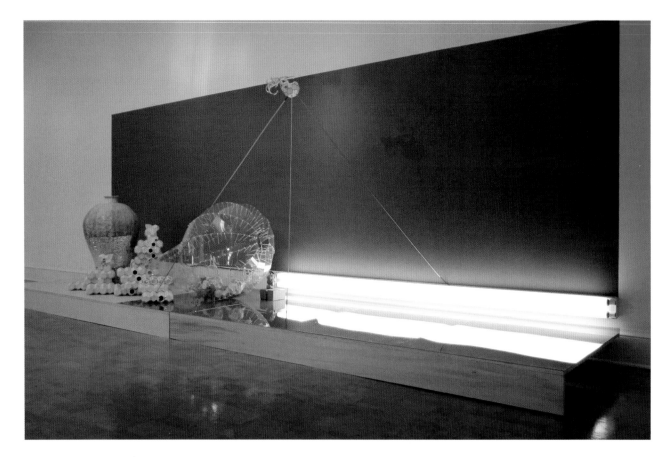

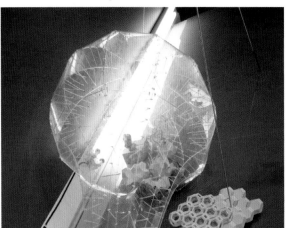

Del Harrow

Chinese Satellite Chandelier | 2008

78 9/16 X 196 1/2 X 78 9/16 INCHES (200 X 500 X 200 CM)

Slip-cast porcelain, hand-built stoneware; electric fired, cone 10; gold luster, electric fired, cone 018; clear plastic sheeting, plywood, paint, fluorescent light

PHOTOS BY ARTIST

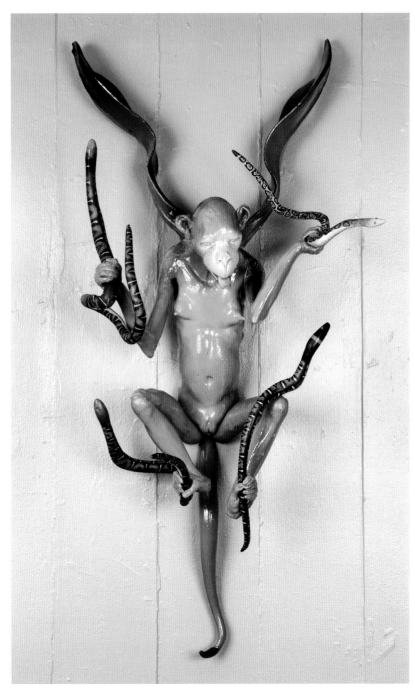

Joe Bova

Unforgiven Enmity | 2008

45¹³/₁₆ X 21 X 14 INCHES
(116.4 X 53.3 X 35.5 CM)

Hand-formed stoneware; electric
fired, cone 5; glazed, ruby luster,
cone 018; paint, acrylic gems

PHOTO BY MIKE SMITH

177

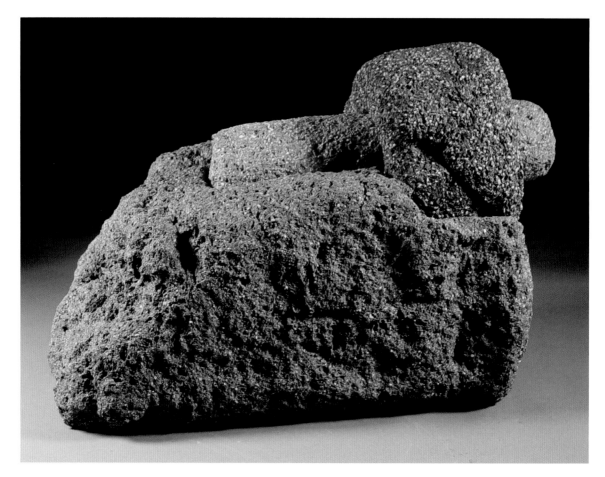

Brian Harper

New Myth Series: The Line | 2006

7⁷/₈ X 7¹/₁₆ X 16¹/₈ INCHES (20 X 18 X 41 CM)

Carved solid earthenware;
reduction fired, cones 1 and 6

PHOTOS BY ARTIST

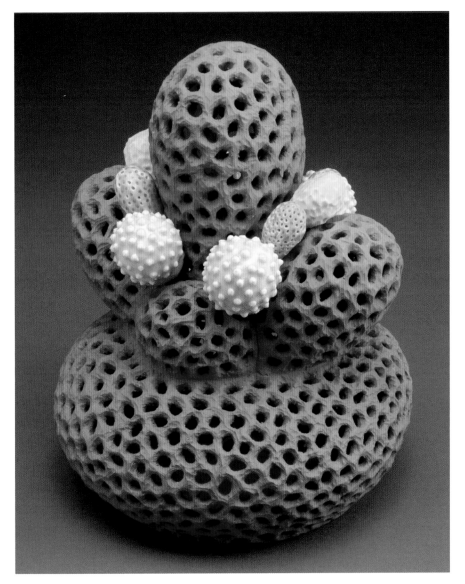

Helen Otterson

Metabolic Fusion | 2007

15 X 10 X 10 INCHES (38.1 X 25.4 X 25.4 CM)

Hand-built stoneware and terra
cotta; electric fired, cones 6 and 02

PHOTO BY BRYAN HEATON

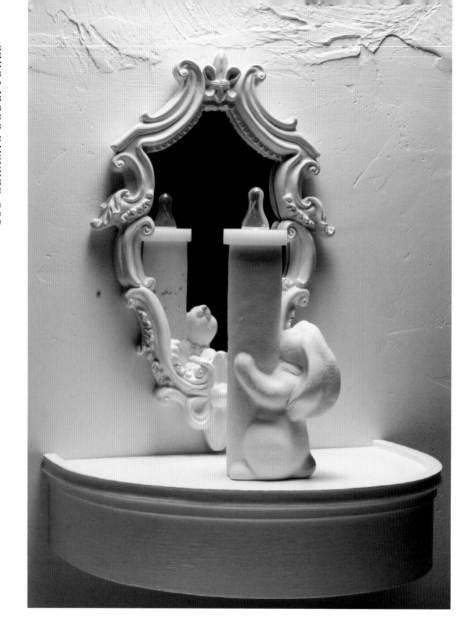

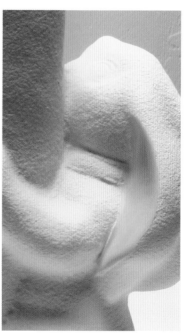

Robin Tieu

Mirror, Mirror On the Wall | 2007

13 X 11 X 14 INCHES (33 X 27.9 X 35.6 CM)

Ceramic found object, clay vase, bunny, mirror, acrylic, wood, silicone; reworked, sandblasted

PHOTOS BY ARTIST

Lindsay Feuer

Hybrid 'Cluster' No. 7 | 2005

18⁷/₈ X 11 X 7¹/₁₆ INCHES (48 X 28 X 18 CM)

Hand-built porcelain;
oxidation fired, cone 10

PHOTO BY JOHN CARLANO

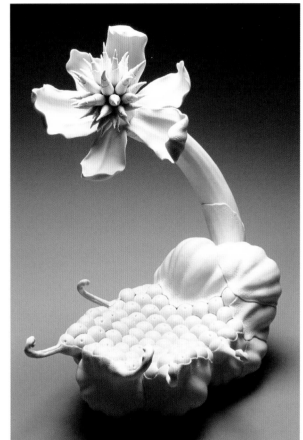

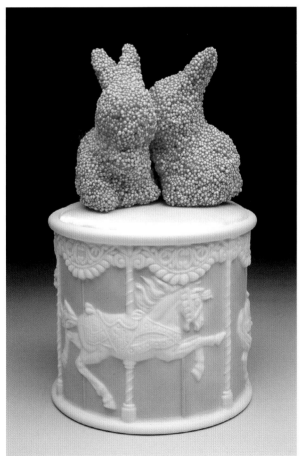

Wesley Harvey

Pink Ladies | 2007

7 X 5 X 5 INCHES (17.8 X 12.7 X 12.7 CM)

Slip-cast porcelain; electric fired, cone 6;
fabric, polystyrene foam beads

PHOTO BY ARTIST

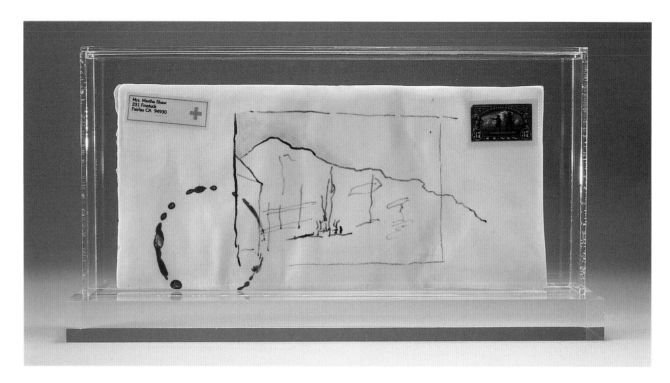

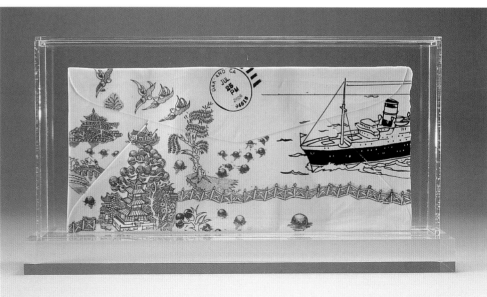

Richard Shaw
Martha Shaw

*Opening of the East
and West* | 2007

4¹/₂ X ¹/₈ X 9³/₄
(11.4 X 0.3 X 24.7 CM)

Slip-cast and modeled
porcelain; glazed, cone 6;
overglaze decals, cone 018

PHOTOS BY CHARLES KENNARD

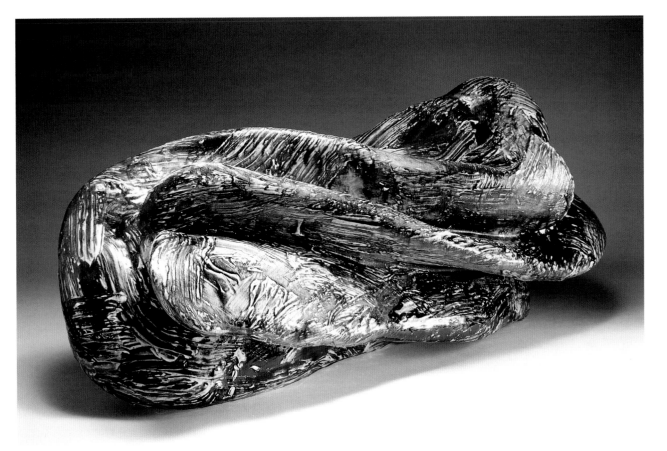

John H. Stephenson
Mariner's Tool #17 | 1999
16¼ X 40 X 15½ INCHES (41.3 X 101.6 X 39.4 CM)
Terra cotta; gas fired, cone 02;
glazed; formed on external armature

PHOTO BY ARTIST

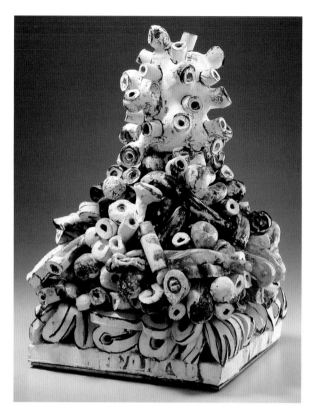

Annabeth Rosen
Tumulus 2 | 2004–2005

30 X 20 X 20 INCHES (76.2 X 50.8 X 50.8 CM)

Hand-built earthenware; multi-fired,
cones 06–03; glaze, slip; steel plate

PHOTO BY LEE FATHERREE

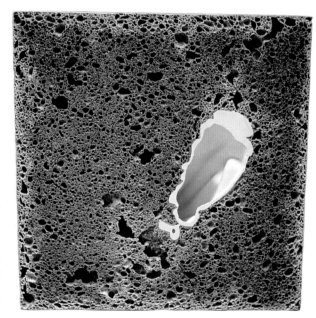

Susannah Biondo
Drawing for Prometheus I | 2006

14³/₁₆ X 4³/₁₆ X 5⁷/₈ INCHES (36 X 36 X 15 CM)

Cast lava glaze; electric fired,
cone 04; embedded slip-cast
porcelain; electric fired, cone 10

PHOTO BY ARTIST

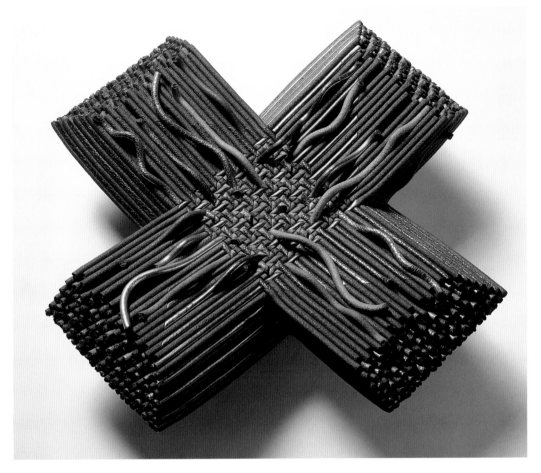

Elina Brandt-Hansen

Warp with Elements | 2002

3¹⁵/₁₆ X 24³/₈ X 24³/₈ INCHES (10 X 62 X 62 CM)

Hand-built stoneware; porcelain; electric fired, cone 9; glazed; gold luster, cone 018

PHOTOS BY ARTIST

Amanda Watson-Will

City Signs 2 | 2002

23 5/8 X 39 3/8 X 23 5/8 INCHES (60 X 100 X 60 CM)

Hand-printed porcelain; electric fired, cone
10; wire, aerated concrete, slide projection

PHOTO BY ALASTAIR BETT

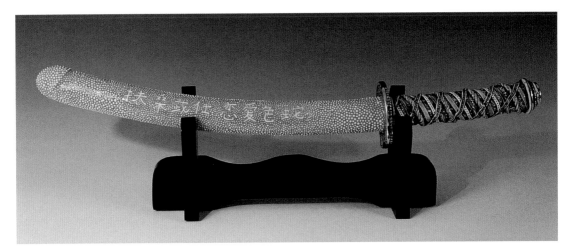

Marko Fields

Ritual Phallus | 2005

LENGTH, 21 INCHES (53.3 CM)

Hand-built white stoneware, porcelain;
oxidation fired, cone 7; gold luster, cone 019;
lacquered birch-wood presentation stand

PHOTO BY ARTIST

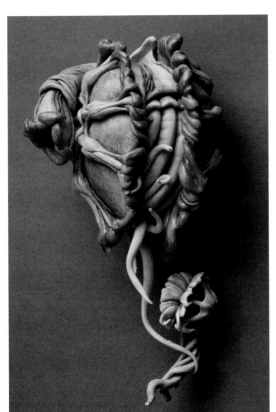

Zacaria Anny

Comfort and Protection #1: Medusa and Child | 2007

8 X 5 X 3 INCHES (20.3 X 12.7 X 7.6 CM)

Hand-built porcelain; electric fired, cone 9;
china paint, cone 019; oil paint

PHOTO BY ARTIST

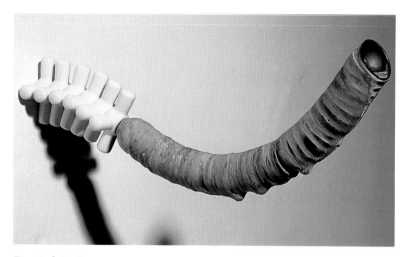

Daniel L. Bare

Contrasting Currents | 2004

8 X 3 X 18 INCHES (20.3 X 7.6 X 45.7 CM)

Yixing cups, Jingdezhen porcelain
knobs; electric fired, cone 6; glazes

PHOTO BY DRAGON FILIPOVIC

Peter Beard

Tall Form | 2007

20⁷/₈ X 3¹⁵/₁₆ X 2³/₄ INCHES (53 X 10 X 7 CM)

Hand-built oxidized stoneware; electric
fired, 2336°F (1280°C); multi-glaze
layering with wax; Scottish mudstone
base, signature mark in bronze

PHOTO BY ARTIST

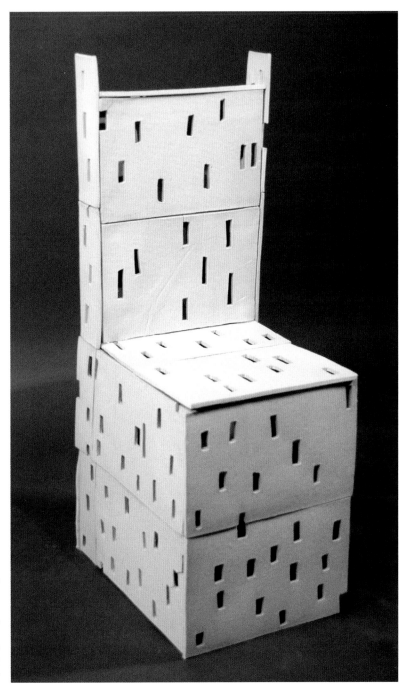

Heidi Fahrenbacher

Maggie | 2002

35³/₁₆ X 16¹/₈ X 18⁷/₈ INCHES
(91 X 41 X 48 CM)

Slab-built porcelain; gas
fired, cone 10; unglazed

PHOTO BY ARTIST

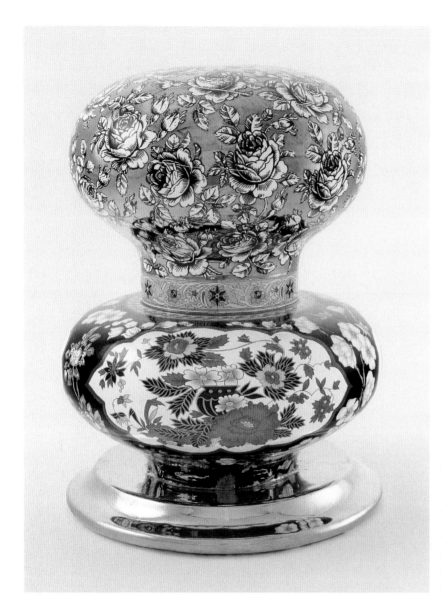

Léopold L. Foulem

Famille Noire Flower Vase with Bouquet of White Roses | 2002–2004

10⅝ X 8⅛ INCHES (27 X 20.7 CM)

Thrown earthenware; electric fired, cone 04; glazed, cone 06; gold luster, china paints, decals, cone 018

PHOTO BY PIERRE GAUVIN

Dalia Lauckaitė-Jakimavičienė
The Plug | 2008

5 1/2 X 3 15/16 X 2 3/4 INCHES (14 X 10 X 7 CM)

Slip-cast porcelain; electric fired, cone 12;
laser-print decals, cone 07; onglaze decals,
china paints, gold luster, cone 016

PHOTO BY VIDMANTAS ILČIUKAS

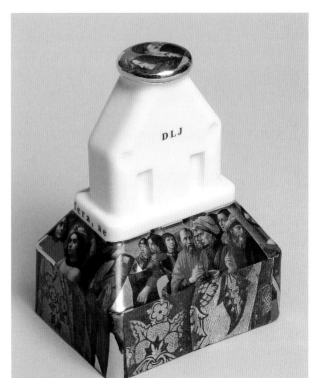

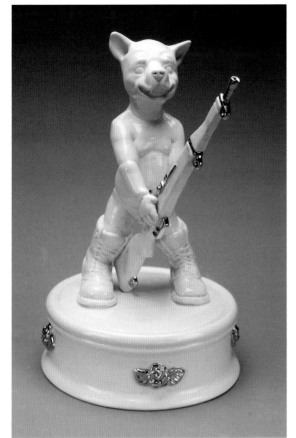

Pavel G. Amromin
This is My Rifle: Allegorical Figure | 2006

9 1/2 X 6 X 6 1/2 INCHES (24.1 X 15.2 X 16.5 CM)

Hand-built, thrown, and press-molded porcelain;
electric fired, cone 6; glaze, underglaze, luster

PHOTO BY ARTIST

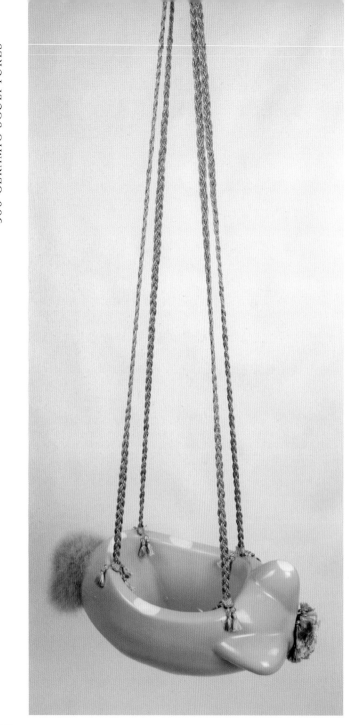

Jeannie Hulen

Nostalgia: From Plastic to Porcelain | 2008

11 13/16 X 23 5/8 INCHES (30 X 60 CM)

Slip-cast porcelain; electric fired, cone 10; glazed;
hand-sewn mixed-media warheads, hand-braided rope

PHOTOS BY AMJAD FAUR

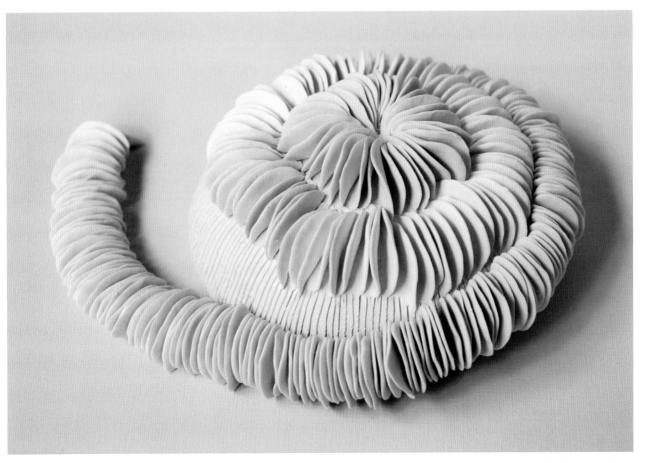

Evelien Sipkes

Moon Coral | 2007

2³/₄ X 5⁷/₈ X 5⁷/₈ INCHES (7 X 15 X 15 CM)

Hand-built porcelain; electric fired,
cone 8; partially threaded with silk

PHOTO BY DOLPH VAN STAPELE

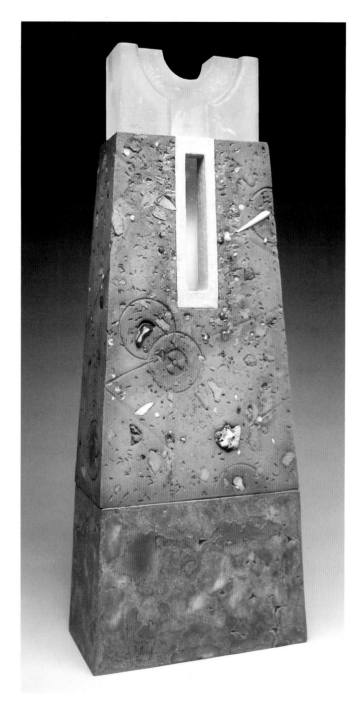

Robert L. Wood

Internalization | 2006

33 X 13 X 6½ INCHES (83.8 X 33 X 16.5 CM)

Slab-built earthenware embedded with pyrometric cones, glass, broken pottery, clay shards, kiln shelves, steel, glaze, found objects; iron-oxide stain and frit pre-firing application; electric fired, cone 1; re-fired, cone 4; kiln-cast glass

PHOTOS BY ARTIST

Jill Oberman

Home | 2005

7 7/8 X 14 3/16 X 2 3/4 INCHES (20 X 36 X 7 CM)

Slab-built porcelain; bisque fired, cone 06;
glazed, soda fired in reduction, cone 10

PHOTO BY ARTIST

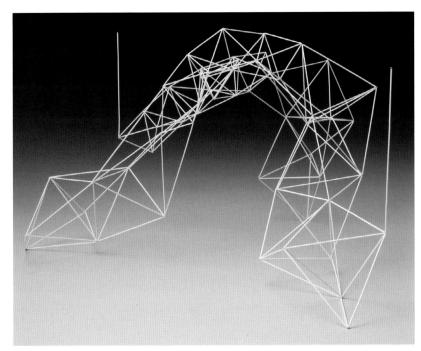

John Chwekun

Untitled | 2007

5 7/8 X 7 7/8 X 7 7/8 INCHES (15 X 20 X 20 CM)

Extruded and rolled porcelain;
electric fired, cone 6

PHOTO BY ARTIST

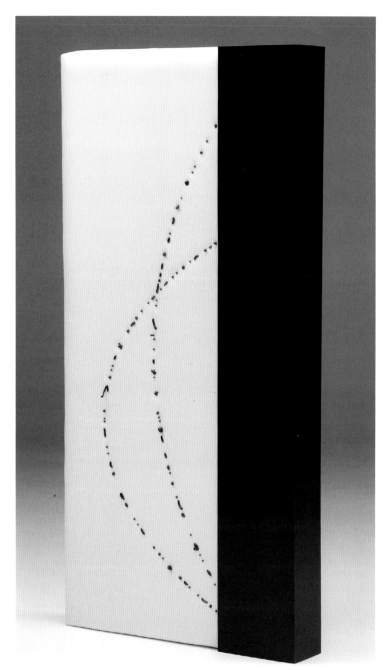

Vincent Burke

Untitled | 2002

71 7/8 X 35 13/16 X 5 7/8 INCHES (183 X 91 X 15 CM)

Porcelain; reduction fired, cone 10;
foam, vinyl, wood, Formica, glue,
nickel-chromium resistance wire

PHOTO BY MARTY SNORTUM

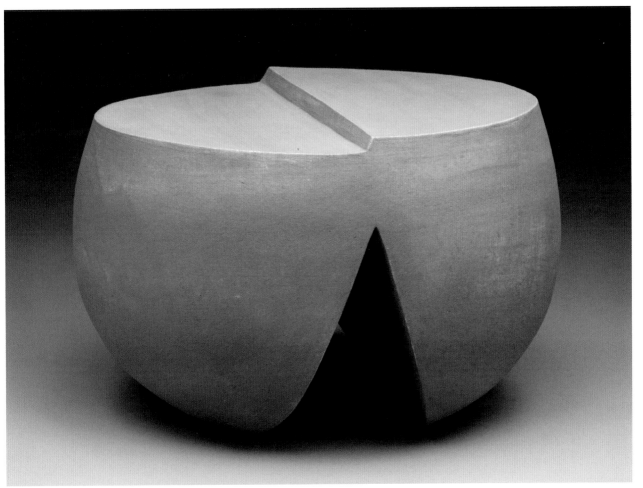

Cynthia Levine
Vessel # 163 | 2008
6 X 9 X 9 INCHES (15 X 22 X 22 CM)
Coil-built earthenware; electric fired,
cone 02; terra sigillata
PHOTO BY PETER LEE

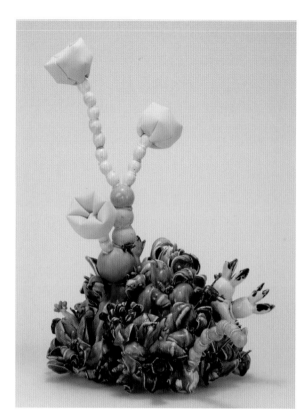

Susan Beiner

Polyunsaturated | 2008

18 X 25 X 14 INCHES (45.7 X 63.5 X 35.6 CM)

Slip-cast and assembled porcelain; gas fired, cone 6; glaze, foam, polyester fiberfill

PHOTO BY ARTIST

Erin B. Furimsky

Congruous | 2008

5 1/5 X 13 3/4 X 4 11/16 INCHES (13 X 35 X 12 CM)

Hand-built stoneware; electric fired, cone 06; glazed, cone 6; china paint, cone 018; underglaze transfer

PHOTO BY TYLER LOTZ

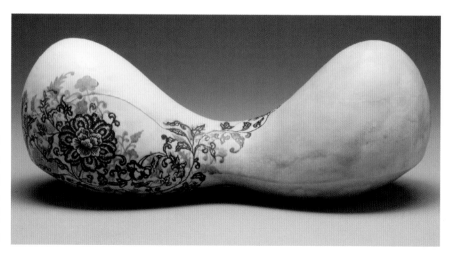

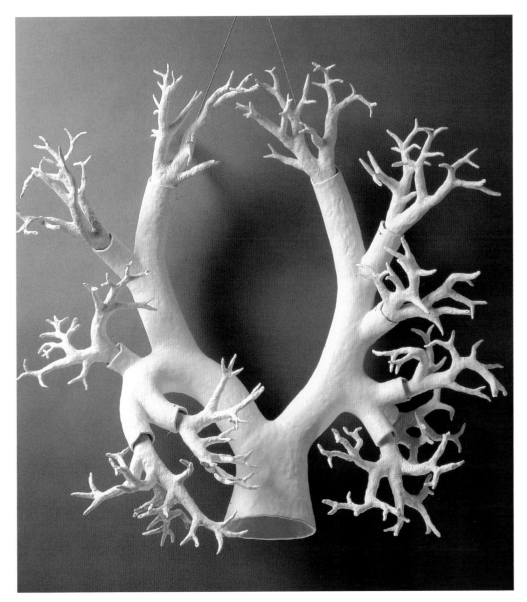

Judy Moonelis
Inversion | 2004
43 X 31 X 12 INCHES (109.2 X 78.7 X 30.5 CM)
Hand-built clay; electric fired, cone 02; steel, wire
PHOTO BY MALCOLM VARON

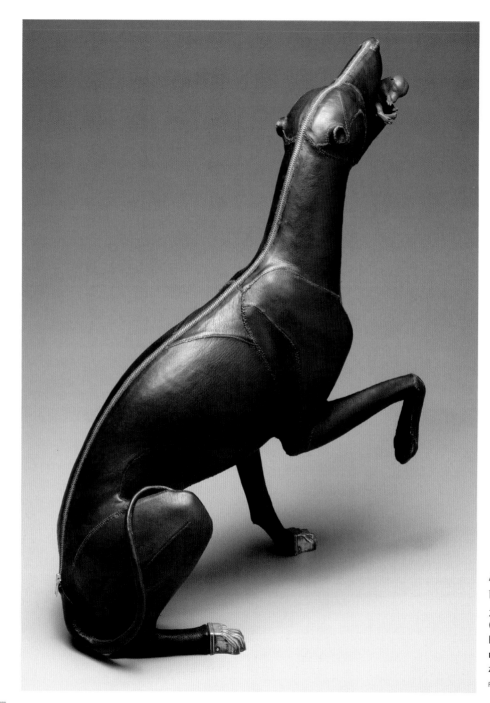

Adelaide Paul
Untitled | 2006
29 15/16 X 18 1/8 X 24 13/16 INCHES
(76 X 46 X 63 CM)

Black porcelain, leather over
modified taxidermist's mannequin,
zipper, brass furniture feet

PHOTO BY JOHN CARLANO

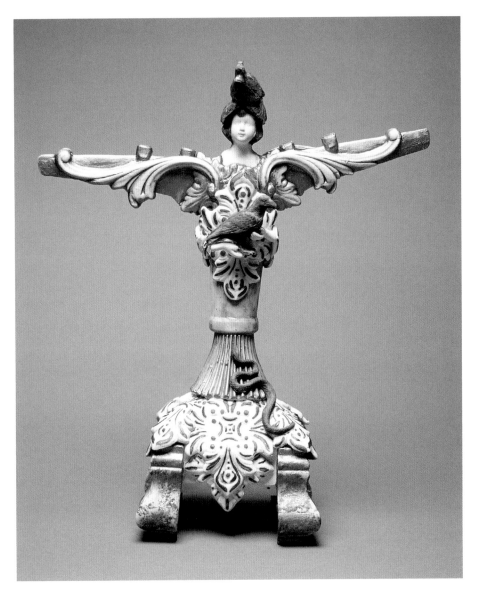

Wm. Reeder Fahnestock

The Maintenance of Desire | 2007

15³/₄ X 10¹/₄ X 4⁵/₁₆ INCHES (40 X 26 X 11 CM)

Slip-cast and assembled porcelain; electric fired,
cone 06; gas fired in reduction, cone 10; oxides

PHOTO BY ARTIST

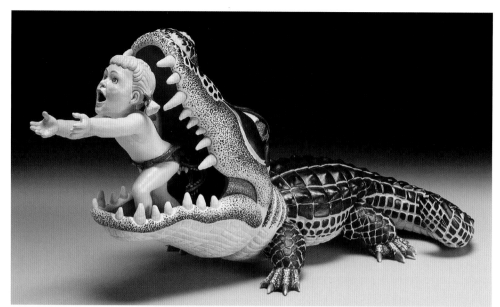

Russell Biles

Gatorland | 2006

9¹³/₁₆ X 18⁷/₈ X 7¹/₁₆ INCHES
(25 X 48 X 18 CM)

Coil-built porcelain; electric
fired, cone 7; underglaze

PHOTO BY TIM BARNWELL

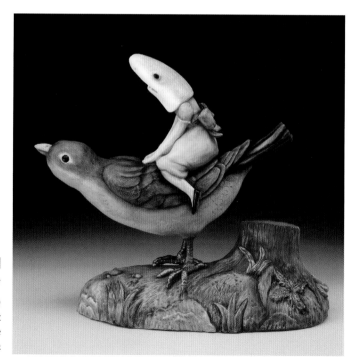

Casey Riordan Millard

Shark Girl Riding Blue Bird | 2007

11 X 6 X 13 INCHES (27.9 X 15.2 X 33 CM)

Hand-built porcelain; electric
fired, cone 8; oil paint; cast bronze

PHOTO BY MEL MITTERMILLER

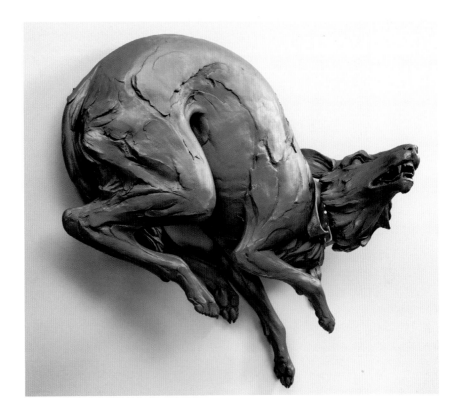

Beth Cavener Stichter

Pleasure | 2006

30⁵/₁₆ X 33¹/₁₆ X 17⁵/₁₆ INCHES (77 X 84 X 44 CM)

Solid-built stoneware; electric fired, cone 3;
cut, hollowed, reassembled; leather belt

PHOTOS BY ARTIST

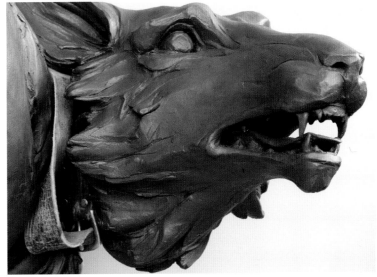

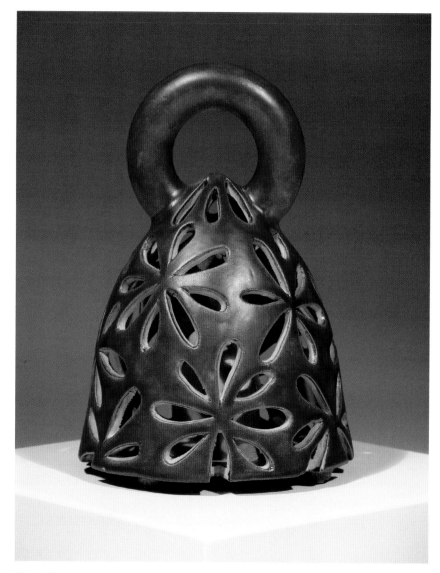

Yves Paquette

Shelter 43 | 2006

188⁵/₈ X 106¹/₈ X 106¹/₈ INCHES (480 X 270 X 270 CM)

Press-molded and hand-built white
earthenware; electric fired, cone 04; pierced
surface with interior slip-cast forms

PHOTO BY ARTIST

Rafael Perez
Untitled | 2007
7⁷/₈ X 7¹/₁₆ X 7¹/₁₆ INCHES (20 X 18 X 18 CM)
Porcelain and personal clay; gas fired in
oxidation, 2138°F (1170°C); sandblasted
PHOTO BY CARLOS E. HERMOSILLA

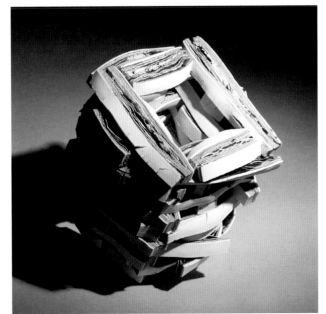

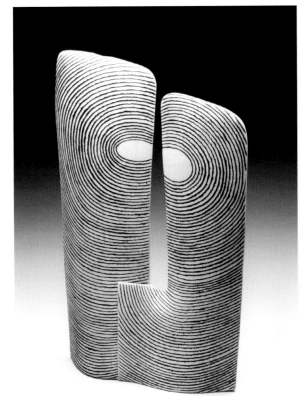

Harris Deller
This and That Series: Untitled | 2007
16¹/₄ X 9¹/₂ X 2¹/₂ INCHES (41.3 X 24.1 X 6.4 CM)
Slab-built porcelain; reduction fired,
cone 10; glaze; incised, inlayed
PHOTO BY ARTIST

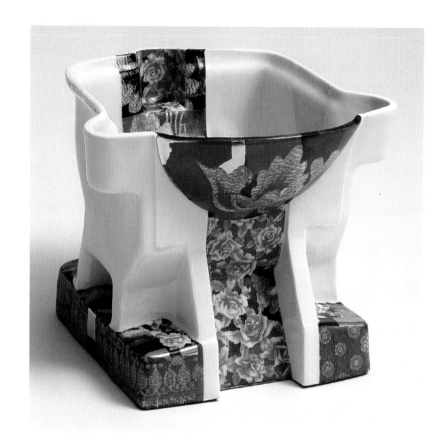

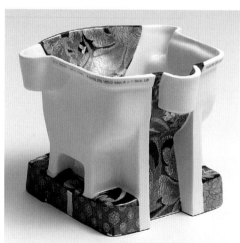

Dalia LauČkaitÉ-JakimavičienÉ
Mechanical Object | 2007

5⁷/₈ X 7⁷/₁₆ X 7⁷/₁₆ INCHES (15 X 19 X 19 CM)

Slip-cast porcelain; electric fired, cone 12; laser-print decals, cone 07; on-glaze decals, china paints, gold luster, cone 016

PHOTO BY VIDMANTAS ILČIUKAS

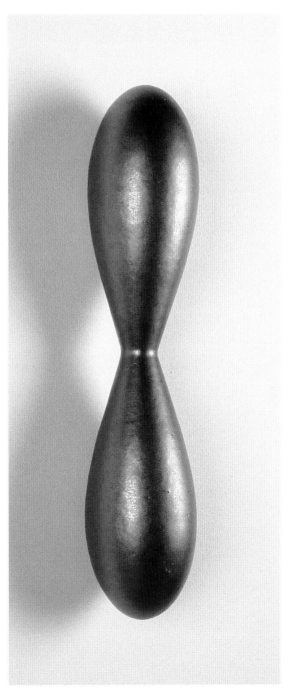

Sally Brogden

Untitled | 2004

20 X 4 X 4 INCHES
(50.8 X 10.2 X 10.2 CM)

Press-molded stoneware;
electric fired, cone 6

PHOTO BY ARTIST

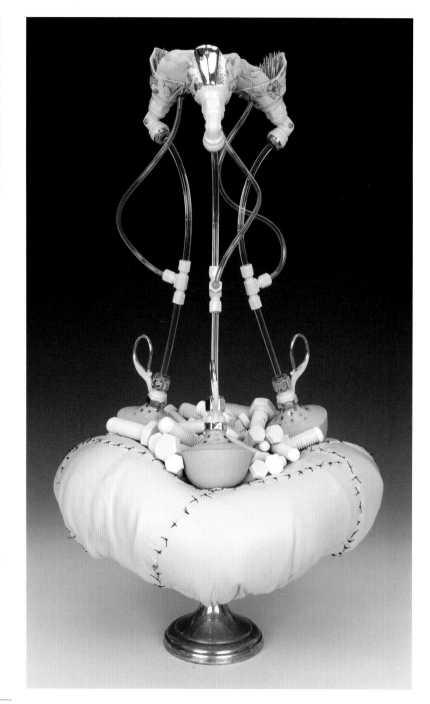

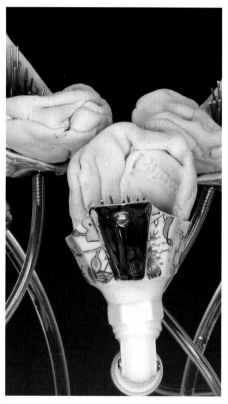

Colleen Toledano

Handled Stitchery IV | 2007

20¹/₁₆ X 7¹/₁₆ X 7¹/₁₆ INCHES (51 X 18 X 18 CM)

Slip-cast porcelain; electric fired, cone 6;
gold luster, decals, cone 018; leather,
glass rods, foam, suture thread

PHOTOS BY ARTIST

Lisa Clague
Temptation | 2006
48 X 30 X 30 INCHES (121.9 X 76.2 X 76.2 CM)
Sculpture clay, white earthenware;
electric fired, cone 05; glazes, wax, metal
PHOTO BY TOM MILLS

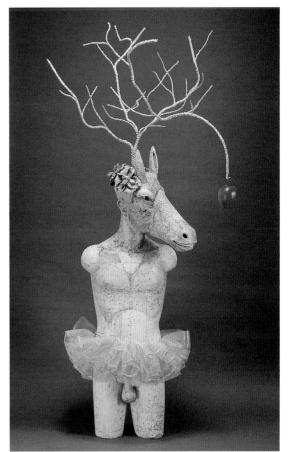

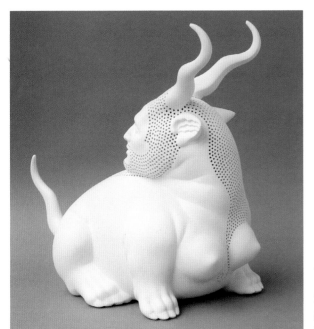

Ilona Romule
Mefisto (Lamp) | 2003
10¼ X 11 X 5½ INCHES (26 X 28 X 14 CM)
Slip-cast porcelain; bisque fired, cone 8;
gas fired in reduction, cone 11; polished
PHOTO BY ARTIST

Nathan Prouty
A Possible Integration | 2007

10 X 10⁷/₁₆ X 10⁷/₁₆ INCHES (25.5 X 26.5 X 26.5 CM)

Slab-built white earthenware; electric fired, cone 02; lacquer, paint, flocking

PHOTOS BY ARTIST

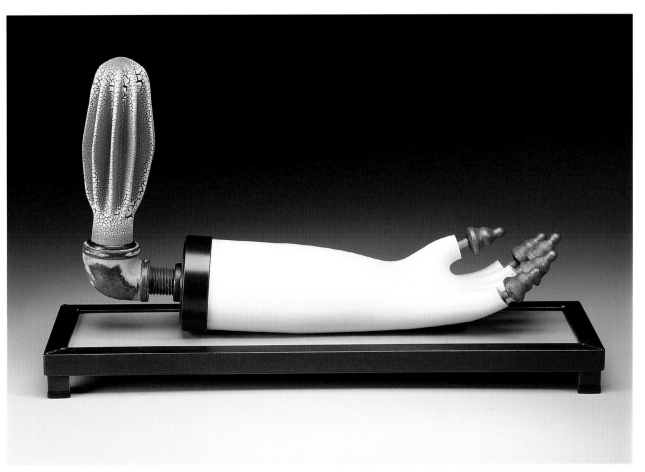

Matt Wilt

Host | 2006

15 X 25 X 7 INCHES (38.1 X 63.5 X 17.8 CM)

Slip-cast and wheel-thrown
stoneware and porcelain; reduction
fired, cone 9; concrete, steel

PHOTO BY TONY DECK

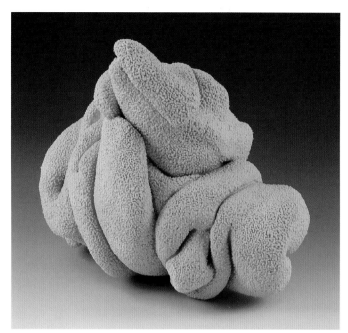

Mary Alison Lucas
Trickle | 2008
16⅛ X 22¹/₁₆ X 13¾ INCHES (41 X 56 X 35 CM)
Stoneware, casting slip; electric fired;
multiple glaze firings, cone 4
PHOTO BY ARTIST

Beth Cavener Stichter
Olympia | 2006
27⅛ X 48 X 35 INCHES (69 X 122 X 89 CM)
Solid-built stoneware, porcelain slip;
electric fired, cone 3; cut, hollowed,
reassembled; silk blindfold, oil blush
PHOTO BY NOEL ALLUM

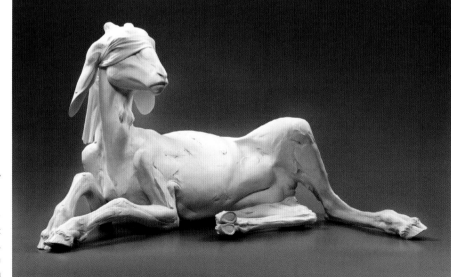

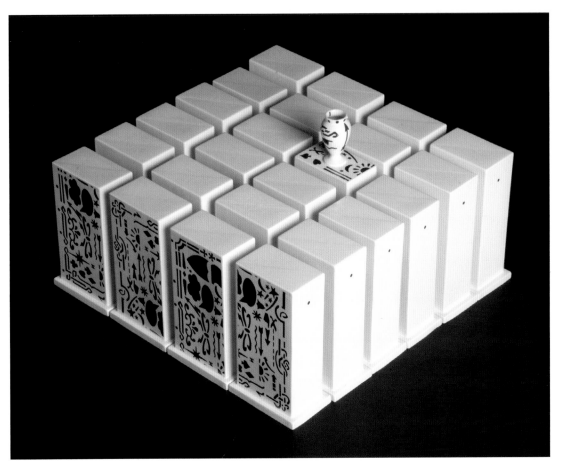

Peter Lewis
You Made It Beautiful | 2006
9 1/16 X 19 11/16 X 19 11/16 INCHES (23 X 50 X 50 CM)
Slip-cast earthenware; electric fired, 2084°F
(1140°C); ceramic transfer, 1508°F (820°C)
PHOTOS BY ADRIAN GREENHALGH

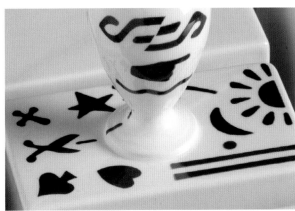

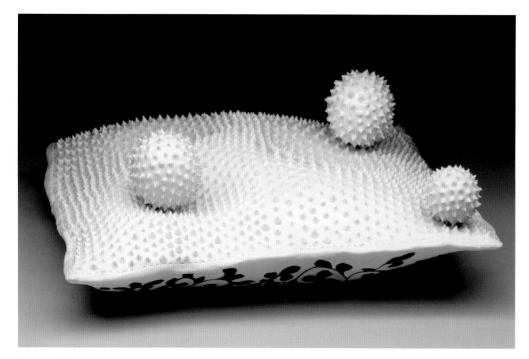

Amy Chase
Restless Countenance | 2008
4 X 9 X 9 INCHES (10.2 X 22.9 X 22.9 CM)
Wheel-thrown and altered earthenware;
electric fired, cone 04; underglaze, glazes
PHOTO BY DAVE TRUESDALE

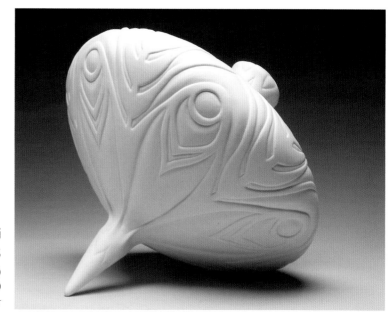

Yoshi Fujii
Hub—#15 | 2006
12 X 11 X 11 INCHES (30.5 X 27.9 X 27.9 CM)
Porcelain; gas fired in reduction, cone 10
PHOTO BY ARTIST

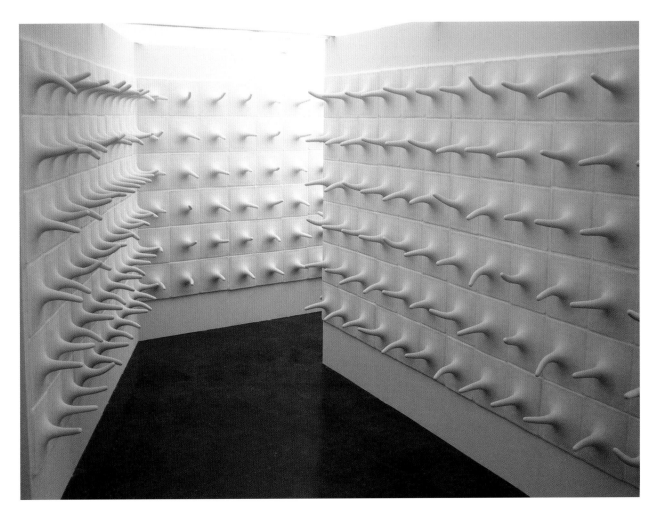

Backa Carin Ivarsdotter

Corridor | 2000

90½ X 82¹¹⁄₁₆ X 248 INCHES
(230 X 210 X 630 CM)

Molded porcelain; electric fired,
1472°F (800°C)

PHOTOS BY ARTIST

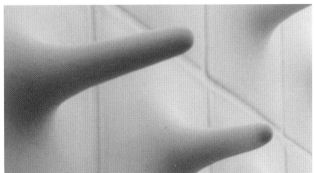

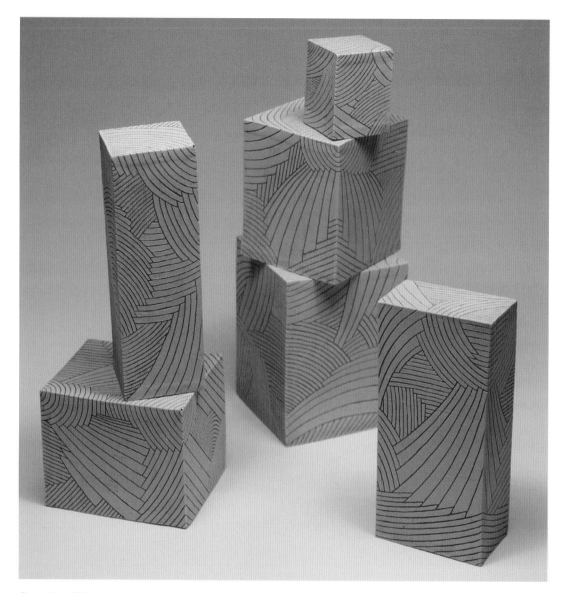

Sangjin Kim

Clay Blocks | 2007

12 X 6 X 13 INCHES (30.5 X 15.2 X 33 CM)

Hand-built carved stoneware; electric
fired, cone 04; inlaid terra sigillata

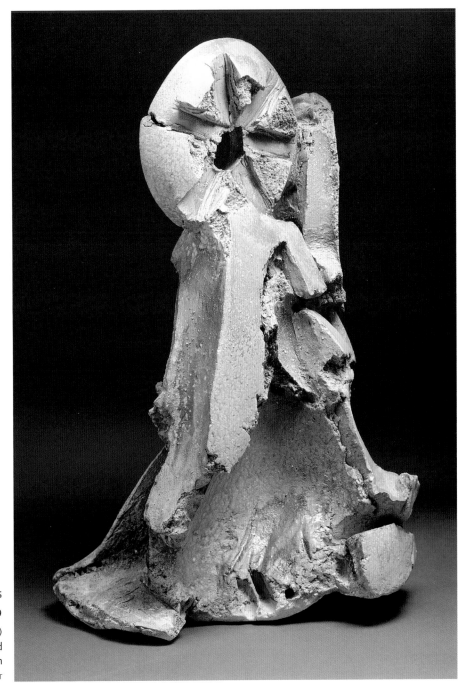

Peter Callas

Exodus | 1999

5¹/₂ X 2³/₄ X 3¹/₈ INCHES (14 X 7 X 8 CM)

Slab-built stoneware; wood
fired, cone 11, natural ash

PHOTO BY ARTIST

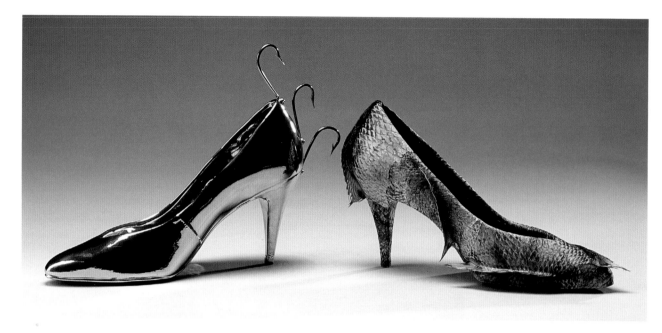

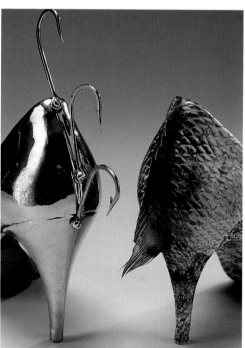

Johannette Rowley

Hooked | 2006

EACH, 7¹/₁₆ X 9¹/₁₆ X 3¹⁵/₁₆ INCHES (18 X 23 X 10 CM)

Slip-cast earthenware; electric fired, cone 04; platinum luster, cone 018; fishhooks, fish skin

PHOTOS BY PAUL KODAMA

David Binns

Square Pierced Form | 2006

11 13/16 X 11 13/16 X 2 3/8 INCHES (30 X 30 X 6 CM)

Mixed ceramic aggregates with glass-forming materials; kiln cast; electric fired, 2192°F (1200°C); ground and polished

PHOTO BY ARTIST

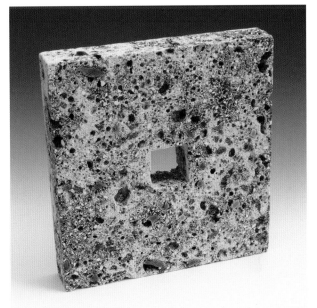

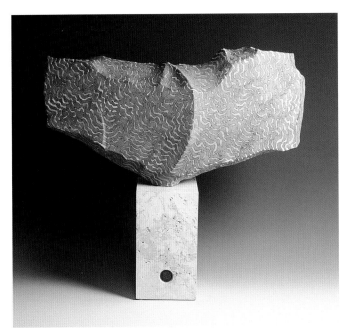

Peter Beard

Cut Form | 2007

19 1/4 X 18 1/8 X 5 7/8 INCHES (49 X 46 X 15 CM)

Hand-built oxidized stoneware; electric fired, 2336°F (1280°C); multi-glaze layering with wax; travertine stone base, signature mark in bronze

PHOTO BY ARTIST

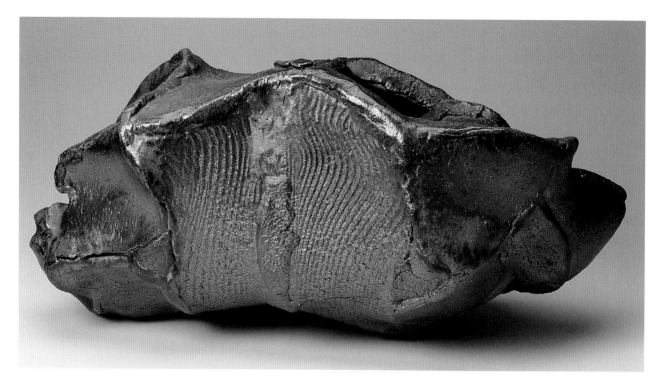

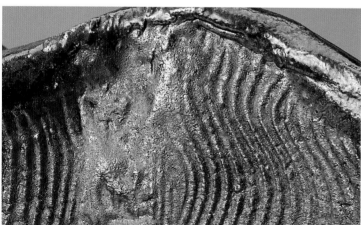

Tota Tsutsui

Rock of Crevasse | 2007

10⅝ X 21⅝ X 12$\frac{9}{16}$ INCHES
(27 X 55 X 32 CM)

Slab-built and stretched
stoneware; wood fired

PHOTOS BY RYOUICHI ARATANI

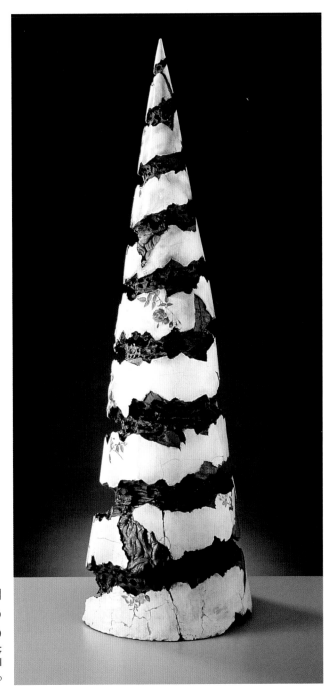

Roderick Bamford
Cone: Aspire | 1989
82 1/2 X 23 5/8 X 23 5/8 INCHES (210 X 60 X 60 CM)
Extruded and assembled earthenware;
glazed; polychrome on-glaze decal
PHOTO BY GEOFF FRIEND

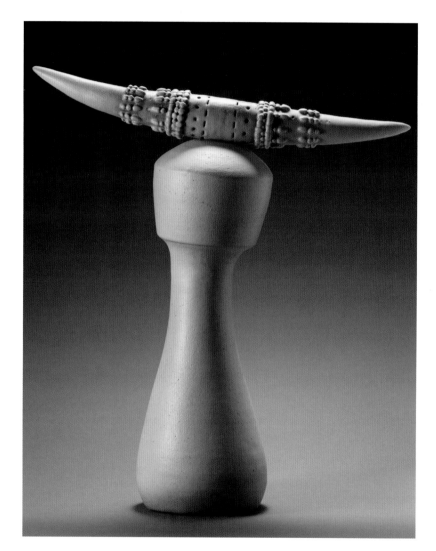

Aneela Dias-D'Sousa

White Ox II | 2006

15 5/16 X 13 3/8 X 4 5/16 INCHES
(39 X 34 X 11 CM)

Thrown and altered stoneware;
electric fired, cone 5

PHOTOS BY ARTIST

Annabeth Rosen

Tope | 2004–2005

10 X 10½ X 17 INCHES (25.4 X 26.7 X 43.2 CM)

Hand-built earthenware; multi-fired,
cones 06–03; glaze, slip

PHOTO BY LEE FATHERREE

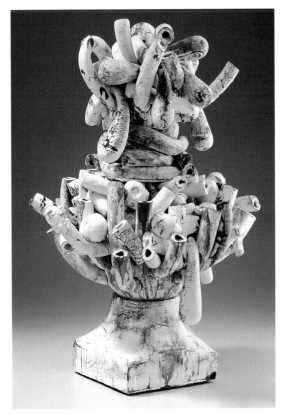

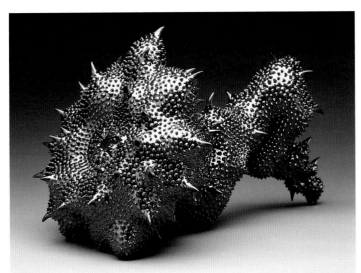

Shane M. Keena

Strongylocentrotus (Ball of Spines) | 2007

10 X 10½ X 17 INCHES (25.4 X 26.7 X 43.2 CM)

Hand-built earthenware; slip-trailed and
hand-built spines; glazed, multi-fired,
cone 04; luster, multi-fired, cone 017

PHOTO BY ETC PHOTOGRAPHY

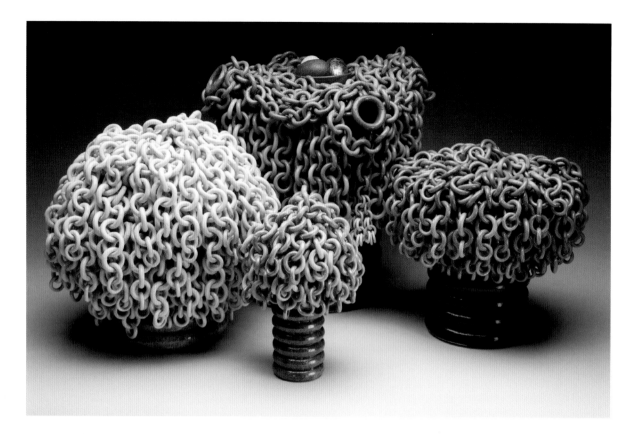

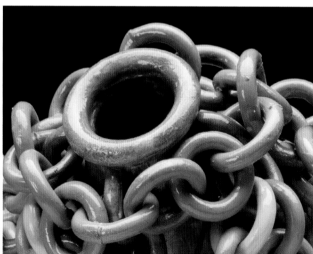

Ruth Borgenicht

Forrestal Villago | 2007

TALLEST, 20$^{1}/_{16}$ INCHES (51 CM)

Slip-cast stoneware and porcelain; salt fired, cone 10

PHOTOS BY JOSEPH PAINTER

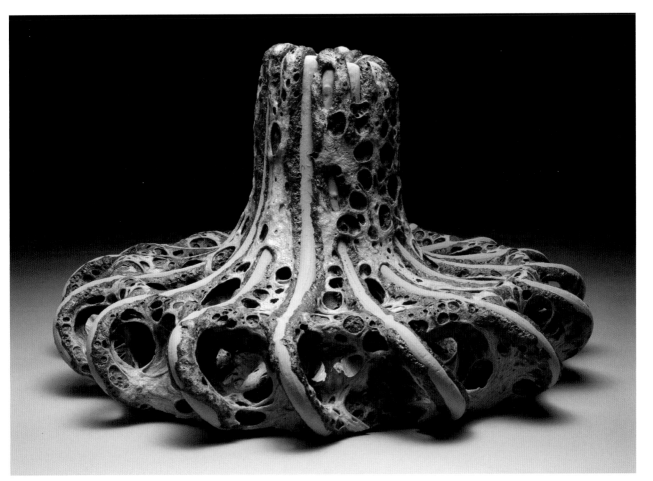

Jeff Kaller
Untitled | 2007
25⁹/₁₆ X 25⁹/₁₆ X 13³/₄ INCHES
(65 X 65 X 35 CM)
Constructed ceramic, glaze
PHOTO BY ARTIST

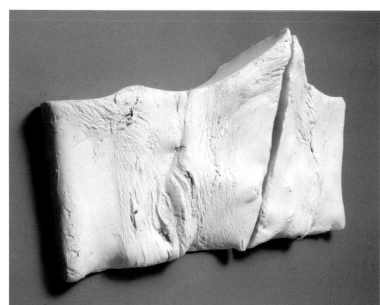

Paula Winokur
Glacier I: Alaskan Memory | 2004
20 1/16 X 37 13/16 X 5 1/8 INCHES (51 X 96 X 13 CM)
Slab-constructed porcelain; reduction
fired, cone 10; unglazed; stains
PHOTO BY JOHN CARLANO

John Chwekun
Untitled | 2008
11 13/16 X 14 3/16 X 14 3/16 INCHES
(30 X 36 X 36 CM)
Extruded and rolled porcelain;
electric fired, cone 6
PHOTO BY ARTIST

Benjamin Fiess
Set: M2 | 2007

5 1/2 X 13 1/2 X 3 INCHES (13.9 X 34.3 X 7.6 CM)

Slip-cast porcelain; electric fired,
cone 8; decals, electric fired, cone 019

PHOTOS BY ARTIST

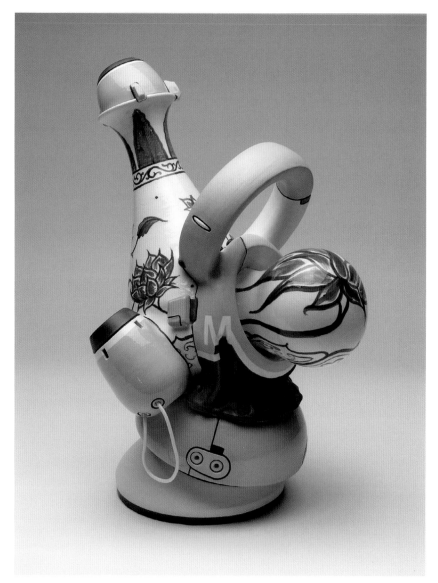

Brendan L.S. Tang

Manga Ormolu version 4.0-b | 2008

16 X 8 X 9¹³/₁₆ INCHES (40.6 X 20.3 X 25 CM)

Wheel-thrown and altered earthenware;
electric fired, cone 04; mixed media

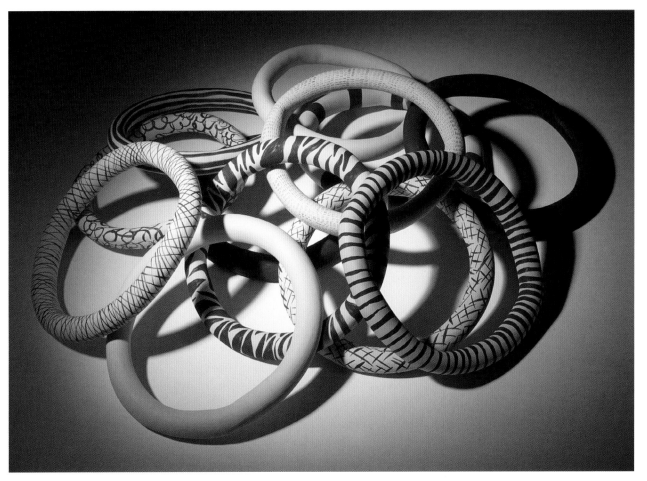

Rosa Cortiella
Holes with Personality | 2005
15³/₄ X 47¹/₄ X 47¹/₄ INCHES (40 X 120 X 120 CM)
Stoneware, black pigment;
electric fired, 2282°F (1250°C)
PHOTOS BY JOSE MIGUEL GARCIA

Brigitte Bouquet

The Coral Suburbs | 2007

DIAMETER, 58 15/16 INCHES (150 CM)

Hand-built earthenware;
electric fired; hessian wood

PHOTO BY DICK DELANGE

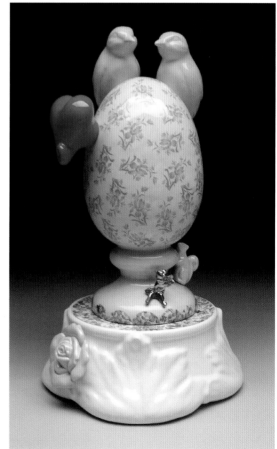

Wesley Harvey

Yellow Birds Singing | 2008

12 X 6 X 6 INCHES (30.5 X 15.2 X 15.2 CM)

Slip-cast porcelain; electric
fired, cones 01, 04, 06; decals,
cone 015; luster, cone 017

PHOTO BY ARTIST

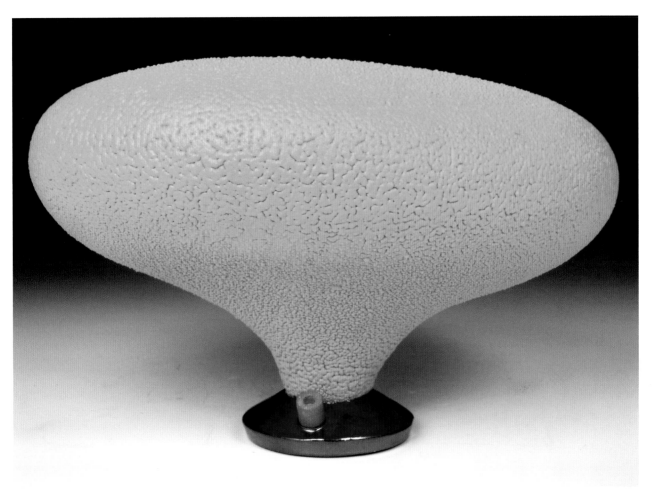

Stephen Wolochowicz

Orange Boom Inflation | 2007

7⅞ X 14³/₁₆ X 10¼ INCHES
(20 X 36 X 26 CM)

Thrown and coil-built terra
cotta; multi-fired, cone 04

PHOTOS BY ARTIST

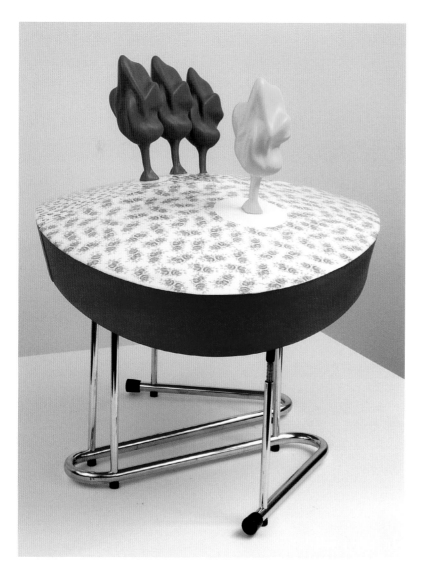

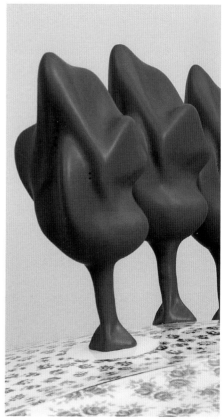

Chad D. Curtis

Floral Landscape with Trees | 2007

14 15/16 X 11 13/16 X 15 3/4 INCHES (38 X 30 X 40 CM)

Slip-cast earthenware; electric fired, cone 04; glazed, cone 04; decals, cone 018; aluminum, hardware, rapid prototyped plastic

PHOTOS BY ARTIST

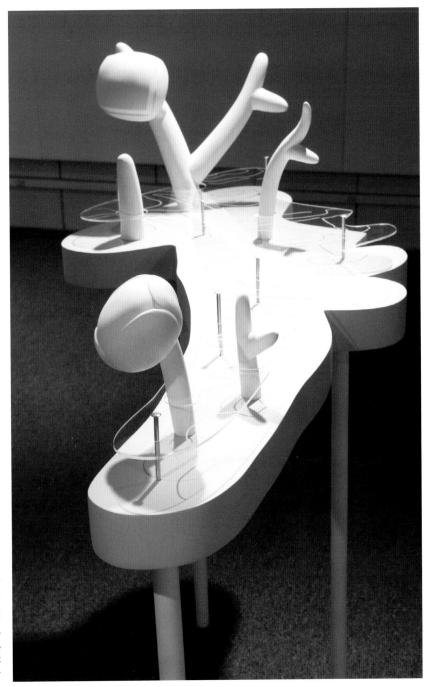

Alex Hibbitt

Souvenir of Louisiana #1 | 2007

36³/₁₆ X 27¹⁵/₁₆ X 38³/₁₆ INCHES (92 X 71 X 97 CM)

Slip-cast porcelain; electric fired,
cone 4; wood, clear plastic sheeting,
steel, aluminum, paint, light

PHOTO BY STEVE PASZT

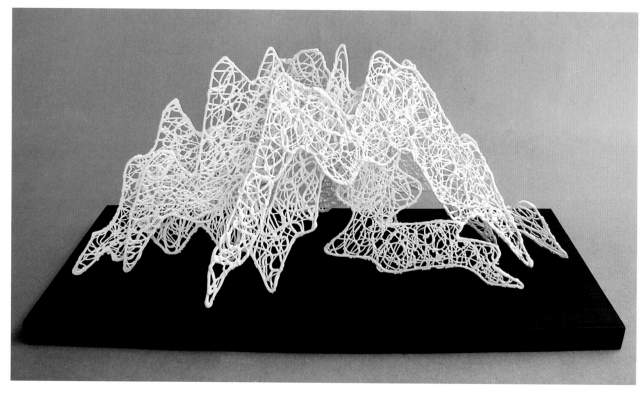

Andrea Vinkovic

Fractal Landscape 2 | 2005

13³/₄ X 25⁹/₁₆ X 7⁷/₈ INCHES (35 X 65 X 20 CM)

Porcelain slip; electric fired,
2192°F (1200°C); wood base

PHOTO BY ARTIST

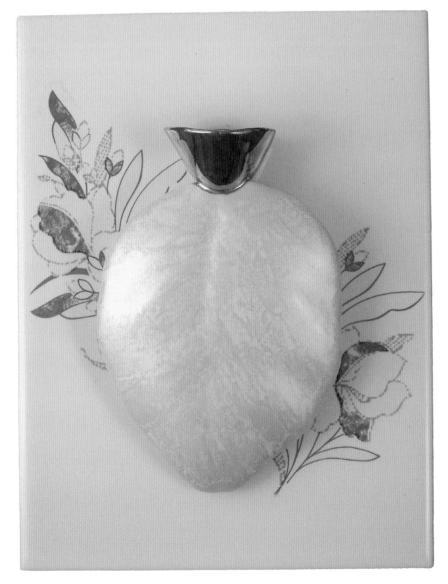

Anna Calluori Holcombe

Anima II | 2008

7⁷/₈ X 5⁷/₈ X 1¹⁵/₁₆ INCHES (20 X 15 X 5 CM)

Slip-cast porcelain; electric fired, cone 6;
commercial tile; decals and luster, cone 018

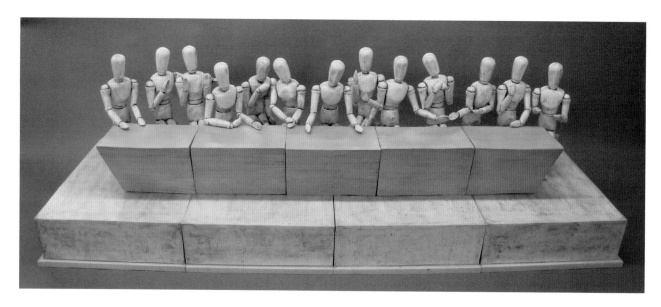

David Furman

The Retirement Dinner | 2007

22 1/16 X 59 13/16 X 19 11/16 INCHES (56 X 152 X 50 CM)

Slip-cast and hand-built mid-range porcelain;
electric fired, cone 1; underglaze, glaze

PHOTOS BY ARTIST

Christyl Boger

Sea Toy | 2007

27 15/16 X 26 X 16 1/8 INCHES
(71 X 66 X 41 CM)

Coil-built earthenware;
electric fired, cone 04; glazed

PHOTO BY GEOFFREY CARR

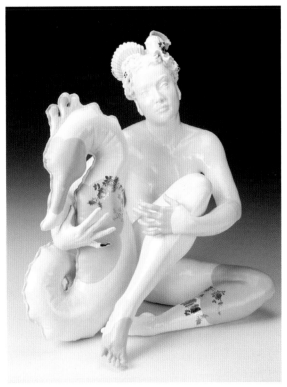

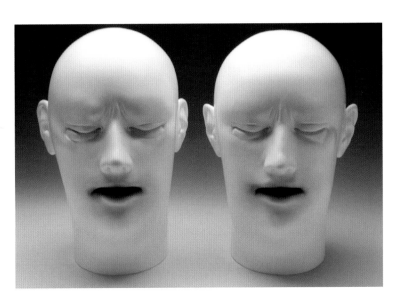

Tanya Batura

Twins | 2007

11 13/16 X 16 3/4 X 8 7/8 INCHES (30 X 42.5 X 22.5 CM)

Coil-built earthenware; electric fired,
cone 04; airbrushed with acrylic paint

PHOTO BY ANTHONY CUÑHA

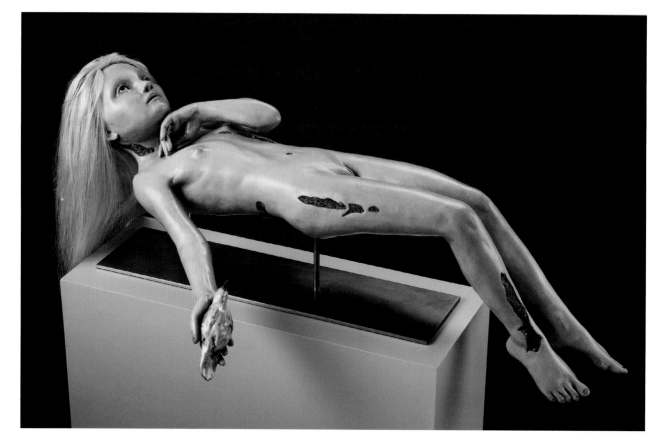

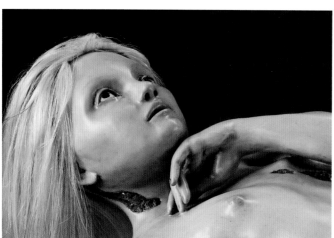

Dana Major Kanovitz

Thing with Feathers | 2007

25 9/16 X 41 5/16 X 21 5/8 INCHES (65 X 105 X 55 CM)

Hand-sculpted, slab-formed stoneware; gas fired, cone 06; glazed, cone 10; oil paint, hand-fabricated horse- and goat-hair wig

PHOTOS BY CINDY TRIM

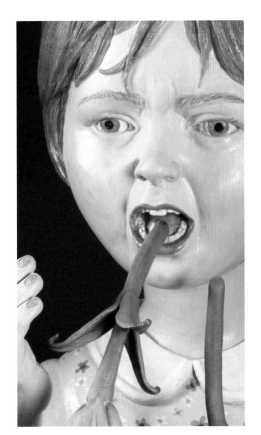

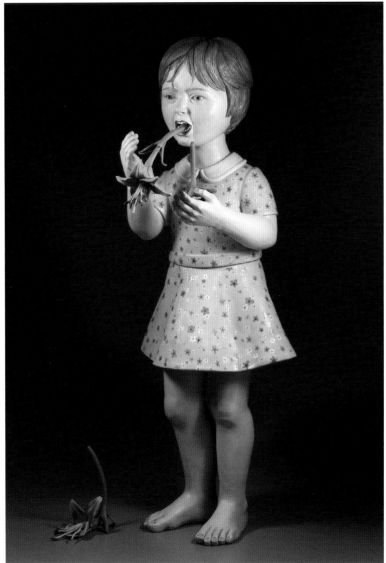

Cynthia Consentino
Flower Girl VI | 2007
40¹/₈ X 14¹⁵/₁₆ X 20¹/₁₆ INCHES (102 X 38 X 51 CM)
Coil- and slab-built stoneware; electric fired, cone 5; glaze, underglaze; oils, cold wax, brass
PHOTOS BY ARTIST

239

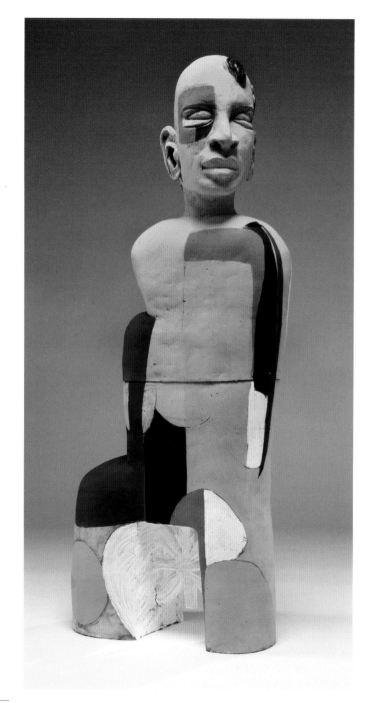

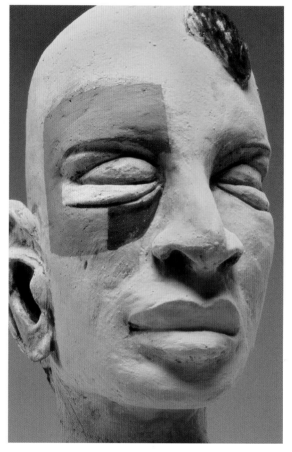

Lydia C. Thompson
If You Come with Me . . . | 2008
38 15/16 X 14 15/16 X 16 15/16 INCHES (99 X 38 X 43 CM)
Coil-built stoneware; multiple oxidation
firings, cones 5 and 6; glazed
PHOTOS BY TAYLOR DABNEY

Horst D.

Montezuma | 2005

30¹¹/₁₆ X 25³/₁₆ X 16¹/₈ INCHES
(78 X 64 X 41 CM)

Slab-built stoneware; gas
fired, cone 04; acrylic patina

PHOTO BY ARTIST

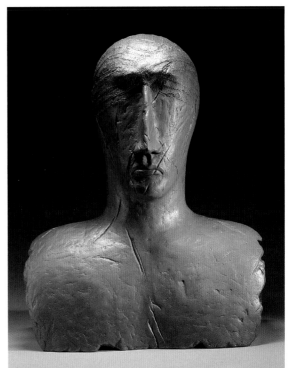

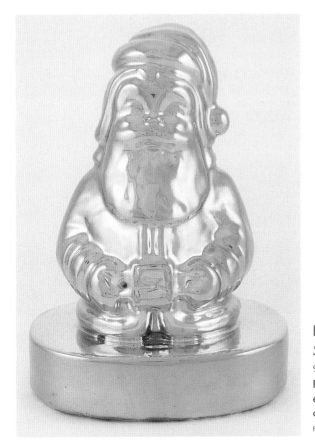

Léopold L. Foulem

Santa Claus Reliquary | 2004

9¹³/₁₆ X 7⁹/₁₆ X 6 INCHES (25 X 19.2 X 15.3 CM)

Press-molded earthenware;
electric fired, cone 04; glazed,
cone 06; gold luster, cone 018

PHOTO BY PIERRE GAUVIN

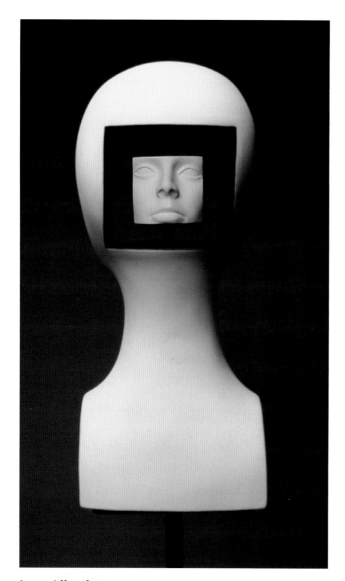

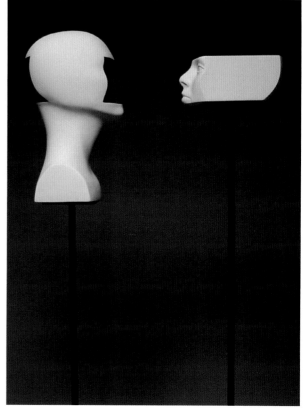

Ivan Albreht

It-Self | 2003

58 15/16 X 24 3/8 X 8 5/8 INCHES (150 X 62 X 22 CM)

Hand-built and slip-cast porcelain;
electric fired, cone 5; stain, cone 5; steel

PHOTOS BY ARTIST

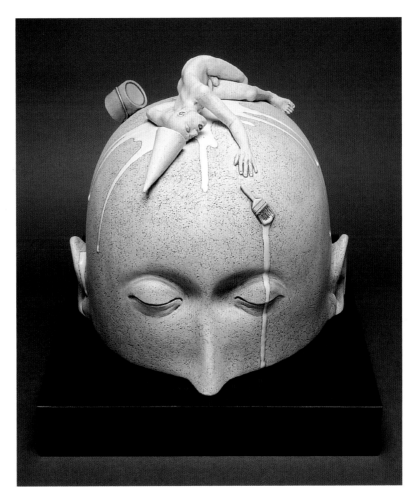

Verne Funk

In the Paint | 2007

12³/₁₆ X 12³/₁₆ X 14³/₁₆ INCHES
(31 X 31 X 36 CM)

Modeled and press-molded white
earthenware; electric fired, cone 04;
underglaze, glaze, cone 06

PHOTOS BY MICHAEL SMITH

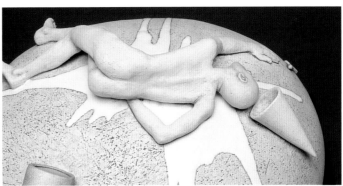

Beverly Mayeri

Hoping | 2006

25³/₁₆ X 13 X 9¹/₁₆ INCHES
(64 X 33 X 23 CM)

Earthenware; electric fired, cone
01; underglaze; acrylic paint

PHOTO BY LEE FATHERREE

Edith Garcia

Fearless I | 2006

5⁷/₈ X 13 X 3¹⁵/₁₆ INCHES (15 X 33 X 10 CM)

Slip-cast earthenware; electric fired,
cone 04; underglazes, cone 04; clear
glaze, cone 06; cast silicone rubber

PHOTO BY ARTIST

Gert Germeraad
POW II (Prisoner of War) | 2007
19 1/4 X 17 5/16 X 15 5/16 INCHES (49 X 44 X 39 CM)
Hand-built earthenware clay; bisque
fired, 1922°F (1050°C); water color paint

PHOTO BY ARTIST

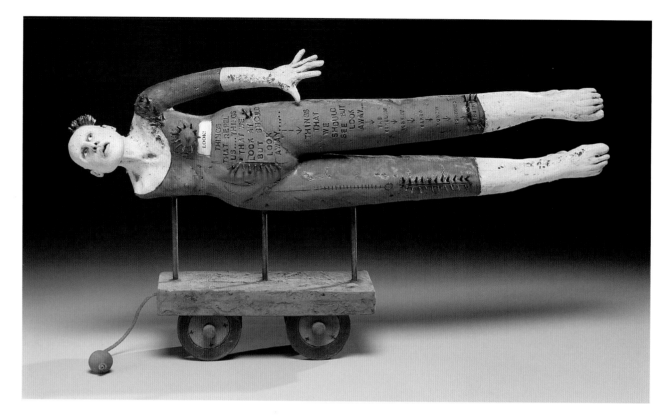

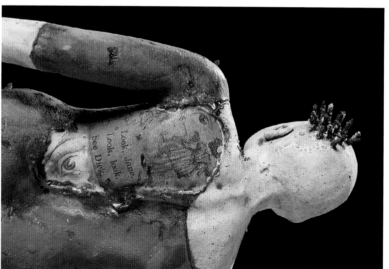

Nancy Kubale

Look | 2007

12 X 18 X 6 INCHES (30.5 X 45.7 X 15.2 CM)

Hand-built stoneware; multiple electric firings;
terra sigillata, oxide, underglaze, glaze, decals

PHOTOS BY TIM BARNWELL

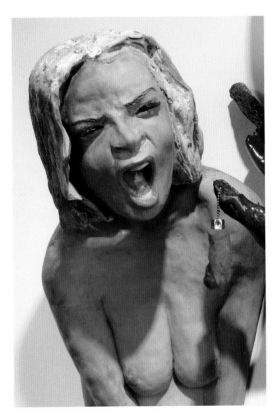

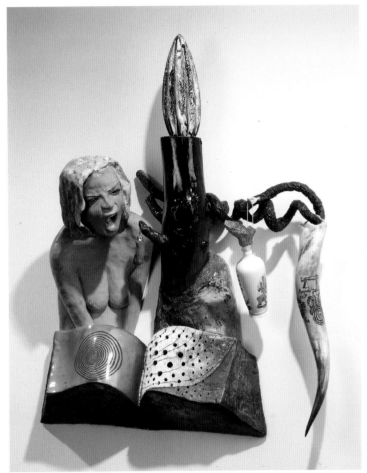

Arthur González

Dialogues with My Abyss | 2007

50 X 38 X 16 INCHES (127 X 96.5 X 40.6 CM)

Hand-built earthenware; reduction fired, cone 2; porcelain bottle; glaze, cones 10 and 018; shellacked wood, rabbit's foot, scrimshawed longhorn, enamel paint, twine, decals

PHOTOS BY JOHN WILSON WHITE

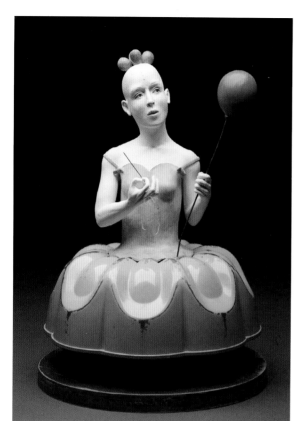

Kirsten Stingle

Remembering to Forget | 2008

15¾ X 11 X 11 INCHES (40.5 X 28 X 28 CM)

Hand-built stoneware; electric fired, cone 2; underglaze; household paint, wood, metal, fiber

PHOTO BY DAVID GULISANO

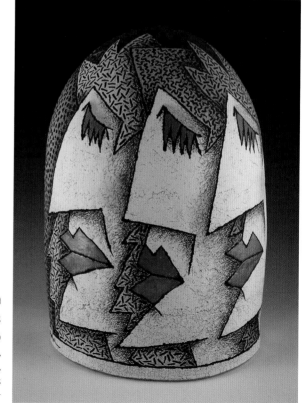

Rimas VisGirda

Untitled | 1997–2008

19 X 14 X 9 INCHES (48 X 36 X 23 CM)

Coil-built stoneware; electric fired, cones 10, 05, 017, 018; white engobe, underglaze pencil, overglazes, lusters

PHOTO BY ARTIST

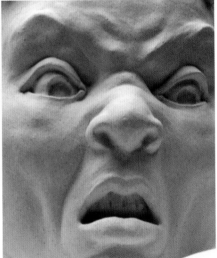

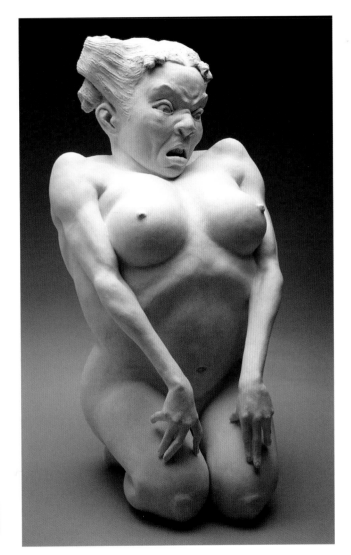

Anne Drew Potter
Tar Baby Number Two | 2007
25³/₁₆ X 18¹/₈ X 20¹/₁₆ INCHES (64 X 46 X 51 CM)
Low-fire porcelain; electric fired, cone 01
PHOTOS BY ARTIST

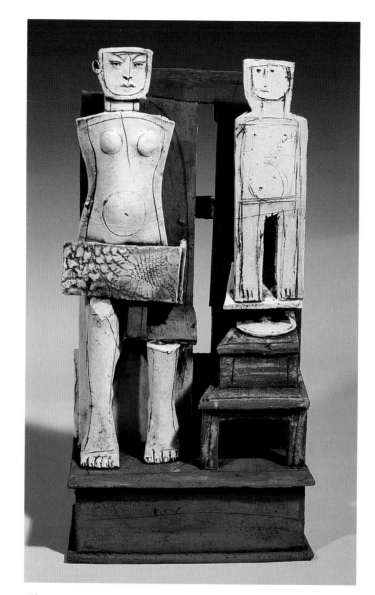

Christy Keeney
Sculptor | 2007
14 15/16 X 7 7/8 X 3 15/16 INCHES (38 X 20 X 10 CM)
Hand-built stoneware; gas fired, cone 6;
glazed, cone 1; stains, slip, oxides
PHOTO BY ARTIST

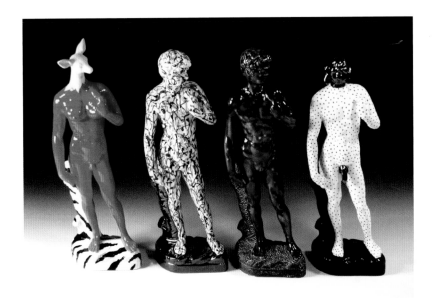

Lenny Dowhie

The David Collection: 1–4 | 2007

EACH, 15 X 5 X 5 INCHES (38.1 X 12.7 X 12.7 CM)

Cast and altered white ware;
multi-fired, cone 05; glazed

PHOTO BY ARTIST

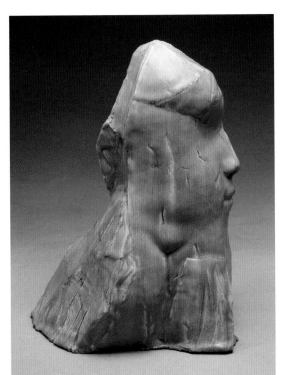

Hongwei Li

Analogue #4

18⁷/₈ X 14¹⁵/₁₆ X 7⁷/₈ INCHES
(48 X 38 X 20 CM)

Porcelain; electric fired, cone 10

PHOTO BY ARTIST

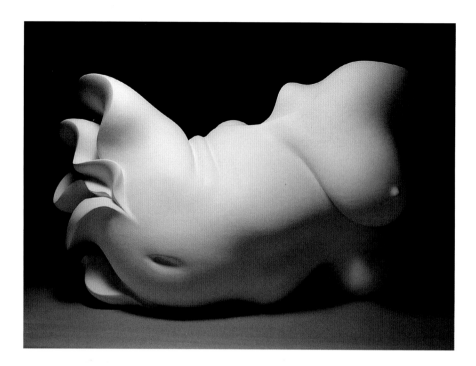

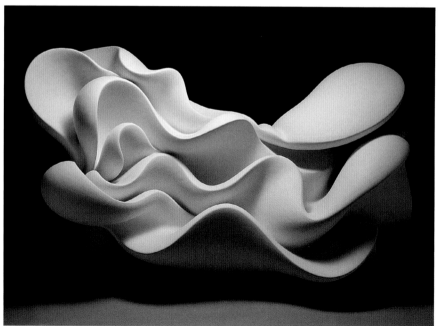

Holly Fischer

Beckon | 2005

18 X 32 X 18 INCHES (45.7 X 81.3 X 45.7 CM)

Coil-constructed white earthenware; gas fired, cone 04; unglazed

PHOTOS BY ARTIST

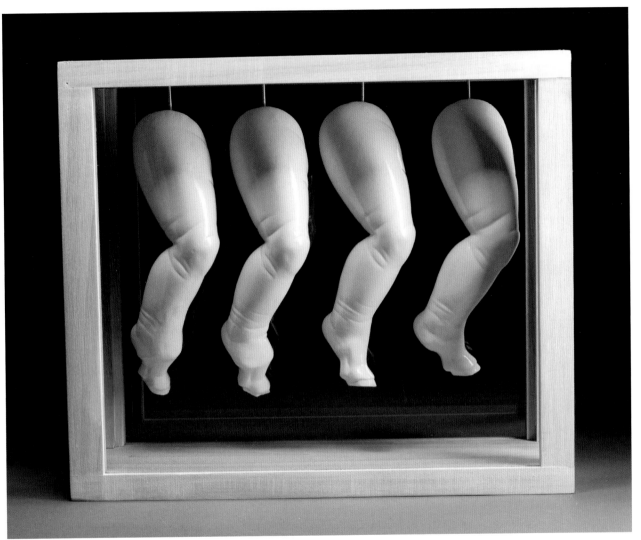

Kyle J. Bauer
Collection Series 5 | 2006
15 X 13 X 5 INCHES (38.1 X 33 X 12.7 CM)
Slip-cast porcelain, cone 6;
glazed, cone 8; wood, glass
PHOTO BY ARTIST

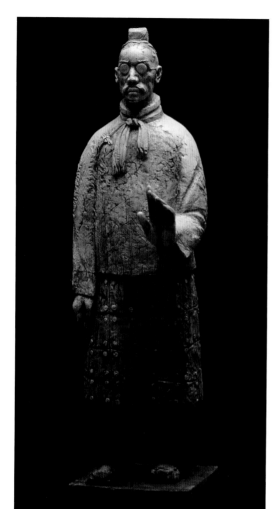

Wanxin Zhang

Philosopher | 2000

40 X 12 X 15 INCHES
(101.6 X 30.5 X 38.1 CM)

Stoneware; electric fired,
cone 04; pigment

PHOTO BY DIANE DING

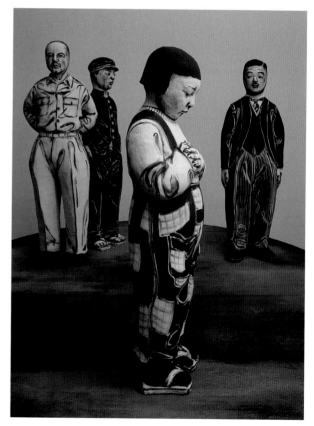

Akio Takamori

Boat | 2001

TALLEST, 40⁹/₁₆ INCHES (103 CM)

Coil-built stoneware; electric
fired, cones 3–4; underglazes

PHOTO BY ARTIST

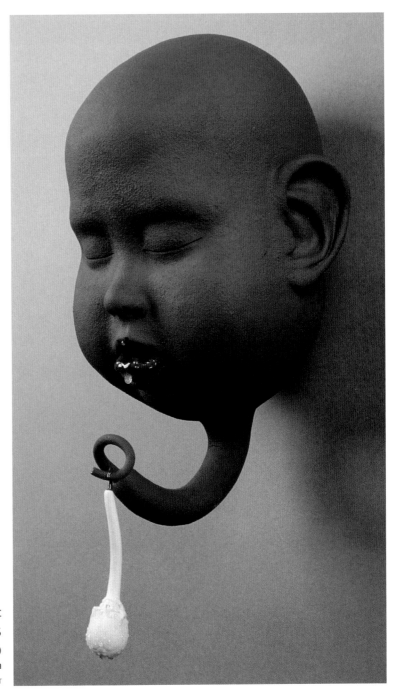

Jared Janovec
An Understatement of Life | 2006
12 X 7 X 7 INCHES (30.5 X 17.8 X 17.8 CM)
Earthenware, porcelain; mixed media
PHOTO BY ARTIST

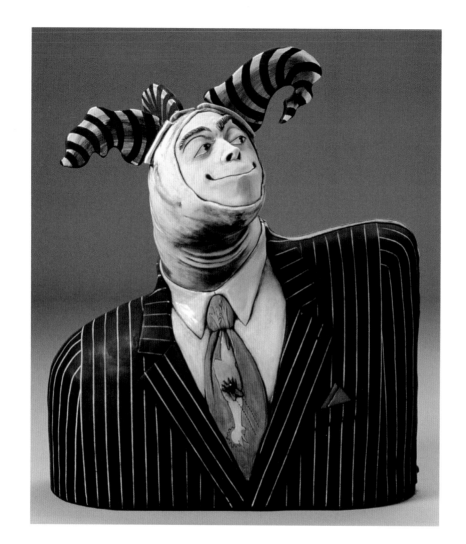

Jean Cappadonna Nichols
Photo Op w/Zipper | 2004
28 X 24 X 14 INCHES (71.1 X 61 X 35.6 CM)
Hand-built earthenware with coils on slab; electric
fired, cone 04; underglaze, cone 04; glaze, cone 05
PHOTOS BY KAREN HARMON

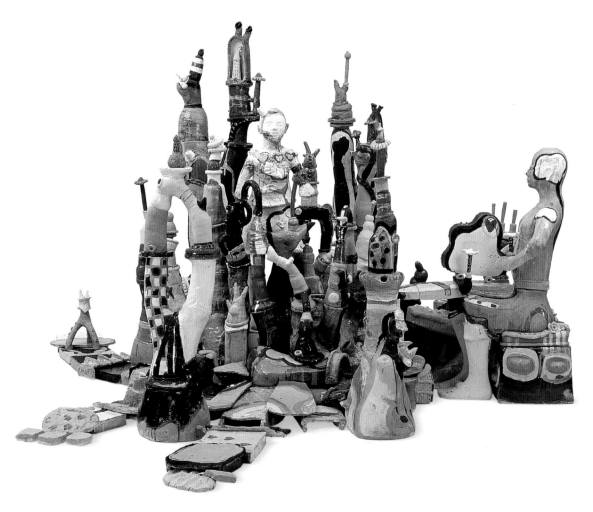

Lisa Marie Barber
Three Hearts | 2007

64 13/16 X 112 3/4 X 98 5/8 INCHES (165 X 287 X 251 CM)

Pinched, coiled, and slab-built recycled clay; electric fired and gas fired in oxidation, cones 05–03; glazed and fired multiple times, cones 04–07

PHOTOS BY DON LITNER

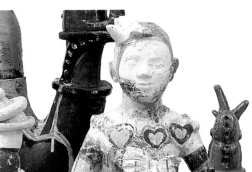

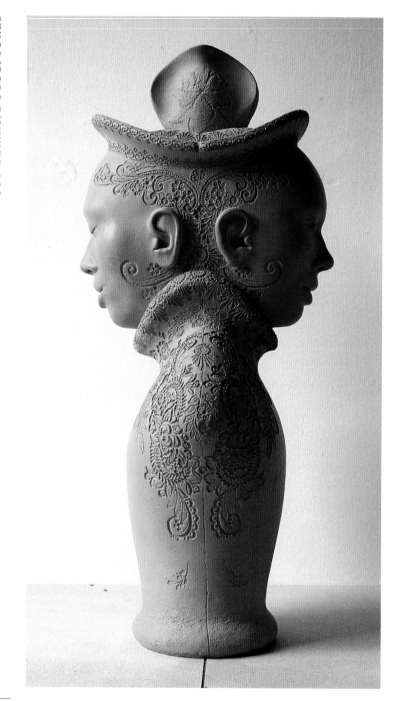

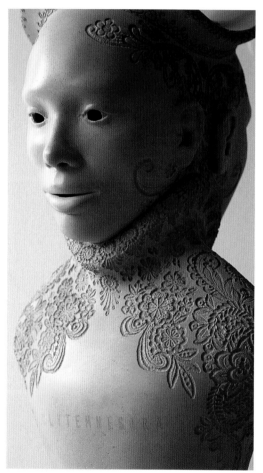

Peter Bevan

Helen's Twin | 2005

25 9/16 X 11 3/8 X 11 3/8 INCHES
(65 X 29 X 29 CM)

Hand-built terra cotta;
electric fired, 1850°F (1010°C)

PHOTOS BY ARTIST

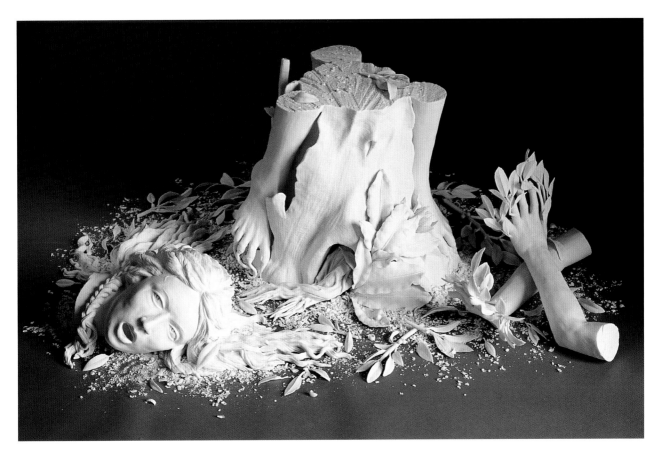

Kate MacDowell

Daphne | 2007

17⁵/₁₆ X 53¹/₈ X 40¹/₈ INCHES
(44 X 135 X 102 CM)

Hand-built porcelain; electric
fired, cones 04 and 07

PHOTOS BY DAN KVITKA

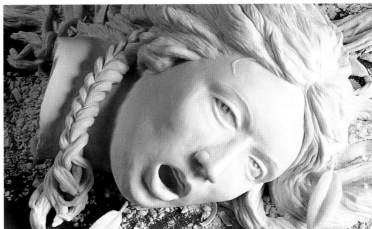

259

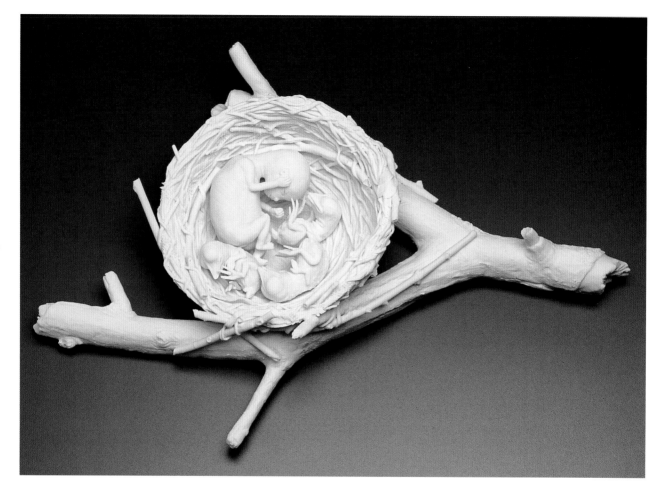

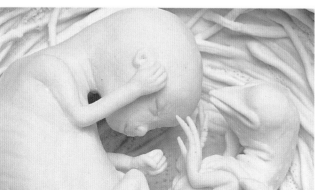

Kate MacDowell

Cuckoo | 2007

3 1/8 X 12 3/16 X 8 1/4 INCHES
(8 X 31 X 21 CM)

Hand-built porcelain; electric
fired, cones 04 and 5

PHOTOS BY DAN KVITKA

Linda Ganstrom

Quan Yin: Eternal Spring | 2005

24 13/16 X 28 5/16 X 21 5/8 INCHES (63 X 72 X 55 CM)

Press-molded stoneware; gas fired, cone 6;
underglazes and stains, cone 04; wax

PHOTO BY SHELDON GANSTROM

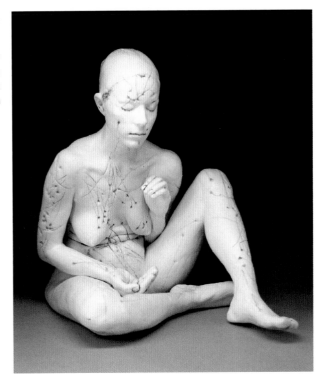

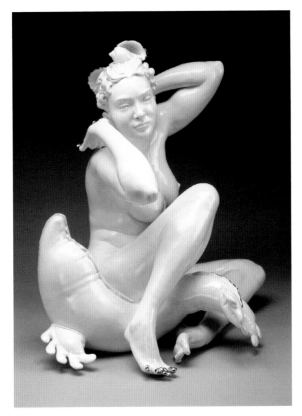

Christyl Boger

Girl with Dolphin | 2007

27 1/8 X 24 X 18 1/8 INCHES (69 X 61 X 46 CM)

Coil-built earthenware; electric
fired, cone 04; glazed

PHOTO BY MICHAEL CAVANAUGH AND KEVIN MONTAGUE

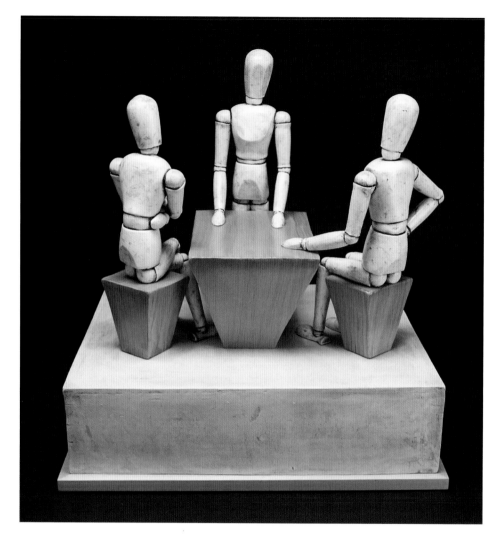

David Furman

Mediation | 2007

20⁷/₁₆ X 19¹¹/₁₆ X 15³/₄ INCHES (52 X 50 X 40 CM)

Slip-cast and hand-built mid-range porcelain;
electric fired, cone 1; underglaze, glaze

PHOTOS BY ARTIST

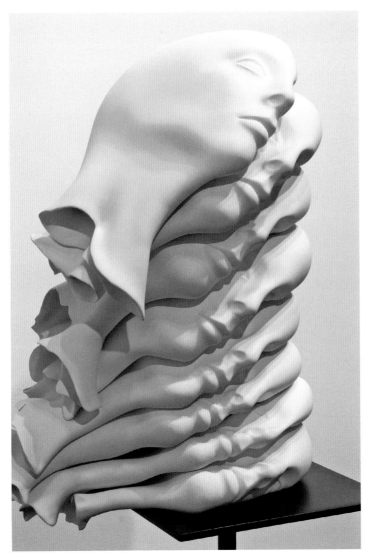

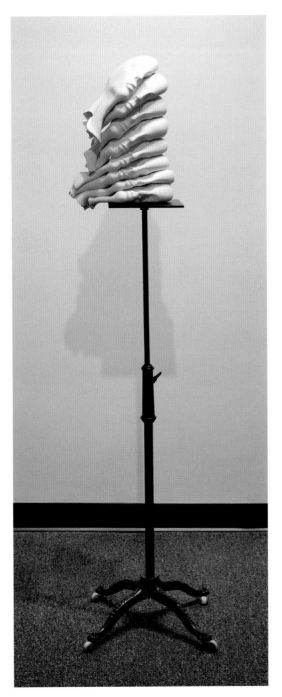

Ivan Albreht

Stack | 2007

62 1/16 X 9 13/16 X 9 13/16 INCHES
(158 X 25 X 25 CM)

Slip-cast and hand-built porcelain;
electric fired, cone 5; unglazed;
welded steel, found object

PHOTOS BY ARTIST

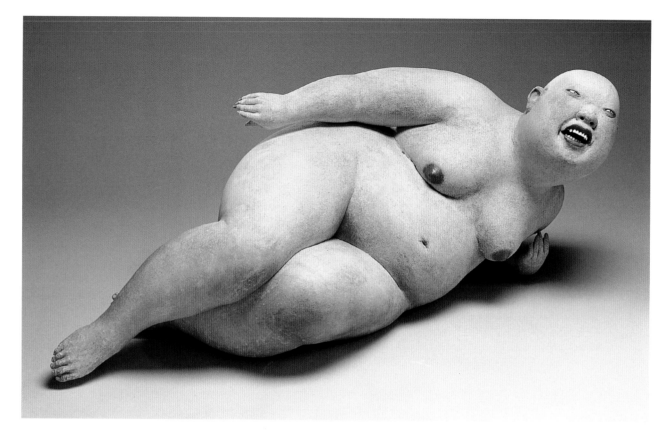

Esther Shimazu

Yowzah | 2007

12 X 29 X 13 INCHES
(30.5 X 73.5 X 33 CM)

Hand-built stoneware; gas
fired, cone 06; glazed, cone 7

PHOTOS BY PAUL KODAMA

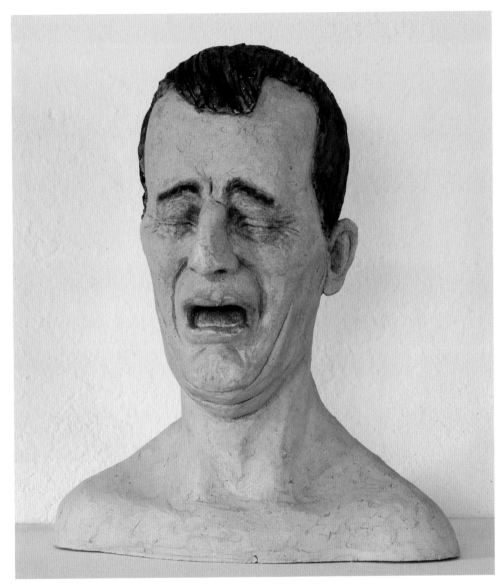

Gert Germeraad

Portrait of a Man (Sadness) | 2006

10 1/4 X 9 1/16 X 7 7/8 INCHES (26 X 23 X 20 CM)

Hand-built; bisque fired,
1922°F (1050°C); watercolor paint

PHOTO BY ARTIST

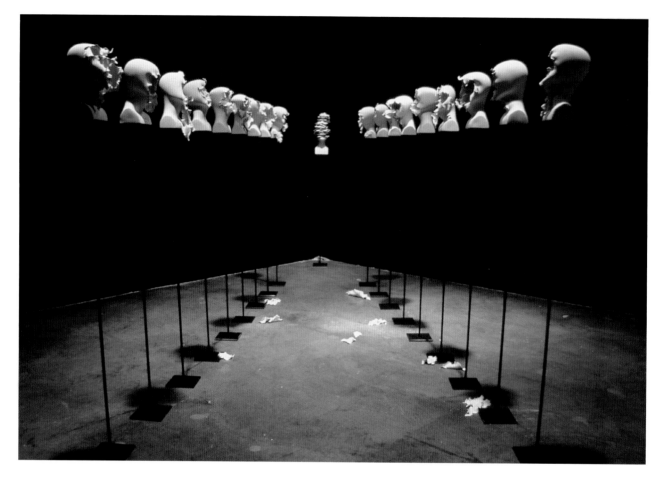

Ivan Albreht
The Other | 2004
EACH PIECE, 64 1/16 INCHES (163 CM) IN HEIGHT
Slip-cast and hand-built porcelain;
electric fired, cone 5; welded steel
PHOTOS BY ARTIST

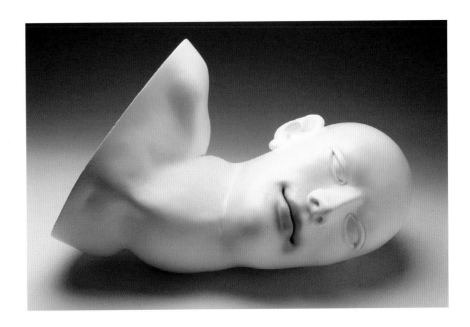

Tanya Batura

Sourire en Bois | 2007

9 13/16 X 13 3/4 X 8 7/8 INCHES (25 X 35 X 22.5 CM)

Coil-built earthenware; electric fired, cone 04; airbrushed with acrylic paint

PHOTOS BY ANTHONY CUÑHA

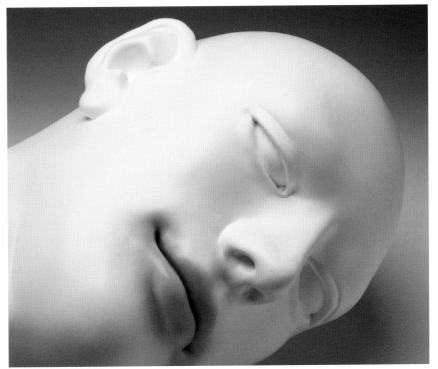

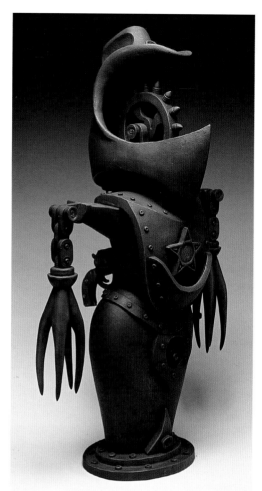

Gerard Justin Ferrari

Synthohuman Series: Good-Ole-Boy | 2006

30 1/2 X 17 7/8 X 13 15/16 INCHES (77.5 X 45.5 X 35.5 CM)

Hand-built terra cotta; electric fired,
cone 04; multi-fired underglazes

PHOTO BY BOB METCALF

Jack Thompson
(AKA Jugo de Vegetales)

Zodiac Series: Leo | 2007

9 7/16 X 18 1/8 X 18 1/8 INCHES (24 X 46 X 46 CM)

Slip-cast paper clay; electric fired, cone 05;
painted with graphite in liquid medium, burnished

PHOTO BY RENA THOMPSON

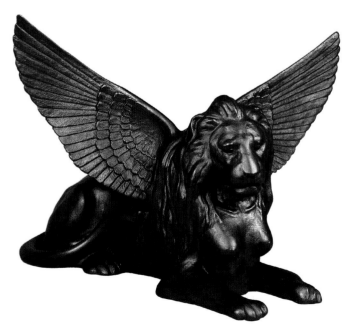

Wesley Anderegg
The Diver | 2007
37 X 19 X 8 INCHES (94 X 48.3 X 20.3 CM)
Hand-built earthenware; electric
fired; slips, glazes; wood, steel, wire
PHOTO BY ARTIST

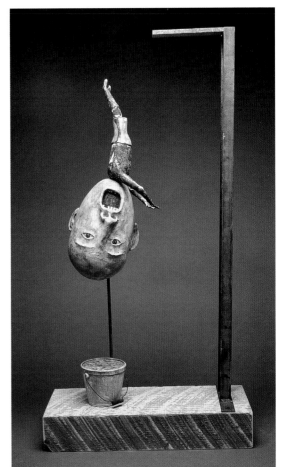

Christy Keeney
Head Study | 2006
24 $^{13}/_{16}$ X 14 $^{15}/_{16}$ X 14 $^{15}/_{16}$ INCHES
(63 X 38 X 38 CM)
Coiled stoneware; gas fired, cone 6;
glazed, cone 1; slip, stain, oxides
PHOTO BY ARTIST

269

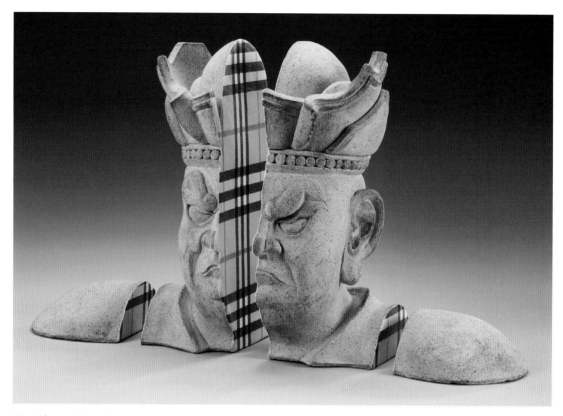

Matthew Harris

Bourgeois Tomb Guardian | 2007

13 X 20 X 8 INCHES (33 X 50.8 X 20.3 CM)

Stoneware, mixed media; gas
fired in reduction, cone 10

PHOTO BY CINDY TRIM

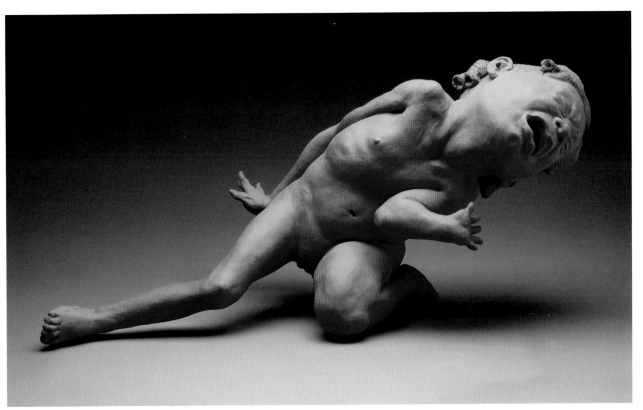

Anne Drew Potter

La Llorona | 2006

14¹⁵/₁₆ X 26 X 13 INCHES (38 X 66 X 33 CM)

Sculpted solid and hollowed
terra cotta; electric fired, cone 1

PHOTO BY ARTIST

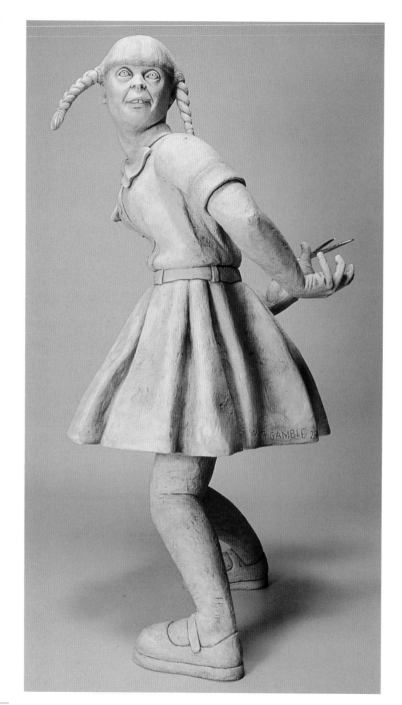

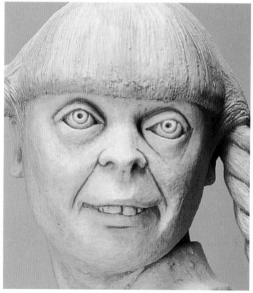

Misty Gamble
Nelly Has Scissors | 2006
57 X 30 X 30 INCHES (144.8 X 76.2 X 76.2 CM)
Stoneware; gas fired, cone 1;
underglaze, glaze, stains, cone 06
PHOTOS BY ARTIST

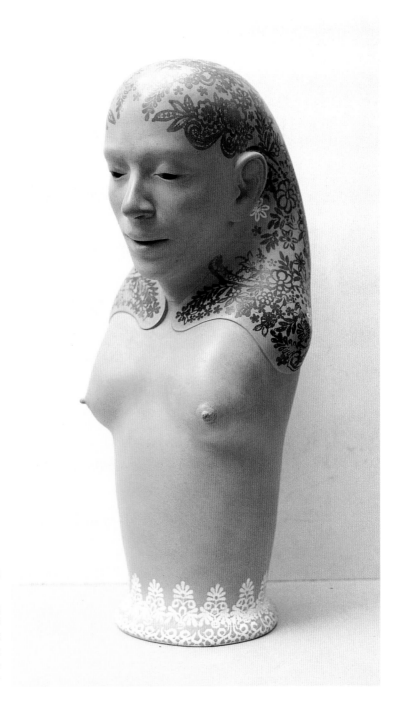

Peter Bevan

Sandy | 2005

21 5/5 X 9 13/16 X 9 1/16 INCHES
(55 X 25 X 23 CM)

Hand-built terra cotta; electric
fired, 1850°F (1010°C) with
inlaid colored jesmonite

PHOTO BY ARTIST

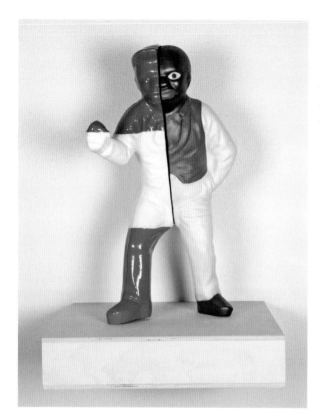

Benjamin Schulman

Part-Time Martyr | 2007

21 X 15 X 7½ INCHES
(53.3 X 38.1 X 19.1 CM)

Terra cotta, mixed media;
electric fired, cone 04

PHOTO BY ARTIST

Russell Biles

Final Showdown | 2006

7¹/₁₆ X 20⁷/₈ X 19¹¹/₁₆ INCHES
(18 X 53 X 50 CM)

Coil-built and slip-cast porcelain;
electric fired, cone 7; underglaze

PHOTO BY TIM BARNWELL

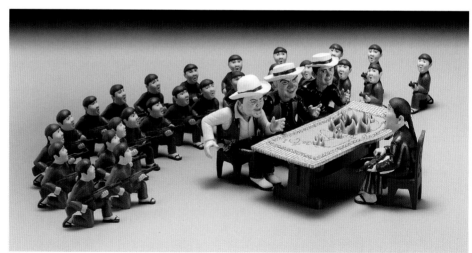

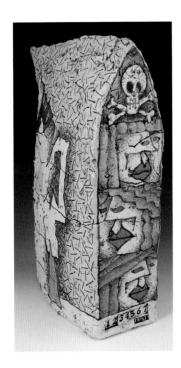

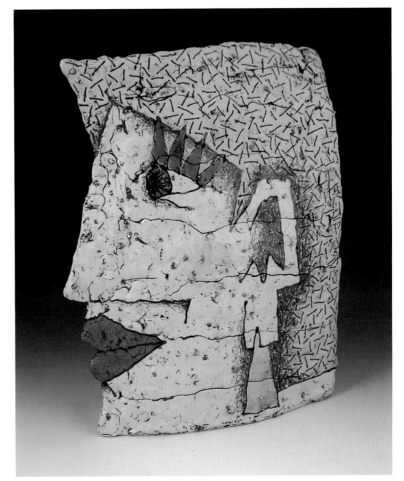

Rimas VisGirda

Lietura 1234567 | 2006

11 X 8 X 3 1/2 INCHES (27.9 X 20.3 X 8.9 CM)

Coil-built and slip-trailed porcelain with
decomposed granite, granite, and grog;
electric fired, cones 10, 05, 016, 018; lusters

PHOTOS BY ARTIST

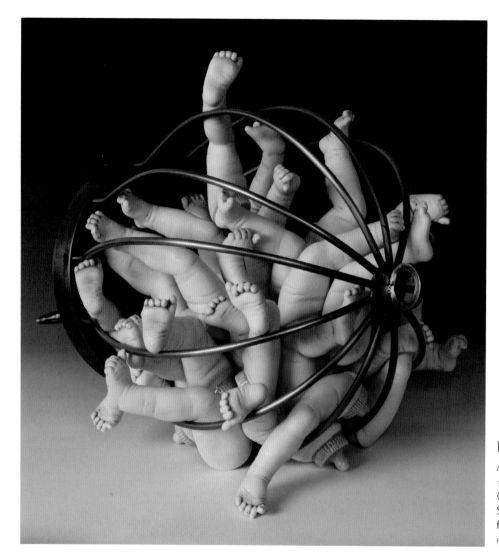

Kinu Watanabe

A New Blanket | 2007

12 X 20 X 12 INCHES
(30.5 X 50.8 X 30.5 CM)

Slip-cast porcelain; electric
fired, cone 6; glazed, steel, wax

PHOTOS BY ARTIST

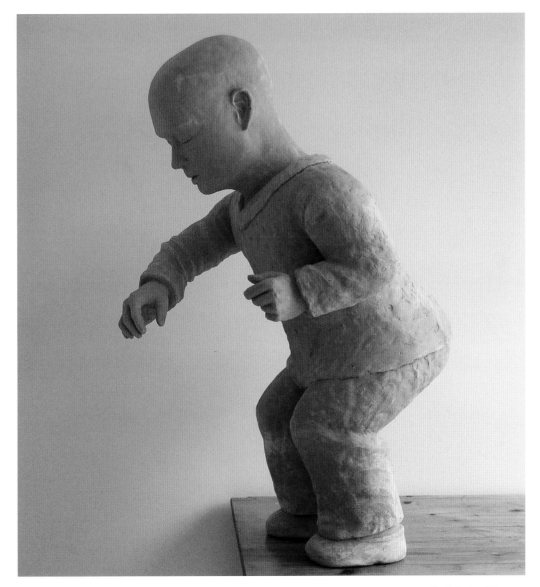

Patricia Rieger
Found. Conversations with a Bird 6 | 2007
35 X 27¹/₈ X 18¹/₈ INCHES (89 X 69 X 46 CM)
Coil-built earthenware; electric
fired, cone 1; unglazed
PHOTO BY ARTIST

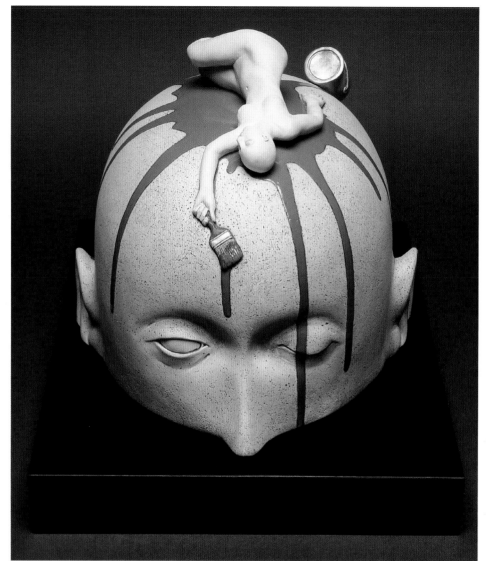

Verne Funk

Painter's Apprentice | 2007

12³/₁₆ X 12³/₁₆ X 14³/₁₆ INCHES
(31 X 31 X 36 CM)

Modeled and press-molded
white ware; electric fired, cone
04; underglaze, glaze, cone 06

PHOTOS BY MICHAEL SMITH

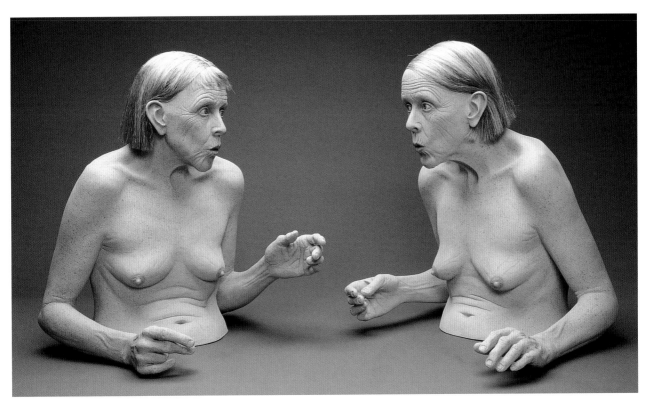

Tip Toland

Untitled | 2005

23 X 40 X 24 INCHES
(58.4 X 101.6 X 61 CM)

Hollowed stoneware; electric
fired, cone 2; paint, chalk
pastel, synthetic hair

PHOTOS BY TOM HOLT

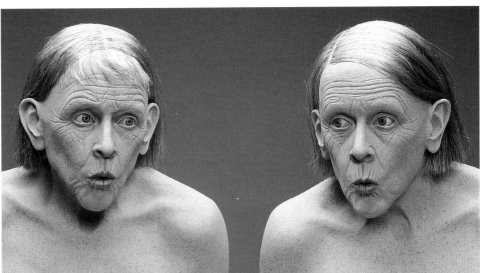

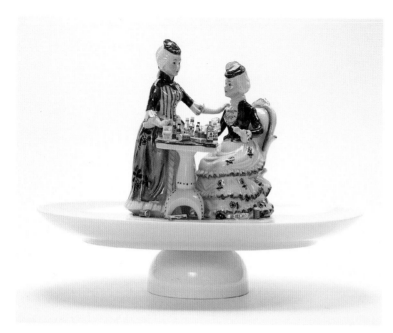

Barnaby Barford

Come On, You Lightweight—Down It! | 2007

11 3/8 X 14 15/16 X 11 INCHES (29 X 38 X 28 CM)

Bone china, porcelain, found objects

PHOTO BY THEODORE COOK

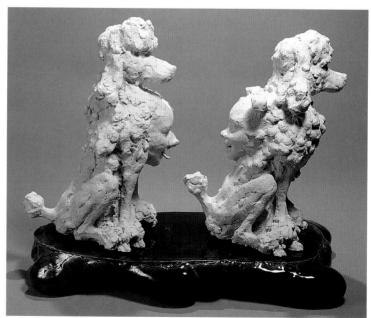

Audrius Janušonis

Flirt | 2004

21 1/4 X 25 9/16 X 13 3/4 INCHES
(54 X 65 X 35 CM)

Hand-built stoneware; gas
fired, 2516°F (1380°C)

PHOTO BY RIČARDAS PAMARNACKAS

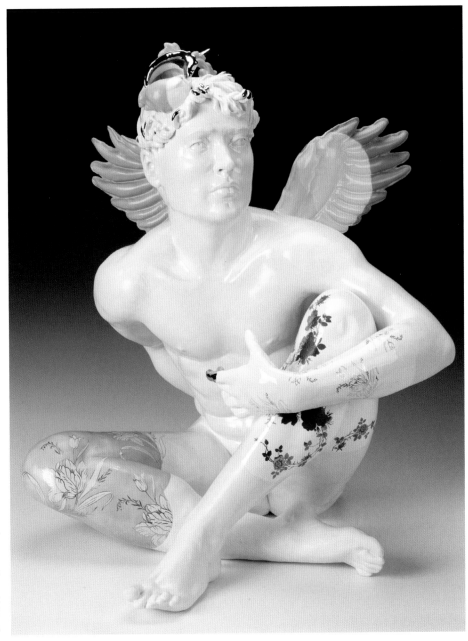

Christyl Boger
Water Wings | 2007
26 X 20¹/₁₆ X 20¹/₁₆ INCHES
(66 X 51 X 51 CM)
Coil-built earthenware; electric
fired, cone 04; glazed
PHOTO BY GEOFFREY CARR

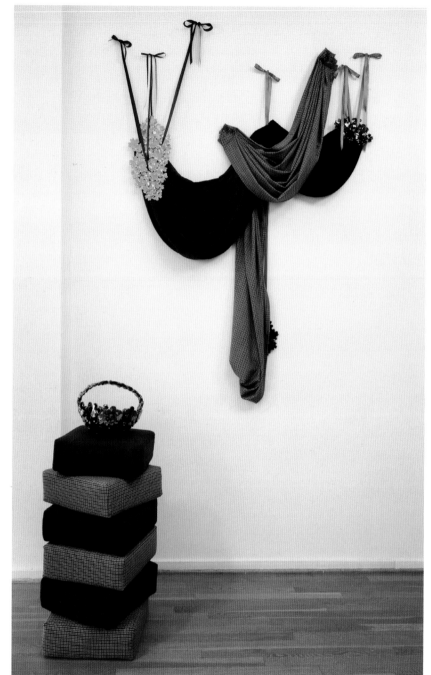

Robert Raphael
Untitled | 2007
118 X 50 X 2 INCHES
(299.7 X 127 X 5.1 CM)
Ceramic; electric fired; luster;
ribbon, men's suiting fabric
PHOTOS BY MATT HOLLERBUSLT

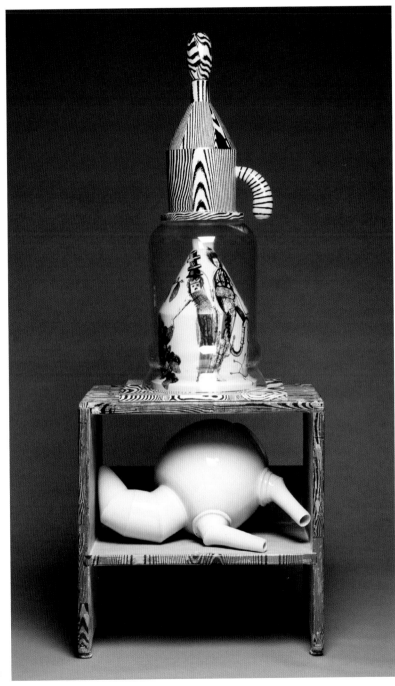

Vince Palacios
Alchemy Series:
Dreaming in Color | 2006
44 1/16 X 16 15/16 X 12 3/16 INCHES (112 X 43 X 31 CM)

Wheel-thrown porcelain forms; reduction
fired, cone 10; decals, tiles; electric
fired, cone 018; wood stand, glass
PHOTO BY LARRY DEAN

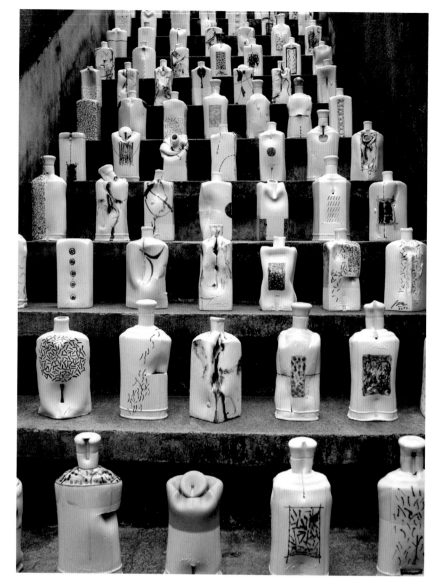

Bai Ming

Appliance—Form and Process | 2004

7⁷/₈ X 5⁷/₈ X 1¹⁵/₁₆ INCHES (20 X 15 X 5 CM)

Porcelain, press-molded stoneware;
restored fired; gas fired, cone 10

PHOTO BY ARTIST

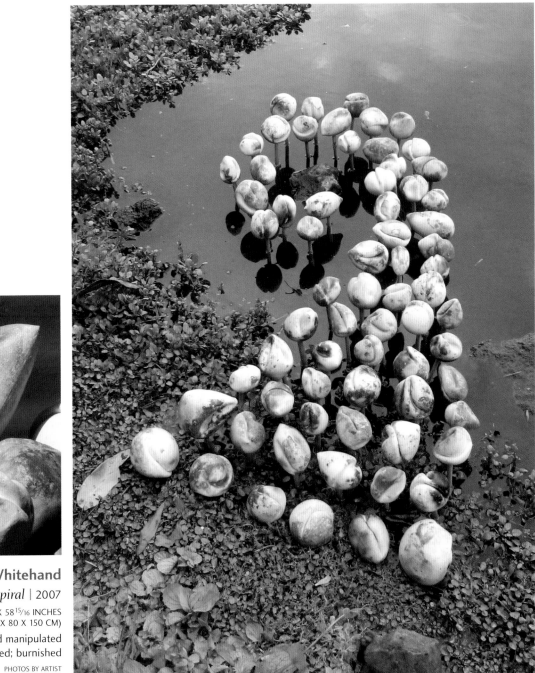

Dawn Whitehand
Water Spiral | 2007

5^{7}/$_{8}$ X 31^{1}/$_{2}$ X 58^{15}/$_{16}$ INCHES
(15 X 80 X 150 CM)

Wheel-thrown and manipulated
stoneware; pit fired; burnished

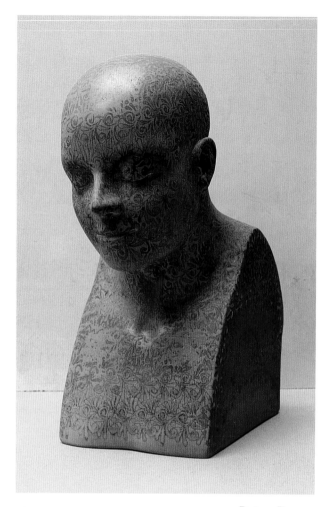

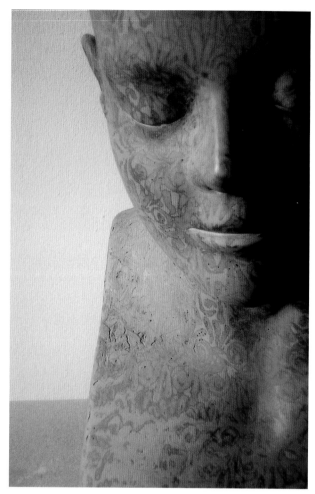

Peter Bevan

Freyamuse | 2005

15 3/4 X 7 1/16 X 9 13/16 INCHES (40 X 18 X 25 CM)

Hand-built terra cotta; electric fired, 1850°F
(1010°C) with inlaid colored jesmonite

PHOTOS BY ARTIST

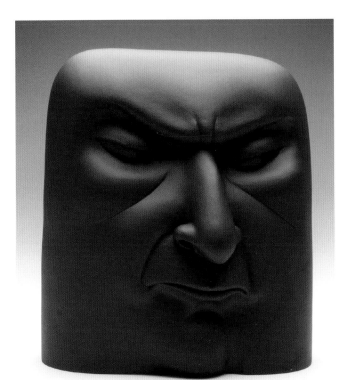

Antigoni Pantazi

Untitled | 2006

11 13/16 X 9 13/16 X 4 11/16 INCHES (30 X 25 X 12 CM)

Hand-built terra cotta; electric
fired, cone 05; terra sigillata, cone 01

PHOTO BY ARTIST

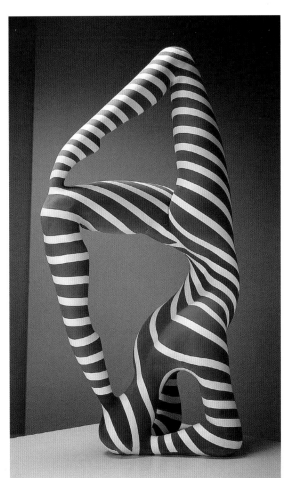

Lola Serkland

Acrobat | 2004

42 7/8 X 27 15/16 X 14 15/16 INCHES
(109 X 71 X 38 CM)

Hand-built stoneware; electric
fired, cone 06; blue velvet over terra
sigillata; electric fired, cone 08

PHOTO BY JOHN SERKLAND

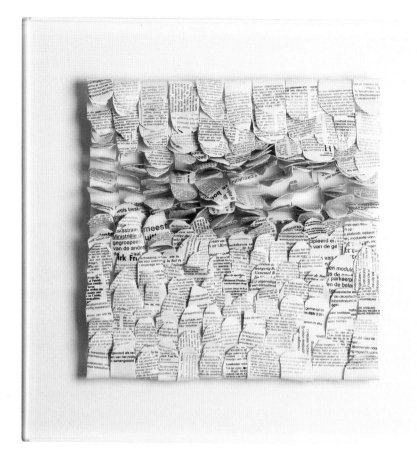

Jeanne Opgenhaffen

With Simple Words | 2007

25⁹/₁₆ X 25⁹/₁₆ X 3¹⁵/₁₆ INCHES (65 X 65 X 10 CM)

Porcelain; electric fired, cone 8;
decal printing, cone 06a

PHOTOS BY STEFAAN VAN HUL

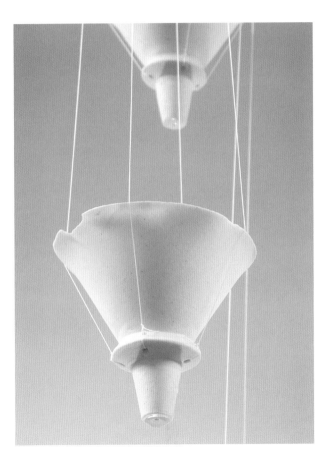

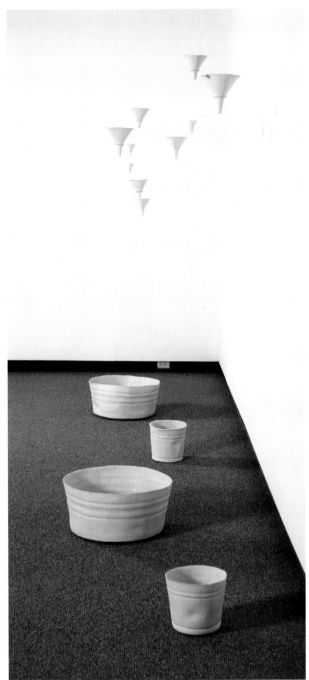

Jennifer Holt
Metaphor for Memory | 2005
VARIOUS DIMENSIONS
Press-molded and slip-cast porcelain;
reduction fired, cone 10; thread
PHOTOS BY PETER GIFFORD

John Williams

Hidden River | 2008

38 X 53 15/16 X 7 7/8 INCHES
(96.5 X 137 X 20 CM)

Slip-cast porcelain; reduction
fired, cone 10; steel

PHOTO BY ARTIST

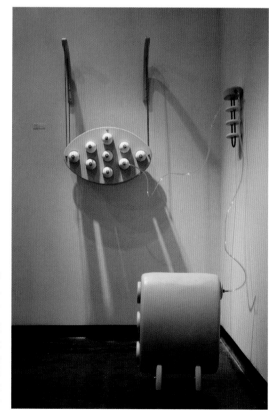

Mahlon Joel Huston

*Future-Water-Industry-
Constructed* | 2007

INSTALLATION

Slip-cast porcelain; electric
fired, cone 6; wood, cold-cast
plastic, vinyl tubing, steel
rod, steel hardware, paint

PHOTO BY ARTIST

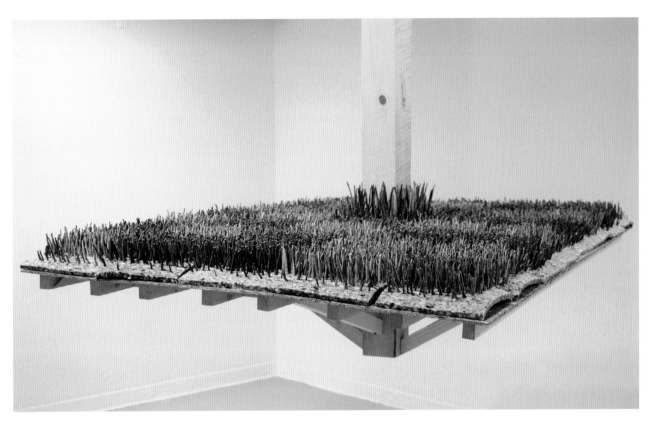

Michael Fujita

Floating | 2007

95⅞ X 42⅛ X 64¹/₁₆ INCHES
(244 X 107 X 163 CM)

Cast feldspar; electric fired,
cone 8; carpet padding, wood

PHOTOS BY ARTIST

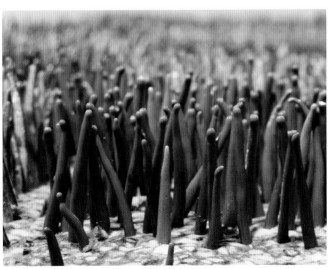

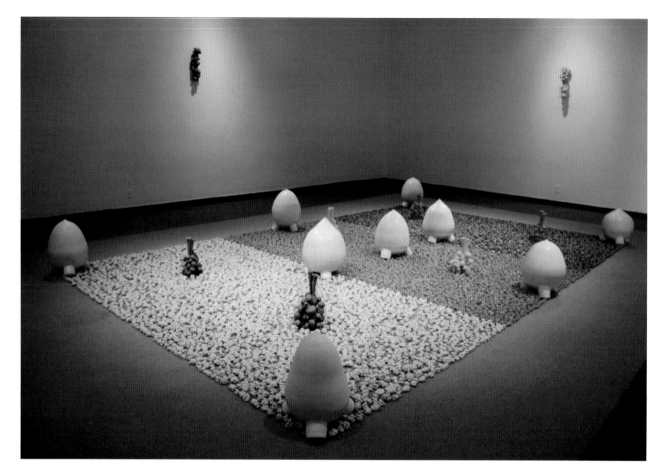

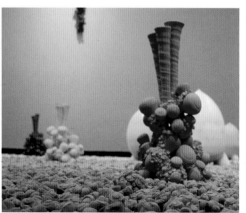

Patsy Cox

Urban Rebutia at W. Keith and Janet Kellogg Art Gallery | 2008

24 X 227¹/₂ X 143⁵/₁₆ INCHES (61 X 579 X 366 CM)

Thrown, hand-built, and assembled porcelain; gas fired in oxidation, cone 10; thrown and assembled terra cotta; gas fired in oxidation, cone 04; vitreous engobe; majolica

PHOTOS BY ARTIST

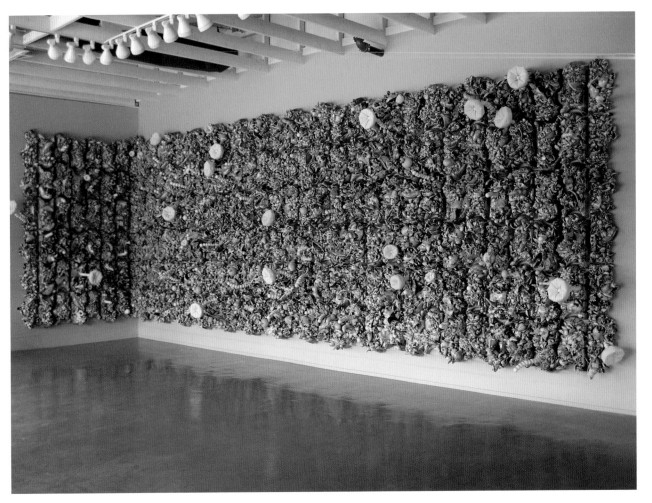

Susan Beiner

Synthetic Reality | 2008

119³/₄ X 299¹/₂ X 15¹⁵/₁₆ INCHES
(304.8 X 762 X 40.6 CM)

Slip-cast and assembled
porcelain; gas fired, cone 6;
glaze, foam, polyester fiberfill

PHOTOS BY ARTIST

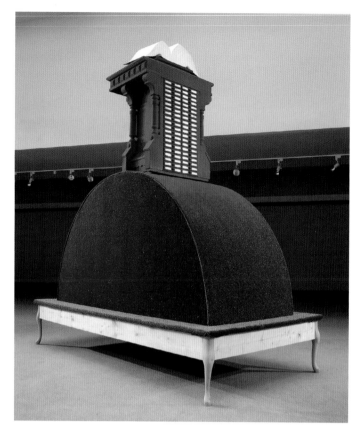

Brian Gillis
A Mystery, the Book, and the
Chicken or the Egg | 2007
131 5/8 X 47 15/16 X 95 7/8 INCHES (335 X 122 X 244 CM)
Hand-carved porcelain; electric fired, cone 10; underglaze, cone 10; steel, aluminum, wood, synthetic grass, nylon flocking, paper
PHOTOS BY ARTIST

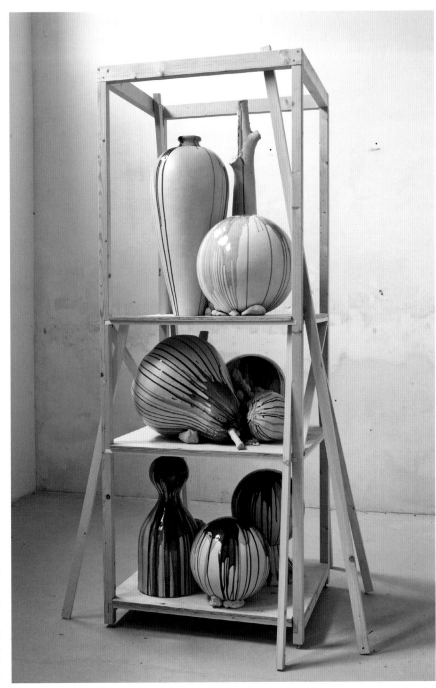

Anton Reijnders

Stage (Levels) | 2006

96⅝ X 56⁵⁄₁₆ X 44⅞ INCHES
(246 X 143 X 114 CM)

Press-molded stoneware; gas
fired in oxidation, cone 7;
glazed, terra sigillata; wood

PHOTO BY ARTIST

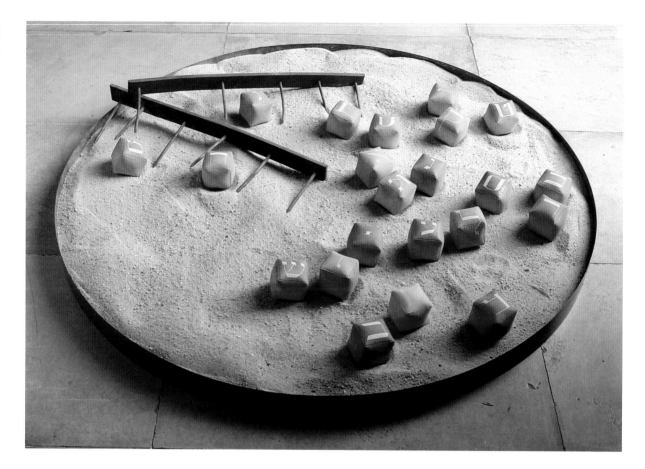

Gabriele Pütz

Eternal Always | 1992

DIAMETER, 39³/₈ INCHES (100 CM)

Ceramic; electric fired, 1940°F (1060°C);
acrylic paint, iron, sand, wood

PHOTOS BY ARTIST

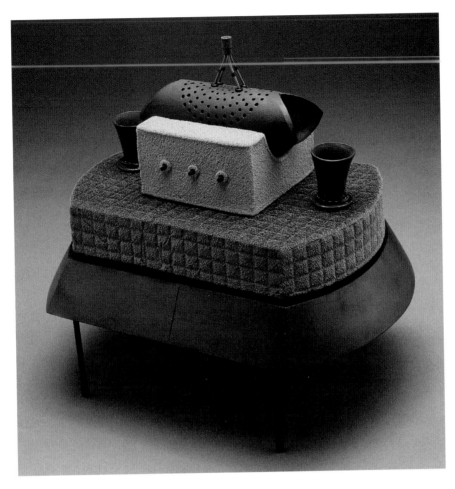

Charlie Olson
ECD | 2006

13 X 8¹/₄ X 11 INCHES (33 X 21 X 28 CM)

Slip-cast and hand-built porcelain;
electric fired, cone 10; glazed, cone 10;
metal additions, wooden base, metal legs

PHOTOS BY ARTIST

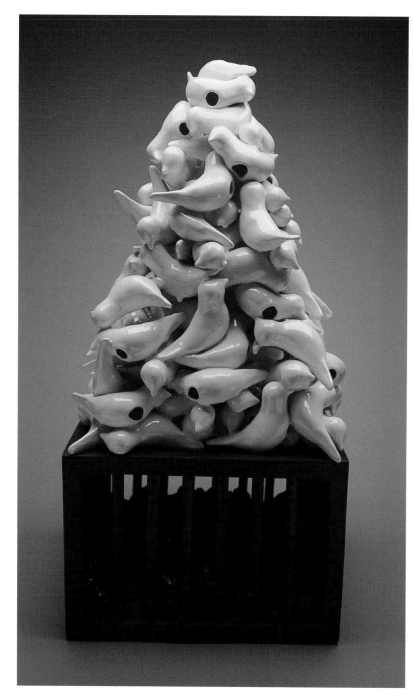

Gregg Moore

The Miner's Canary Project | 2005

47 X 23 X 23 INCHES (119.4 X 58.4 X 58.4 CM)

Slip-cast porcelain; bisque fired, cone 10; glazed, cone 04; anthracite coal, wood

PHOTO BY ARTIST

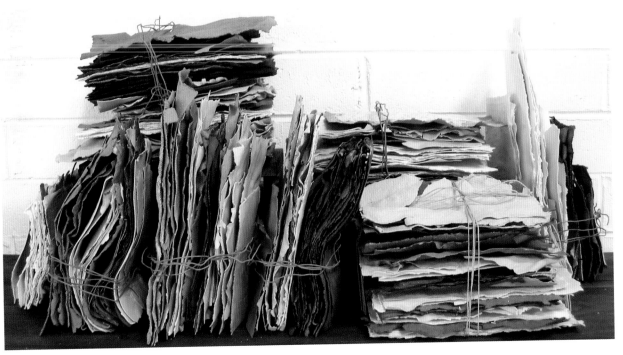

Cyrus (Wai-Kuen) Tang

Untitled | 2003

21 5/8 X 39 3/8 X 19 11/16 INCHES
(55 X 100 X 50 CM)

Paper clay; electric fired,
cone 10; smoke fired; unglazed

PHOTOS BY ARTIST

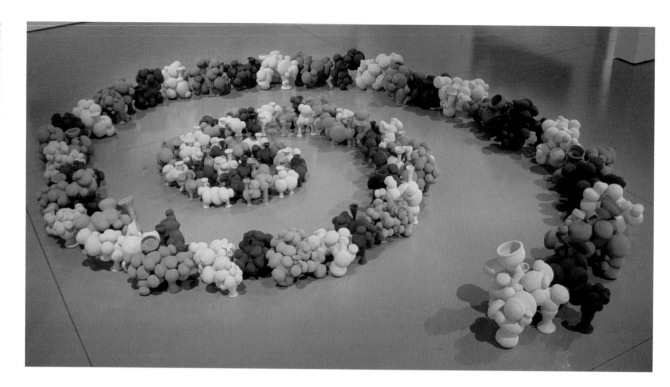

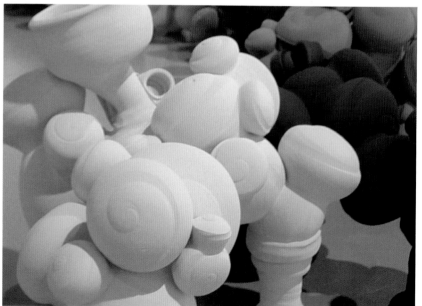

Patsy Cox

L.A. County Conglomeration
for Free Range | 2003

24 X 240 X 240 INCHES (61 X 610 X 610 CM)

Thrown and assembled porcelain; gas fired
in oxidation, cone 10; vitreous engobe

PHOTOS BY ARTIST

Marc Leuthold

Field | 2007

58 15/16 X 55 1/8 X 648 1/2 INCHES
(150 X 140 X 1650 CM)

Modeled and carved
stoneware; electric fired,
cone 03; glazed, unglazed

PHOTO BY ARTIST

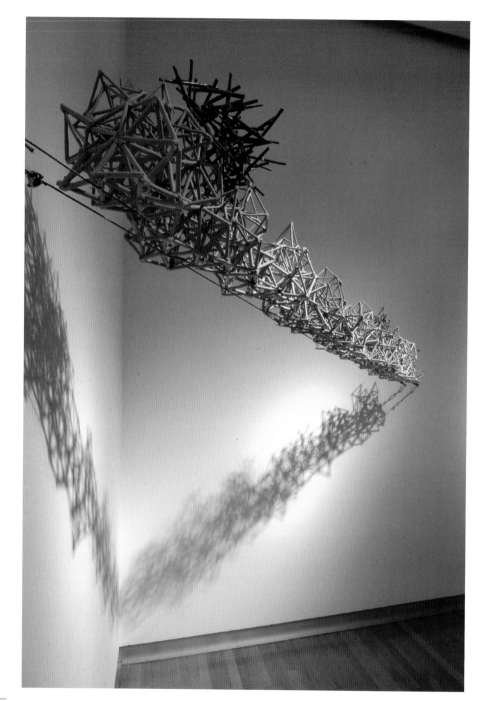

Stanton Hunter

Migration Grid #6 | 2006

14 X 108 X 12 INCHES
(35.6 X 274.3 X 30.5 CM)

Coiled porcelaneous stoneware;
reduction fired, cone 9; unglazed

PHOTOS BY GENE OGAMI

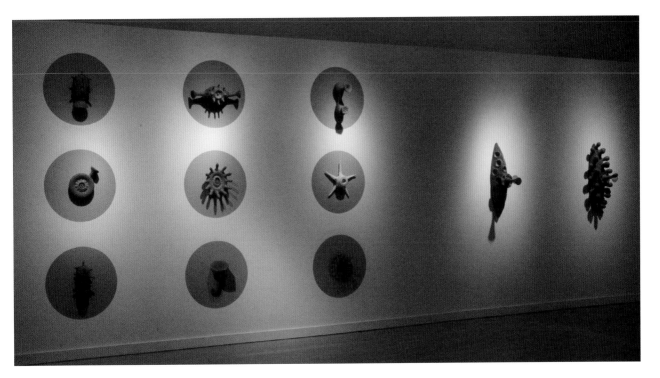

Sadashi Inuzuka
Can You Hear Me? | 2008
INSTALLATION

Thrown and altered earthenware;
electric fired, cone 4; thrown and
altered porcelain; electric fired,
cone 10; terra sigillata; computer
video camera, microphone, LCD
monitor, speakers, paint, text

PHOTOS BY ARTIST

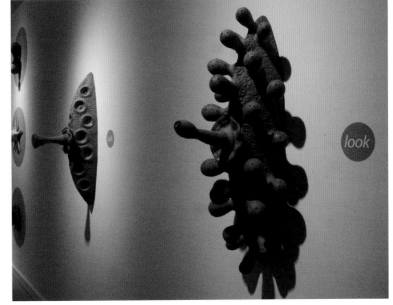

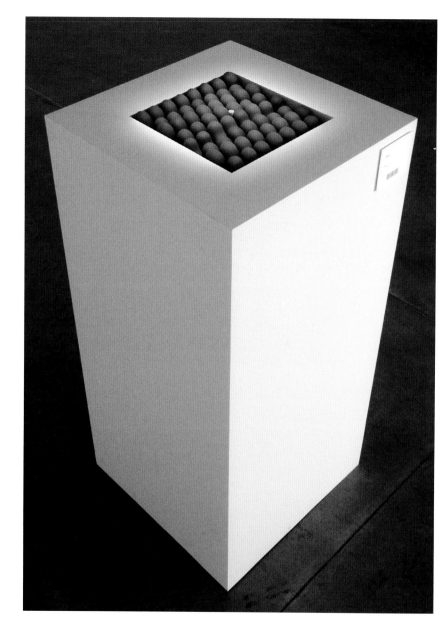

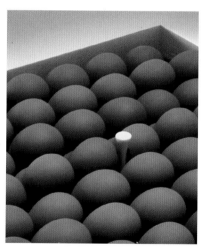

Jeremy R. Brooks

Green | 2007

42 1/8 X 22 1/16 X 22 1/16 INCHES
(107 X 56 X 56 CM)

Slip-cast porcelain; electric fired, cone 02; underglaze, cone 05; fragrant paraffin wax, soil, fabricated stand, fiberboard, found object, golf tee

PHOTOS BY ARTIST

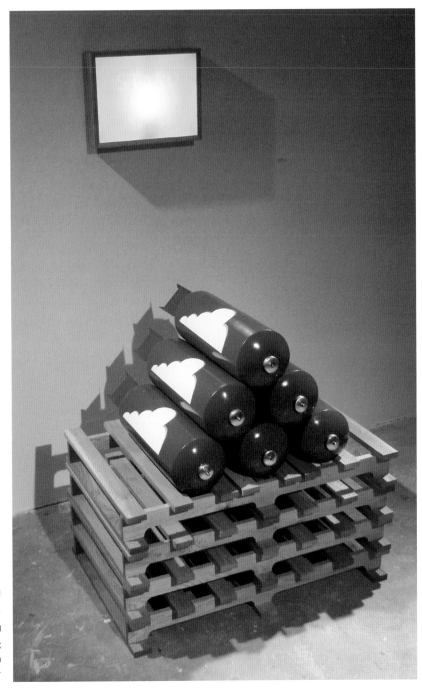

Mahlon Joel Huston
Sky's Falling: Orange Alert | 2008
INSTALLATION
Slip-cast stoneware; electric fired, cone 04;
white oak, glass, light, paint, cast aluminum
PHOTO BY ARTIST

Brigitte Bouquet

Tulip Fields | 2006

41 5/16 X 157 3/16 X 3 1/8 INCHES
(105 X 400 X 8 CM)

Earthenware clogs; electric
fired; wood, nails

PHOTO BY DICK DELANGE

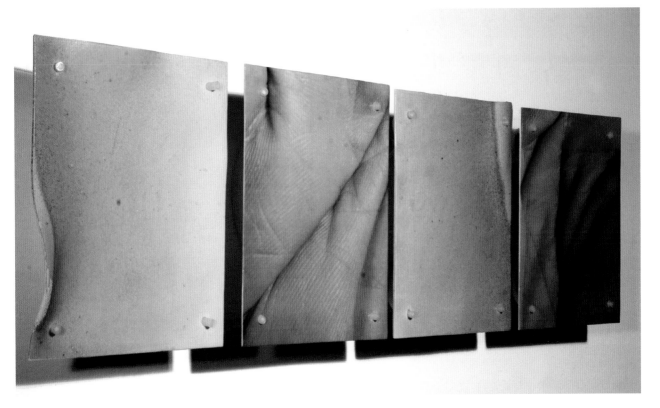

Brian Boldon

Cover/Recover | 2005

11 13/16 X 45 1/4 X 4 11/16 INCHES
(30 X 115 X 12 CM)

Cast porcelain slabs, porcelain;
wood fired, cone 11; decals;
electric fired, cone 012

PHOTOS BY AMY BAUR

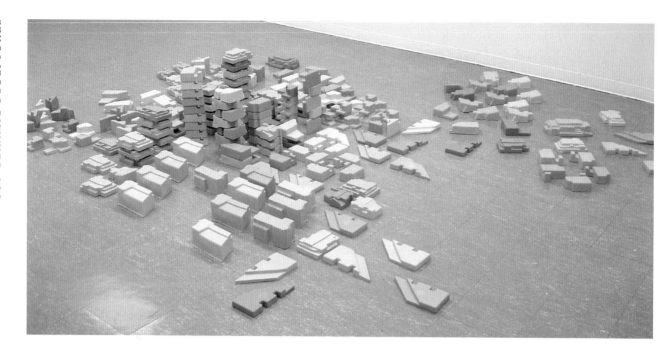

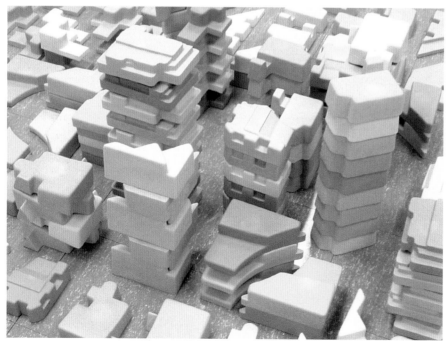

Dylan J. Beck
A Modular City | 2007
VARIOUS DIMENSIONS
Slip-cast porcelain;
electric fired, cone 6
PHOTOS BY ARTIST

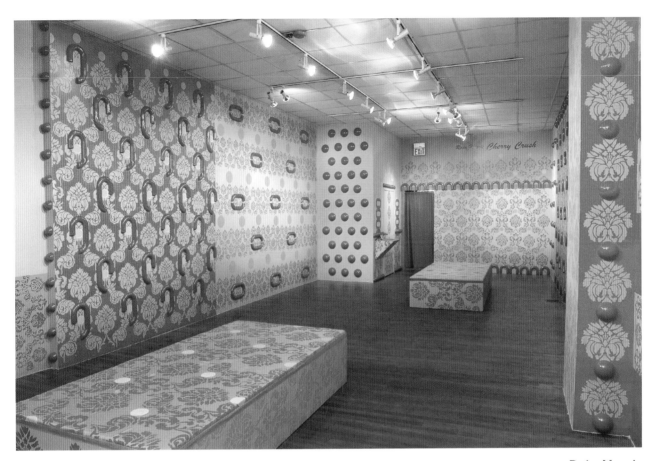

Rain Harris
Cherry Crush | 2005
VARIOUS DIMENSIONS
Slip-cast porcelain; electric fired,
cone 6; paint, fabric, wood
PHOTO BY DOUG WEISMAN

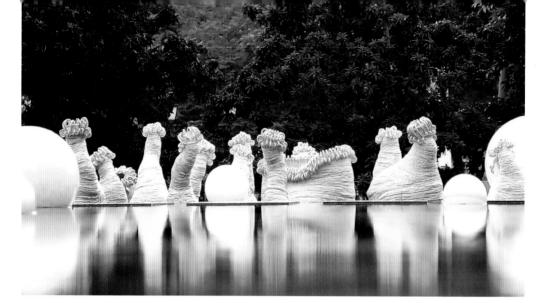

Jason Lim

Swimming with Sweaty Palms | 2005

LARGEST, 47 ¼ X 55 ⅛ X 19 ¹¹⁄₁₆ INCHES (120 X 140 X 50 CM)

Coiled stoneware; gas fired, cone 5; glazed

PHOTO BY ARTIST

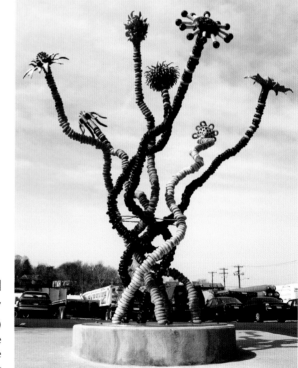

Susan Small

Joyful Experience | 2007

151 ⅝ X 119 ¾ X 107 ¾ INCHES (385.8 X 304.8 X 274.3 CM)

Hand-built stoneware; electric fired, bisque, cone
06; glazed, cone 9; stainless steel armature

PHOTO BY KEVIN BRETT

Wynn Bauer

Untitled | 2007

29¹⁵/₁₆ X 95¹/₂ X 143⁷/₁₆ INCHES
(76 X 243 X 365 CM)

Slab-built stoneware;
oxidation fired, cone 6; glazed;
rocks, dirt, landscaping

PHOTOS BY ARTIST

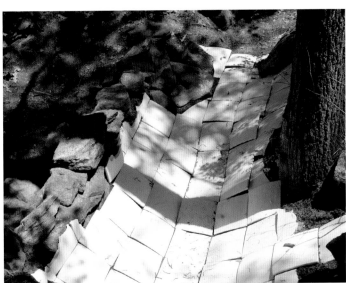

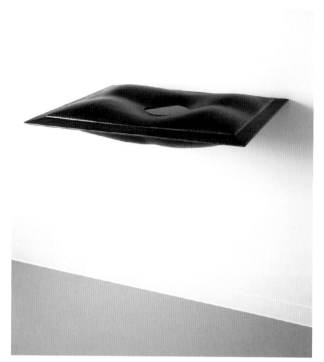

Jeffrey Mongrain

An Evening's Breath | 2001

6 X 29 X 21 INCHES (15.2 X 73.7 X 53.3 CM)

Slab-built stoneware; electric fired, cone 1; clay, water, polished wax surface

PHOTO BY CATHY CARVER

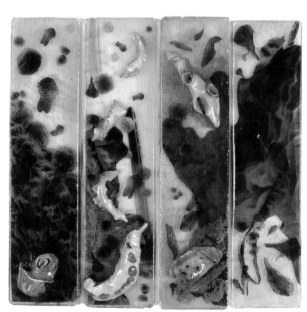

Amanda Small

Disseminate | 2007

EACH, 7¹/₁₆ X 2³/₈ X 1³/₁₆ INCHES
(18 X 6 X 3 CM)

Hand-built stoneware; electric fired, cone 04; glazed; digital imagery, resin, clear plastic sheeting

PHOTO BY ARTIST

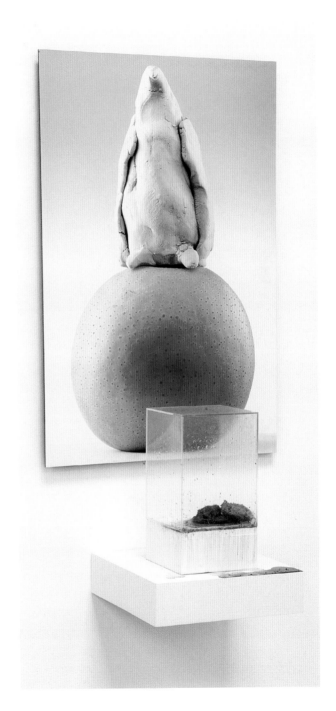

Thomas Müller

Emperor | 2005

34 X 20 X 12 INCHES
(86.4 X 50.8 X 30.5 CM)

Unfired porcelain, Asian pear,
photo, wood, clear plastic sheeting

PHOTOS BY ALLEN KING

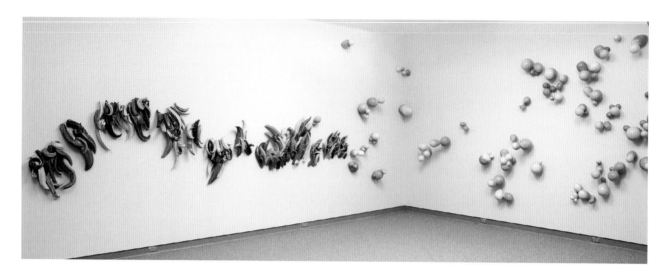

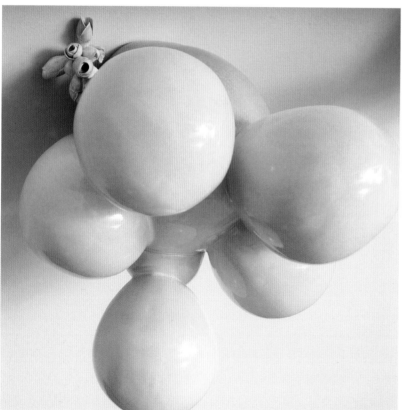

Firth MacMillan

Pink Grow Green | 2006

143 7/16 X 514 13/16 X 11 13/16 INCHES
(365 X 1310 X 30 CM)

Low-fire, hand-built, and slip-cast white earthenware; electric fired, cone 04; glazed

PHOTOS BY JOHN NOLLENDORFS

Rosa Cortiella

Portable Garden | 2007

3 1/8 X 47 1/4 X 9 7/16 INCHES (8 X 120 X 24 CM)

Press-molded white ware; electric
fired, 1886°F (1030°C); glazed,
1796°F (980°C); black acrylic paint

PHOTOS BY ELOY ESTEBAN

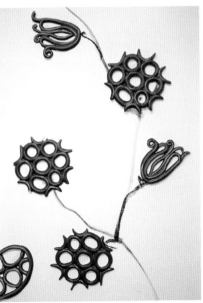

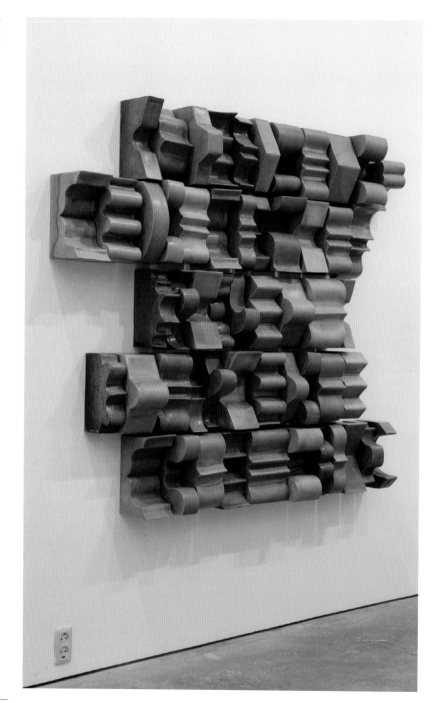

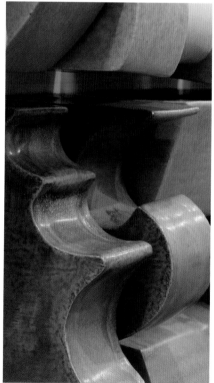

Veronica Juyoun Byun
Misty Dawn | 2005
60 X 64 X 5 INCHES
(152.4 X 162.6 X 12.7 CM)

Slab-built stoneware; gas fired,
cone 10; glazed, cone 10

PHOTOS BY ARTIST

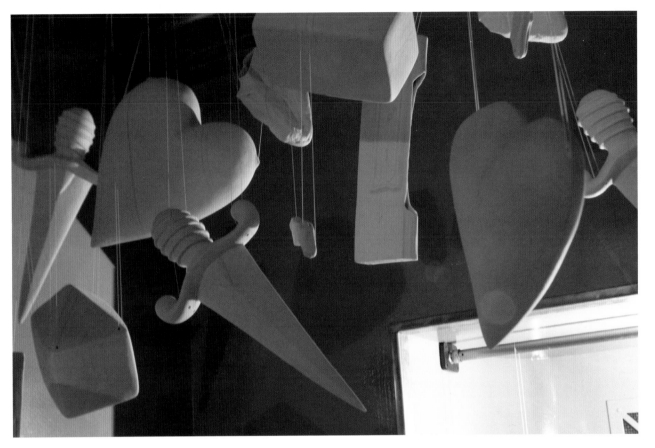

Jennifer Holt
Mediations: A Memory of Place
VARIOUS DIMENSIONS
Slip-cast porcelain; reduction
fired, cone 10; audio, mixed media
PHOTOS BY BENJAMIN STERN

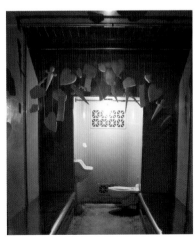

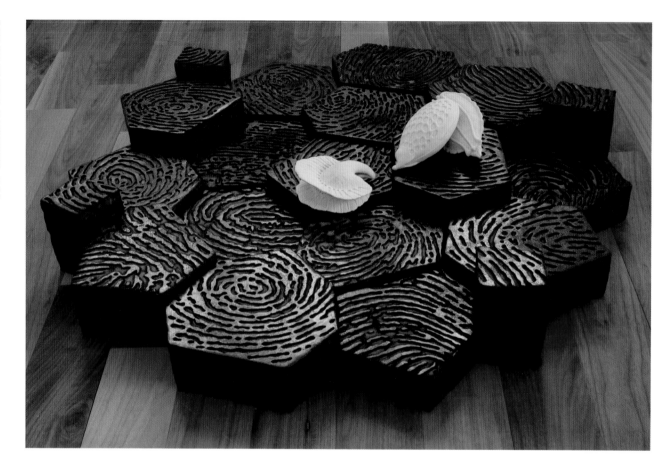

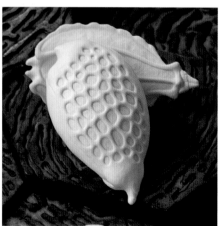

Ana England

Touching the Earth | 2007

7⁷⁄₈ X 37 X 33⁷⁄₈ INCHES (20 X 94 X 86 CM)

Slab-built stoneware; raku fired; unglazed;
post-fire reduction; burnished; hand-built
porcelain; electric fired, cone 8; unglazed

PHOTOS BY ARTIST

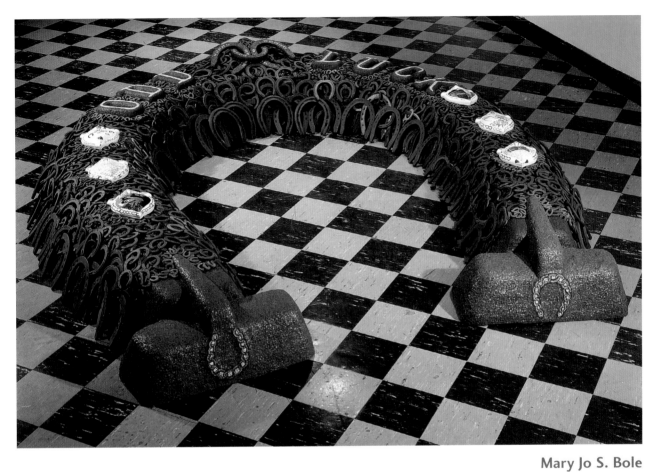

Mary Jo S. Bole

Odd Luck | 1998–2000

19 X 102 X 112 INCHES (48.3 X 259.1 X 284.5 CM)

Slip-cast bone china, mosaic; transfers

PHOTO BY CHAS RAY KRIDER

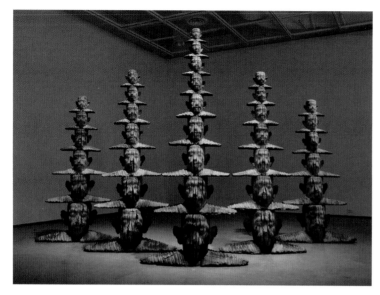

Hongwei Li

Landscape #6 | 2007

100 5/8 X 151 11/16 X 71 15/16 INCHES
(256 X 386 X 183 CM)

Earthenware; raku fired, cone 6

PHOTO BY ARTIST

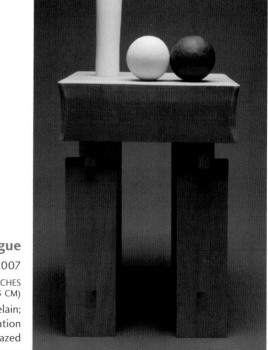

Benjamin Teague

Level Weight | 2007

22 7/16 X 13 X 13 INCHES
(57 X 33 X 33 CM)

Hand-built stoneware and porcelain;
reduction fired, cone 10; oxidation
fired, cone 04; unglazed

PHOTO BY ARTIST

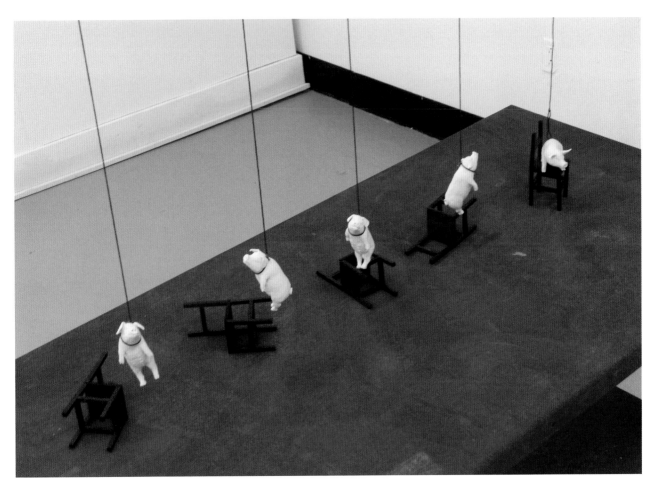

Chang Hyun Bang

Wednesday Morning 3 A.M. | 2007

VARIOUS DIMENSIONS

Press-molded stoneware; electric fired, cone 6; glazed; strings, wood, iron

PHOTOS BY ARTIST

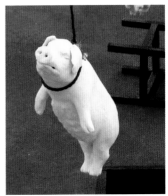

Nina Hole

Two Taarns | 2006

137$\frac{1}{2}$ X 64$\frac{13}{16}$ X 64$\frac{13}{16}$ INCHES
(350 X 165 X 165 CM)

Terra sigillatas; wood fired

PHOTOS BY ARTIST

Allison Newsome

Grotto Clay Sketch | 2006

119³/₄ X 191⁵/₈ X 59⁷/₈ INCHES
(304.8 X 487.7 X 152.4 CM)

Clay, mussel, and slipper shells

PHOTOS BY ARTIST

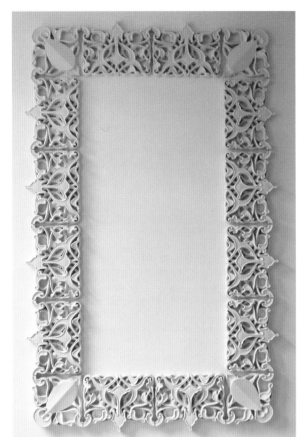

Rem Posthuma
Untitled | 2007

106 X 67 X 32 INCHES (2.7 X 1.7 X 0.8 M)

Slip-cast stoneware; bisque
fired, 1922°F (1050°C); unglazed

PHOTO BY ARTIST

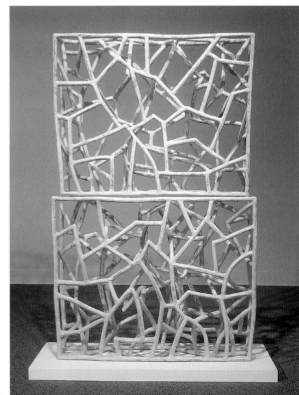

Linda Casbon
Interior | 2001

48 X 28 X 8 INCHES
(121.9 X 71.1 X 20.3 CM)

Coil-built earthenware;
gas fired, cone 04; glazed

PHOTO BY ARTIST

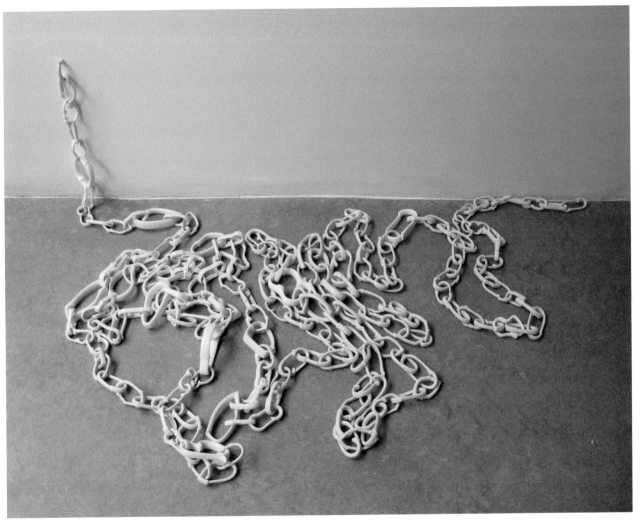

Kjell Rylander
Rest | 2005–2007

2³/₄ X 308¹/₂ X 1³/₁₆ INCHES
(7 X 785 X 3 CM)

Ceramic readymades,
cups, glue; sawed

PHOTO BY ARTIST

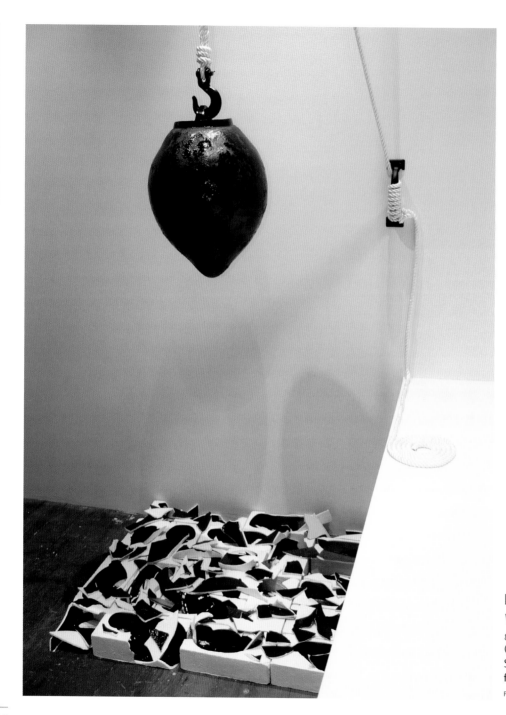

Ianna Nova Frisby
Wrecking Ball I | 2008
84 X 36 X 36 INCHES
(53.3 X 38.1 X 19.1 CM)

Slip-cast earthenware; electric
fired, cone 1; glazed, cone 06
PHOTO BY ARTIST

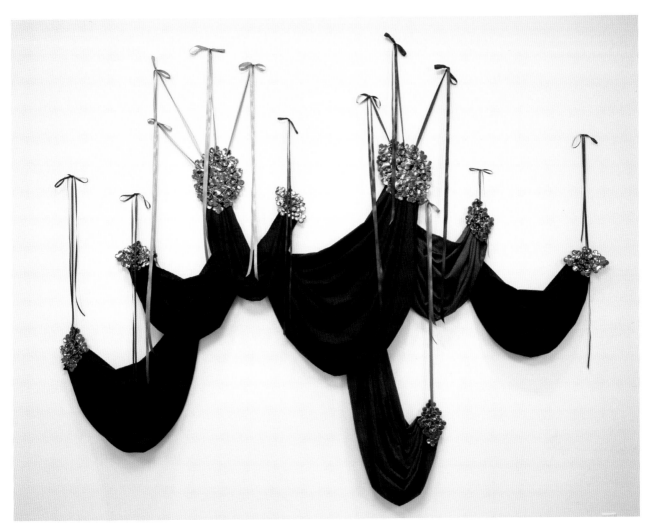

Robert Raphael

Untitled | 2007

93 X 107 X 2 INCHES
(236.2 X 271.8 X 5.1 CM)

Ceramic; electric fired; luster;
men's suiting fabric, ribbon

PHOTO BY MATT HELLERBUSLT

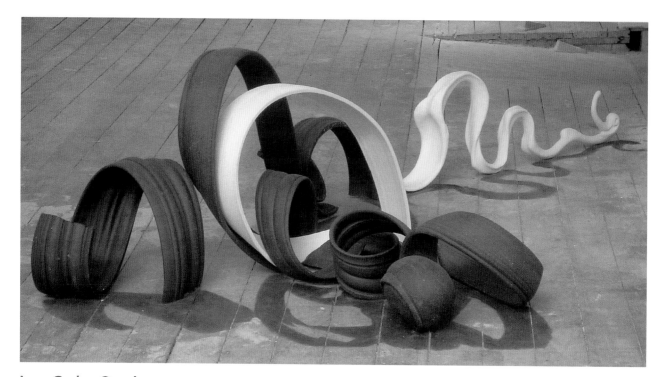

Juan Carlos Ornelas

El Vortex | 2007

60 X 36 X 18 INCHES (152.4 X 91.4 X 45.7 CM)

Wheel-thrown and hand-built stoneware;
gas fired in oxidation, cone 6

PHOTO BY ARTIST

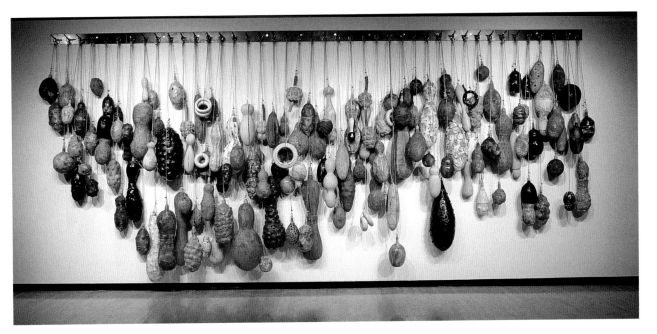

David Hicks
Still Life at 27 | 2004
120⅝ X 299½ X 24 INCHES (307 X 762 X 61 CM)

Hand-built, wheel-thrown, altered, and slip-cast terra cotta stoneware; reduction fired, oxidation fired, and multi-fired; terra sigillata, glaze, resin, paint; wood, steel cable

PHOTOS BY ARTIST

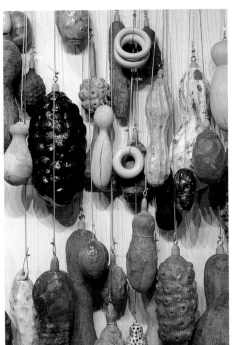

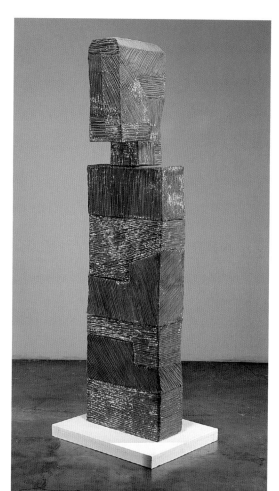

Francisco "Pancho" Jiménez

Assertive | 2007

48 X 26 X 11 $^{13}/_{16}$ INCHES
(122 X 66 X 30 CM)

Slab-built; electric fired,
cone 1; glazed, cone 06

PHOTO BY JACK TOOLIN

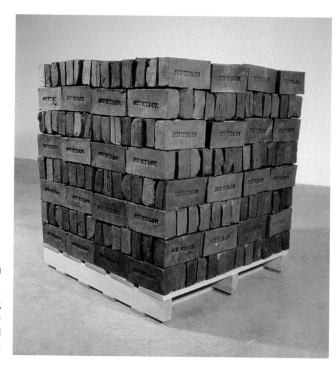

Adam Welch

Handmade Stacki Pallet | 2003

40 $^1/_8$ X 36 $^3/_{16}$ X 36 $^3/_{16}$ INCHES
(102 X 92 X 92 CM)

Handmade brick, wood

PHOTO BY ARTIST

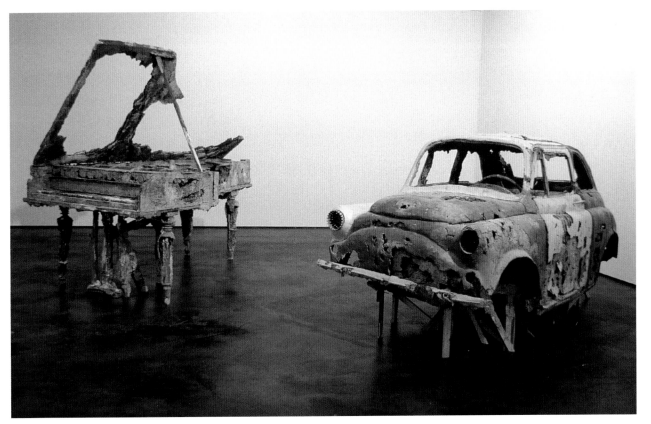

Kristen L. Morgin

Pianoforte and Topolino | 2003–2004

TALLEST, 71⁷/₈ X 46¹/₁₆ X 96⁵/₈ INCHES (183 X 117 X 246 CM)

Unfired clay, wood, wire, cement, glue, salt

PHOTO BY JAMES O. MILMOE

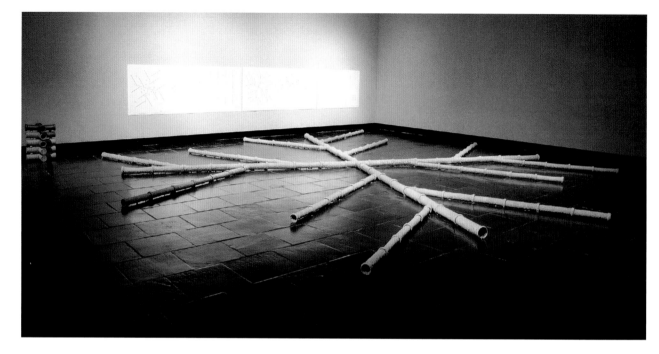

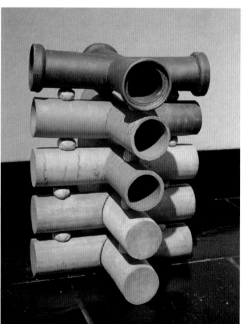

John Roloff

Devonian Shale: Aquifer I | 2000

4 $^{11}/_{16}$ X 299 $^{1}/_{2}$ X 299 $^{1}/_{2}$ INCHES (12 X 762 X 762 CM)

Processed and extruded Devonian shale; gas fired, cone 01; unglazed; raw Devonian shale, industrial Xerox on paper

PHOTOS BY ARTIST

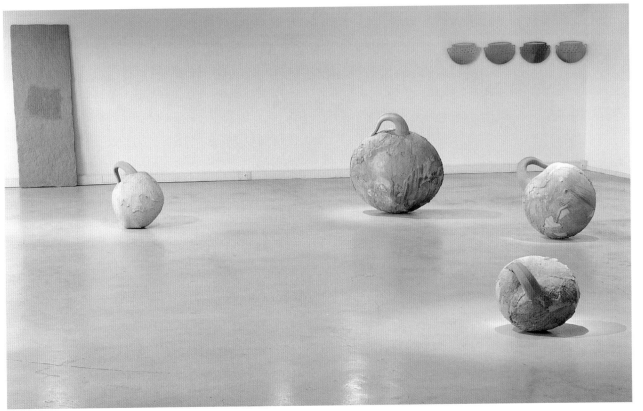

Muller –B–

Hanging Onto | 1991

LARGEST, 55 1/8 INCHES (140 CM) IN DIAMETER

Hand-built and pulled clay; gas
fired, 2012°F (1100°C); concrete

PHOTO BY ARTIST

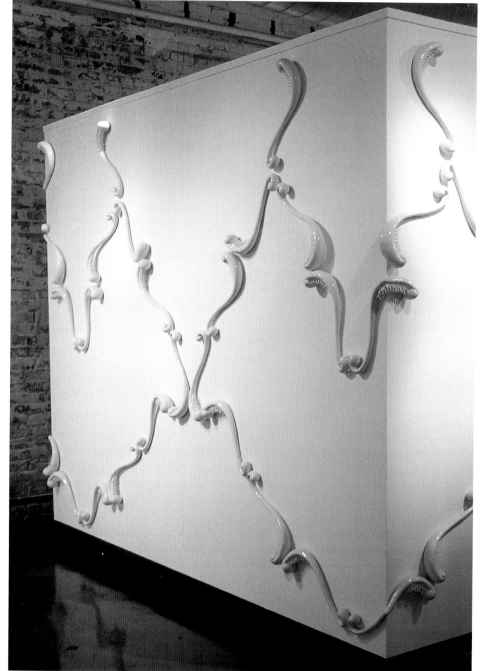

Tsehai Johnson
Field #4 | 2006

82 15/16 X 134 3/4 X 2 3/8 INCHES
(211 X 343 X 6 CM)

Slip-cast porcelain and bristles;
electric fired, cone 6; glazed

PHOTOS BY WES MAGYAR

Nathan Betschart
Meat Hooks | 2007

18¹/₂ X 38³/₁₆ X 31⁷/₈ INCHES
(47 X 97 X 81 CM)

Slab and rolled stoneware; electric
fired, cone 1; underglaze; steel pulley

PHOTOS BY ARTIST

Lisa Marie Barber

Heart-Shaped World | 2004

107 ¹¹/₁₆ X 199 ⁵/₈ X 157 ⁹/₁₆ INCHES (274 X 508 X 401 CM)

Pinched, coiled, and slab-built recycled clay; electric fired and gas fired in oxidation, cones 05–03; glazed and fired multiple times, cones 04–07

PHOTO BY KEVIN STRANDBERG

Wendy Walgate
I Had a Little Pony | 2007
20⁷/₈ X 24 X 4¹¹/₁₆ INCHES (53 X 61 X 12 CM)

Slip-cast white earthenware; electric
fired, cone 04; glazed, cone 06; wooden
insert from toy box, hand-colored
paper decals, wooden mantle

PHOTOS BY ARTIST

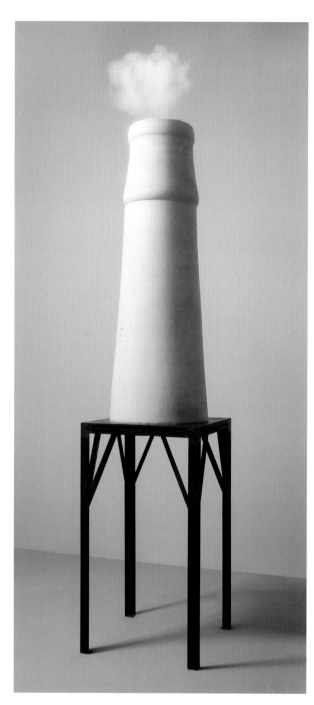

Jeffrey Mongrain

Chimney | 2007

120 X 28 X 28 INCHES
(304.8 X 71.1 X 71.1 CM)

Wheel-thrown and coiled white stoneware; electric fired, cone 1; clay, steel, water, humidifier, Viagra

PHOTO BY CATHY CARVER

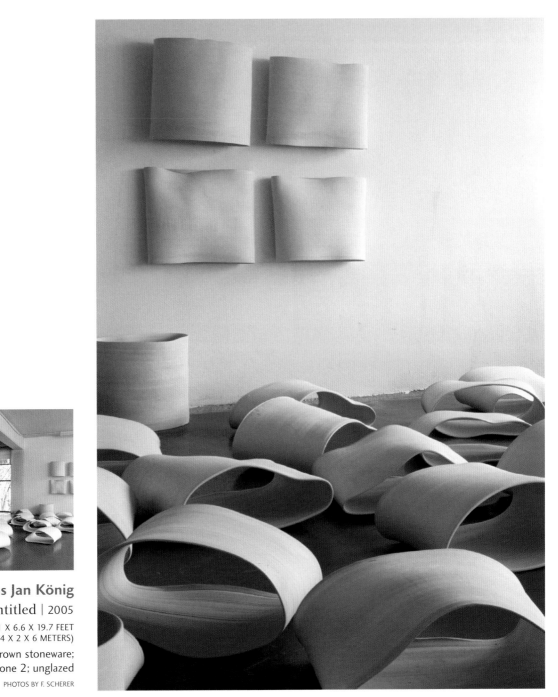

Thomas Jan König

Untitled | 2005

13.1 X 6.6 X 19.7 FEET
(4 X 2 X 6 METERS)

Wheel-thrown stoneware;
electric fired, cone 2; unglazed

PHOTOS BY F. SCHERER

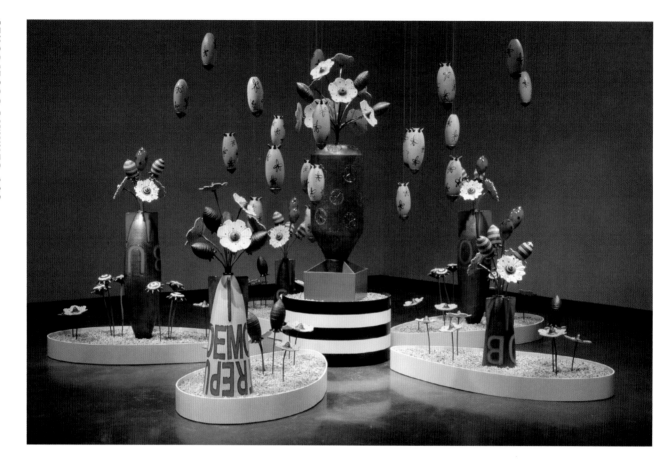

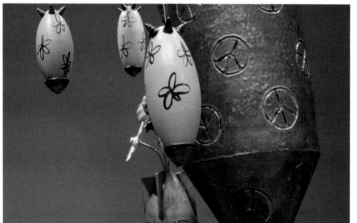

Michael Ceschiat

POWer Flower | 2008

107¾ X 191⅝ X 191⅝ INCHES
(274.3 X 487.7 X 487.7 CM)

Thrown, hand-built ceramic; reduction
fired, cone 6; oxidation fired,
cone 06, multi-fired; painted steel

PHOTOS BY ARTIST

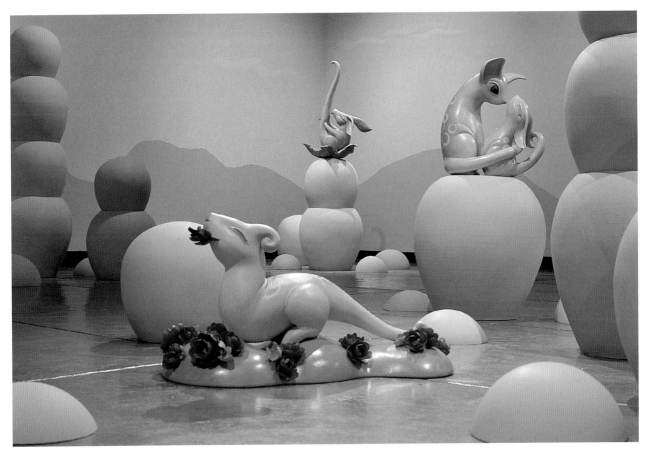

Rebekah Bogard

Perfect Day | 2006

15 X 26 X 14 INCHES
(38.1 X 66 X 35.6 CM)

Slab-constructed earthenware;
electric fired, cone 04;
underglaze, cone 04

PHOTOS BY ARTIST

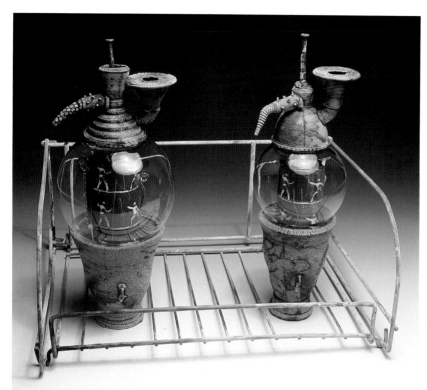

Todd Shanafelt
Binary Sectionalism | 2006
11 ¹³/₁₆ X 13 ³/₄ X 9 ¹³/₁₆ INCHES (30 X 35 X 25 CM)
Wheel-thrown earthenware; electric fired,
cone 04; silkscreen monoprint; metal, glass
PHOTO BY ARTIST

Güngör Güner
Untitled | 1999
3 ¹⁵/₁₆ X 141 ¹/₂ X 117 ⁷/₈ INCHES
(10 X 360 X 300 CM)
Hand-built stoneware and
quartz ceramic; natural gas fired,
2102°F (1150°C); ash glaze;
plastic bags filled with water
PHOTO BY ARTIST

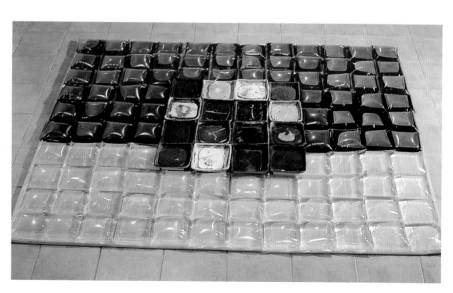

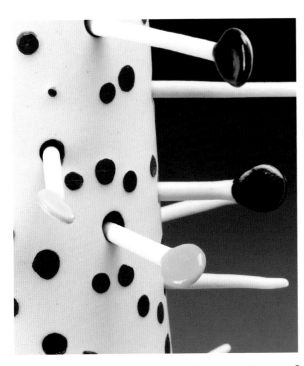

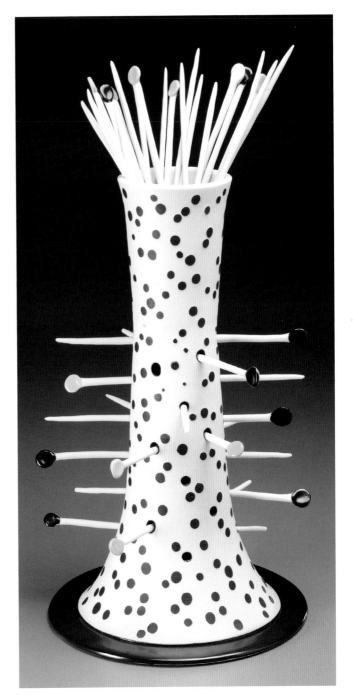

Suzanne Stumpf

Interactive Sculpture No. 9 | 2008

16 1/8 X 7 7/8 X 7 7/8 INCHES (41 X 20 X 20 CM)

Wheel-thrown porcelain with hand-built components; gas fired in reduction, cone 10; gas fired in oxidation, cone 10; black slip with shellac resist

PHOTOS BY JOHN POLAK

Roma Babuniak

Ascending | 2007

39³⁄₈ X 9¹³⁄₁₆ X ³⁄₄ INCHES
(100 X 25 X 2 CM)

Unglazed porcelain; electric
fired, cone 8; wire, Japanese
washi paper, ink, clear
plastic sheeting panels

PHOTO BY JAN BETKE

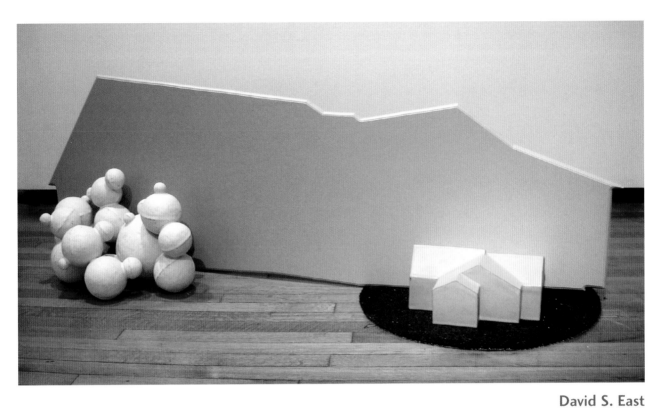

David S. East

Ideal Bio Prop | 2007

20¹/₁₆ X 62¹/₁₆ X 24 INCHES (51 X 158 X 61 CM)

Press-molded, assembled, and slab-built
earthenware; electric fired, cone 04; glazed,
cone 3; fiberboard, paint, synthetic grass

PHOTO BY ARTIST

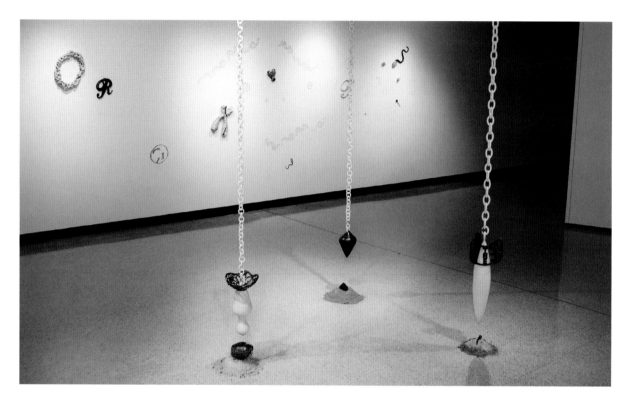

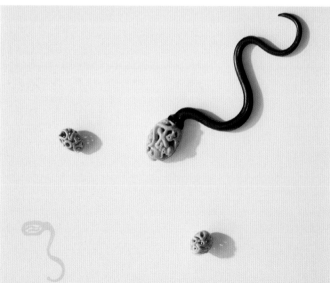

Holly Hanessian
Xx and Y Installation | 2008
20 X 15 FEET (6.1 X 4.6 METERS)
Pinched, carved, coiled, and
slab-built porcelain; electric fired,
cone 6; glazed; screen-printed
PHOTOS BY ARTIST

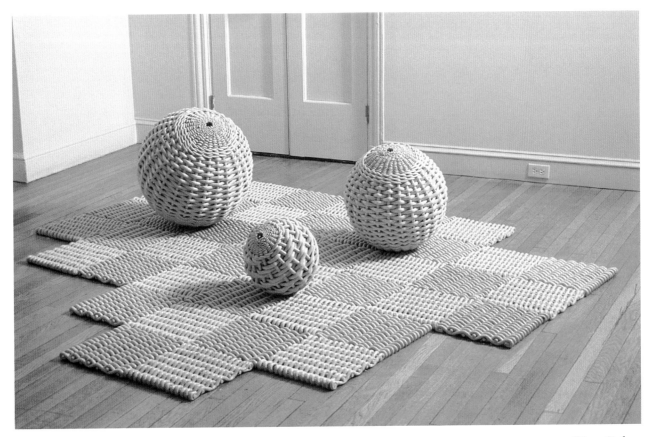

Rina Peleg

Earth Web #4 | 2004

26 X 60 X 48 INCHES
(66 X 152.4 X 121.9 CM)

Clay, woven clay; electric
fired, cone 04; crackle glaze

PHOTO BY D. JAMES DEE

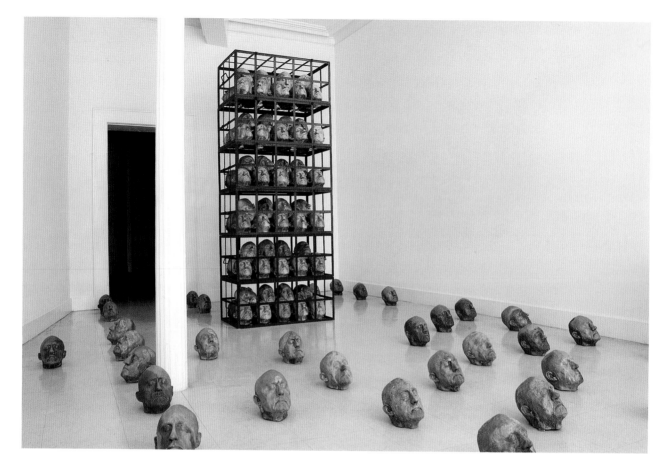

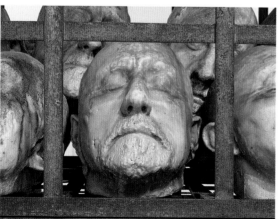

Tony Moore

Who Knows Why? | 2006

VARIOUS DIMENSIONS

Body-cast heads, press-molded architectural stoneware clay; wood fired, cone 12; steel, barium blue matte glaze

PHOTOS BY ARTIST

Sarah Britten-Jones

Your Life in Motion: Geriatric Miniatures | 2007

EACH, 2 15/16 X 2 3/8 X 1 9/16 INCHES (7.5 X 6 X 4 CM)

Hand-built porcelain; electric fired, cone 6

PHOTOS BY ARTIST

Rachel Menashe-Dor

Communication | 2003

71 1/2 X 107 11/16 X 65 5/8 INCHES
(182 X 274 X 167 CM)

Slip-trailed porcelain;
gas fired, cone 10

PHOTOS BY ARTIST

Forrest Snyder

A Lot of Work | 2004

EACH, 2 15/16 X 5 7/8 X 2 9/16 INCHES
(7.5 X 15 X 6.5 CM)

Slip-cast sheets, hand-cut
porcelain; electric fired, cone 7;
toner, transfer, wood

PHOTOS BY ARTIST

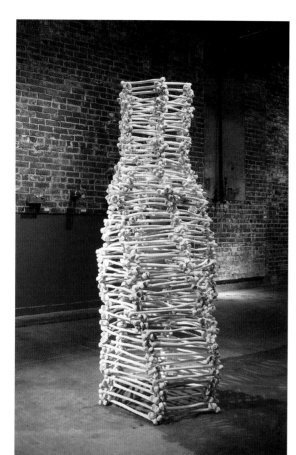

Ianna Nova Frisby

Unit(e) | 2005

84 X 36 X 36 INCHES
(213.4 X 91.4 X 91.4 CM)

Hand-pulled porcelain;
electric fired, cone 5

PHOTO BY JOHN HARGREAVES

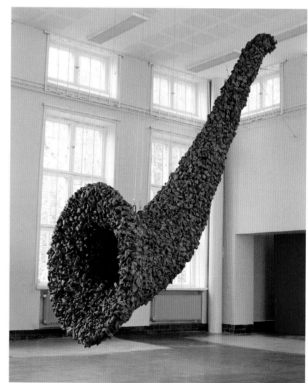

Pekka Paikkari

Scream | 2006

HEIGHT, 157¹/₂ INCHES (4 METERS)

Clay; oxidation fired, 2300°F
(1260°C); second firing with lithium
glaze, 1832°F (1000°C); steel frame

PHOTO BY TIMO KAUPPILA

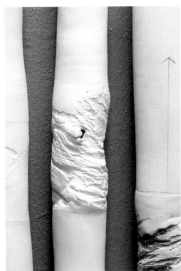

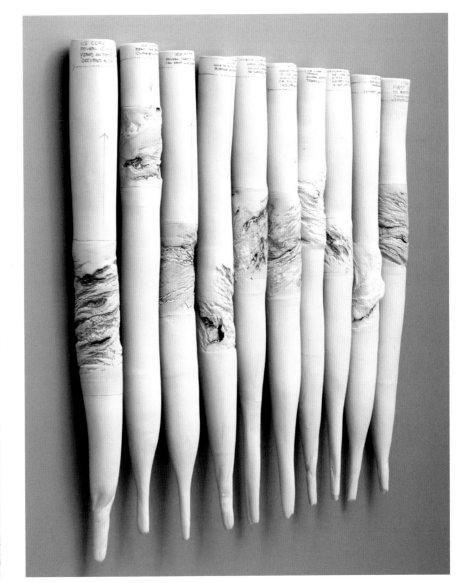

Paula Winokur

Ice Cores | 2005

EACH, 3 1/8 INCHES (8 CM) IN DIAMETER

Constructed porcelain; reduction fired,
cone 10; unglazed; stains, ceramic pencil

PHOTOS BY ARTIST

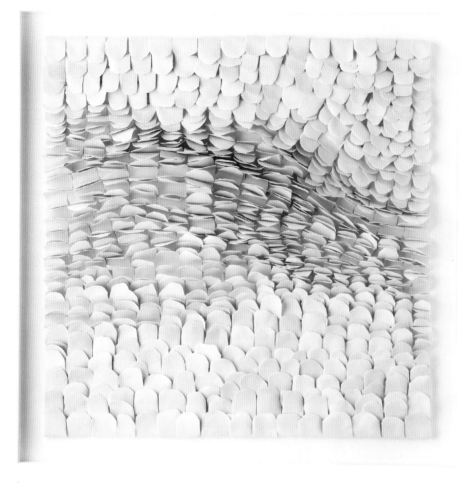

Jeanne Opgenhaffen

A Breeze Blows Over It | 2008

43 5/16 X 43 5/16 X 4 11/16 INCHES
(110 X 110 X 12 CM)

Porcelain; electric fired, cone 8

PHOTOS BY STEFAAN VAN HUL

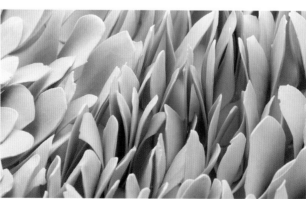

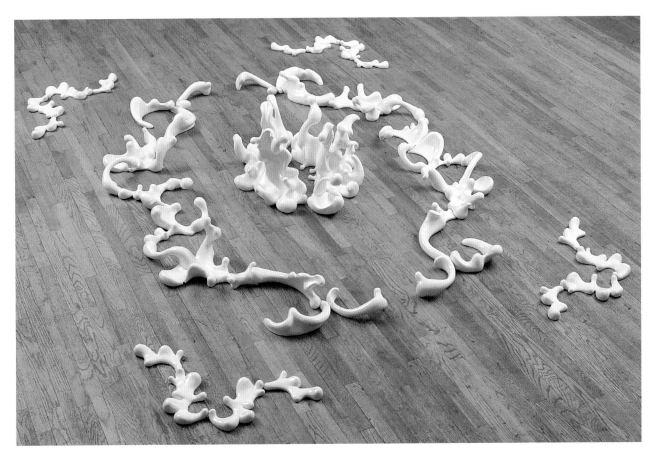

Tsehai Johnson

Exploding Carpet | 2007

26 X 93⅛ X 114 INCHES
(66 X 237 X 290 CM)

Slip-cast porcelain; electric
fired, cone 6; glazed

PHOTOS BY WES MAGYAR

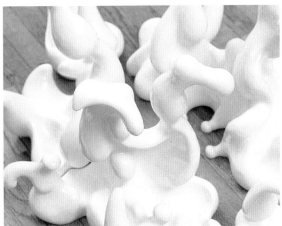

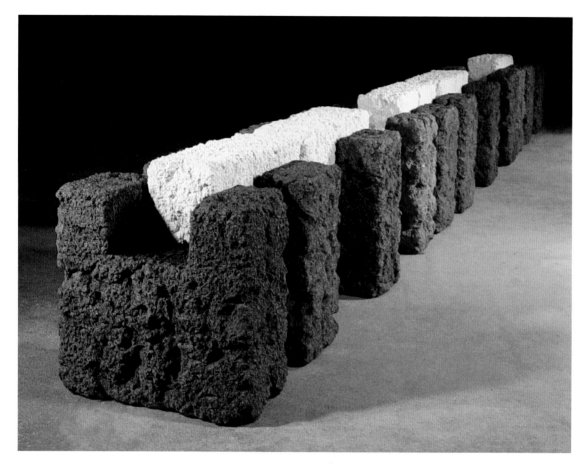

Brian Harper

New Myth Series: Boundary | 2006

26 X 21 1/4 X 263 5/16 INCHES (66 X 54 X 670 CM)

Carved solid porcelain; reduction fired, cone 10;
carved solid earthenware; reduction fired, cone 4

PHOTOS BY ARTIST

Nina Hole

Islote | 2007

117⁷/₈ X 157³/₁₆ X 47¹/₈ INCHES
(300 X 400 X 120 CM)

Terra sigillatas; wood fired

PHOTOS BY ARTIST

Adriana Hartley
Generation | 2007
23 X 23 FEET (7 X 7 METERS)
Slip-cast porcelain, molochite
PHOTOS BY ARTIST

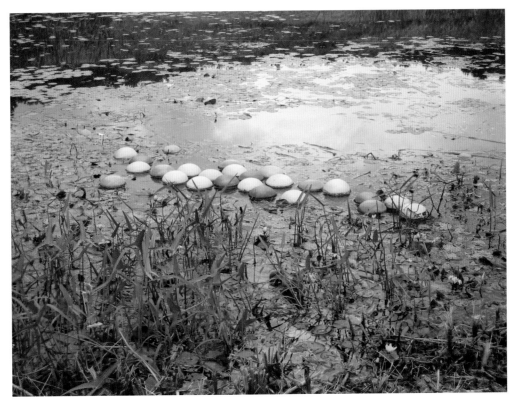

Sara Mills
At Large | 2005
58 15/16 X 7 7/16 INCHES (150 X 19 CM)
Thrown stoneware; oil fired
in reduction, cone 10; glazed
PHOTO BY ARTIST

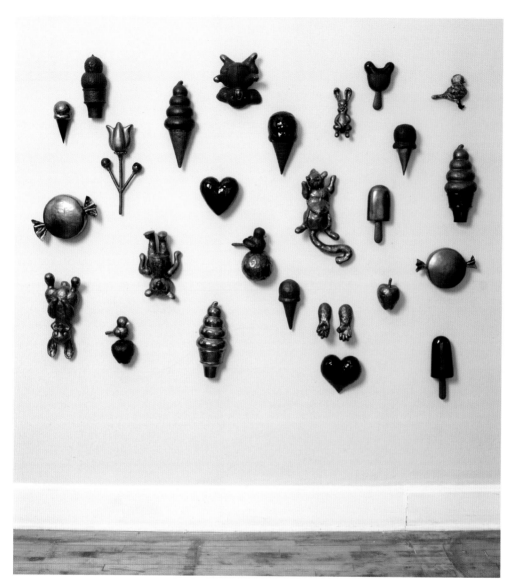

Michaelene Walsh
Elegy | 2006
96 X 96 X 5 INCHES
(243.8 X 243.8 X 12.7 CM)
Slip-cast and hand-built
earthenware; electric fired,
cone 05; glaze, epoxy
PHOTO BY ARTIST

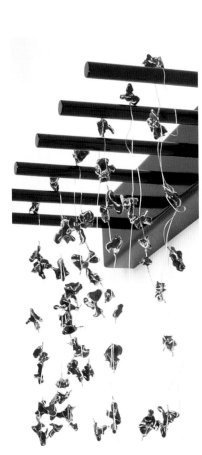

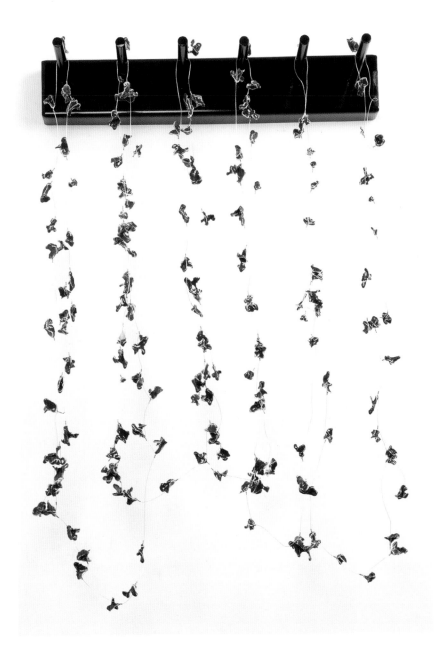

Vincent Burke

Prufrock #6 | 2002

71 7/8 X 35 13/16 X 24 INCHES
(183 X 91 X 61 CM)

Porcelain; reduction fired,
cone 10; painted steel, wire

PHOTOS BY MARTY SNORTUM

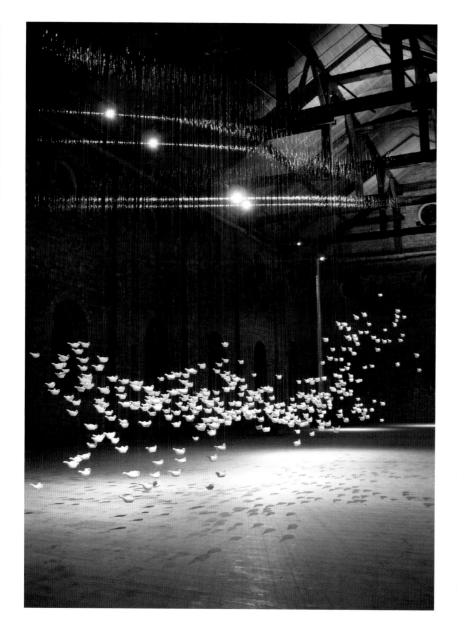

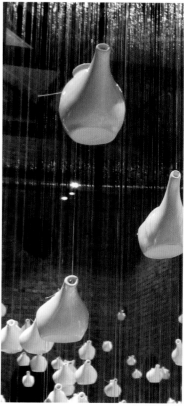

Denise Pelletier
Vapours | 2005
23 X 36 X 75 1/2 FEET (7 X 11 X 23 METERS)
Cast industrial china clay, monofilament
PHOTOS BY ARTIST

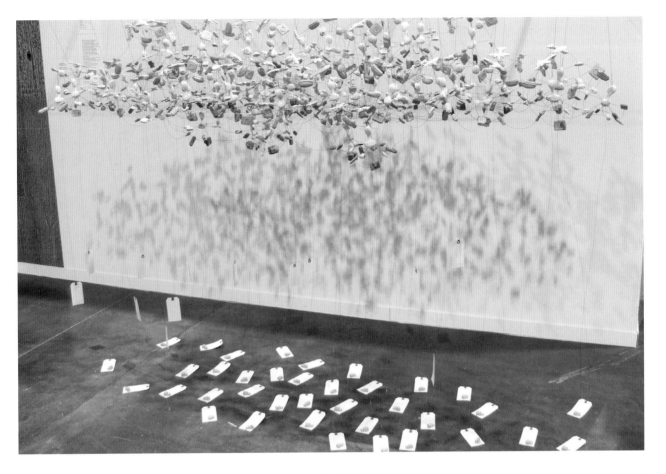

Casey McDonough

Network Study: MySpace/Facebook | 2007

10 X 10 X 4 FEET
(3.1 X 3.1 X 1.2 METERS)

Ceramic and mixed media

PHOTOS BY ARTIST

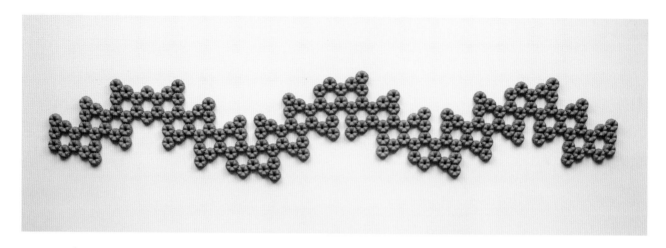

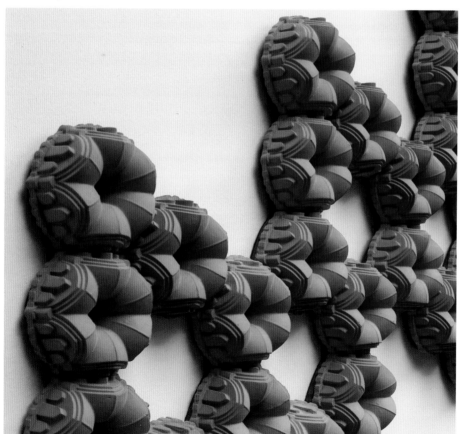

Nicholas Kripal

W.S. Variation No. 5 | 2008

27 15/16 X 148 15/16 X 1 15/16 INCHES
(71 X 379 X 5 CM)

Slip-cast terra cotta

PHOTOS BY JOHN CARLANO

Jeffrey Mongrain

The Philosopher's Halo | 2005

32 X 32 X 8 INCHES (81.3 X 81.3 X 20.3 CM)

Wheel-thrown white stoneware; electric
fired, cone 1; clay, optical lens, gold leaf

PHOTO BY JON CARLONO

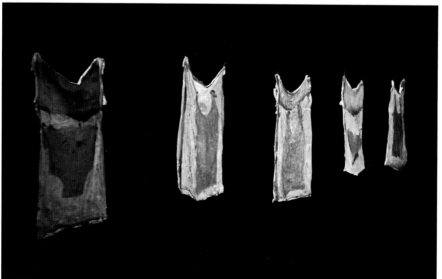

Kris Coad

Washing Day | 2007

EACH, 15 3/4 X 9 13/16 X 3 15/16 INCHES
(40 X 25 X 10 CM)

Bone china and translucent porcelain;
electric fired, 2336°F (1280°C)

PHOTOS BY ARTIST

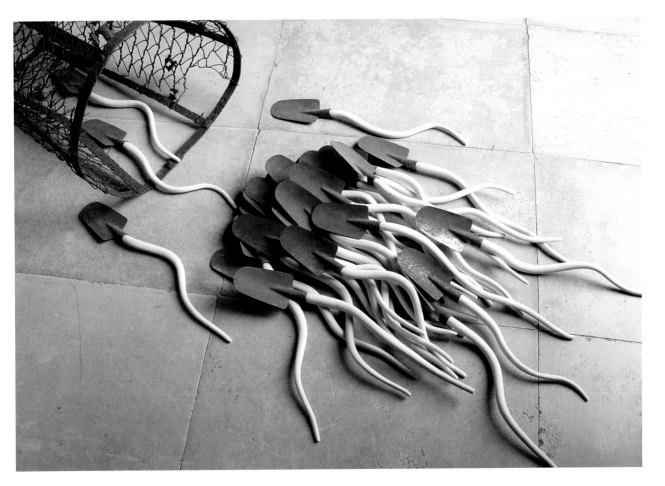

Gabriele Pütz
Untitled | 2001
VARIOUS SIZES
Ceramic; electric fired,
1940°F (1060°C); iron
PHOTOS BY ARTIST

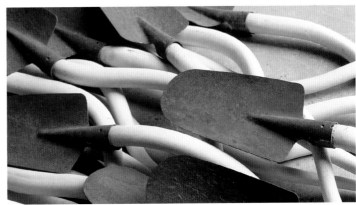

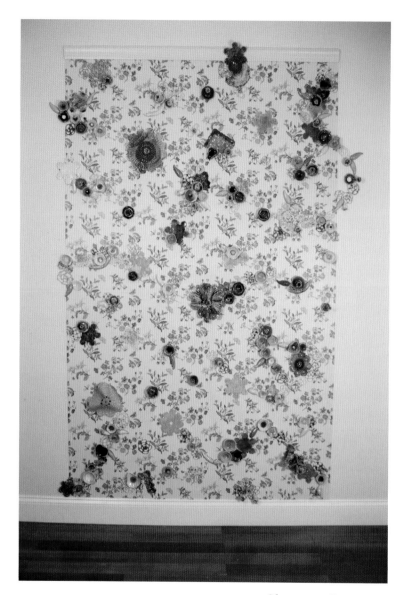

Shannon Donovan

Exuberance is Better Than Taste | 2007

95⁷⁄₈ X 48⁵⁄₁₆ INCHES (244 X 123 CM)

Wheel-thrown, press-molded, slip-trailed, and
slip-cast porcelain; glazed, cone 6; wallpaper

PHOTO BY ARTIST

Muller –B–
Pairings | 2000
EACH, 125¼ X 78⁹/₁₆ X ³/₈ INCHES
(320 X 200 X 1 CM)
Liquid terra cotta; gas fired,
cone 03a; silicone, wood, foam

PHOTO BY ARTIST

Neil Forrest

Hiving Mesh | 2000–2002

117⁷/₈ X 235³/₄ X 35⁷/₁₆ INCHES
(300 X 600 X 90 CM)

Press-molded, slip-cast, and hand-built porcelain; electric fired, cone 6; inlaid, cone 010; Egyptian faience, stainless steel wire and fittings

PHOTOS BY DAN WAYNE

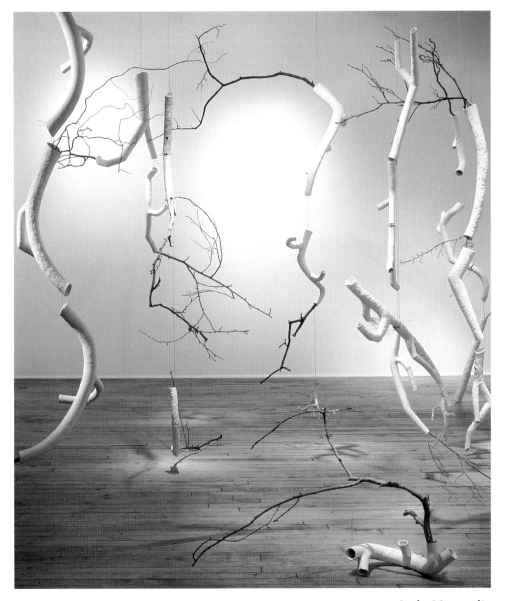

Judy Moonelis
Branched Matrice | 2004–2007

150 X 240 X 180 INCHES (381 X 609.6 X 457.2 CM)

Hand-built clay; electric fired, cone 2; branches, wire

PHOTO BY ARTIST

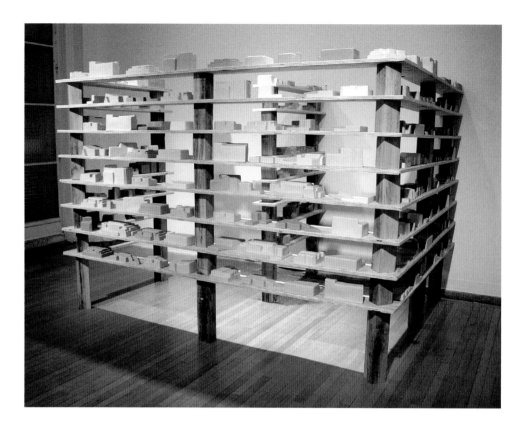

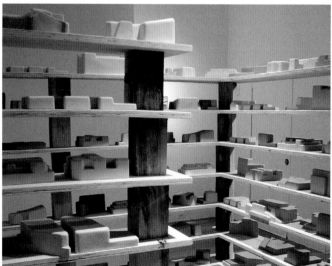

Dylan J. Beck
Road to Nowhere | 2006
71 7/8 X 95 7/8 X 79 3/4 INCHES
(183 X 244 X 203 CM)
Slip-cast porcelain;
electric fired, cone 6; wood
PHOTOS BY ARTIST

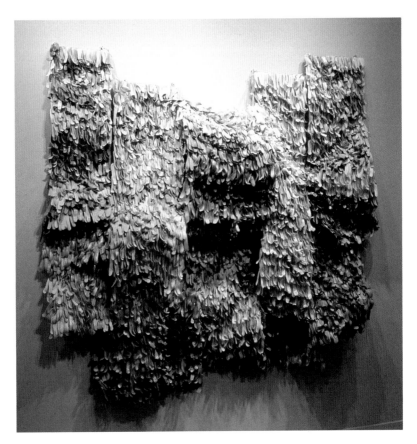

Myung Jin Choi

Déjà Vu II | 2004

50³/₄ X 48¹³/₁₆ X 11¹³/₁₆ INCHES
(129 X 124 X 30 CM)

Cast-slip and hand-built porcelain;
electric fired in oxidation, cone 8;
commercial stain, mixed media

PHOTOS BY ARTIST

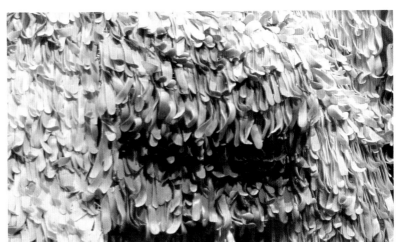

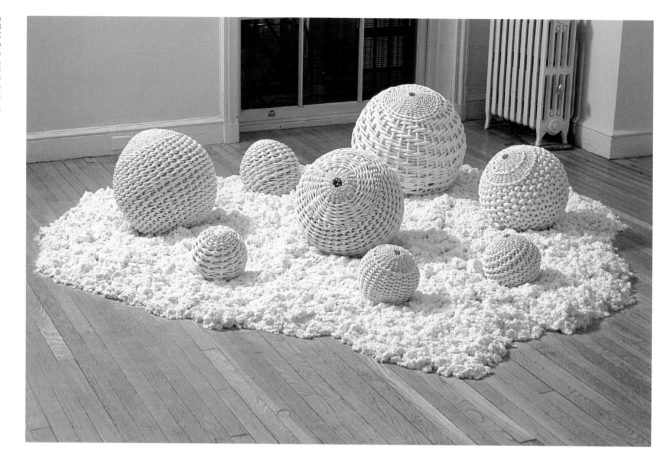

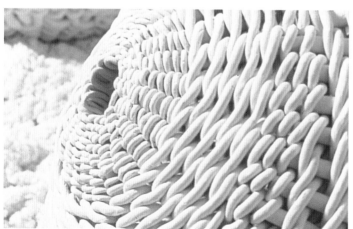

Rina Peleg

Raw Earth | 2004

26 X 84 X 108 INCHES
(66 X 213.4 X 274.3 CM)

Clay, woven clay, papier-mâché;
electric fired, cone 04; unglazed

PHOTOS BY D. JAMES DEE

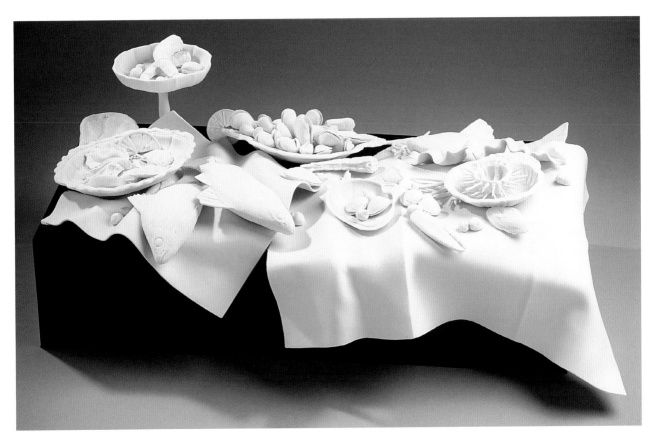

Susan Schultz

Fruits de la Mer | 2008

10 X 26 X 15 INCHES
(25.4 X 66 X 38 CM)

Hand-formed, sculpted, carved,
and press-molded porcelain
paper clay; electric fired,
cone 6; unglazed; wood base

PHOTOS BY DEAN POWELL

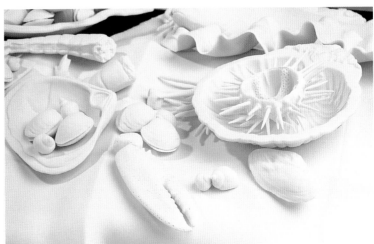

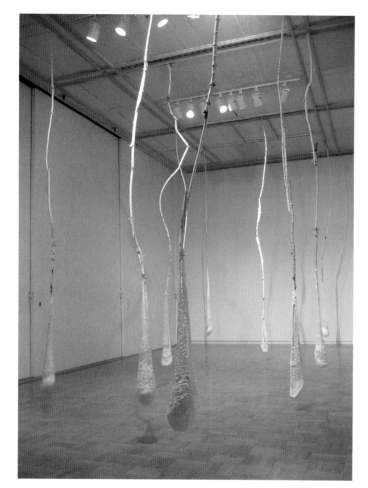

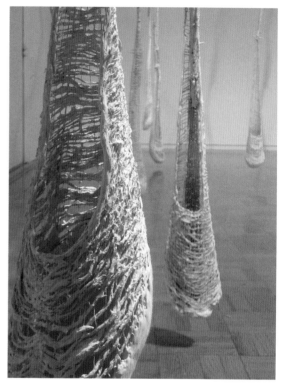

Rebecca Hutchinson
WSU Pullman Installation | 2005
39 X 18 FEET (11.9 X 5.5 METERS)
Porcelain paper clay, organic
material, woven, unfired adobe

PHOTOS BY ARTIST

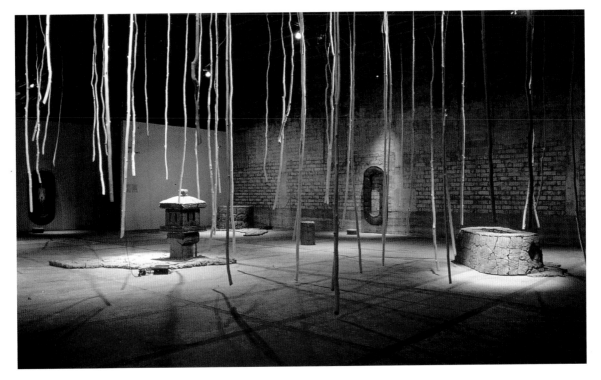

Bill Gilbert

The Kiss | 1999

236¹/₄ X 393³/₄ X 590¹/₂ INCHES
(6 X 10 X 15 METERS)

Adobe soil, peeled aspen
trees; gas fired, cone 7; video

PHOTOS BY ARTIST

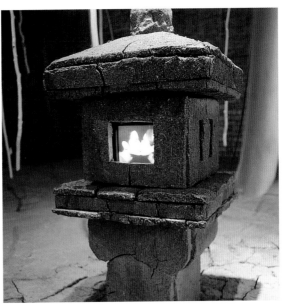

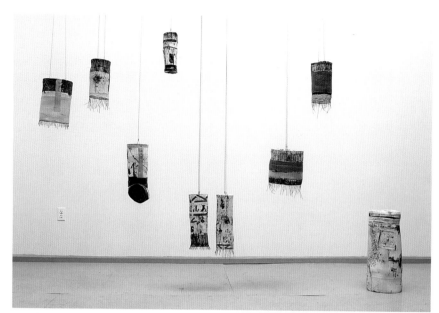

Mia Fernandes

Wish | 2005–2007

98 1/4 X 265 1/4 X 19 11/16 INCHES
(250 X 675 X 50 CM)

Hand-built porcelain; electric fired,
2300°F (1260°C); cobalt drawing

PHOTO BY CLARE BOURKE

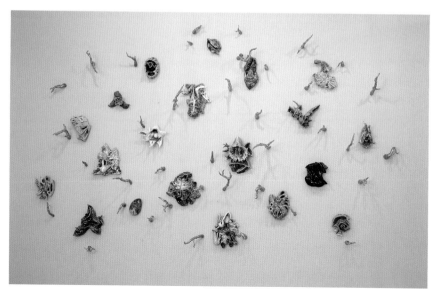

Julia Whitney Barnes

Orchid-Bat (Tree of Life) | 2006

119 1/2 X 167 3/8 X 11 13/16 INCHES
(304 X 426 X 30 CM)

Hand-built earthenware; electric
fired, cone 04; glazed, cone 06;
gold luster, cone 019

PHOTO BY ARTIST

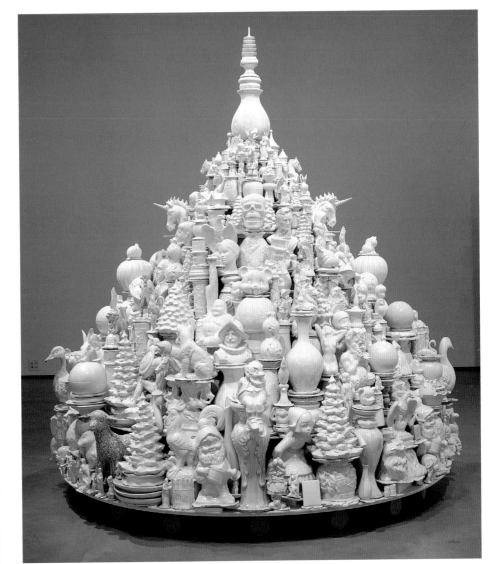

Walter McConnell

A Theory of Everything | 2006

10 X 9 X 9 FEET (3.1 X 2.7 X 2.7 METERS)

Cast porcelain figurines, pottery,
knickknacks from commercial molds,
plywood shelving, zinc crystalline glaze

PHOTOS BY ARTIST

Myung Jin Choi

Relative Time IV | 2004

84⁷/₈ X 33¹/₁₆ X 33¹/₁₆ INCHES
(216 X 84 X 84 CM)

Slip-cast porcelain, colored
clay; oxidation fired, cone 10;
commercial stains

PHOTOS BY ARTIST

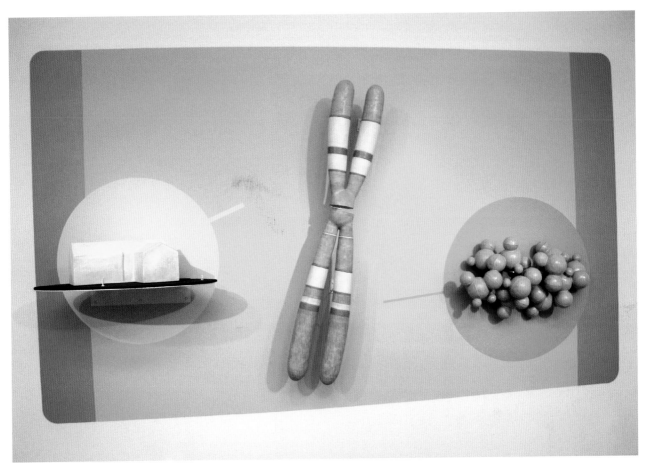

David S. East

Suburban Biochemical Transcription | 2006

83 11/16 X 143 13/16 X 24 INCHES (213 X 366 X 61 CM)

Press-molded, assembled, slab- and coil-built earthenware;
electric fired, cone 04; glazed, cone 3; synthetic grass, steel,
painted backgrounds, and plastic figures

PHOTOS BY ARTIST

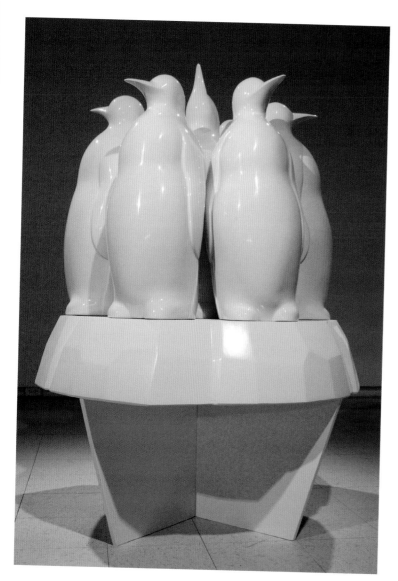

Timothy John Berg

Tip of the Iceberg | 2007

61 ¹¹/₁₆ X 44⁷/₈ X 44⁷/₈ INCHES (157 X 114 X 114 CM)

Slip-cast and sculpted stoneware; gas fired, cone 1; auto body paint, wood, polystyrene foam, cement, polyester resin, spray paint

PHOTOS BY ARTIST

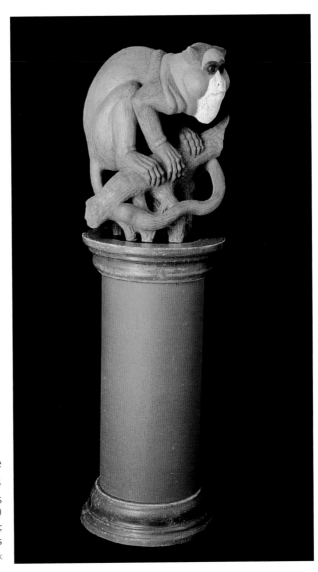

Claudia Reese

Isabella | 2004

64 13/16 X 18 7/8 X 18 7/8 INCHES
(165 X 48 X 48 CM)

Pinched and coiled stoneware;
electric fired, cone 4; low-fire slips

PHOTO BY RICK PATRICK

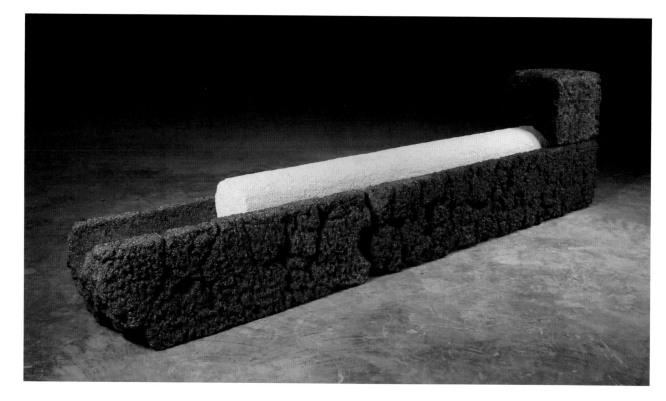

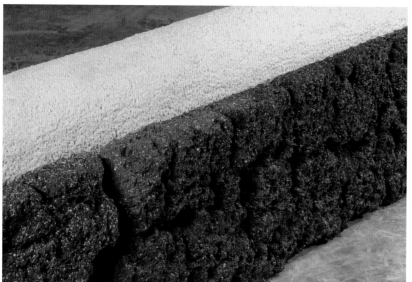

Brian Harper

New Myth Series: The Rod | 2007

21 ¼ X 11 X 68 INCHES (54 X 28 X 173 CM)

Carved solid earthenware; reduction fired, cone 5; carved limestone

PHOTOS BY ARTIST

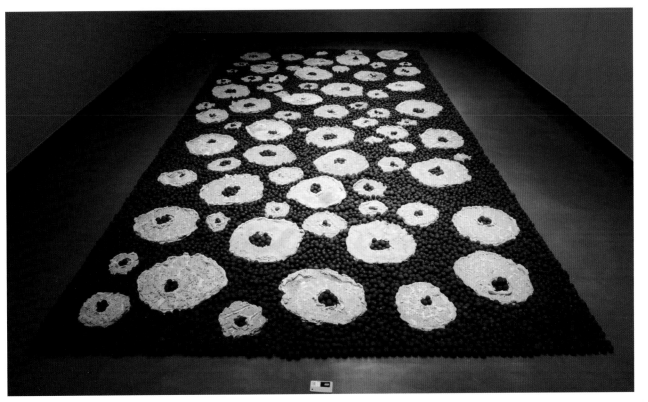

Steve Hilton
Untitled | 2008
3 5/16 X 96 1/16 X 191 3/4 INCHES (10 X 244 X 488 CM)
Stoneware, hand-rolled marbles; electric fired,
cone 04; stained; sand cast glaze, cone 04
PHOTO BY BRIAN DONALDSON

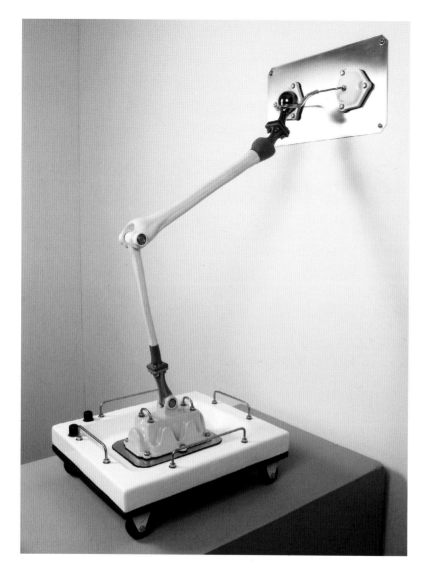

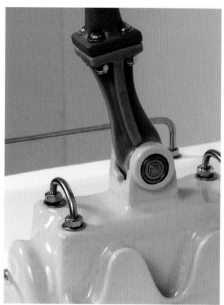

Bryan Czibesz

Realization 3000: An Articulator | 2007

44 1/16 X 11 13/16 X 29 15/16 INCHES (112 X 30 X 76 CM)

Hand-built and extruded porcelain; oxidation fired, cone
10; unglazed; hand-built and slip-cast earthenware;
electric fired, cone 03; glazed, cones 05, 06; stainless
steel, industrial bearings, vinyl, rubber, wood

PHOTOS BY ARTIST

Rina Peleg
American Flag | 2001
4 X 60 X 120 INCHES (10.2 X 152.4 X 304.8 CM)
Clay, woven tiles; electric fired, cone 04; glazed

PHOTO BY D. JAMES DEE

David Packer

Flower Power | 2006

15³/₄ X 58¹⁵/₁₆ X 47¹/₄ INCHES
(40 X 150 X 120 CM)

Hand-built earthenware; electric
fired, cone 04; additional parts,
aluminum, acrylic paint, graphite

PHOTO BY KEVIN NOBLE

Roma Babuniak

Floating | 2007

39 X 10 X ¹³/₁₆ INCHES (100 X 25 X 2 CM)

Unglazed porcelain; electric fired,
cone 7; sgrafitto; wire, Japanese washi
paper, ink, clear plastic sheeting panels

PHOTO BY JAN BETKE

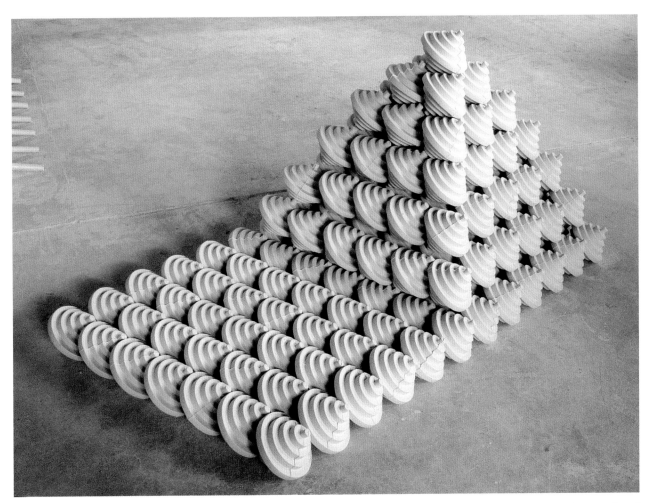

Roderick Bamford

Insensible Order | 1989

39⅜ X 39⅜ X 78⁹⁄₁₆ INCHES
(100 X 100 X 200 CM)

Assembled slip-cast vitreous china

PHOTO BY ARTIST

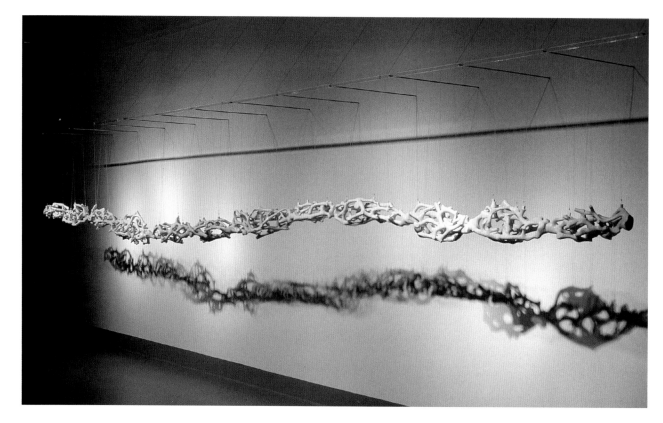

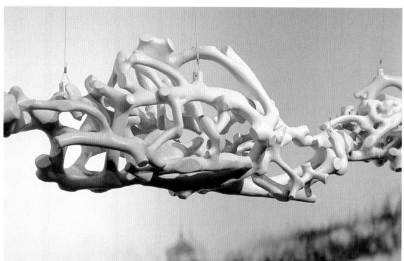

Neil Forrest

Scaff | 2004

125 1/4 X 283 X 31 1/2 INCHES
(320 X 720 X 80 CM)

Ram-pressed, assembled, and
glazed porcelain; electric
fired, cone 6; magnets, acrylic
rod, steel cable, wood

PHOTOS BY ARTIST

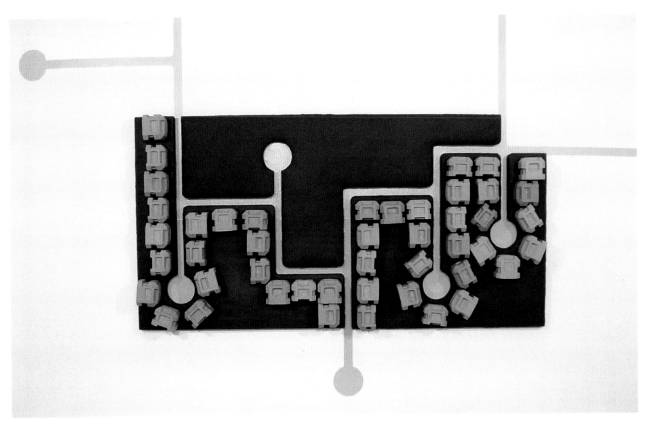

Dylan J. Beck

Privatopia | 2006

95⁷/₈ X 179⁹/₁₆ X 79³/₄ INCHES
(244 X 457 X 203 CM)

Slip-cast porcelain;
gas fired, cone 10;
upholstered wood, paint

PHOTOS BY ARTIST

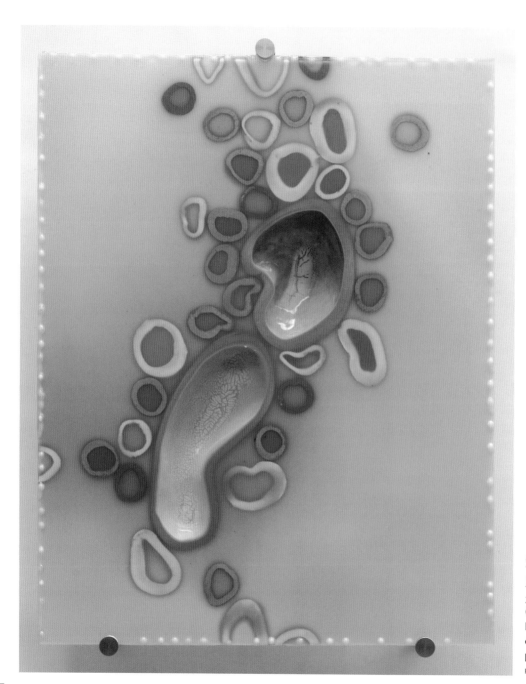

Shannon Sullivan

Hybrid Bound | 2007

25 X 20 X 3 INCHES
(63.5 X 50.8 X 7.6 CM)

Low-fire ceramic, resin,
clear plastic sheeting;
post-fire assembly

PHOTO BY MARSHALL L'HERAULT

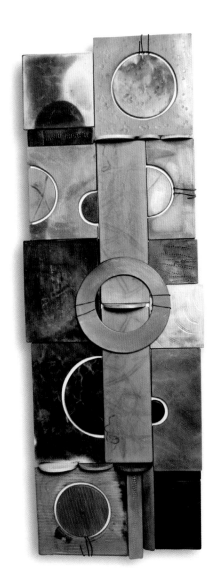
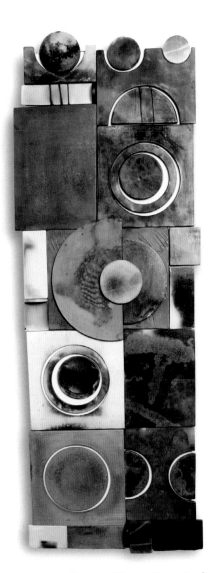

Susan Elena Esquivel

Lunar Scrolls | 2008

EACH, 42 X 14 X 4 INCHES
(106.7 X 5.5 X 1.6 CM)

Hand-built porcelain;
saggar fired, cone 1

PHOTO BY ARTIST

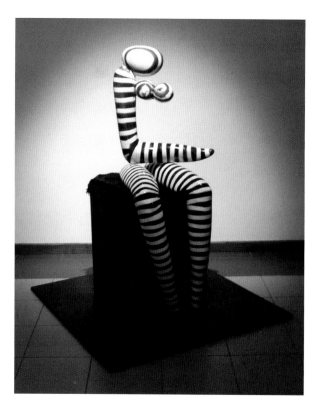

Alejandrina Cappadoro
Las Señoritas de San Nicolas | 2007

55 1/8 X 31 1/2 X 23 5/8 INCHES (140 X 80 X 60 CM)

Hand-made modeling clay; electric fired, 1976°F (1080°C); glazed; enameled with underglazes and glazes

PHOTO BY ARTIST

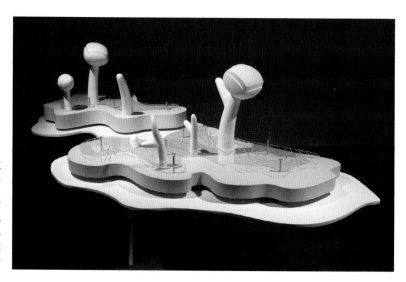

Alex Hibbitt
Souvenir of Louisiana #6 | 2007

40 15/16 X 46 1/16 X 31 7/8 INCHES (104 X 117 X 81 CM)

Slip-cast porcelain; electric fired, cone 4; wood, clear plastic sheeting, steel, aluminum, paint, light

PHOTO BY STEVE PASZT

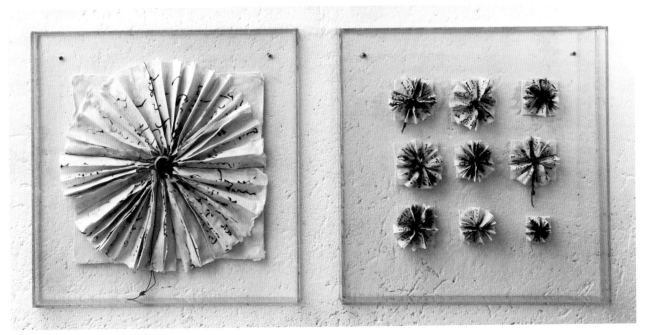

Margrieta Jeltema
Folded Love Letters | 2007
15³/₄ X 15³/₄ INCHES (40 X 40 CM)
Hand-built Southern Ice porcelain;
electric fired, 1922°F (1050°C);
Chinese glaze, 2300°F (1260°C)
PHOTOS BY ARTIST

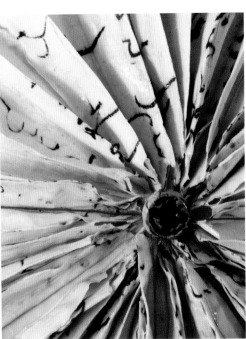

Piet Stockmans

Administration Building—
De Ryp, Netherlands | 2004

$^3/_8$ X 15$^3/_4$ X 117$^7/_8$ INCHES (1 X 40 X 300 CM)

Porcelain; gas fired; unglazed

PHOTOS BY ARTIST

Yuki Nakamura

Dream | 2005

131 5/8 X 83 11/16 X 71 7/8 INCHES
(335 X 213 X 183 CM)

Cast porcelain; electric fired, cone 6

PHOTO BY ARTIST

Jess Benjamin

38-State Battle | 2008

32 X 32 X 79 13/16 INCHES
(81.3 X 274.3 X 203.2 CM)

Slab-built stoneware;
salt fired, cone 6

PHOTO BY KEITH MEISER

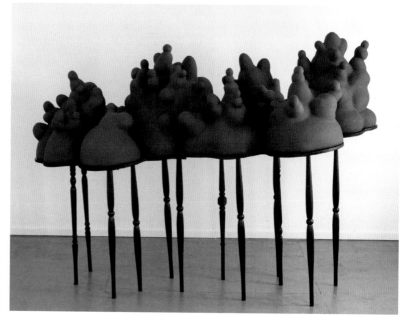

Jennifer Forsberg

In the Middle | 2007

55⅛ X 78⁹/₁₆ X 39⅜ INCHES (140 X 200 X 100 CM)

Hand-built and coiled stoneware; electric
fired, cone 6; wooden table, wooden legs

PHOTO BY GERT GERMERAAD

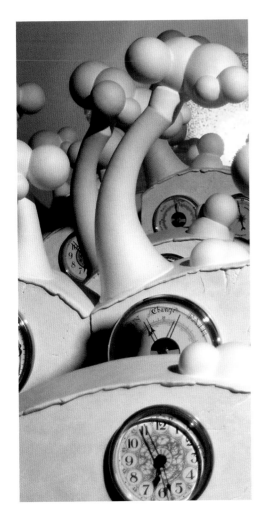

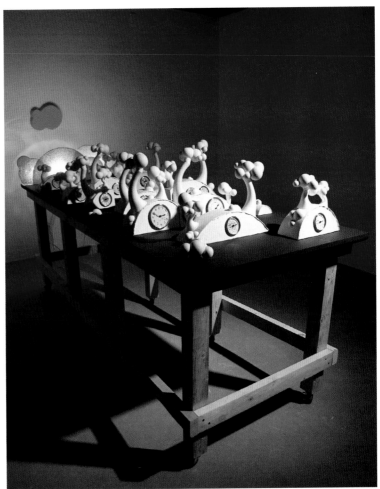

Joseph Page

Clock Table | 2006

51 ³⁄₁₆ X 39 ³⁄₈ X 95 ¹⁄₁₆ INCHES (130 X 100 X 242 CM)

Slip-cast and press-molded porcelain; terra sigillata; electric fired, cone 8; wood, clock hardware

PHOTOS BY ARTIST

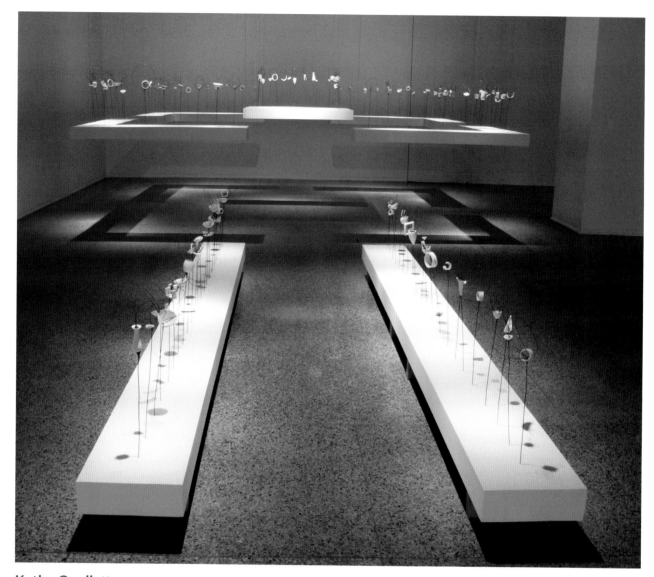

Kathy Ouellette

Jardin Français: Ordre et Desordre | 2007

46$^{7}/_{16}$ X 156 X 323$^{13}/_{16}$ INCHES (118 X 397 X 824 CM)

Hand-built, thrown, and extruded paper porcelain;
electric fired, cone 6; unglazed; metal wire, wood

PHOTO BY ARTIST

Elizabeth MacDonald

Markings | 2005

21 X 21 X 1¹/₂ INCHES (53.3 X 53.3 X 3.8 CM)

Stoneware with porcelain; gas fired,
cone 10; pressed, electric fired, cone 6

PHOTO BY NATHANIEL CARDONSKY

E. Elizabeth Peters
Gilded Age (Installation) | 2007
VARIOUS DIMENSIONS
Slip-cast porcelain; reduction and electric fired, cones 6 and 10; glazed; soda fired, cone 10; atmospheric glaze; unfired clay, wood, clear plastic sheeting, steel

PHOTOS BY CHRIS KENDALL

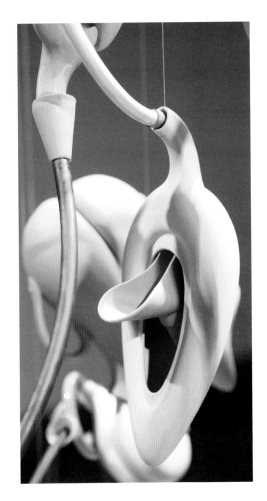

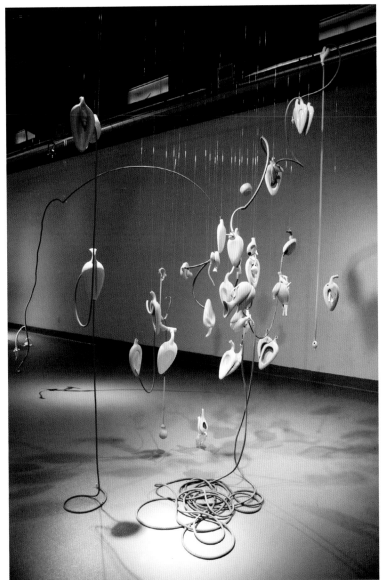

Denise Pelletier
Purgaré | 2006
HEIGHT, 32³/₄ FEET (10 METERS)
Cast porcelain, decals, copper, rubber
PHOTOS BY MARTY SNORTUM

Pekka Paikkari

Bath | 2006

HEIGHT, 31 ¹/₂ INCHES (80 CM)

Thrown ceramic bowls; saggar fired with sawdust, 2300°F (1260°C); water, concrete

PHOTOS BY TIMO KAUPPILA

Jason Lim

Just Dharma | 2007

176¹³⁄₁₆ X 59¹⁄₁₆ X 39³⁄₈ INCHES
(450 X 150 X 100 CM)

Hand-built and assembled
porcelain; electric fired, cone 5

Julianne Harvey

The Pit | 2006

2 X 4 X 2 FEET (0.6 X 1.2 X 0.6 METERS)

Hand-built porcelain; electric fired, cone 10; underglaze, glaze; paint, cast bronze, wood, metal, feathers

PHOTOS BY ARTIST

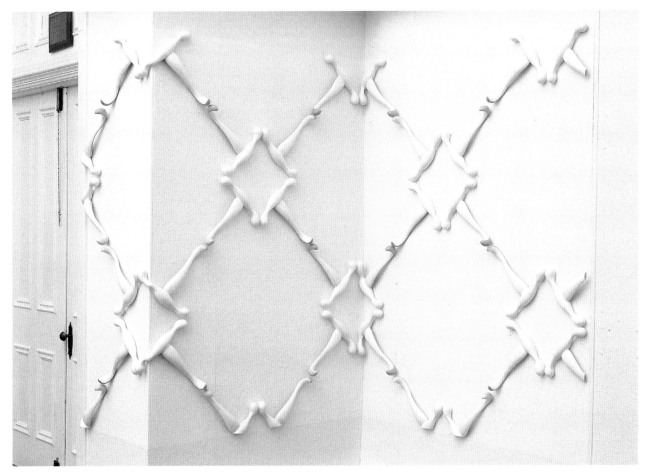

Tsehai Johnson
Field # 10 | 2007

62 $^1/_{16}$ X 114 X 1$^3/_4$ INCHES
(158 X 290 X 4.5 CM)

Slip-cast porcelain; electric
fired, cone 8; glazed

PHOTO BY WES MAGYAR

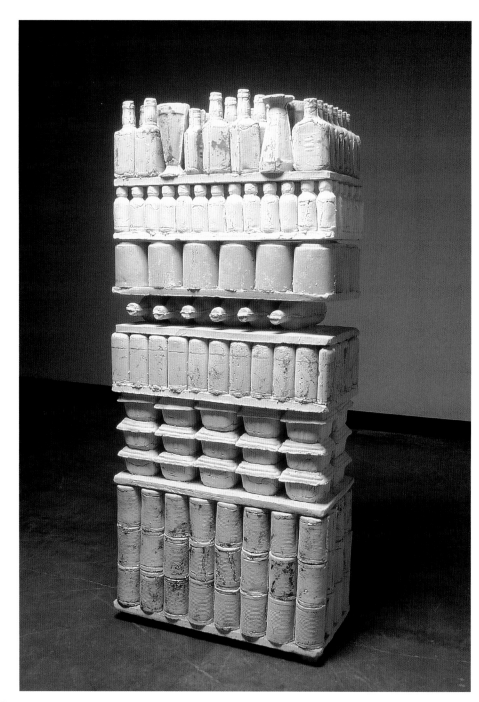

Jennifer Rogers
Accumulation | 2006
54 X 23 X 11 INCHES
(137.2 X 58.4 X 27.9 CM)
Press-molded earthenware;
electric fired, cone 04; assembled
PHOTO BY ARTIST

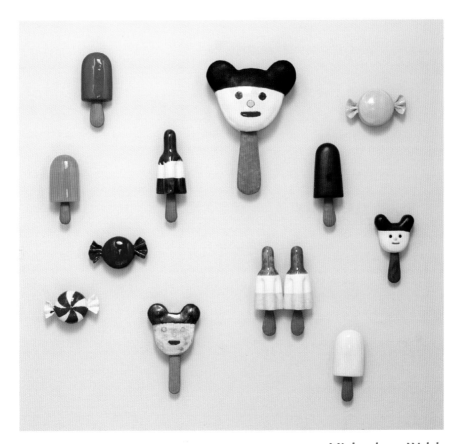

Michaelene Walsh

Bittersweet | 2006

72 X 72 X 4 INCHES (182.9 X 182.9 X 10.2 CM)

Slip-cast and hand-built earthenware; electric fired, cone 05; terra sigillata, wax, epoxy

PHOTO BY ARTIST

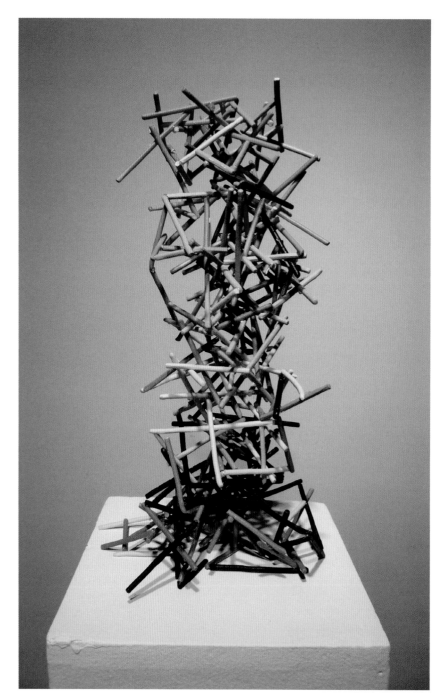

Hiroyuki Someya
Untitled | 2008
18 1/2 X 9 X 9 INCHES
(47 X 22.9 X 22.9 CM)
Extruded stoneware;
electric fired, cone 04
PHOTO BY ARTIST

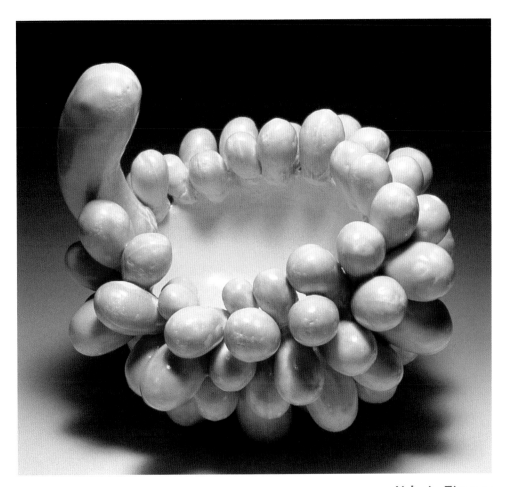

Valerie Zimany
Collocate | 2005

10¹/₄ X 11 ¹³/₁₆ X 9⁷/₁₆ INCHES
(26 X 30 X 24 CM)

Slip-cast and press-molded
porcelain; electric
fired, cone 9; glazes

PHOTO BY ARTIST

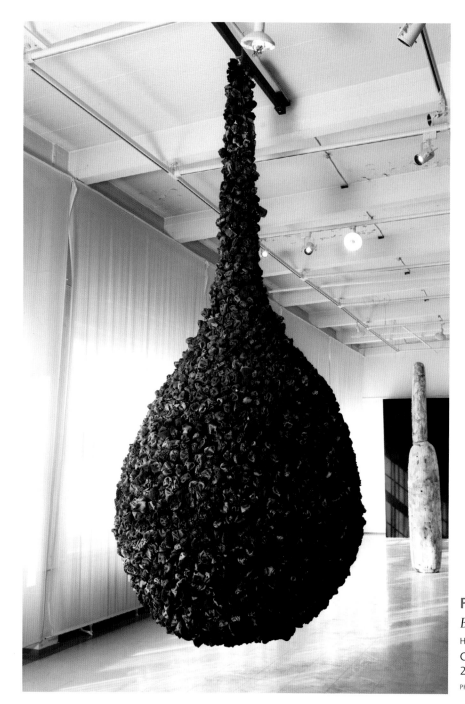

Pekka Paikkari

Black Tear | 2005

HEIGHT, 157½ INCHES (4 METERS)

Clay; saggar fired with sawdust,
2300°F (1260°C); steel frame

PHOTO BY TIMO KAUPPILA

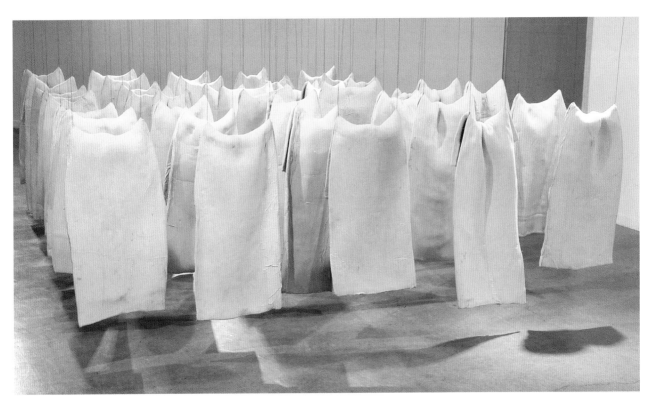

Anne Cofer

Untitled | 2005

41 5/16 X 165 X 176 13/16 INCHES
(105 X 420 X 450 CM)

Unfired clay, muslin

PHOTOS BY ARTIST

Timothy John Berg

*Apples Taste Sweetest When
They Are Going* | 2006

33⁷/₈ X 22¹/₁₆ X 9¹³/₁₆ INCHES (86 X 56 X 25 CM)

Slip-cast earthenware; electric fired,
cone 04; glazed, cone 06; powder coated;
silicon carbide, birch veneer plywood

PHOTOS BY ARTIST

Holly Hanessian
As If | 2006
15 X 15 FEET (4.6 X 4.6 METERS)
Pinched, coiled, and slab-built porcelain;
electric fired, cone 6; grolleg terra
sigillata, cone 2, covered with encaustic
PHOTO BY ARTIST

About the Juror

Glen R. Brown is an art historian, critic, and full professor of modern and contemporary art history at Kansas State University. He holds an M.A. and a Ph.D. in Art History from Stanford University; an M.A. in Art Criticism from the State University of New York at Stony Brook; and a B.A. in Art from The Colorado College. He completed additional postgraduate studies in art history and theory at the University of Warwick and the University of Essex and recently earned a certificate in Arts Management through the University of Massachusetts, Amherst.

An elected member of the International Academy of Ceramics in Geneva and an Associate Fellow of the International Quilt Study Center at the University of Nebraska, Lincoln, Brown has dedicated much of his research to marginalized media in contemporary art. More than 40 of his essays have appeared in books and exhibition catalogs, most recently "Object Factory: The Art of Industrial Ceramics," the Gardiner Museum, Toronto. He has also authored nearly 300 articles and reviews for magazines such as *Ceramics: Art and Perception; Sculpture; Ceramics Monthly; Ceramics Technical; American Ceramics; American Craft; Ceramica; Ceramic Review; Kerameiki Techni;* and *World Sculpture News.*

In addition to ceramics criticism and theory, Brown's current interests include the relationship between contemporary art and science, particularly genetics and theoretical physics, the impact of architectural concepts and urban planning issues on contemporary sculpture, and the need for sustainability in contemporary industrial ceramic design and production.

Acknowledgments

To the hundreds of artists who submitted work for this book, I extend my sincere appreciation. A special thanks goes to juror Glen Brown, whose knowledge and patience made the selection process a pleasure. Without his discerning eye, this volume wouldn't have been possible. Thanks also goes to Lark's ceramics editor Suzanne J. E. Tourtillott, who brought her impeccable aesthetic sense to bear on every aspect of this book. I'm indebted to Dawn Dillingham for her first-class editorial support, and to Shannon Yokeley and Jeff Hamilton for their art-production expertise. Proofreader Wolf Hoelscher also provided invaluable assistance, and art director Matt Shay produced a beautiful layout. My thanks to all.

—Julie Hale, editor

Contributing Artists

Lanter, Stephanie Topeka, Kansas 150

Lauckaite-Jakimaviciene, Dalia Vilnius, Lithuania 191, 206

Lebreton, Carol Banks, Oregon 65

Leech, Todd Strongsville, Ohio 20

Leuthold, Marc Potsdam, New York 301

Levine, Cynthia Minneapolis, Minnesota 135, 197

Lewis, John Oliver San Diego, California 90

Lewis, Peter Colwyn Bay, Wales, United Kingdom 213

Lewis, Roger Bradford, West Yorkshire, England 141

Li, Hongwei Beijing, China 251, 320

Liang, Jia-Haur Sydney, New South Wales, Australia 119

Lighton, Linda Kansas City, Missouri 16

Lim, Jason Singapore 310, 405

Lotz, Tyler Bloomington, Illinois 135, 155

Lucas, Mary Alison Oakland, California 212

Lutz, Gerhard Niederalteich, Germany 48

M

MacDonald, Elizabeth Bridgewater, Connecticut 401

MacDowell, Kate Portland, Oregon 81, 259, 260

MacMillan, Firth Brooklyn, New York 314

Maeshima, Sumi Philadelphia, Pennsylvania 31

Maria, Veronique Lyminster, West Sussex, England 51

Marquis, Belinda Sandy Bay, Tasmania, Australia 139

Mattison, Steve Colwyn Bay, Wales, United Kingdom 58, 121

Mayer, Billy R. Holland, Michigan 42

Mayeri, Beverly Mill Valley, California 244

McConnell, Walter Belmont, New York 379

McDonough, Casey Allentown, Pennsylvania 363

Menashe-Dor, Rachel Providence, Rhode Island 350

Millard, Casey Riordan Cincinnati, Ohio 202

Mills, Jen Seattle, Washington 90

Mills, Sara Pigeon Hill, Quebec, Canada 359

Ming, Bai Beijing, China 39, 284

Minn, Sewon Seoul, South Korea 26

Mongrain, Jeffrey New York, New York 312, 338, 365

Moonelis, Judy New York, New York 199, 371

Moore, Gregg Glenside, Pennsylvania 298

Moore, Tony Cold Spring, New York 348

Morgin, Kristen L. Long Beach, California 331

Morris, Paul F. Fort Collins, Colorado 23

Moyer, Matt Columbia, Missouri 99

Müller, Thomas Los Angeles, California 313

Muller –B– Zurich, Switzerland 333, 369

N

Nakamura, Yuki Tacoma, Washington 397

Newsome, Allison Warren, Rhode Island 323

Nichols, Jean Cappadonna Fort Myers, Florida 256

Nichols, Jeffrey Morehead, Kentucky 44

Nolan, Jennifer Mettlen Dodge City, Kansas 175

O

Oberman, Jill Winnetica, Illinois 195

Oh, KyoungHwa Carbondale, Illinois 124

Olson, Carrie Edith Granville, Ohio 129

Olson, Charlie Fort Atkinson, Wisconsin 297

Opgenhaffen, Jeanne Kruibeke, Belgium 288, 354

Ornelas, Juan Carlos Bell, California 328

Otterson, Helen West Palm Beach, Florida 179

Ouellette, Kathy Quebec City, Quebec, Canada 400

P

Packer, David New York, New York 388

Page, Joseph Alfred, New York 399

Paikkari, Pekka Talma, Finland 7, 352, 404, 412

Pakarklyte, Ruta Fagerstrand, Norway 80

Palacios, Vince Macomb, Illinois 43, 283

Pantazi, Antigoni Athens, Greece 287

Paquette, Yves Savannah, Georgia 204

Pärnamets, Kadri Tallinn, Estonia 25

Paschke, Allison Providence, Rhode Island 118

Paul, Adelaide Philadelphia, Pennsylvania 137, 200

Pei, Xueli Suzhou, Jiangsu Province, China 69

Peleg, Rina New York, New York 347, 374, 387

Pelletier, Denise East Greenwich, Rhode Island 362, 403

Perez, Rafael Haro, Spain 88, 140, 205

Peters, E. Elizabeth Staatsburg, New York 158, 402

Pintz, Joseph E. Bowling Green, Ohio 82

Popova, Biliana La Crescenta, California 76

Portigal, Steven Culver City, California 40

Posthuma, Rem Amsterdam, Netherlands 324

Potter, Anne Drew Helena, Montana 249, 271

Powell, Anita D. Muncie, Indiana 166

Prouty, Nathan Philadelphia, Pennsylvania 87, 154, 210

Pütz, Gabriele Bad Honnef, Germany 296, 367

Q

Quadrone, Gina Buffalo, New York 68

R

Ragguette, Alison Petty Claremont, California 62

Raphael, Robert Brooklyn, New York 282, 327

Rasmussen, Merete London, England 170

Raude, Maruta Riga, Latvia 159

Reese, Claudia Austin, Texas 383

Reijnders, Anton 's-Hertogenbosch, Netherlands 295

Rieger, Patricia Oak Park, Illinois 277

Rogers, Andy Maryville, Missouri 151

Rogers, Jennifer Brooklyn Center, Minnesota 408

Roloff, John Oakland, California 332

Romule, Ilona Riga, Latvia 209

Rosen, Annabeth Davis, California 184, 223

Rosenbaum, Allan Richmond, Virginia 86

Rottach, Lazare Becker, Minnesota 107

Rowan, Tim Stone Ridge, New York 83

Rowley, Johannette Honolulu, Hawaii 218